LEONARDO'S
HOLY CHILD

The Discovery of a Leonardo da Vinci Masterpiece:
A Connoisseur's Search for Lost Art in America

A MEMOIR OF DISCOVERY BY

FRED R. KLINE

PEGASUS BOOKS
NEW YORK LONDON

LEONARDO'S HOLY CHILD

Pegasus Books Ltd.
80 Broad Street, 5th Floor
New York, NY 10004

First Pegasus Books cloth edition April 2016

Interior design by Maria Fernandez

Library of Congress Cataloging-in-Publication Data is available.

ISBN: 978-1-60598-979-2

10 9 8 7 6 5 4 3 2 1

Printed in the United States of America
Distributed by W. W. Norton & Company

In memory
Jann Arbogust Kline (1945–2011)
Long lost
Long found
Love by my side

Connoisseurship, in the technical sense of identifying the authors of works of art, is not exactly a science, in the sense of being a rational system of inference from verifiable data, nor is it exactly an art. It stands somewhere between the two and it calls for a particular combination of qualities of mind, some more scientific than artistic, and others more artistic than scientific: [1] a visual memory for compositions and details of compositions, [2] exhaustive knowledge of the school or period in question, [3] an awareness of all the possible answers, [4] a sense of artistic quality, [5] a capacity for assessing evidence, and [6] a power of empathy with the creative processes of each individual artist and a positive conception of him as an individual artistic personality.

[Appended by Brigstocke and Osborne] Connoisseurs have no quarrel with those who prefer to study art in terms of social context, iconography, or the history of taste. However, their respect for the artist and the identification of his work is fundamental to the discipline of art history and to the informed appreciation of works of art.

—John Gere (1921–1995), British art historian, curator, connoisseur of Old Master drawings: as quoted in the essay "Connoisseur, Connoisseurship" by Hugh Brigstocke, with Harold Osborne/ *The Oxford Companion to Western Art*, Hugh Brigstocke, Editor (2001)

I believe in intuition and inspiration. Imagination is more important than knowledge. For knowledge is limited, whereas imagination embraces the entire world, stimulating progress, giving birth to evolution. It is, strictly speaking, a real factor in scientific research.

—Albert Einstein (1879–1955, German-American
theoretical physicist and philosopher)

Where observation is concerned, chance favors only the prepared mind.

—Louis Pasteur (1822–1895, French chemist
and microbiologist)

I do not know what I may appear to the world; but to myself I seem to have been only a boy playing on the seashore, and diverting myself in now and then finding a smoother pebble or a prettier shell than ordinary, whilst the great ocean of truth lay all undiscovered before me.

—Sir Isaac Newton (1642–1727, English physicist),
Memoirs of Newton

For me, a picture is neither an end nor an achievement but rather a lucky chance, an art experience. I try to represent what I have found, not what I am seeking. I do not seek . . . I find.

—Pablo Picasso (1881–1973, Spanish artist)

CONTENTS

PART I
Leonardo's Holy Child

CHAPTER 1

The Discovery

Discovery consists of seeing what everybody has seen and thinking what nobody has thought . . . a discovery is said to be an accident meeting a prepared mind.

—Albert von Szent-Gyorgyi (Hungarian-American scientist, 1893–1986)

Three classes: Those who see, Those who see when shown, Those who do not see.

—Leonardo da Vinci (Florentine artist, scientist, and thinker, 1452–1519)

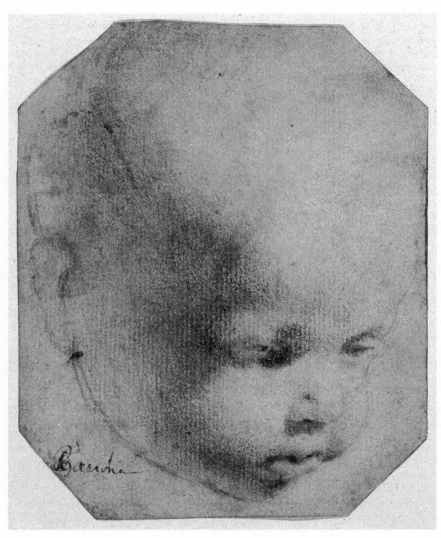

Leonardo da Vinci, *Holy Child.*
Copyright © 2016, Kline Art Research Library

T he child appeared, not like the drawing it was, but like a living thing, the head of a baby so delicately rendered as if blown onto the paper by the wind, or by an artist with magical powers.

The child looked spellbound by something outside of the picture. And there I was, spellbound, looking at him for the first time.

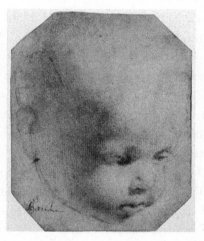

The drawing as presented in black and white in Christie's East catalogue, attributed to
"Annibale Carracci, The head of a child looking down: Red chalk on paper, 5¼ x 4¼ inches"

By chance, since I was not a subscriber, the Christie's East auction catalogue had come in the mail to my gallery in Santa Fe. A small black-and-white image in the catalogue (in reality it was drawn in red chalk) had spoken instantly of genius and beauty.

Recognition came like a shock, as nothing less than an epiphany, a bolt from the blue. *Leonardo da Vinci!* Could it possibly be?

As it was attributed to Annibale Carracci (1560–1609), one of the great Italian Old Masters, the specialist at Christie's had apparently agreed and confirmed the age of the drawing, and even its quality, and given it Old Master status. The cataloguer had also confirmed the Carracci idea, which was vaguely suggested by the boldly written antique inscription on the drawing which I could not see clearly in the catalogue at first glance. But Christie's was wrong about the artist. I knew Carracci's drawings, and owned a beautiful one myself. I quickly rejected the idea of his authorship.

It was an old attribution, always a problematical clue that warranted a second guess, written in by a collector to establish his opinion or by a long-gone dealer to facilitate a sale.

I recalled images from many past studies of Leonardo's complete works and remembered a child standing out in several large photographs of paintings in a book I had recently bought about Leonardo's early years. It was uncanny. I found the book in my library and looked for the blown-up images of the paintings representing Infant Jesus. Then I made a quick comparative study with the catalogue image. I was right. The drawing seemed to have a clear relationship to Leonardo's two earliest paintings of the Madonna and Child from the 1470s, specifically to the head of Infant Jesus. None of Leonardo's other drawings were suggesting themselves the way that drawing in the catalogue did. I put the book away and resisted looking at the paintings again. I had to settle down.

From what I could see in the small catalogue photograph, this drawing had a very high quality, particularly in the unusual sensitivity of the face. I wanted to call Christie's for more information, to supply a larger color image or at least offer a word about its history and condition. I could see it was in amazingly good condition, but you never know about old repairs and added makeovers. But I decided not to alert Christie's to my interest. I felt the best strategy was to run with what I had been given.

I have been studying, buying and selling, and enjoying as a collector Old Master drawings for over thirty years. Even as a black-and-white reproduction, just the direct intuitive feel of this drawing suggested that it could be from the Italian Renaissance, and even more directly suggested the Florentine style of portraiture of the 1450–1550 period. I could count on its not being a print placed by mistake in a drawings sale or a copy of a famous drawing, which I would have remembered. No other artist but Leonardo was talking to me. I stretched my visual memory and raced through my books into the 15th, 16th, 17th centuries, and no other artists' style came readily to mind or asserted itself in other drawings the more I looked at his tiny face. I really needed to settle down! A drawing by Leonardo da Vinci was the holy grail of lost art by any reckoning—the wildest dream! Leonardo's drawings just don't turn up, and even a

scrap with sketched ideas would bring millions of dollars at auction. An unknown lost drawing floating around at a major auction house in New York City, a beautiful drawing of the highest quality which I actually thought could be Leonardo da Vinci had to be a daydream, my imagination riding a runaway horse.

Authenticated drawings by Leonardo are extremely rare in the art market, since virtually all of them are accounted for in museums and libraries and in a few in private collections. The rare and established Leonardo drawing appears from time to time to be sold usually at public auction with its worldwide audience of bidders. The latest sale in 2001, at Christie's London, came from a renowned estate where it had been since the 1930s—an exquisite horse and rider, a very small study related to Leonardo's famous painting *Adoration of the Magi*; it sold for $11.5 million. The drawing was well established—essentially signed, sealed, delivered—awaiting some very wealthy buyer who in this case bid over the telephone. The buyer's name and location remain known only to Christie's, who have no legal obligation to disclose a buyer or a seller. Eventually, the mysterious new owner may be recognized by a loan of the drawing to an exhibition or by the new owner donating to a museum for public enjoyment (and possibly for an income-tax deduction).

Even a very public auction holds many secrets. The drawing of the child I was studying was oddly listed in the catalogue with no provenance, not even the usual anonymous "Private Collection," which could mean practically anyone, or any group, although I could feel assured it was at least not stolen. Had the drawing materialized out of nowhere? This was another strange and invisible clue I had to think about as I puzzled over the drawing's true artist.

Drawings by Leonardo are scattered in only a few museums, but the vast majority are found in institutional collections of his notebooks called codices, which are several thousand pages of illustrated manuscripts, written left-handed in his amazing mirror (backward) script and containing thousands of drawings of varied size, quality, and finish, ranging from scientific and anatomical studies, studies for paintings, to a multitude of sketched-out random ideas, and even doodles. These codices are kept for

the most part in historic and national libraries in Great Britain, France, and Italy. The Queen of England owns the Codex Windsor, which contain the finest finished drawings. The Codex Atlanticus at the Biblioteca Ambrosiana in Milan is the largest set, with twelve notebooks of drawings and writings on every conceivable subject. Bill and Melinda Gates own the Codex Leicester, which theorizes—often correctly in light of future studies—about the flow of rivers, celestial moonlight, and fossils found on mountains—a playful and poetic mix, very much in keeping with Leonardo's character. No unknown single drawing of major importance by Leonardo had been discovered and universally accepted for over a hundred years. A few odd sheets with notes and sketches have turned up and are quickly grabbed by the wealthiest museums like the Metropolitan Museum in New York or the Getty in California. A suggested Leonardo drawing that suddenly appears may have been put forth by an institutional scholar who has rummaged through their museum's archival drawers. It is then duly received with academic debate, which often continues for a lifetime. The Met's Leonardo specialist, Carmen Bambach, attributed and published such a Leonardo drawing in 2003—a rich portrait-like study of the Virgin Mary that was originally acquired by the Met in 1951—and her museum has accepted it as Leonardo. Most of Leonardo's drawings have never been seen by the general public—books are essentially the only place to go, and happily there are many where Leonardo is on "exhibit" in full glory.

<p style="text-align:center">∽✇∾</p>

In spite of all the roadblocks cautioning *"Dead End—No More Lost Drawings to Be Found,"* the pensive child in the Christie's catalogue would not stop whispering Leonardo to me, and I have learned over the past thirty-five years that my eye, and my instinct, can be trusted.

So I kept listening and started to dig. I returned to the book with the beautiful illustrations of Leonardo's earliest Madonna paintings, *Leonardo da Vinci, Origins of a Genius* by the National Gallery of Art specialist David Alan Brown. In both of the paintings, *Madonna of the Carnation*

and *Benois Madonna*, the head and focused look of Infant Jesus compared almost exactly to the infant in the drawing, who appeared to be looking at something out of the picture. In the two paintings, Infant Jesus was looking at a flower, which was missing from the drawing. In the drawing, the infant was looking pensively at something out of the picture— conceivably a flower. The correspondences seemed too good to be true. Using my normal test of going beyond my eye to testing the signature comparative details, comparing the drawing of the child with the two established paintings by Leonardo, I could see the clear relationship in all three of their contemplative faces.

Although changes in Leonardo's drawings usually occur from initial sketches to a fully realized painting, his preparatory drawings are more highly finished and change very little. The drawing in the catalogue appeared to be a preparatory drawing. With the all-important attitude of the child's eyes looking with that focused, curious intention—showing intention being one of Leonardo's guiding artistic principles—combined with the twin-like shape of the infant's head, cheeks, nose, mouth, and chin, I could see the distinct correspondences from drawing to these two paintings that featured the Infant Jesus. It was uncanny.

The drawing, which would have come prior to either of these paintings, must have been a remarkably quick, yet superbly finished, sketch from life of a momentarily distracted baby; a flower, likely his first flower, would have been a perfect distraction. The paintings of course would be developed slowly over a much longer period of time. Yet clearly the drawing and the paintings were tied together in an integral and timely relationship. The two paintings were from the 1470s. For comparison, however, there were no 1470s portrait drawings of a child by Leonardo yet found. The 1470s are considered Leonardo's lost period. Only a handful of drawings and three paintings—including these two—were known to exist from this time when he was in the Florence workshop-studio of his teacher, the renowned artist Andrea del Verrocchio (1435–1488). It would certainly fill a hole of a missing preparatory drawing to coincide with the two paintings from this period. Could the child be one of the lost works? It was a riveting question.

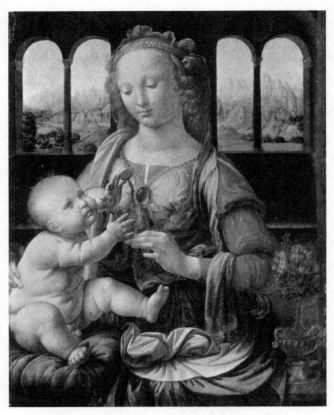

Leonardo da Vinci, *Madonna of the Carnation*, 1470s, Munich

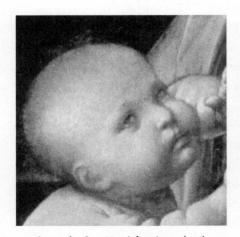

Leonardo, *Carnation*, Infant Jesus, detail

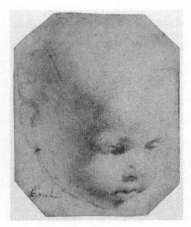

Christie's East catalogue image

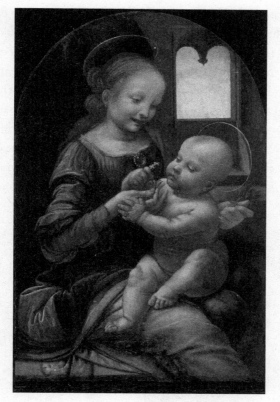

Leonardo da Vinci, *Benois Madonna*, 1470s, St. Petersburg

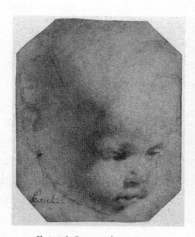

Christie's East catalogue image

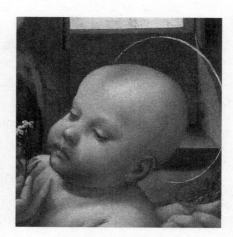

Benois Madonna, Infant Jesus

My intuition was telling me I still had something more to do. I imagined the child in the drawing reversed (see illustration below), looking the other way, as he was in the painting. My wife, Jann, who was also my gallery partner and now sharing my excitement with the drawing, ran the catalogue image through several computer processes and photographically reversed the image of the drawing for comparative study with Infant Jesus in the *Benois Madonna*. This procedure, I suddenly realized, was in the manner of Leonardo's mirror writing, which would automatically reposition the child in the drawing to be looking left instead of right. He might have done that very reversal holding the original drawing up to the light. Leonardo was teaching me one of his tricks.

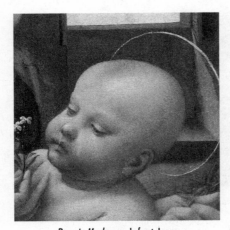
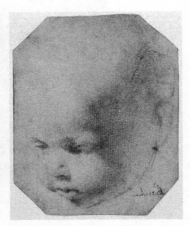

Benois Madonna, Infant Jesus *Benois Madonna*, Infant Jesus Catalogue image reversed

With the reversal, a very close relationship between the drawing and the paintings materialized. There it was! Infant Jesus in both early paintings appeared to be an acceptable revision of the drawing, given the overall composition of the two paintings.

Drawings are always altered in some way when transferred into a painting. A drawing from life, as the child appeared to be, would be true to life; a painting was a fiction more creatively rendered, with imaginative revisions responding to new suggestions and inspirations in the artist's mind. So the painted child would normally change from the drawn child. I was making slow, careful steps.

My logical assumption was that the drawing very likely could have provided the model for the two paintings. At this point, I was taking a

leap of faith like the daring young man on the flying trapeze. With the good visual evidence I had already found, my intuition and imagination was carrying me off. I knew Leonardo was there, but I was still in midair.

❦

Christie's improbably low auction estimate of $1,500 to $2,000 for such a beautiful drawing, the weird attribution to Annibale Carracci, the mixed-bag of a minor sale—it all seemed surreal. The sale was scheduled for May 23, 2000, and in the days preceding the sale I would look at the catalogue again and again, just think about the drawing, go to sleep thinking about Leonardo, all the while asking myself if it could possibly be anyone else.

Jann looked at me one day. "You're buzzin'," she said. And I was, like a honeybee around a flower.

I remembered a fine realistic portrait drawing of a young boy named Quaratesi and another of a bambino by Michelangelo, Leonardo's younger rival. I went through all Michelangelo's known drawings in my library, a sparse body of work due to the fact that most have been lost. I compared the drawing of the child with the closest established drawings by Michelangelo and I could see from his distinctive styles of drawing it was *not* Michelangelo. One down.

Michelangelo, *Portrait of Andrea Quaratesi*, ca 1528–1532,
Black chalk, British Museum, London

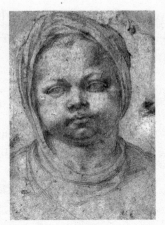 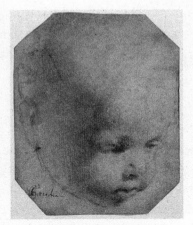

Michelangelo, *Head of a Child*, ca 1525, *Head of a Child*, Christie's catalogue
Black chalk, Teyler Museum, Haarlem

⁓

"Besides learning to see, there is another art to be learned—*not* to see what is not," wrote the American astronomer, Maria Mitchell (1818–1889), who, after a lifetime of looking at the stars, noted this insight in her journal. It had resonated with me. I had been learning that lesson over many years with my own constellation of art discoveries and could only hope that I had finally learned *to see what is*. And of course it remained to be seen if I could buy the drawing against the expected competition at auction and then, even if I succeeded, could I then prove it was Leonardo, as I now believed. Lost art is a point of light, flickering in the earthy sphere, and I was looking very closely at the outer limits of possibility with the Leonardo question and remembering how my quest for lost art had begun in earnest, back in 1984. The auction was a week away.

⁓

"Where do we come from? What are we? Where are we going?" It was late at night and I was thinking about Gauguin, thinking about the title and looking at this very painting in a book. I was dreaming of his escape to

Tahiti and his new life as an artist. At the time, 1984 in San Antonio, I was at loose ends myself, divorced and living alone, working at a silly make-do job, and those were my questions too. I had just bought a $5 painting in a thrift shop which suggested a Gauguin Breton landscape, but alas, it was not Gauguin. In fact, with closer study and the backing removed from the frame which hid a modern context, it was laughable to think so. My imagination was too hopeful and I knew it. But I had allowed the thrift store painting to lead me to the real Gauguin in my mind and then to Gauguin's paintings in one of the beautifully illustrated books in the Time-Life Library of Art series, which I always kept around, and that in itself was wonderful. In the face of this irrational and unlikely chance encounter, I had a sudden awakening. There I was, walking on a glimmering road and searching for lost art in America, with a spring in my step—having fun! My mind and heart were dancing and I went singing out into the night! That was the person I wanted to be. And I was shouting *Yes! Yes!* as I walked and waking the neighborhood.

Fred R. Kline, *Revelation*
12 x 18 in., mixed media,
collection of the artist

I recognized that my search for lost art, which I call *art exploring*, would be an improbable and romantic occupation based on the chance of discovery

and faith in my eye and my scholarship. Yet my heart was in it, and the ways of the heart are mysterious and defy logic. This was a calculated gamble that somehow inspired me to go on in spite of great obstacles that invariably develop in any exploration worth doing. Against all odds and good sense, there is passion.

And so my quest began. I looked for lost art everywhere. It washed in like flotsam and jetsam to consignment shops and flea markets. I ran ads in local newspapers seeking to buy art, "Any Subject, Any Condition." I searched through antique shops. At estate and storage sales, I found wayward art hung on dark walls, stuffed roughly in filthy bins, stored in cluttered closets, forgotten in attics and basements. In auction catalogues, in worldwide public view, unnoticed art awaited recognition. Among the thousand choices, I was searching for lost masterpieces. Good luck, pilgrim!

The *Metaphysics of Chance*—my invented concept—had revealed to me an often-unrecognized, unexploited, and little-understood force at play in my life. Coincidence and luck cannot really explain the idea. The best definition I have come up with is *the play of things in the poem of the world*, a tantalizing metaphor, which also falls short of a rational or scientific explanation. Perhaps the formula might be *chance + an attitude of serendipity = opportunity*. Aristotle had offered his explanation: "Every action must be due to one or the other of seven causes: Chance, Nature, Compulsion, Habit, Reasoning, Anger, or Appetite." That pretty well covers it. In any case, the poet in me understood.

Somehow, I made the Aristotelian principle of chance work for me in a thrilling way and over a long period of time. It was like a resurrection from the mundane of everyday life, and so life became the unscheduled adventure I wanted it to be. My motto became: *If anything can be anywhere, then chance will favor the prepared mind.* The chaos of the universe can only be tamed one adventure at a time.

Most of my art adventures dealt with chance discoveries of actual lost art. The identities of the artists were most often a mystery until I was able to prove a name and finally associate them into the wider work of an artist. I then hoped the artwork in question could take its place in the archives of art history, and then at long last (and with luck) take

a necessary place into my impatient bank account. This would at least validate and encourage my precarious livelihood. Nevertheless, most of the time, Jann and I worked without the assistance of financial security. I always seemed to have enough because lost art was rarely too expensive to purchase. Most of my work was done for long periods without a research staff—just Jann and me—and in this I am no different than an inventor or a consumed artist, working away in obscurity on a new idea floating in the air. In fact, I am also an artist under the skin, painting and sculpting my own work, seeking a title for the illusive image of myself and for the world beyond its obvious appearance.

Before I embarked on my quest for lost art, I had to know a lot about art and art history, retain it, and be willing to learn a great deal more. That, of course, was imperative. I had a rare comparative eye, a talent which could spot established quality and relationships in art's many distinctions. Yet I also knew the eye can be fooled, which is why I knew to look again. And again. Beyond the blink, there comes the stare of judgment.

There was no model lifestyle I could follow with my underfunded quest, so I invented one that suited me. My combined decade as a journalist and sometime Arctic explorer at *National Geographic* magazine in the 1970s and as an English teacher, lastly at Cornell, offered few clues to the eccentric direction where I was headed. I had grabbed many tempting golden rings on my merry-go-round ride but never kept them for long. I had tried the corporate life, but soon enough I knew it was not for me. I needed a vocation where I was constantly inventing myself with new challenges.

There was something deeper that came from my inner poet, a clear direction I tacked up in a terse note to myself: "A Poet Must Be a Poet or Die!" With that feeling of enlightened desperation, I said this once to a remarkable teacher I encountered, Joseph Campbell (1904–1987), the mythologist and philosopher, whose books and lectures had inspired my quest. We were smoking a cigarette together during a break in his seminar, teacher and student chatting on a lovely day in Santa Fe in 1981. Joe gave me a big smile and raised both hands in a victory salute and said one word: "Perfect!"

Every good myth needs a hero and heroine, and I held the nurturing dream of participating in my own personal mythology and made friends with the muses of art and poetry. The idea of seeing my life as a poem inspired me and even made good sense. I wanted it all and I wanted to do it my way.

The closest historical model I could find for my chosen path—which combined art explorer, scholar, art dealer, connoisseur, and poet—was Bernard Berenson (1865–1959), whom I admired although we were as different as day and night in personality and life experience. Berenson was a proper, snobbish, Edwardian-era, Harvard-educated Bostonian and a self-made connoisseur of Italian Renaissance art. An exemplary connoisseur. He lived most of his life in Italy and bought and sold and authenticated Old Master paintings through the moneyed assistance and the elegant galleries of Joseph Duveen (1869–1939), a charming and clever man and the leading art dealer of his time. As a team, Berenson the connoisseur and Duveen the dealer astutely bought great paintings from European aristocrats who needed money and then sold them for a huge profit to the legendary millionaire Americans of the time, including John D. Rockefeller, J. P. Morgan, Andrew Mellon, and Isabella Stewart Gardner, who was Berenson's earliest benefactor. Duveen often wisely noted that "When you pay a high price for the priceless, you're getting it cheap." Seeing today's astronomical prices in the art marketplace, Duveen's maxim has stood the test of time. The statistics regarding Berenson's attributions of unsigned Renaissance paintings over his long life can be appreciated today as about 70% correct and 30% close, if debatable, but I have never heard of a fake in the bunch. That's as close to a perfect eye as anyone practicing connoisseurship could hope for. But then, he was a specialist in Italian Renaissance artists, and he would have been skeptical of my idealistic approach to connoisseurship and my attempt to be a generalist in art history.

Then I discovered Eugene Victor Thaw, who I felt epitomized the world-class art dealer. Thaw fit my ideal model even better than Berenson, and I admired him from afar. We had a brief telephone acquaintance from my base in Santa Fe to his private Park Avenue gallery in Manhattan, and he was always friendly and helpful. Then suddenly he was

retiring—semi-retiring as he called it—to Santa Fe, of all places! Of all wonderful coincidences, combined with his surprising kindness, we became friends. Gene Thaw improved and considerably updated my ideal by bringing in facets of scholarship, collecting, and philanthropy, and he too never lost his thrill for exploration.

Thaw regaled me once with the story of his finding van Gogh's gorgeous *Garden with Flowers* under the bed of a wealthy elderly woman in Switzerland who had nervously kept it there for years. She asked him to please take it off her hands. He obligingly paid her a princely sum, which later blossomed into a king's ransom when he sold it to the Met for $40 million. This nest egg became the Thaw Charitable Trust and the vehicle of his donations to the arts.

Gene became a friend and my most supportive collector. In 1988, when we actually met for the first time, he had just moved to Santa Fe, where he began to collect historic American Indian art, which had never been a commercial interest of his, but a private passion. Historic American Indian art was a far cry from his dealing in Rembrandt, Goya, and van Gogh, but he dove headlong into it and amassed one of the great private collections in America, now housed in the Eugene and Clare Thaw wing of the Fenimore Art Museum in Cooperstown, New York. To qualify for his attention, a work of art had only to be "rare and beautiful." Money was no object if he truly loved it. This was my dream approach to collecting—which, of course, did not happen every day.

But one day it did happen. After several years of Thaw's always instructional rejection of minor offerings, the great moment arrived with his first purchase from me of a rare and beautiful (unsigned) Old Master drawing by the Austrian-German master Joseph Anton Koch (1768–1839), who was virtually unrepresented in American museums. I had literally kicked over the drawing while it rested on the floor of an obscure flea market shop in San Antonio, Texas. And so it entered the Thaw Collection of Master Drawings at the Morgan Library in New York, to be joined by many other discoveries I offered to him. A magic door had opened. Over the next twenty years, Eugene Thaw would again and again make my day. With his inspiration and advice, I sharpened my eye and learned a great deal about connoisseurship—including

study of drawings, importance of provenance, concentration on works of the masters, and not least integrity.

Both Berenson and Thaw were art dealers who operated on a grand scale. Thanks to their connoisseurship and the earned trust of collectors, museums around the world are filled with their carefully selected masterpieces. In Thaw's case, no dealer in history has been a greater philanthropist. The Morgan Library alone has received his collection of master drawings, including sketchbooks of French masters Cezanne and Degas. The entire Thaw collection donated to the Morgan is valued at more than $100 million. Unlikely as it may seem, Thaw also established the catalogue raisonne of abstract expressionist Jackson Pollock, which he co-authored with Francis V. O'Connor. Thaw often accepted the ultimate challenge of authenticating the cosmic chaos of Pollock paintings and drawings against hundreds of hopeful bad ideas and endless forgeries. From the refined drawings of Degas to the ethereal swirls and dancing lines of Pollock, Thaw's journey as a connoisseur was one only a poet could make successfully. Few can compete with Thaw's legacy of art giving except perhaps the actual artists and their works, which represent a life of dedicated creativity.

<p style="text-align:center">∽</p>

At first I just danced around the Leonardo idea, as I was busy with my Santa Fe gallery and trying to talk myself out of magical thinking. I put my normally intense research process on hold. It seemed too good to be true, or else too good to be false. Much deeper testing was needed. I kept looking at the catalogue image, dreaming about it, imagining it in red chalk, memorizing and comparing it with a wide range of artists' drawings, and letting it settle in my mind, which I admit was racing.

I showed the image again to Jann, whose judgment always offered fresh insight and the perfect balance to my enthusiasms. I told her again of my epiphany and all my ideas about the drawing. She smiled. "It's very beautiful. Do you really think it could be Leonardo?" She knew I did.

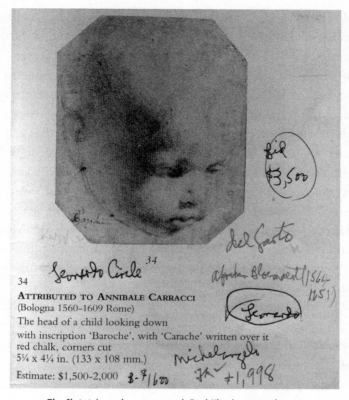

The Christie's catalogue page with Fred Kline's scattered notes

I took time to concentrate on the given evidence. The drawing was titled *The Head of a Child Looking Down.* The authorship had been oddly given to Annibale Carracci (Italy, 1560–1609). I tested the attribution again and included Carracci's paintings, which might have suggested an idea for a study drawing, but it was clear Christie's was mistaken. Annibale Carracci was a great and innovative Italian artist, a brilliant draftsman of many elusive styles with a workshop of talented artists, but someone had grabbed the idea by an odd misreading of the name that was written on the drawing. Under high magnification of the drawing in the catalogue, I was able to read it as something closer to "Barocci," which was clearly the original attribution; but was it the *true* attribution? I was certain it was not a signature, judging from its careless placement and the insensitive, boldly written name in ink on a red chalk drawing. Federico Barocci (Italy,

1535–1612) was another classic Italian artist I had studied. After looking again at Barocci's beautiful paintings and drawings, I thought the drawing was much closer to Barocci in a superficial way but still wrong. Barocci drew uniformly in colored chalks, sometimes black chalk, but never to my knowledge red chalk, and I could not see the ethereal elegance of his style in this drawing of an infant. Old attributions are often mistaken or hopeful, although they are sometimes correct, and thus always worth investigating. In any case, the antique inscription, written in what appeared to be French, I thought actually read "Barache," or "Carache" if misread by an English speaker. No provenance was listed in the catalogue—not even "Private Collection." How very strange. It had appeared without the entourage of provenance—the known history of previous ownership. Apparently, it had come out of nowhere and was just tossed into this minor auction. France, long ago, seemed the only previous direction. Leonardo had died in France in 1519.

How could Christie's have made this error in judgment? Old Master drawings in particular, which come to auction houses like Christie's and Sotheby's without the support of research or provenance or an established attribution, require the trained eye of a connoisseur in search of a credible answer or an educated guess. They would come up with the name of an artist or a follower associated with the style or the subject, or possibly find a painting where the echo of the drawing might be recognized. It is a difficult and demanding specialty to practice successfully. Finally, it depends subjectively on who is looking and if they think it is worth continued investigation. Christie's attributor was probably inexperienced and working quickly to complete catalogue descriptions in this secondary, lesser sale.

Many errors in judgment with Old Master drawings occur at auctions and within the broader art market, and with Old Master paintings as well. I knew from past success that it was always a good place to search for lost art, but past failures haunted me.

My hope of buying *Head of a Child* began to fade as I vividly remembered my excitement around a Flemish school drawing I had bid on—and lost—at a Sotheby's Old Master drawings auction a year before. I believed that the drawing was by Pieter Brueghel the Elder (1525–1569), the greatest Netherlandish painter and draftsman of the 16th century.

The small drawing had depicted a detailed village landscape of Brueghel's time, made in his exquisitely detailed and sharp-pencil style of drawing. It fit perfectly comparative into his rare and immensely valuable body of drawings. I supported my idea with renewed study of all Brueghel's known works represented in my library. I was also guided by previous encounters with the Brueghel family. I had already discovered two lost, unsigned paintings by his famous son, Jan Brueghel the Elder, and both works were now accredited in the catalogue raisonne of his paintings. Both were mythological scenes. The first, an unsigned and unattributed painting of Orpheus playing music in an Edenic paradise, had been offered to me out of the blue by a stranger in a consignment shop; the second, which I spotted years later unattributed in an auction, depicted satyrs leering at sleeping nymphs. But Pieter Brueghel was the rarest treasure, another elusive holy grail of lost art. Only a small group of artists would fit that category, Pieter Brueghel the Elder and Leonardo da Vinci foremost among them. My Brueghel idea, I admit, would have been obvious if you had studied his works. Could Brueghel have done it? Imagination and connoisseurship would have answered *yes*. I was not naïve enough to believe I was one in a million who could have imagined it, but then again I had been proved wrong about that many times. I stayed a little optimistic. The drawing was estimated with a mind-boggling lack of connoisseurship at a bargain-basement $3,000 to $4,000. I could not believe the estimate was actually a shrewd calculation on the part of Sotheby's for enticing bidders. That would have been reckless. It was clearly a mistake. I went overboard with my budget and bid $8,000. You never know. It sold for over $400,000! I lost it, but it was a clear win for the anonymous and clueless seller. It probably transformed later with a scholar's expertise into a Brueghel treasure that could be offered at $3 million.

The bidders on the Brueghel, probably a number of Dutch and Flemish dealers and collectors, were gambling a lot of money on their eye, no doubt seeing what I saw. The question remained if they could be proved right. Very likely, they *knew* they could be proved right. It was clear to me that the wealthy bidders had already found an art historian to support it. It was a pretty little feather to have in your scholar's cap and really not that difficult to accomplish with the traditional canon of the artist's complete

works at your fingertips and a perfectly typical drawing to authenticate. Pieter Brueghel's drawings and paintings were so rare and already so closely examined, in almost the same category with Leonardo, that no single scholar was standing by to sanctify it, as it was also with what I believed to be my Leonardo. There would have been many scholar candidates willing to write an erudite authenticating essay for an enticing fee. The likely buyer at $400,000, with a chosen scholar in place, would succeed in establishing its authenticity and its value. The Old Master drawings field had many dealers and collectors in that category. Not that the truth of the drawing might be fabricated—like finding someone to justify a found scribble as Jackson Pollock—but today's legal risks involved with connoisseurship and very valuable art had to be compensated. Fakes were hiding under every rock. The caution today was not just *buyer beware* but *dealer beware* as well. I too would have found a way had I won the prize with my optimistic $8,000, but at best I had only managed a small walk-on part and the thrill of being right. Pieter Brueghel was the only answer. The odds were astronomical for finding a great unknown Brueghel drawing at Sotheby's or Christie's with an absurd $2,000 reserve (usually half of the low estimate), but I am certain that is exactly what happened. Yet I couldn't imagine the owner and the auction specialists agreeing to just letting it go and relying on the market to decide. That experience still had an amazingly lucky ending, except for me. I had missed out.

❦

Art auctions have a little-known twilight zone which have always offered me some of my best discoveries, but I had missed buying many as well. I feared the *Head of a Child* was another sleeper and would probably go through the roof. All I could think of were worst-case scenarios for myself. A biblical hex was needed to stop anyone from seeing it. *Head of a Child* would of course have a stratospheric value if proven to be Leonardo, obviously a wondrous thought. But there was more to it than that for Jann and me. A distant memory floated to the surface.

"The baby is so beautiful, you have to bid, so just do it," Jann said. "It reminds me of our Peruzzi *Holy Family*."

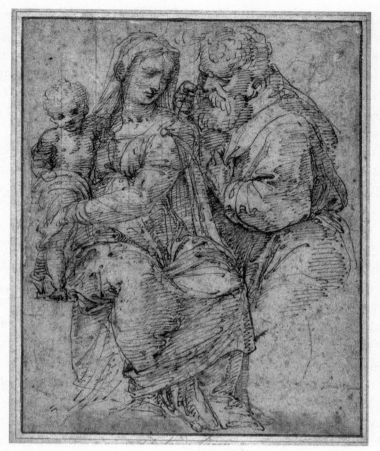

Baldassare Peruzzi, *Holy Family*, Getty Museum. (Ex-Collection, Jann and Fred Kline)

The Peruzzi had been on my mind too, the magnificent Renaissance drawing by Baldassare Peruzzi that had been in Jann's collection since her college days. It had also been my first venture as a dealer into Old Master drawings with its many lessons, which included insight into Machiavellian art politics as practiced by museums and curators.

But Jann was thinking of something else as well. "The reason I kept the Peruzzi with me all those years, the Holy Family . . . us . . . our lost child . . . our lost love . . . I could never let it go." In spite of her restraint and mine, we could not hold back our tears in remembering. I too had suddenly felt an immediate and uncanny resonance with the drawing of a baby but

25

thought better about mentioning it. We had not brought up the subject for many years. Mention of the lost child from our youth, a very distant ghost, was actually a rare occurrence for us, bringing up the sad circumstance of a miscarriage forty years in the past, which precipitated our breaking up. Within our personal history, we had been childhood sweethearts, married others and had children, then miraculously found each other after 22 years and at last married, our love returning like a renewed spring.

"We did get another chance," I said. "We found love again, and the Peruzzi. Two treasures."

"Two miracles," Jann whispered.

<center>⚬∞⚬</center>

With the Christie's auction coming up, we built our strategy around $3,500, an embarrassingly paltry amount we could barely afford at that moment, yet it was a credible possibility knowing the reserve of $750 could have bought it if no one else decided to bid. It could happen. As usual, I had been spending too much time on finding and researching lost art projects and not enough time marketing and selling our inventory of artwork.

It was always touch and go for us. With a combined family of five children, a household to maintain, and the real challenge of supporting a gallery of fine art, it was a lot to juggle. Unlike most dealers, Jann and I worked a thin line of success or failure, without financial independence and with little in reserve, and with a workforce of just the two of us. Somehow, with this eccentric business plan, which more accurately was a labor of love while riding a rollercoaster's highs and lows, we had persevered and succeeded. Here and there we had even prospered, but we were not prosperous at this moment.

With Jann's encouragement, I settled on our optimistic bid and left it to the metaphysics of chance—as if I had a deeper understanding of it all. The goddess Fortuna might enjoy a laugh and show mercy. The sale was toward the end of the season, and it was filled with an eclectic mix of lesser and problematic Old Master and 19th century paintings and drawings and even a group of pretty frames thrown in for good measure. It was scheduled about a month before the important July Old Master sales at Christie's and

Sotheby's, which were both filled with anticipation. Christie's would be offering a great Michelangelo drawing (later sold for $12.5 million) and Sotheby's had a sheet of minor Leonardo sketches that would go unsold but after the auction sold for a reputed $1 million. I hoped these so-called important sales would be distracting. A few days before the sale, I faxed our bid of $3,500 and received a confirmation by reply. Then we waited. On the day of the auction we won the drawing for $1,700! It was as unlikely as hitting a lottery jackpot.

In that jubilant spirit, we closed the gallery for a long lunch at Santacafe and sat outside on their patio under a giant cottonwood tree, a celebratory party of two. Even the ancient cottonwood tree towering above us was celebrating, spring in this case, and a thousand cottonwood seeds were floating everywhere like confetti. We were in a New York mood and drank Manhattans with cottonwood seeds and they made very good cocktails that day. We looked around for resident movie stars. We waved to friends. A giant restaurant raven, as big as a rooster, began cawing overhead in our tree and I could tell what he wanted. I tossed a peace offering over from our platter of fried calamari and he quieted down when he spied it; he was playing a waiting game with obvious success. We toasted our recent 15th wedding anniversary. We reminisced about the time in the early 1960s, long before our marriage in 1985, when we had been childhood sweethearts and lost each other, and lost a child that had not made the passage into life, and then we drifted apart. It seemed obvious to both of us, without ever expressly saying so, that somehow the drawing of the child was imbued with that memory.

CHAPTER 2

Two Miracles

The wheel of fortune spins.
 —Traditional saying

A foolish faith in authority is the worst enemy of truth.
 —Albert Einstein (German-American
 physicist and philosopher, 1879–1955)

I t was 1966 and Jann was then twenty years old and a student at the University of Texas at Austin. Her flirting art history professor had stuck a note in a book he'd loaned her of Leonardo da Vinci's art works, remarking that she reminded him of Leonardo's beautiful Virgin Mary in the famous *Burlington House Cartoon*. The professor had a good eye. Jann and I were no longer dating in her college years. We had met four years earlier, and some of our initial dates were to the McNay Art Museum in San Antonio, where we loved to admire their small masterworks collection.

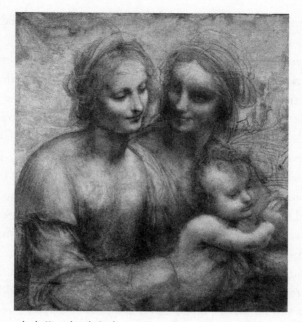

Leonardo da Vinci detail, *Burlington House Cartoon*, National Gallery, London
(Virgin Mary at left)

Jann had recently been asked to help out with the small estate of an elderly man who had died in a nursing home with no family to claim what few possessions he left behind, the most intriguing being a portfolio of antique Old Master prints and one Old Master drawing, a kind of scrapbook with loose leaves. Jann, who knew the owner of the nursing home, was asked to help evaluate the collection, which totaled some fifty items. While interesting, none had any assured authorship and none seemed especially valuable to her. Her knowledge of values and the art market, especially Old Masters, was very limited at this young age, but her museum and reading experience as an interested student of art history had been serious over the years, and she had an educated eye.

Two works from the estate collection at the nursing home caught Jann's eye, however, and one in particular. It was the only drawing in the group, a pen-and-brown-ink scene of the Holy Family. The other was a Dürer-like woodcut of St. Christopher carrying the Infant Jesus across a river. She did not hold back her enthusiasm for them. In both works, the drawing and the

woodcut, Infant Jesus was depicted, which she said influenced her prefer-
ence. Jann's week of researching the collection between classes included
driving seventy-five miles from Austin to San Antonio to show the works
to the imperious director of the McNay Art Museum, who lorded over their
small collection of master paintings, which she of course remembered from
our time there. The museum director, who had once been a minor curator
at Harvard's Fogg Museum, found nothing of notable value. Jann reported
back that no treasures had appeared in her research. In thanks for her help,
the owner of the nursing home gave Jann the drawing and the woodcut
she had so admired. Jann gave the St. Christopher woodcut to her parents
and she had the *Holy Family* framed and hung it in her college apartment.

The years passed. We had no contact after our early romance. After
college, Jann married, as did I, and we had our children. The drawing of
the Holy Family hung in a special place in Jann's home year after year. It
was her personal icon and not an object that she yearned to know more
about. *Who was the artist? When was it made? Where did it come from? Was
it valuable?* The questions simmered half-answered, but were not pursued;
Jann simply loved the drawing and that was enough.

In 1978, twelve years after *Holy Family* had entered Jann's small collec-
tion, a friend and former professor from her university days, Tom Cranfill,
took a good photograph of the drawing to Christie's London. There they
noted on the drawing two old attributions to the same artist. One was
written on the drawing itself and the other was on the old mount. Jann
had wisely left everything intact when she had it framed. The attribution
on the drawing was written in ink below the figures but it was so badly
faded it seemed someone long ago had tried to erase it and it was easily
missed. The other notation was clear and likely a much later transcription
in pencil. Both said "Baldassare da Siena."

This archaic nickname, first noted in 1563 by Giorgio Vasari in his
classic *Lives of the Most Excellent Painters, Sculptors, and Architects*, identi-
fied Baldassare Peruzzi (1481–1536)—Sienese painter, architect of St.
Peter's, draftsman, and stage designer. After Michelangelo and Raphael,
Peruzzi was widely considered the most important artist of the Roman
High Renaissance. However, Christie's response to the attribution kept it
deceitfully simple. They did not mention to Jann the slightest possibility of

it actually being by Peruzzi—a judgment that could have been based on its high quality alone—nor did they mention the extreme rarity or importance of his drawings nor was anything biographical mentioned. Christie's did not choose to get Jann's hopes up based on the inscription, which they knew was commonly added to old drawings and often just a mistaken guess, but in this case, noted twice on an extraordinary drawing, it might have been correct and a clue worth researching. Like his contemporary Michelangelo, whose drawings are also extremely rare, it would seem Peruzzi chose to keep his drawings locked away from possible plagiarists who might have stolen his ideas, a common problem. A body of many hundreds of drawings likely remained for both artists after their death but have since been lost.

"I think the attribution to Peruzzi is quite likely to be uncertain," wrote Christie's Noel Annesley in 1978 [he later became vice-chairman]. "Judging on pictorial style an attribution to Peruzzi's contemporary, Girolamo del Pacchia, is more plausible." This was an extremely odd statement. Drawings by Pacchia (1477–1535) were as unknown then as they are now—a shot in the dark. Christie's imperiously estimated the value of the drawing at a ridiculously low 1,000 to 1,500 pounds (which would have carried a 500 pound reserve). What could they have been thinking? No doubt—*Hush, hush, let's have an auction should she choose to sell this with us.* In spite of the insignificant value assigned to the drawing, Annesley could barely contain his enthusiasm for it and offered to lay out the red carpet if it were brought to London and Christie's might offer it at auction where "the drawing should still make an excellent price." Jann was not impressed with this sly, and puzzling, invitation to gamble away the drawing she so loved. She promptly forgot about it. Annesley's vague attribution, which did not attempt to educate her, and his timid estimate were both less than interesting, if not confusing. When she referred to the drawing she liked to say, with a little dramatic emphasis, that it was possibly by *Baldassare da Siena* and left it at that.

⌒∞⌒

When we first met, Jann had just turned seventeen and looked forward to her senior year in high school. We met at the swimming pool of Trinity

University in San Antonio during the summer of 1962. I was twenty-two, recently discharged from two years service in the Marine Corps, and had returned to college in my hometown and enrolled for the summer session. She had come to the swimming pool with a college friend of mine. We were immediately attracted to each other, but Jann was still sheltered by her parents and seriously constrained from going out with me. Thus we became Romeo and Juliet and began a clandestine romance that lasted into the summer of 1963.

<div align="center">∽</div>

During that year, I introduced Jann to the McNay Art Museum—a romantic, intimate, and breathtakingly beautiful Spanish Colonial–style villa that was filled with rare art from Marion Koogler McNay's personal collection. After Marion's death, her home became an endowed private museum, which opened to the public in 1954, free of charge. I had discovered its sanctuary early in high school, when it first opened, and still remember the quaint ritual of signing the guestbook, the only requirement for entry. Often I was the only person in the museum.

Jann and I had wandered through the collection on weekends and she studied every picture she stood in front of, absorbing and memorizing its qualities with deep concentration. Her hunger to learn about art was devoted and newly awakened. We returned again and again to our favorites: a van Gogh landscape, an El Greco head of Christ, Picasso's early portrait of a lady of the night, a Gauguin self-portrait with a Tahitian idol, Cezanne's man with a cigar that reminded me of Winston Churchill, Diego Rivera's tender portrait of a little girl named Delfina Flores (my personal favorite). Upstairs, in a chapel-like room filled with Old Masters and religious icons, a striking portrait of an Old Testament prophet attributed to Rembrandt attracted us. So friendly and uncrowded was the ambience that it seemed like our own collection. We ambled through the parklike grounds, kissing under mossy live oaks, enjoying a fountain's cool mist in our hair and the myriad flower gardens where the red canna bloomed. Few people were ever around. Back inside the quiet museum, we would steal more kisses, and the only person to glimpse us was the kind and elderly guard I remember

as Otto, a powerfully built German-Texan, whom I had known since high school and who treated us as sweetly as grandchildren. We adopted him and so had Mrs. McNay, who bequeathed him a lifetime job in her will.

Youth and ambition played out with their practical and unforeseen imperatives, which included Jann's pregnancy and miscarriage. Marriage, which had been our plan, now seemed a misplaced destiny and was not to be. We went our separate ways, both of us with broken hearts. Jann headed for the University of Texas with a choice of scholarships, and I was off to the University of the Americas in Mexico City, following my dream of being a writer. Our diverging roads through life would take us far away from each other. I later learned that those roads converged from time to time without our knowing it, so close, in fact, that I might have seen her on several occasions had I turned left instead of right. The wheel of fortune spins.

∞

By 1985, I had already been living back in San Antonio for several years, a self-imposed exile in my hometown after my divorce and early art-dealing days in Santa Fe. One afternoon my phone rang, and I wasn't there to answer. My machine took the call. It was Jann! "You probably don't remember me," her message began. I listened to it again and again. The shock was seismic after twenty-two years of total silence and no contact. I had thought about Jann often with deep affection and with a broken heart at what might have been.

The recorded message held me in a trance of tearful remembrance. How had she found me? Apparently, Jann had seen an article in *Texas Homes* magazine featuring less than a handful of art dealers across the state specializing in 19th and early 20th century Texas paintings—then a largely unexploited area of American art history and filled with rare works—and I was mentioned. She was now living in Austin and coming to San Antonio for a conference and wanted to make an appointment to see the art I was showing. I was then a private dealer working out of my home. I couldn't wait any longer and called her back. Neither of us knew what to say. We had a brief conversation and made a formal arrangement to meet the coming weekend.

I was at once panicked and thrilled that I might be pulled back into a past life with her, into sweet and bitter memories. I was now forty-five and Jann thirty-nine, a far and distant cry from our lost moments together at twenty-two and seventeen. The time span of a generation and the dramas of a thousand stories had come and gone. My life and whereabouts were a mystery until she turned that fateful page in *Texas Homes*, and as she later mentioned, it had taken her a year of gathering courage and confidence to call. She had missed seeing my articles in *National Geographic* in the 1970s, even the one on San Antonio, which might have been an earlier catalyst for a reunion. I had tried to find her once but gave up when her married name eluded me. A heavy conscience prevailed and I gave up.

<div align="center">∞</div>

Jann was staying at the Four Seasons Hotel on the San Antonio River in the heart of the city, close to the romantic old quarter of La Villita and the Alamo. It was a warm evening bathed in amber twilight as I walked to the hotel; downtown had quieted and street lights had begun to glow. I floated along in old memories and I tried not to hurry the dream. Jann and I had often strolled along the river holding hands, talking and dreaming of our future. From a sidewalk bridge I could see and hear the festive Riverwalk below, glistening with rainbow lights, with people laughing and leisurely walking, costumed mariachis strumming guitars and singing. It was still the place we had once known. Delicious aromas of Mexican food and bar-bequed steaks passed by on the breeze. In the distance, New Orleans–style jazz bounced its lighthearted spirit along the winding river.

<div align="center">∞</div>

I stopped in the hotel lobby before I took the elevator to Jann's room. A shaft of yellow light suddenly caught my eye; a radiant bouquet of yellow daffodils were blooming on the reception desk. Then it struck me—this was the first day of spring. Coming on this very moment at sunset. The transition of the seasons was palpable, and I seemed to be changing with it. Just then, with perfect timing as if it were staged, the Vespers bell began to

ring out at the little church nearby in the old quarter of La Villita. At that moment, I knew I wanted Jann back in my heart, and, if by some miracle she would have me, I wanted to be back in hers. The bell was ringing like crazy, wildly joyful, welcoming sunset and spring—it was all too much! I found a sheet of the hotel's notepaper and spontaneously wrote a poem.

> *The bells are ringing*
> *In La Villita*
> *On the night I see*
> *You again.*

I held the poem, intending to give it to her when she opened the door. The door opened by itself as I knocked, and I walked in. Jann was standing across the room. Her hair was strawberry blonde and long and she was wearing large dark sunglasses and a tangerine dress and smoking a cigarette—Lauren Bacall right out of a film noir—and she was totally gorgeous.

"This is for you." I said, offering the little haiku from my heart.

"Read it to me," she said softly.

And I did, and I could not hold back the tears, nor could she. We knew our finding each other was a true miracle and our time back in each other's arms had come round at last.

"I heard the bells too," she whispered.

Within weeks of our reunion, Jann filed for her long-anticipated divorce, and for the next eight months, as her divorce was slowly and rather scandalously proceeding in Austin, we lived together in my small house in San Antonio and in her newly rented creekside apartment in Austin. Our time was shared with her three children, all of whom were in school in Austin; my two children were in school back in Santa Fe and in Idaho, and they occasionally visited.

❦

My house in San Antonio was a short tree-lined walk to Trinity University, on Princess Pass, a one-block street on a little hill and as pretty as it sounds.

Trinity, of course, held our earliest memories. The lovely Romanesque swimming pool set below a limestone cliff, where we first met, was still there.

Fred and Jann Kline: a little yard sale at Princess Pass,
San Antonio, Summer 1985

Jann's new apartment in Austin came already furnished, but there were a few special items she had brought with her. One of them was the framed drawing of the Holy Family, which hung on a wall near the television set.

"Is that a print or a drawing?" I asked one evening, my gaze diverted from television. I had never seen it before.

"It's a drawing of the Holy Family."

"A drawing! My god, it looks like a Raphael from here." I got up and took it off the wall and went back and sat down next to Jann on the couch, my excitement rising.

"This looks like the real thing. Can I take it out of the frame? Are you sure it's a drawing? " It was behind nonglare glass, very protective of the drawing but rendering it slightly blurred.

"It's definitely a drawing. Have you ever heard of Baldassare da Siena? See, it's written on the bottom, kind of faded."

"Who?"

"Baldassare da Sienna. Christie's didn't really think it was Peruzzi. They wanted to attribute it to Pacchia."

"Did Christie's think you had an Italian Renaissance drawing?"

"I think so, but they didn't think it was worth very much. About a thousand pounds. They saw a photo maybe seven years ago."

When I had finished with the frame and had studied the drawing in lamplight free of glass, I knew it was the real thing and very fine.

"Jann, my darling girl, this drawing is more likely to be *a hundred* thousand pounds or more!" I was examining every part of it, and I could see that the drawing was authentic and without question by the hand of a master.

Looking with my ever-present loupe, all aspects of the drawing's quality were confirmed as I narrated my findings to Jann. It was in pristine condition. The flawless and sensitively crafted figures—the Virgin Mary holding the Christ Child and St. Joseph giving them his exceptionally tender support—showed the artist at the top of his skills as a draftsman. Its originality and warmth of feeling for the subject, its classic Italian Renaissance beauty, could not have been more profound. I told Jann in the fervor of discovery that I would rank it unquestionably alongside a contemporaneous circle of Leonardo, Michelangelo, and Raphael—all of whose drawings I had studied. The paper was handmade, antique and flexible, with a little expected foxing. The sepia ink had a settled permanence with a slightly mineralized patina. Some faint graphite squaring and sketching in the background suggested a preparatory drawing that might be transferred and enlarged to a painting or a fresco. This was no student, no follower, no later copy of a famous drawing—never in a million years! Our amazing recent string of magical luck was continuing.

Jann then told me the story of how she had acquired it and about its limited provenance: a deceased man whose name had remained anonymous from Jann's first contact with the collection. I kept repeating my conviction that this was a treasure, a 500-year-old Renaissance drawing of the highest quality, a masterpiece in perfect condition. There was no question in my mind.

With our seriously underfinanced marriage looming in the near future, the possible high value of the drawing that could transform into a dowry worthy of a Medici princess was not far from either of our minds. I felt this was a rational hope, and Jann, who was probably praying to the Holy Family with a PS for my sanity, allowed me to take the drawing back to

San Antonio for further study and photography. Before long, I was thinking $250,000 to $500,000, a range I stayed with and increasingly found to be the prize we might win.

Before we could make a move, however, the Peruzzi clues had to be thoroughly investigated thanks to the two inscriptions on the drawing. I could not understand Christie's past conservatism in at least not attributing to Peruzzi over Pacchia. Peruzzi was a major figure of the Italian High Renaissance, and extremely rare in public collections; the Louvre seemed to have the largest collection, but I was not able to see them. Examples of drawings by Peruzzi's illustrious contemporaries—Michelangelo, Raphael, Leonardo—were easily found, and before long I pushed them to the background as possible authors of Jann's drawing. Analogous, yes, but not the artist. Yet it was impossible to find any illustrated drawings by Peruzzi, comparable or otherwise. Not one. It seemed a dead end.

I was then inexperienced in the buying and selling of Old Master drawings, probably the most demanding of connoisseurship of all the areas of art history, due to the easily missed differences in style and quality among the legion of students and followers of a given master. In fact, this was my first experience in that category as a dealer. I had studied enough master drawings to be conversant with a good stylistic range from Leonardo to Picasso, but with the Peruzzi I was at the mercy of the experts. Until I had some idea of his drawing style I had to live with that painful state of affairs. Google and the Internet, which can today offer an instant survey course, did not exist.

No one could be expert in all artists, by any means, yet it continued to upset me that the Old Master drawings specialist at Christie's, Noel Annesley, neglected to mention the masterpiece quality of the drawing and did not pursue or suggest further research on Peruzzi. It seemed utterly deceitful or woefully ignorant. Who else could we turn to?

The J. Paul Getty Museum was the ideal and logical buyer of the *Holy Family* with their well-publicized budget of multimillions for purchasing Old Master paintings and drawings, but it would have to be a very tricky offer and I felt nervous and not very optimistic. I had no specialist's expertise to offer, and I had not found books to study or a Peruzzi scholar who could have possibly supported it. If I attributed to Peruzzi, without

comparables or expertise, it could easily be put down and refuted since I couldn't argue the case, and our dream of getting a fortune for it would be found laughable. I thought there was still a chance it could be Raphael and I anxiously looked to study his complete drawings *oeuvre*. The need for additional study on my part had stalled any offering of the *Holy Family* and the wait had become stressful. My research had to include a more complete overview not only of Raphael's drawings but of Leonardo's and Michelangelo's (whom St. Joseph in the drawing somewhat resembled) and a wide range of 16th century Italian artists, a category of which I had no doubt. But whose was it? I could finally see that Raphael's style would have been more clean-cut for this formal drawing, the faces more expressive, overall the drawing less busy with hatching lines, and not a good match. I soon discovered that books of Old Master drawings were not abundant in San Antonio libraries or bookstores, and so, with an impatience bred by financial necessity, I did not wait very long to knock on the Getty's door with our treasure.

In a bold move, I wrote to the Getty drawings curator, George Goldner, an established connoisseur of Old Master drawings, and asked him if he had an idea whom the artist might be from the slides I sent. I did not offer it for sale. Surely, I thought, part of the altruistic and educational mission of a great nonprofit cultural institution like the Getty Museum would be attuned to teaching and answering questions. Idealistically, I had hoped that not only would Goldner have the answer but that he would be struck by the quality of the drawing and recognize its rarity. I was sure he would have to have it and not stand on ceremony. I naïvely expected him to tell me that it was Peruzzi or perhaps Raphael, that it was rare and beautiful, that he loved it and had to have it for the Getty, and what price did I have in mind. What harm to ask? He could spend millions and I was betting that he would not risk letting this drawing get away. I had never dealt with a museum before.

Weeks passed after I sent my offer. Apparently, Goldner waited for me to call him, which of course I did. I clearly remember the conversation.

"Mr. Goldner, did you get my inquiry regarding the *Holy Family*? "

"Oh, yes, a very nice drawing. Did you want to offer it to the Getty?" His voice had a distant superior edge.

"Do you have any idea of the artist? I was hoping you could help identify it and in turn I might offer it to you first."

"I'm sorry, we don't attribute drawings that may be offered to us."

"So you're not interested in the drawing?"

"I do like the drawing and we would love to have it. Would you by chance consider a donation?"

"I will be interested in selling it, not donating it. Wouldn't you agree it's most likely a 16th century Italian Renaissance masterpiece?"

"The drawing has many attractive qualities."

"Would you be interested in buying it?"

"What are you asking?"

"I will be asking a price befitting an Italian Renaissance masterpiece. Would you like to make an offer on that premise?"

"I'm really sorry but this would go against museum policy. We don't make offers. Why don't you think about a price and then offer it to us."

"Do you think it could be Peruzzi as the inscription suggests? Or even Raphael?"

"I really couldn't say. Have you thought about putting it up for auction? Then the market will decide."

Goldner's expertise, as I understood, was in 16th century Italian drawings, and of the handful of scholars in the world with that specialty he probably had the best eye, and it was a well-known fact that with the Getty's millions at his disposal he could probably best any collector or institution in the running. His recent high-priced purchases at auction were the big buzz of the art world. Anyone *knowingly* bidding against the Getty for a great drawing in the mid-1980s, 16th century Italian or any other masterpiece, either was prepared to go to the moon of the millionaires (betting on Goldner's eye) or to concede early defeat knowing that further bidding was futile. I naïvely believed that few would know, until after an auction, if in fact Goldner and the Getty were bidding.

"What do you think the auction estimate might be?" I dared to ask the sphinx.

"I really couldn't say."

"Would you bid on it?"

"I really couldn't say."

"You certainly don't make me want to do business with the Getty."

"I have to adhere to museum policy."

"That's it?"

"I do hope you think of us, Mr. Kline, if you decide to offer it. It's a very nice drawing. May I keep the images you sent?"

"Well, Mr. Goldner, this may be your one and only chance to get it. You have my number if you want to make an offer. In the meantime, I'll see what the rest of the world has to say. And please keep the slides. I hope to hear from you if you have an idea about the artist."

⟶∞⟵

I heard nothing more from Goldner. This had been a foolish and amateurish approach and I knew it, but I had to test Goldner for myself and risk seeming like a babe in the woods, which I was now sure that I did! But it gave me at least some bearings on what to do next.

My interlude with the Getty sphinx spurred me to get moving with the *Holy Family* and I quickly organized inquiries with good detailed slides to Christie's and Sotheby's without any attribution except *Italian school, 16th century*, with the hope that their research could turn up evidence for Peruzzi or Raphael, or their illustrious circle. It was not an unfounded hope and not without its ironies.

Within a week I heard from a Christie's specialist in New York, Rachel Kaminsky, effusively congratulating me on our rare and wonderful Peruzzi. She loved it—as did her boss, the very same Noel Annesley from Jann's past Christie's encounter! Right then and there she offered the cover of their most important Old Master drawings sale catalogue, which would be out in January 1986, some four months away. Unknown to me then, in the days before computer technology could conjure auction data banks, the rival auction house Sotheby's had sold (as I recall), for a modest price, a less finished but stylistically related and documented Peruzzi drawing of the *Holy Family* in their January 1984 sale. Now, with that example established, there was an excellent comparable which enabled Christie's to accept our *Holy Family* as Peruzzi. They doubtless had other scholars in the wings who would support it. And Goldner was probably the first one they called.

Suddenly, the quest for the drawing's identity had ended almost as quickly as it began, with Rachael Kaminsky's eye, which then led to Christie's authoritative acceptance of Peruzzi. Certainly Goldner had known all along but wasn't saying, at least not to me. Now, with Christie's enthusiasm and the auction gamble becoming very attractive, we decided not to go back to the Getty and Goldner. Let him bid for it, I reasoned, let him fight for it. I imagined that every museum and drawings collector in the world would want this magnificent drawing and push its value at least to the hundreds of thousands. Then passion of bidding at auction for this coveted rarity would surely take hold.

⁗

Two weeks later, I received a call from Julian Stock, an Old Masters consultant at Sotheby's who lived in Florence. Some years later, Stock would discover an $11 million Michelangelo drawing, a mere decorative design for a candelabra, unsigned of course, as well as unattributed and unnoticed since 1747, lying undisturbed in a bound album in the library of Castle Howard in Yorkshire. Stock advised me with words I have never forgotten: "Mr. Kline, if you don't need to sell the Peruzzi, I strongly advise you not to sell it right now. Hold on to it, it's better than gold, far better than gold. It will be worth a fortune if you can just hold on to it and exhibit and publish it." If only we had a fortune then, we would have held on to it, but there was a reasonable chance it could turn into a fortune at auction, and that was very attractive. Jann had held on to it for twenty years and she was ready to pass it on if it meant securing our future. It was now clear that auction was its inevitable destination.

Back at Christie's, when Kaminsky mentioned a possible estimate at $15,000 to $25,000, with a reserve at $10,000, I was stunned that it was so low and I told her I would never consider it. She said that it was a little higher than the price range of the Peruzzi that had sold at Sotheby's two years before. It was likely to go higher, she said, and the catalogue cover and ads in magazines and a special postcard would give it the presale celebrity it deserved. They wanted to see the drawing in person but I

held back sending it. I had sent good slides. We continued to talk on the phone, and finally Jann and I agreed that we had to have a reserve of no less than $30,000, the reserve being the minimum we would sell it for at auction. The reserve was an auction safety net for sellers, but we felt that it was extremely unlikely to sell that low and so we compromised and made it part of our gamble. Christie's insisted that it was too high. Annesley called, now encouraging a $15,000 reserve. I said no. If we couldn't get the reserve up, we would hold on to the drawing, as Stock had suggested. Finally, as I was about to walk away, Annesley agreed to the $30,000 reserve and an estimate of $30,000–$40,000, and we sent the drawing to New York.

Jann and I awaited the sale as optimistic gamblers, the typical mindset for people selling at auction. The auction presentation of the Peruzzi was exceptional but of course with far less an estimate than we had hoped. According to Christie's, *they* were in the uncomfortable zone of having too aggressive an estimate. I was dissatisfied because it wasn't more aggressive, but, like many situations in life, you move forward because you agree to compromise, and I knew that it was quite common for art at auction to far exceed its estimate. That was our bet. We talked to tax lawyers and accountants in preparation for a fabulous sale.

While we waited for the sale, Jann's divorce was finalized and we were married in Austin unceremoniously at city hall. The "honeymoon" at a dude ranch in Bandera included four of our combined five children plus several of their friends and was even attended by the parents of the bride and groom, who were still bewildered at our reunion.

Back in New York, Christie's did everything they promised to do. The drawing was highlighted in every ad for the Old Master drawings sale. They sent out thousands of postcards with an image of the Peruzzi. Finally, the catalogue was published and there it was on the cover and with a full-page inside. First publication, first exhibition; our first discovery together of lost art.

On January 6, 1986, we were in San Antonio anxiously waiting for the results of the auction. Before we lost our nerve and called Rachel, she called and congratulated us on our $66,000 sale! With Christie's very fair commission our net came to around $60,000. This wasn't the fortune

we were expecting, but it was nevertheless a huge amount for us and our attitude was celebratory indeed.

Too happy to be practical, and with not a little ecstasy, we followed our hearts into a lucky honeymoon life that just went on and on, a better-financed sequel to the previous eight months. We were now accompanied by a happy Golden Retriever pup Jann named California Golden Girl, aka Cali, an adorable little pooch we rescued from neighbors bent on euthanizing her because her father was a wandering gypsy rejected by the AKA genealogists; a veterinarian had also recommended "putting her to sleep" because of a common hip problem with dogs called dysplasia. Out of the blue this blithe spirit came to our family, and she proved more of a magnet to the kids than even our own charming selves. Cali was a sweetheart with a million-dollar smile for everyone on every occasion for the twelve years she graced our lives, never once complaining about the condition that kept her from running and jumping like the average dog but not from swimming in every pool she came across. A life-enhancing pooch if ever there was.

After the sale of the *Holy Family*, Jann and I settled into a routine, often frequenting a restaurant called the Liberty Bar, a rickety old wooden house somewhat restored with a hammer and nails, a few weathered boards, a little paint, spit, and a broom. It became our hangout, our bohemian bistro reincarnated from the Old West with a touch of 1920s Paris. Here cowboys could find comfort in wobbly tables and chairs as if on horseback; here artists and writers could congregate and gossip in a rough-hewn salon; sailors and explorers could recognize wavy floors that creaked and rolled you forward as if on the high seas; best of all, food lovers found a rustic kitchen that created the best home-grown country food in town. The grand carved wood bar, in the middle of two dining halls, had been brought in from an old saloon in Mexico. The atmosphere was as fine as the food. Our mood there was always festive, to say the least, and we often talked and dreamed away the afternoon hours, filling in the past and dreaming of the future. How could a life based on the romantic search for lost art possibly continue beyond the Peruzzi?

I didn't learn who had bought the Peruzzi until I read about the sale in a magazine. It had sold to a German dealer who was bidding for the Getty. Goldner had grabbed it after all. But I would never know for sure what had happened behind the scenes; I could only guess. If word of the Getty's proxy bidding had leaked out, which I now feel certain it did because of the subdued bidding, then it was not a level playing field as many bidders would have been scared away from climbing the bidding Everest which the Getty represented. It would then have been a diminished field with a much lowered auction fever. The German shill may have whispered around the room during previews, as conspirators will, cautions of questionable authenticity and provenance. All probable intrigue. However, I had to admit, this was an effective psychological ploy, like bluffing in poker or a sneaky curveball, and all part of the game I had been initiated into. All was fair in love and war, and apparently in art bidding. And the Machiavellian deceits of Goldner and Annesley had been part of the game, too. I was a rookie playing in the major leagues now and learning the ropes. That day, $66,000 was as high as anyone in the world wanted to go, a homerun surely but not one with the bases loaded and that was the end of it. (Yes, I have been a baseball fan since I was a kid.) Fair enough and really more than good enough. There were some valuable lessons to be learned.

The Getty's maximum was never tested that day against a determined underbidder, as it would have been today with billionaire private collectors in the game. Had it been called to a fairly matched test today, $3–$5 million would have been likely. Julian Stock was right. I should have waited; but, alas, we couldn't wait.

It had been beyond planning or praying, this miracle of long-lost lovers back in each other's arms, and then another miracle materialized in the Peruzzi. In this, our first year of marriage, how could we not feel we were entering into a wondrous reality?

The Peruzzi became the inspiration and catalyst to seek and find many more Old Master drawings and paintings over the ensuing years. I pursued connoisseurship as a generalist in art history, and my eye became increasingly educated. When I entered the fray again, I wanted to have as much

background and confidence in my judgment as the other experts playing in the field. With Jann's ever-present enthusiasm and encouragement, we feasted daily from books in all periods of art history and created our own museum without walls.

Fifteen years later, the lost drawing of a child had miraculously appeared, literally from out of nowhere. Now we would see if Leonardo da Vinci could also appear as Peruzzi had once done.

CHAPTER 3

The Pursuit of Connoisseurship

Certain things in his [Leonardo's] art are clear and definable
. . . his passionate curiosity into the secrets of nature, and the
inhumanly sharp eye with which he noted down the most
trivial gesture or most evasive glance. . . . Of his affections,
his tastes, his health, his opinions on current events we know
nothing. *Yet if we turn from his writings to his drawings, we
find a subtle and tender understanding of human feelings.*
 —Sir Kenneth Clark (1903–1983, British art historian,
 author of the classic *Leonardo da Vinci*)

T he exquisite head of an infant with its early premonition of Leonardo
 da Vinci arrived in Santa Fe from Christie's within a few weeks.
Finally in our hands, the drawing was a miracle confirmed, its mastery and
amazingly good condition true to what we had seen and imagined in the
catalogue image. Now, holding the actual drawing, rich with the patina of
age, I could breathe a sigh of relief.

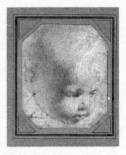

Head of a Child Looking Down, as received from Christie's

As experienced as I was in my study of photographic reproductions, there was always the stress of possible self-deception until the moment of holding the real thing. This was a challenge I often chose since the chaos and expense of constant travel to see every opportunity that came up was, to say the least, an unworkable lifestyle. Not that I didn't travel, but when I could rely on professionals for basic details of a work of art and good photographs, I would then trust my eye from afar.

Before I was swept away by even greater hope, a critical examination was of course essential. I had to approach the drawing as an uncompromising inquisitor and attempt to disqualify, in every possible way, my wildest dream of Leonardo da Vinci.

❧

Special objects, like people, always respond better when you call them by name, and before long I was calling the drawing *Holy Child*. Not only did the name have personal resonance for Jann and me, but most appropriately in the context of Leonardo and the Renaissance period I had already considered it a possible, although unusual, study for the head of Infant Jesus. Infants drawn or painted by the early Old Masters almost always referred to the infancy of Jesus, but they rarely depicted the head alone. Raphael did many, but none as sensitive as *Holy Child*. Depictions of Infant Jesus tended to look alike, with a "general baby look," if you will, with little qualitative or characterizing distinction. *Holy Child* had an unusually pensive expression, and it was clearly an anomaly within that genre. Whatever the outcome,

this was an exciting and singular opportunity to look again into Leonardo's oeuvre of art with a possibility of a fresh discovery in mind. All the while I knew that if it did not work out with Leonardo, I would sadly have to revise my thinking, but it would not be wholly tragic. If expectations failed in the Leonardo direction, it would not be the end of exploration; the drawing's quality would not diminish and another artist would win the prize.

꿍

At the beginning of my research on *Holy Child*, I knew it would be the most daunting project in art attribution I had ever faced, and in the ensuing years since the sale of our Peruzzi, I had been through many. If I did not disqualify the drawing at the outset, I intended to proceed in an intensive course of study that would include all of Leonardo's widely illustrated drawings and paintings; seeing as many of the actual works as possible; reading scores of academic papers, books, Leonardo's notebooks, and a good current biography (which I found in Charles Nicholl's extraordinary *Leonardo da Vinci: Flights of Mind*).

Finally, with the accumulated Leonardo canon at my fingertips, I could assess and reassess the evidence that might further place the drawing in or out of the running. But first, some basic facts needed to be understood.

꿍

Leonardo da Vinci, *Self-Portrait*, ca. 1515–1519, Turin Royal Library, born Vinci, Italy 1452, died Cloux, near Amboise, France 1519. Florentine artist, scientist, and thinker

Leonardo da Vinci grew up during the Italian Renaissance as an untutored, autodidactic, prodigiously curious country boy in the region of Florence, Italy—an unrecognized genius, the illegitimate son of a wealthy notary of respectable lineage and a peasant girl, who is known to have married other men and had more children after her affair with the notary. Young Leonardo was raised affectionately by his mother in his earliest years, and then by his father's family around Vinci until fourteen, when he was apprenticed into Verrocchio's prestigious workshop in Florence, where he was quickly recognized as a prodigy. He remained there until his early twenties. With support from his father, Leonardo then proceeded to establish his own studio in Florence, chose several assistants, and quickly found work as an artist. Thereafter he traveled in Italy with a devoted entourage, a number of whom were artists, accepting art commissions from nobles of city and church while spending the majority of his spare time with scientific observations which he ultimately recorded in thousands of illustrated notebook pages, most of which survived, written in his cryptic and inventive left-handed mirror script.

This backward handwriting would have struck most people of his time as the insane scribbling of a madman or a magus with supernatural and magical powers. But in fact, his willfully confusing handwriting was part of his playful childlike nature, which he exploited in many ways during his lifetime, seen in his creative doodling and even in the invention of a parachute in case his flying machine took a nosedive. He died in France at sixty-seven at the chateau of the young King Francis I, who regarded Leonardo as occupying a throne higher than his own.

⁓

Leonardo da Vinci has been acclaimed for centuries as a multifaceted genius, a polymath of the Italian Renaissance, a seminal influence in the history of Western art and culture. Leonardo's legendary renown as an artist has remained on the highest level from his own time to the present day in spite of his surprisingly small body of acknowledged work: traditionally some fifteen paintings, including *Mona Lisa*, and only seventy sketches and drawings relating to those paintings. Of those seventy drawings,

only a small percentage might be considered more finished preparatory studies. However, some 4,000 additional drawings of diverse subjects, from the anatomy of horses to fantastic war machines—in red chalk, ink, and pencil—are found in his Notebooks and speak of his mastery of the medium and his dedication to drawing. The incomparable quality of Leonardo's artistic body of work and the creative vigor of his scientific intellect have combined to idealize him as the classic Renaissance man.

Among Leonardo's acknowledged works of art, *no* painting is signed or dated, *no* drawing is signed, and only one date exists on a single early landscape drawing of the Arno Valley: 1473. Authentication of his authorship and dating of his artistic work is totally based on individual connoisseurship—educated opinion that is finally subjective while merged with a certain scientifically minded objectivity. The accumulated knowledge of Leonardo's body of artistic work, including published critical and scientific studies, is altogether tied to individually perceived evidence from the actual works themselves, their comparative relationships, a few documents, and not least of all his voluminous Notebooks of scientific, philosophical, and general observations.

Several personal entries in the Notebooks inspire speculation to this day. Leonardo recorded his first and only memory of childhood, a dream where he was treated as a hatchling by a mother bird, specifically a kite, a small hawk common to the Vinci area. Thus, he surmised, his lifelong passion for birds began, and study of their flight became his destiny from birth. And just as surprising, among the thousands of Notebook pages there is only one undated entry relating to his artworks, probably from the 1470s, which speaks vaguely of planning "two paintings of the Madonna." It is little wonder that questions of authorship, dating, and psychological insights can occupy generations of scholars for their lifetimes.

For close to a hundred years, not one new drawing or painting by Leonardo had been added with unanimous acceptance to his canon, and even when something is suggested, consensus among specialist academic scholars has been impossible to achieve. With Leonardo, it can be said, there is always a question coming up and going down with the sun although, as he emphatically stated in his Notebooks, "The sun does not move," echoing his contemporary Copernicus. To look again, beyond the illusion and the glare, is to see Leonardo da Vinci hiding in plain sight.

The writings and observations of Leonardo da Vinci and Albert Einstein had always offered me guidance and inspiration in the pursuit of connoisseurship, no doubt roads less traveled on the traditional art historian's map. I found amusement in imagining the Einsteinian idea of a Unified Theory of *Holy Child*. But then, why not? It would take that many variables coming together in a unified whole to prove *Holy Child* was drawn by the hand of Leonardo. It seemed a challenge worth considering, but how could it be accomplished?

Einstein and Leonardo encouraged curiosity, the imagination, and the special qualities of perception. Einstein had written of the limitations of knowledge and the evolutionary quality of intuition and the creative imagination when applied to that knowledge. Leonardo echoed his support with a caution: "Three classes: those who see, those who see when shown, those who do not see." Much of what lay in the archives needed to be rigorously tested.

I continued to speculate with my outside-the-box idea: How would Einstein create a theory of a lost Leonardo drawing? I knew he would have proceeded from his intuition to develop a theory and test it, and, if correct, with evidence in hand, he would publish it, allowing others to then confirm or negate. Einstein did not first seek permission from his peers, nor did he fear being proven wrong. As he said, it would be simple to prove him wrong by just presenting one wrong calculation. And if so, then so be it. The process of the testing itself was where true enlightenment lay. Einstein knew what he was doing. Though I had many previous successes with lost art, I had also learned from my mistakes or disproven theories. I could take a wrong direction and or even change my course midstream based on new evidence or information.

There was naturally a big difference with a hypothetical Unified Theory of *Holy Child*. It was not a theory of relativity or quantum mechanics for masterminds of physics and mathematics to test objectively. In pursuing connoisseurship in art, subjectivity and experience had to be part of the equation as well. A proven eye was imperative. I was imagining the theory of a drawing that, with the support of all evidence, might prove it to be

Leonardo's "lost" *Holy Child*. Or with lack of evidence or contrary evidence, disprove my theory, which I would be personally disappointed about, but that in itself would have yielded its own new mystery—if it wasn't a Leonardo drawing, then whose was it? As a guiding metaphor, perhaps too crude for an image of an infant, I knew the drawing had to be a smoking gun.

<p style="text-align:center">∽</p>

Throughout his body of work, Leonardo's children were holy children, namely the Infant Jesus and Infant St. John, and they appeared in many of his paintings, including *Adoration of the Magi, Virgin of the Rocks*, and *Virgin and Child with St. Anne and a Lamb*. From the first time I had seen *Holy Child* in the auction catalogue, I recognized its comparative relationship to the head of Infant Jesus specifically to Leonardo's two earliest paintings of the Madonna and Child: *Madonna of the Carnation* and *Benois Madonna*, This subjective and converging intuition has guided me. More objective questions could wait. But when the examination of those questions began in earnest, the answers were often confusing.

I became stuck in a big problem of connoisseurship. Specifically, I needed an established red chalk drawing from the 1470s for support, but I couldn't find one. There was nothing I could find in the Leonardo canon. *Holy Child*'s compelling comparisons to Leonardo's painted heads of Infant Jesus lacked related supportive evidence among his preparatory drawings, a type of finished drawing, which were all important and yet extremely rare. Only seventy among his thousands are known and none were red chalk from his early Florentine period, which I needed. Did I possibly have such a drawing? *Holy Child* clearly could be considered a preparatory drawing of masterpiece quality—but how could a drawing by Leonardo have traveled this far without a name, so well cared for, homeless and abandoned?

I thought *Holy Child*'s close relationship to Leonardo's two earliest paintings could possibly support his authorship, but then I knew it was imperative that I reinforce that relationship with an example from his already established drawings. I had a drawing that had come out of nowhere and it would be seen as uncharacteristic for Leonardo in the 1470s, when

the established thought on his use of red chalk at this time believed it was too early. For any claim I might make for Leonardo, I had to take a hard-headed position: *there had to be no reasonable doubt.* The evidence had to be conclusive for the High Court of Art History to accept it. Even so, I felt that *that* judgment in itself could take a hundred years to find consensus. I believed in the Leonardian quality of *Holy Child*, and I was determined to leave no stone unturned. Of course, I could only do this through books and the Internet, but my eye was practiced and reliable and I had learned from experience *not to see what was not there.*

The traditional Leonardo canon stated that his probable first use of red chalk was a small head study of St. James the Greater for *The Last Supper*, Leonardo's recently restored fresco in Milan.

Leonardo da Vinci, *Study for St. James*, Royal Collection, Windsor Castle, London

Leonardo's *Last Supper* project, and the related red chalk drawing of St. James didn't come along until 1497, some twenty years after his first two Madonna and Child paintings of the 1470s—*Madonna of the Carnation* and *Benois Madonna*—both of which I felt held an intimate and unmistakable relationship to *Holy Child*. No refined preparatory drawing had ever

Leonardo's "lost" *Holy Child*. Or with lack of evidence or contrary evidence, disprove my theory, which I would be personally disappointed about, but that in itself would have yielded its own new mystery—if it wasn't a Leonardo drawing, then whose was it? As a guiding metaphor, perhaps too crude for an image of an infant, I knew the drawing had to be a smoking gun.

❦

Throughout his body of work, Leonardo's children were holy children, namely the Infant Jesus and Infant St. John, and they appeared in many of his paintings, including *Adoration of the Magi*, *Virgin of the Rocks*, and *Virgin and Child with St. Anne and a Lamb*. From the first time I had seen *Holy Child* in the auction catalogue, I recognized its comparative relationship to the head of Infant Jesus specifically to Leonardo's two earliest paintings of the Madonna and Child: *Madonna of the Carnation* and *Benois Madonna*, This subjective and converging intuition has guided me. More objective questions could wait. But when the examination of those questions began in earnest, the answers were often confusing.

I became stuck in a big problem of connoisseurship. Specifically, I needed an established red chalk drawing from the 1470s for support, but I couldn't find one. There was nothing I could find in the Leonardo canon. *Holy Child*'s compelling comparisons to Leonardo's painted heads of Infant Jesus lacked related supportive evidence among his preparatory drawings, a type of finished drawing, which were all important and yet extremely rare. Only seventy among his thousands are known and none were red chalk from his early Florentine period, which I needed. Did I possibly have such a drawing? *Holy Child* clearly could be considered a preparatory drawing of masterpiece quality—but how could a drawing by Leonardo have traveled this far without a name, so well cared for, homeless and abandoned?

I thought *Holy Child*'s close relationship to Leonardo's two earliest paintings could possibly support his authorship, but then I knew it was imperative that I reinforce that relationship with an example from his already established drawings. I had a drawing that had come out of nowhere and it would be seen as uncharacteristic for Leonardo in the 1470s, when

the established thought on his use of red chalk at this time believed it was too early. For any claim I might make for Leonardo, I had to take a hard-headed position: *there had to be no reasonable doubt.* The evidence had to be conclusive for the High Court of Art History to accept it. Even so, I felt that *that* judgment in itself could take a hundred years to find consensus. I believed in the Leonardian quality of *Holy Child*, and I was determined to leave no stone unturned. Of course, I could only do this through books and the Internet, but my eye was practiced and reliable and I had learned from experience *not to see what was not there.*

The traditional Leonardo canon stated that his probable first use of red chalk was a small head study of St. James the Greater for *The Last Supper*, Leonardo's recently restored fresco in Milan.

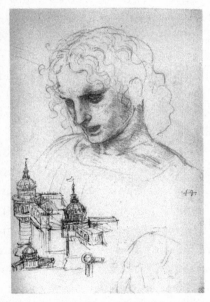

Leonardo da Vinci, *Study for St. James*, Royal Collection, Windsor Castle, London

Leonardo's *Last Supper* project, and the related red chalk drawing of St. James didn't come along until 1497, some twenty years after his first two Madonna and Child paintings of the 1470s—*Madonna of the Carnation* and *Benois Madonna*—both of which I felt held an intimate and unmistakable relationship to *Holy Child*. No refined preparatory drawing had ever

been found for the two paintings—only two small, snapshot-like, quick sketches in pen and ink of the Madonna and Child, with the Madonna holding a flower, show a relationship among Leonardo's acknowledged drawings—but it was reasonable to assume a preparatory drawing may have existed and it looked like I might have it with *Holy Child*. With the actual drawing now in hand, I made the comparative analysis again and saw the relationship strongly confirmed with Infant Jesus in both paintings.

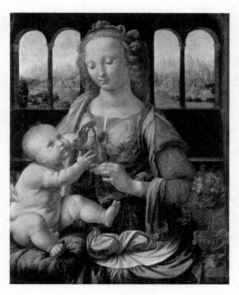

Leonardo, *Madonna of the Carnation*, Munich

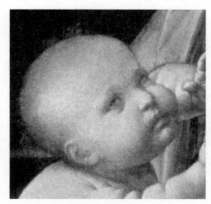

Leonardo, *Carnation*, Infant Jesus, detail

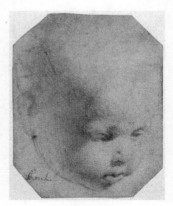

Holy Child

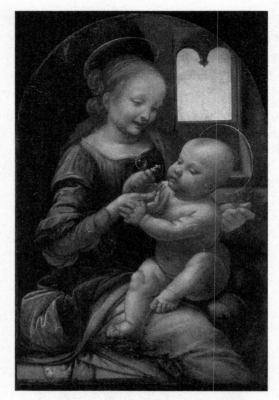

Leonardo, *Benois Madonna*, St. Petersburg

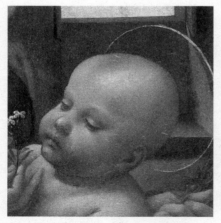

Leonardo, *Benois*, Infant Jesus, detail

Holy Child, reversed

To add another daunting obstacle, much of the 1470s were considered Leonardo's lost years—from circa 1472 to 1478, Leonardo's First Florentine Period—and almost all of his drawings, red or black chalk or ink, that had surely existed from the 1470s had inexplicitly disappeared and scholars can only speculate as to why. Drawings in red chalk, the medium closest to Leonardo's heart by all evidence, were conspicuously missing from the 1470s. Why couldn't *Holy Child* be Leonardo's earliest red chalk drawing among those lost? Indeed, on the face of it, this recognition was an immediate *eureka* connection, and extremely encouraging, but it was too early in the investigation. I needed to take a more basic direction as devil's advocate seeking first to disqualify *Holy Child*.

⊗

What about *Holy Child* was not supportable as a work by Leonardo? What qualities could immediately put it out of the running? I had to start with the actual paper itself and work my way up from there into larger issues. If the paper test failed, if it proved to have been made past Leonardo's lifetime, I would be back to square one. Simple logic.

When I went to examine the paper, instead of disqualifying Leonardo, supportive clues began to appear. The paper on which *Holy Child* was drawn was handmade, with an uneven organic texture consistent with the type of paper used in Italy in the 1470s. From other drawings I had studied dating to Renaissance-era Italy, including the close study of the Baldassare Peruzzi drawing from circa 1500 that Jann and I had discovered, I was certain of the paper's comparative quality. But there was still more to explore with the paper, and I did not have the skills to attempt it. The drawing had at some point in the past been pasted securely onto two other sheets of paper, which possibly concealed another drawing or writing on the back of *Holy Child*. The backing papers were then again glued down on what I recognized as a 19th century decorated French mat—yet another connection to France, where Leonardo had resided for three years until his death in 1519. It was impossible to see through the three backings, which I would have wanted to do as the next step in my investigation, so a paper conservator was the next step in the investigation, and it could not be just

anyone. I had previously sent drawings needing similar delicate operations to Marjorie Shelley, the renowned head conservator of works on paper at the Metropolitan Museum of Art, and she agreed to work on *Holy Child*. I was thrilled. It was always a privilege to work with Marjorie, and I had peace of mind knowing the drawing would be in her expert care. Off it went, always an anxious moment, hoping and praying nothing goes wrong in transit. Marjorie had said it would take a few months to finish the job. Her goal was to remove the three backings with the hope of finding some hidden clue and to repair several holes in the paper, neither of which affected the actual drawing itself, which amazingly was in pristine condition and had never been repaired. Then it would be on its own and ready to be thoroughly examined.

When the work was done, she informed me that no other drawing had appeared. The back was totally blank, a disappointing result in my search for further clues, as additional drawings or handwritten inscriptions connected to Leonardo or another artist could have offered new directions. She had successfully made a few minor repairs to the paper in the process of removing the backings. The child's face did not require restoring and so was left pristine. *Holy Child* was in remarkably good condition, actually not that rare to find in Old Master drawings because they are treated as precious objects. That was evidently the situation with *Holy Child* throughout its entire hidden provenance, even with the owners not knowing the identity of the artist. I did have several clues that pointed to France, and the French have a long history as collectors of master drawings. Most supportively, however, and the bottom line, Marjorie found nothing in her restoration and study of the drawing to question *Holy Child*'s paper quality as circa 1470's. She glowingly praised its beauty, a great compliment coming from someone who had worked on conserving drawings from all the Old Masters, including Leonardo.

I thought of Marjorie Shelley as an art doctor, a top specialist who operates on drawings and brings them back cured of many possible problems—like water damage, mold, disfiguring stains, and tears—and ready for a longer life in art history. Conservators of paintings and drawings play a vital role, and I could not get along without their talents. *Holy Child* had passed its first and most important test. Had it failed, I would have no choice but to start over. But now, the first step had been taken and so far, so good. With the drawing now returned and the paper in a clear light, I still had miles to go.

Holy Child (after conservation)

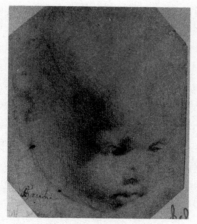

Christie's catalogue image

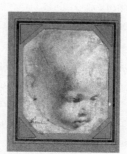

Holy Child before conservation

Once restored, *Holy Child* measured only 5¼ x 4¼ inches and had obviously been cut from a larger sheet, the fate of many of Leonardo's drawings after his death. The small size was also entirely compatible with Leonardo's numerous drawings of heads and figurative subjects, like the diminutive horse and rider, which sold in 2001 for some $11.5 million in a Christie's auction. Generally, Leonardo liked to draw in a small format. We moved ahead with another step in the right direction.

With the backing removed, a watermark was now revealed by backlighting the paper. The once-hidden watermark now offered promise of a fresh insight. Due to the paper being cut, the watermark was only half there, a remnant that appeared to be a rather primitive sun or star symbol. The dating of old watermarks is an inexact science, and my research could only suggest that the watermark on *Holy Child* bore a relatedness to early Italian marks, and dating it to the 1470s could, again, not be ruled out, a fact also supported by Marjorie Shelley. According to Leonardo scholar Carlo Pedretti, only sixteen watermarks, most of them unique and occurring only once, had been found on a number of Leonardo's drawings and papers, with most sheets yet to be examined. Our watermark did not appear among those already verbally described; unfortunately, illustrative images have not been published. In close comparison of antique paper, British art historian Jane Roberts's study of sixty-four (clearly illustrated) watermarks on drawings and letters by Michelangelo, Leonardo's younger contemporary, revealed that fifty of them were also unique, while only fourteen had two examples. One of them was a related variant found on *Holy Child*. Obviously, a watermark appearing for the first time on a suggested Leonardo or Michelangelo drawing would be no reason to deny its serious consideration. Without a more complete study of Leonardo's watermarks, we could not go further in the watermark investigation. In any case, the paper was of the right make and era, and the watermark, applied like a trademark by one of a multitude of paper makers in Italy and elsewhere, held promise to be found associated with a Leonardo drawing or one of his Notebook sheets. Another piece of qualifying news.

Now it was time to move on to the drawing itself. The time-fixed patina—the settled color and texture of the red chalk—coupled with the fact that Leonardo purportedly pioneered the red chalk medium,

were the next facets of the drawing I would investigate. Could he have used red chalk earlier than supposed? The earliest documented red chalk drawing was 1497. However, there was clear evidence of the use of red chalk by other artists in Florence during the 1470s—the period I increasingly believed related to *Holy Child*. Leonardo's great contemporary and rival Filippino Lippi, then a precocious student in Botticelli's workshop, used red chalk on drawings as a toning for prepared paper and for highlighting, not for actually drawing, as far as I knew, based on an illustrated book of his drawings. Leonardo had been in Verrocchio's workshop at the same time. It would be unreasonable to suppose that the inventive Leonardo did not innovate and add some glue to the red powder, make a stick, and draw with it. The ingredients for red chalk were clearly available. But there was no hard proof that he had done so yet.

As I looked at *Holy Child* under intense magnification, one discovery shocked me. Hard to believe, but it seemed vestiges of fingerprints, like hardened imprints of a fossil, were left in the red chalk and in a contrasting ground of white chalk. Any chalk dust that had been originally there had vanished over the centuries. The use of white was so artfully blended that without magnification I had not even noticed its application. Both red and white chalks had been rubbed in and pressed down, some areas with more thickness of application. This shadowing technique is known as *sfumato*, which Leonardo innovated in his paintings, wherein tones and colors meld gradually into one another, producing softened and invisible outlines or hazy forms. *Sfumato* was an advancement in the technique of *chiaroscuro*, the general term for the treatment of light and shade in drawing and painting. A chalk drawing on paper was the perfect medium for the *sfumato* technique to develop during the Renaissance. In its earliest form, using charcoal and natural pigments some shadowing is found in 40,000-year-old wall drawings among Europe's prehistoric caves. In *Holy Child*, the overall melding of these qualities seemed brilliantly precise, lifelike, and inventive. Leonardo's fingerprints would most likely be reliably detectible on his chalk drawings, if anywhere, but as yet there was nothing for comparison. If fingerprinting forensics were applied to the body of Leonardo's established chalk drawings, a file of DNA-like comparative evidence could be added to the connoisseur's toolbox.

By the time period in question—the 1470s—Leonardo was in his twenties and already blossomed as an artist of extraordinary talent. For the most part, these years were spent helping to fulfill sculpture and painting commissions in his teacher Andrea del Verrocchio's well-established workshop. Here, fortunately, were widely recognized examples of Leonardo's earliest work as a painter. Studies done in a traditional vein—figurative additions in several paintings made by Verrocchio, none of which were depictions of Infant Jesus—nevertheless stood out for their brilliant Leonardian quality and matched with certain stylistic elements seen in *Holy Child*, including the sensitivity and naturalistic qualities of the faces.

Leonardo had distinctly assisted in Verrocchio's paintings *Baptism of Christ* (ca. 1470s, Uffizi, Florence) and *Annunciation* (ca. 1470s, Uffizi). As noted by the 16th century biographer and artist Giorgio Vasari, Leonardo made such brilliant figurative additions to the paintings that Verrocchio declared, in light of Leonardo's extraordinary talent, he would thereafter put down the brush and stick to chiseling sculpture, his true métier. I would agree with Vasari's anecdotal evidence, as highly probable in a lighthearted and ironic way, since the additions were indeed masterful, although it must be said that by all evidence Verrocchio was himself a very fine painter.

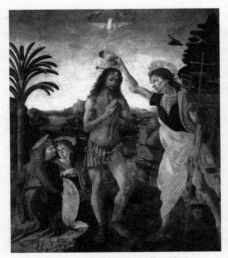

Verrocchio, *Baptism of Christ*, Uffizi, Florence

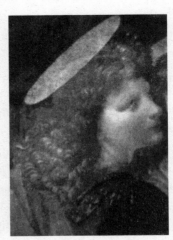

Baptism of Christ detail by Leonardo

A short time after *Annunciation*, Leonardo made his first independent painting, *Madonna of the Carnation*—which does include an Infant Jesus and is one of the direct comparative works to *Holy Child*—and then within a space of a few years, made two other independent paintings, *Ginevra de' Benci*, a portrait (ca. 1474, National Gallery, Washington), and the *Benois Madonna*—which again offers a precise comparison of Infant Jesus to Holy Child.

Ginevra, although lacking an Infant Jesus for comparison, offered a masterpiece of portraiture and a concrete example of Leonardo's artistic genius at this early period. *Ginevra*, clearly an early precursor to *Mona Lisa* (ca. 1503), shows comparable skill and uncanny psychological insight. The painted portrait, with its close-to-photographic realistic quality, was a breathtaking tour de force from Leonardo's First Florentine Period. *Holy Child*, as a drawn portrait with the same photorealistic qualities, was surely in that same category. On the literal face of it, this was strong evidence for *Holy Child* being made around the same early time. Based on Vasari's earliest anecdotal accounts, the flowering of Leonardo's talent had been coming on steadily like a force of nature since his youth. The beautiful Ginevra, lost in thought, as beguiling and mysterious as Mona Lisa, seemed a close relative to the pensive expressiveness of *Holy Child*. Much of the originality found in *Ginevra* could also be seen in *Holy Child*. No artist before Leonardo had observed and recorded the dawning of intelligence and curiosity on the face of an awakening infant, or treated an infant's face as a sensitive portrait of Infant Jesus. To date, most Infant Jesus portraits still had a generic expressionless face. And no earlier artist had captured the lurking and sultry sensuality found in Ginevra's gaze. A recently discovered haiku-like poem Ginevra wrote to a suitor echoes Leonardo's insight: "I ask your forgiveness/ I am a mountain tiger." (This erotic little gem is her only literary legacy.) Both *Ginevra* and *Holy Child* were fresh psychological perceptions of their subject. The three-quarter view of their faces and the all but invisible lines of facial contours were both Leonardo's original stylistic developments at the time. It was obvious the painted portrait of Ginevra was imbued with the same spirit and artistry, the same serious intention as the drawn portrait of *Holy Child*. The revelatory example of *Ginevra de' Benci*

opens that entire early period to more imaginative thinking regarding Leonardo's lost artistic legacy. The beautiful Ginevra, lost in thought, as beguiling and mysterious as Mona Lisa, seemed a close relative to the pensive expressiveness of *Holy Child*.

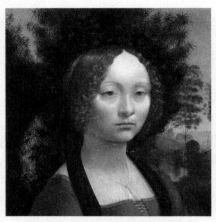

Leonardo, *Ginevra de' Benci*, NG Washington

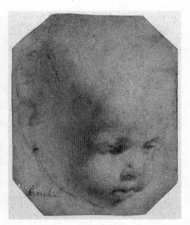

Holy Child

Leonardo, *Mona Lisa*, Louvre, Paris

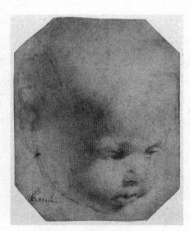

Holy Child

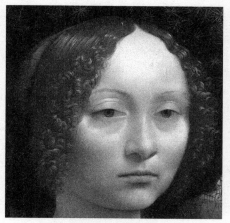

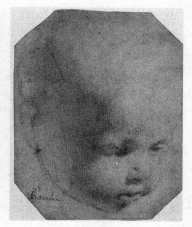

Detail of *Ginevra de' Benci* *Holy Child*

Leonardo's handful of drawings from the 1470s offered brilliantly diverse styles: flawless drapery studies; a small plein air landscape sketch (his only dated work of art); quick figurative sketches of amazing perception and dexterity; a caricature-like bust of a stiff military officer. Each notably different drawing suggested a tip of the Leonardo iceberg. As his later approaches to drawing developed, diversity would in fact become Leonardo's hallmark. His so-called style in drawing was as elusive and multifaceted as his personality and as unpredictable as the great world of his changing interests. Along with *Ginevra*, only *Madonna of the Carnation* and *Benois Madonna* were made independently as paintings by Leonardo during the 1470s, and only a very few rough but brilliant quick sketches exist suggesting the Madonna scenes, drawings that could be considered first ideas for the early paintings. There had to have been more studies for the paintings. *Holy Child* seemed a very likely possibility, but the canon's conventional thinking about this period in Leonardo's career was still a roadblock.

Drawing styles for artists are usually quite different from painting styles but even the greatest Old Master draftsmen like Dürer, Michelangelo, Rembrandt, Rubens, Goya, and Daumier rarely strayed from recognizable styles for drawing. Other Old Masters like Titian, Caravaggio, Vermeer, Velasquez, and El Greco have left virtually no drawings to enhance their body of paintings, so we are not able to compare their drawing versus their painting style. But Leonardo was quite different—he was primarily

a draftsman, with thousands of drawings to his credit and only some fifteen to twenty paintings, depending on who is counting them. Leonardo's painting style was realistic, whereas his drawing style and technique and subject matter varied greatly and gives a magnificent overview of his broad talent, totaling some 4,100 assorted works, contained mostly in his journals, according to Leonardo scholar Carmen Bambach's fastidious count. Among that vast constellation are sketched sequential ideas of figures in motion, as incisive as action photographs; a sole-surviving, large and unfinished preparatory drawing (*The Burlington House Cartoon*), a great masterpiece that copied closely his realistic painting style, and clearly related to *Holy Child*; anatomical studies that are masterpieces of medical illustration; delicate portrait-like head studies in a realistic style again like *Holy Child* (see below); brilliant studies of horses; grotesque facial caricatures; scientific and technical schemes; landscapes; countless doodles; daydreaming fantasies; maps; and even more if the list of categories were exhaustive. And only one early drawing of landscape was dated! The evidence was apparent: Leonardo was that rare genius who could draw anything in any style that suited his mood—using red or black chalk, pencil or sepia ink—and clearly from the beginning of his First Florentine Period in Verrocchio's workshop. By all measure, it was apparent that *Holy Child*'s rare quality would place it very high among the masterworks of Leonardo's drawings.

Leonardo's left-handed approach, familiar to me as an "odd" left-hander myself, appeared obvious in the right-to-left development of *Holy Child*'s head. A clear left-handed drawing offered resounding support for Leonardo's authorship, another gold star detail in attributing the drawing to Leonardo. For Leonardo, the quick sketching of *Holy Child* dictated a spontaneous and natural approach, which could catch the attitude of the eyes and also avoid smearing of the chalk. Smearing is the bane of left-handers. It must be said, however, that in Leonardo's drawings and in his paintings particularly, detecting the left-handed approach is finally a subjective observation since a drawn line or a painted brushstroke in an artist's hand is subject to many variables. However, in this case, the right-to-left rendering of *Holy Child* left me with little doubt that the drawing was made by a left-handed artist working quickly from life to capture in a fleeting instant an inquisitive and easily distracted infant model.

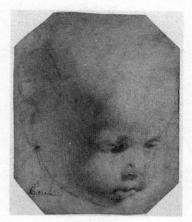

Leonardo, *Head of a Warrior Shouting*, Budapest
Museum (red chalk, 1503–1504)

Holy Child
(red chalk, circa 1470s)

Leonardo's *Head of a Warrior Shouting*, made some twenty-five years after *Holy Child*: two
portrait-like head studies made with red chalk in a realistic style of closely comparative quality
but showing in this comparison a contrasting psychological range suggesting Leonardo's
diversity of subject choices and his skill at characterization and intention.

Leonardo's mirror script handwriting—writing backward and left-handed—
had to be considered an important aspect of his drawing talent, and his
personality. It was a marriage of playful virtuosity and his eccentricity,
which included a secretive nature. Mirror script enabled him to hide his
ideas from possible plagiarists and likely took hold in the 1470s, when he
was a teenager in Verrocchio's workshop. It was a very difficult trick even
for a left-handed genius. He could write in the accepted right-handed
manner, too, if he wished, and judging from rare examples, he sometimes
did. But to be openly left-handed was rare in Leonardo's time period.
Left-handedness was actually ridiculed and even feared as abnormal and
suspicious, even sinister. To willfully underscore his eccentric personality
and turn convention upside down, he would write backward—and legibly
backward if reflected into a mirror. What next? It was clear from many
perspectives that Leonardo was a master draftsman and also unpredictably
eccentric and eclectic in those early blossoming years when I felt, more and
more strongly, that *Holy Child* was drawn.

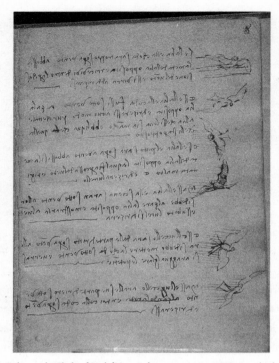

Leonardo, *Codex on the Flight of Birds* (13 pages) in mirror script, 1505. Royal Library, Turin

Thus far in my investigation, *Holy Child* was displaying in its Leonardian qualities the hand of Leonardo da Vinci, starting with the paper it was drawn upon. *Holy Child* was rendered in a realistic (or naturalistic) red chalk drawing style, very closely and specifically related to the heads of Infant Jesus in Leonardo's earliest paintings, completed within the same time period, and by logical extension related to the exquisite early portrait of Ginevra; and more generally, to his other head-study drawings. Here was Infant Jesus personified, a subject for which Leonardo clearly had a special passion, given that two of his first independent paintings feature the Holy Child.

In this drawing, a portrait technique of such faint outlining, illusionistic space, and penetrating observation was on display that magically captured a fleeting instant of life itself. And there was no question that it was made from life, completed within a few minutes, with the baby preoccupied for the briefest moment—perhaps seeing something for the first time, perhaps

a flower, like a flower that would be depicted in the two early Madonna paintings. The virtuosity of such a quick drawing was breathtaking.

⌐∞⌐

In almost every painting by Leonardo that features the Madonna and Child theme, I could see that *Holy Child* bore comparison, not as a traced copy but as a guiding model, an archetype for the various and nuanced depictions of Infant Jesus in formal paintings. Leonardo did not trace his drawings onto paintings; he interpreted them to suit the overall composition of whatever painting he was working on. In *Holy Child*, Leonardo had surely found with this inquisitive baby his ideal model, and with his "inhuman eye" captured the extraordinarily difficult intention of mind of the infant, that intention he emphasized later in his writings and which he may have discovered here for the first time with an innocent baby in the undiscovered country of infancy. *Holy Child*'s expression was a great psychological advance from the bland and static expressions given to Infant Jesus by his predecessors and contemporaries. With *Holy Child*, Leonardo had made it clear that infants were sentient beings with a natural curiosity, and he wanted to impart that very human attitude to Infant Jesus in his paintings. Perhaps he was even thinking of himself and drawing on his earliest memories of being enthralled by the natural world around him.

⌐∞⌐

Of all unlikely details attributable to Leonardo in *Holy Child* was the simple sepia-ink enclosure around the drawing. Renowned Leonardo scholar Carlo Pedretti had observed that Leonardo consistently liked to frame his drawings on a page using a simple outline of brown ink. This feature was usually lost on many drawings which were cut from the page after Leonardo's death, but enough evidence existed to show it was a frequent characteristic. I had never noticed even a remnant of this enclosure on *Holy Child*, but then I wasn't looking for one either until I had read Pedretti's study. When I went back to look with my loupe I found, to my utter delight, unmistakable vestiges of the sepia ink framing around the

drawing, not quite cut off at the edges. This was remarkable evidence—a touch of icing left on a cake, a delicious clue. As insignificant as it may seem, this was not trivial. Here was another encouraging piece of the puzzle come together. One by one, important hidden clues were adding up to a big answer. All the evidence thus far was pointing toward Leonardo, not away from him.

Holy Child detail: one of several areas with remnants of sepia ink framing

But there was still more work to be done. The next item awaiting deciphering was the ambiguous inscription. My reading was "Barache," which I interpreted as antique French for "Barocci." It was written in an old-fashioned hurried script in dark gray ink on a red chalk drawing, doubtless an early attribution added insensitively by a dealer or collector and quite common on Old Master drawings to suggest an "attribution"—sometimes correct but often wrong. It was far from convincing as a signature. Leonardo's name had appeared in 16th century French as "Leyenard de Vince." The age of the inscription, I guessed from its style, was sometime during the mid to late 17th century, long after Leonardo's death, and I would think made as well after Federico Barocci's death in 1612, after his multitude of drawings and prints were widely dispersed throughout Italy and France and his distinctive style, with its serene saintly faces, became widely known. Attribution to Barocci was a decent guess for the era but with the advantage of my 20th century

study of his complete works, which represented a wholly different drawing style whose hallmark was his practically invariable use of multicolored chalks in his drawings—and never red chalk alone—not at all supportable.

The French inscription on *Holy Child* became a resonating clue of some circumstantial importance to its provenance, as did the late 19th century French mat, which Marjorie had removed, which because of the fragile and acidic quality of the manufactured paper could not have been made earlier when paper still had sturdy rag content. Leonardo, at age 67, had died in France on May 2, 1519, at the king's manor house, still standing today, at Cloux (now Clos Luce) near Amboise. Long ago, in my twenties, while driving around the Loire Valley, I had found my way to the legendary chateaux and lingered in the bedroom where Leonardo had died, a memory that still resonates with me five decades later. Leonardo had been named "Painter to the King" by the young Francoise I, who idolized him to a worshipful degree. Francoise had invited Leonardo to be in his service in 1516, offering a royal stipend and a royal residence for the rest of his life, which sadly only lasted three more years: three regal years as an aged philosopher king waited upon by an anointed king still in his early twenties who was as devoted as a son. In the chaotic days following Leonardo's death, his effects were vulnerable, and perhaps *Holy Child* lay hidden among them. Many things surely stayed in France after Leonardo's death, in spite of his will, which bequeathed, to his close companion Francesco Melzi and an entourage of close-by friends, his estate of artworks and land in Italy. It was a guessing game, but I felt the likelihood of an early French provenance had merit as a logical speculation.

cⱭ⌒

When I first inquired after purchasing the drawing and many times afterward, Christie's had repeatedly refused saying anything more to me about provenance other than it came from a "private collection" (which oddly was not even designated in the catalogue), honoring a strict legal covenant from the consignor of *Holy Child* that I could not get beyond. The immediate provenance and the past provenances that might be further revealed were all bound in an ironclad legal contract. Far from an unusual circumstance in

the auction world and among dealers, it had long been accepted and honored as a traditional claim for privacy and legal protection for the owner and former owners, the seller, and the buyer. Ownership of great art is finally a matter of responsible caretaking, often emanating from private collections and then possibly onward into museums as gifts or purchases. Within the history of art, private pleasure over the centuries invariably leads to public appreciation. Jann and I had done our part in that continuum, also. What was important now was that *Holy Child* was at hand. The drawing itself held the ultimate truth and, with luck, all the answers we needed. I had to move on with an inferred history of ownership, as I was not going to get any answers from Christie's due to the legal binding of their own agreements. Evolving one way or another, I could deduce with good evidence that a French provenance at some point had probably occurred for *Holy Child*. The chateau of the king of France was Leonardo's last residence and where he died, and that was where his artistic estate was disbursed, according to his will, to his entourage of close associates. Some items were probably gifted to the king as well. I dared to speculate there was a good chance *Holy Child* had remained in France, perhaps even with King Francoise I, who may have stuck it away in a book, a favored safe place for drawings. Even in recent years, an unidentified drawing by Michelangelo had emerged in that manner from an English lord's library, but no similar discovery had been reported in a French royal library.

I set about untangling the inscription. The attribution to "Barache" (or Barocci) was originally misread by Christie's as "Carache" due to what mistakenly appeared to be a reinforced "C" mixed into "Barache." With magnification, I recognized the "C" is actually not a letter as such but part of a drawn sepia ink notation like an ampersand [&], the symbol or logogram meaning continuation or et cetera. "Barache" had been written over the ampersand, which itself was already reinforced. Right above and touching the "B" of "Barache," a simple curved line floated near the child's cheek. It reminded me of a fingertip. These two details, the ampersand and the fingertip, were drawn in the same sepia ink as found in the outlining around the drawing and were likely original to the period of *Holy Child*'s creation. Leonardo often made an odd assortment of notes and doodles in his folio sheets and journals.

Holy Child ampersand and fingertip details at lower left

Wondering if the ampersand was ever used by Leonardo, I began looking around and I found what clearly appeared to be a related ampersand on a page from his *Codex on the Flight of Birds* (ca. 1490–1503, Manuscript B, Biblioteca Reale, Torino), which I found illustrated on the brilliant and quite extraordinary Universal Leonardo website created by Leonardo scholars Martin Kemp and Marina Wallace. It suggested a closely comparative and logical fit with *Holy Child*, with the *Codex* ampersand denoting an obvious continuation of the 13-page manuscript and with *Holy Child*'s ampersand pointing to the fingertip, suggesting an evolving idea. It seemed reasonable to accept that another piece of the puzzle, linking *Holy Child* to Leonardo's *Codex on the Flight of Birds*, had virtually *flown* into place with the ampersand.

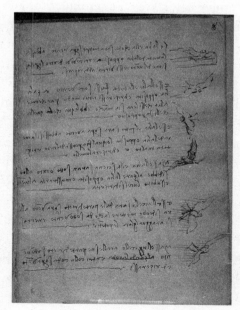

Leonardo, *Codex on the Flight of Birds*

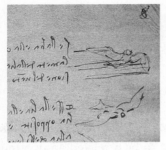

Holy Child, ampersand within inscription
leading to fingertip,
lower left detail.

Ampersand on *Codex*, upper right detail

Historical ampersands: 1–3 Ancient Rome; 4–6 Italian Renaissance,
finding comparison to those found on *Codex on the Flight of Birds* and *Holy Child*

The imagined fingertip stayed in my mind. Why would a fingertip be there with an ampersand? Was it a reminder for an addition, a work in progress? Perhaps one of Leonardo's paintings with the Holy Child held the answer. I began yet another review. An artist's paintings very often refer back to unsigned drawings as a point of origin, which in turn can suggest authorship of the drawing itself, but the two notations were very unusual and suggested a direct link in to something in Leonardo's mind. But what?

The curved line was in fact a "fingertip notation" at the side of the child, where his neck would have been. The actual finger with its tip appeared in Leonardo's ca. 1482–1483 painting *Virgin of the Rocks* at the Louvre (opposite), a painting that closely connected to *Holy Child*. It appeared in the precise spot where Leonardo had placed the Virgin's thumb, by the head and neck of Infant St. John. I was elated!

(I accept Sir Kenneth Clark's identification for the figure of the holy child as Infant St. John, found in his classic study, *Leonardo da Vinci*. It has also been suggested that the infant figure alongside the Virgin Mary could instead be Infant Jesus [suggested by Dan Brown in his best-selling

novel *The Da Vinci Code*]. It is today a moot point. This scene draws on legendary sources because there is no biblical reference to Jesus and John meeting early in life, although Luke's account [Luke 1:30–37] describes the pregnancies of Mary with Jesus, and Elizabeth with John, as overlapping.)

The pictorial theme of the Holy Family is a late one in Christian art, and it was very popular during Leonardo's time with sacred personages variously portrayed in different roles, as here with Leonardo's depiction of Jesus baptizing John, a reversal of more traditional thinking, which could be expected from Leonardo. John is often represented as being somewhat older than Jesus, although in the Louvre picture Leonardo has made them appear to be the same age.

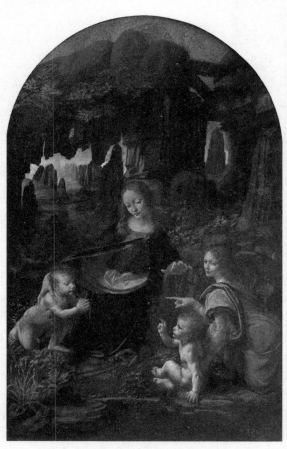

Leonardo, *Virgin of the Rocks*, Louvre, Paris

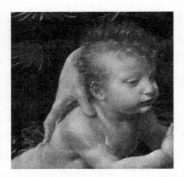

Detail, showing Virgin's thumb at neck of Infant St. John, *Virgin of the Rocks*, Louvre

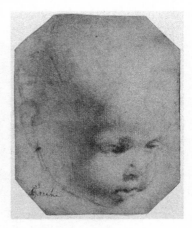

Holy Child, lower left detail showing fingertip notation and directed ink spot
for placement of Virgin's thumb in neck area

Then another clue became evident in the same area. In identical sepia ink, I noticed an ink spot by the Holy Child's ear and concluded that this was a directed notation, not an accidental drip, but more likely a measured calculation for placement of the Virgin's fingertip in *Virgin of the Rocks*. Yet again, that made sense. And judging by the dating of *Virgin of the Rocks*, it would have meant that Holy Child had stayed with Leonardo for about ten years and that the fingertip was a later notation on the drawing at the time of the *Virgin* painting—otherwise, red chalk would have been used. Then another question came along and lingered. Could Leonardo have kept lifelong possession of *Holy Child* as a model drawing?

Thus led on to *Virgin of the Rocks* by the fingertip detail, where I had previously only focused on his two Madonna and Child paintings, more evidence of Leonardo's authorship began to develop. First of all, I could see that *Holy Child* had a close to exact physical relationship and a calculated size relationship to the actual painted head of Infant St. John in *Virgin of the Rocks*. I was not seeking exactitude, since Leonardo never traced or repeated his drawings into a painting like a carbon copy, nor did he repeat exact details of a facial expression or an exact gesture in a painting. With Leonardo there were always evolving nuances of change, second thoughts, fresh insight. While the drawing of *Holy Child* did not show hair on his head, hair had grown on the head of the slightly older infant in the painting.

While I was studying the Louvre's *Virgin of the Rocks*, I looked to other drawings connected to it, the most celebrated of which is *Study of the Angel's Head* (1483, Royal Library, Turin). Kenneth Clark called it "one of the most beautiful (drawings) in the world."

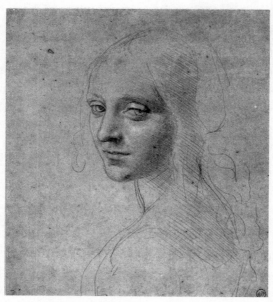

Leonardo, *Study of the Angel's Head in Virgin of the Rocks* (1483, Royal Library, Turin)

To the left of the angel's mouth in the drawing, I saw what was apparently another curved-fingertip notation, a singular variance among her stands of

hair, and again it connected, this time close to exactly to the placement of the Virgin's other outstretched hand in *Virgin of the Rocks*. This was no random coincidence but rather a studied reference Leonardo had made in both the drawing of *Holy Child*, and again in *Angel*, for the placement of the Virgin's two hands in the painting. This evidence, coming along in my piece-by-piece-of-the-puzzle process, fit hand-in-glove and clearly pointed to a very suggestive linkage of the two drawings. Both notations were likely made when Leonardo was painting the original version of *Virgin of the Rocks* (the second version, with probable studio assistance, hangs at National Gallery, London). With all the affirmative direction, I felt I was now on a clear track to Leonardo. So far, nothing I found had disqualified *Holy Child*. The angel could also be found in the details.

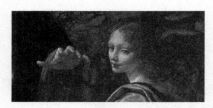

Detail: Virgin's hand with fingers pointing down near angel's face in painting, *Virgin of the Rocks*, Louvre.

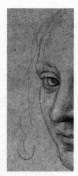

Detail: fingertip notation pointing down by angel's mouth in drawing, in close to exact placement of Virgin's hand in painting.

Although the puzzle pieces of evidence were so far very convincing, still more research was needed which might conclusively and undeniably support Leonardo's authorship of *Holy Child*, or possibly exclude it from serious consideration. I continued to study Leonardo's body of work with a growing sense of expectation.

I was not building a case that had begun with a conclusion, but certainly a theory guided by intuition with a goal in mind. The evidence represented an observable trend, not multiple accidental coincidence. I

was searching for clues within Leonardo's traditional body of works—and, to my astonishment, the clues were increasingly proving my theory. Rather startling affirmative evidence was revealing itself. I was certain I wasn't reading tea leaves and fooling myself. I would have been a fool if in fact I thought it were all mere coincidence and I did not continue with the investigation. I kept searching for an entire summer.

⁂

Leonardo's most famous drawing and his largest one to survive, the great masterpiece *Virgin and Child with Saints Anne and John the Baptist* (aka *The Burlington House Cartoon*, London National Gallery, 50 x 40 in.; a mixed media work on paper now transferred onto canvas—see figure 4 in the insert), offered a haunting similarity, and from the beginning it was never out of my mind, even in these early stages. Here, Infant Jesus and *Holy Child* had always appeared related and now I could see clearly that *Holy Child* had again been the prototype and had been applied in the *Burlington House Cartoon* about thirty years after Leonardo's First Florentine Period. Again, *Holy Child* seemed the likely preparatory drawing Leonardo had kept with him with the care of a precious object.

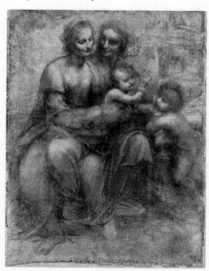

Leonardo, *Burlington House Cartoon*, National Gallery London

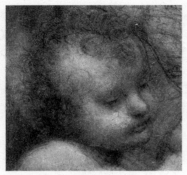

Burlington House Cartoon,
Infant Jesus detail

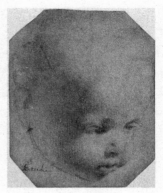

Holy Child

As I continued to dig, for Jann and myself, *Holy Child* became Jann's and my secret Leonardo, framed on an inconspicuous wall, and it remained so for years as we developed connoisseurship with continued study of stylistic, documentary, and historical evidence. Leonardo was a movable feast and should not be digested in one sitting. In a way, studying his works and his life was like reading a wonderful and exciting book that you kept putting down, prolonging the pleasure for another day, not wanting it to end, and feeling there was much more to come in the story, in this case, before a conclusive *yes* could stand rooted like a tree. I still had not found a drawing that would connect conclusively with *Holy Child*, namely a red chalk drawing from the 1470s. Could the Leonardo canon and other preconceived notions I already had in my head about Leonardo's work have steered me away from anything that might have made sense?

As I dug, *Holy Child* became a haunting metaphor of the immortal child, mythic and timeless, a lost child who was once a living being and now after 500 years, nameless and long dead, had transformed into a symbol of resurrection for all children that had come and gone in the human continuum. *Holy Child* had touched my heart, and Jann's heart, as few works of art ever had.

I tried to imagine the circumstance of *Holy Child*'s creation and Leonardo's thinking. Perhaps it was the baby's curiosity that initially caught

young Leonardo's eye. He must have wondered if he could bring out that quality of perception in a drawing of an infant. If it were possible to capture that intention, that dawning of curiosity, something essential to life yet transcendently spiritual, it would be a new invention, a new unrecognized attitude to represent Infant Jesus. Leonardo recorded in a notebook, in a unique entry noting his artistic intentions, that he was planning "two paintings of the Madonna." No doubt he was thinking about Infant Jesus as well, since he never painted the Madonna without the addition of her holy child. When I again compared *Holy Child* to Infant Jesus in the *Madonna of the Carnation* and the *Benois Madonna*, I clearly saw that echo in the paintings: an inquisitive newborn spellbound in both paintings by a flower. *Holy Child* was surely looking at that very flower if the same flower motif repeated itself in both finished paintings. In the two paintings, and implied in the drawing, it was as if that first perception of a flower was the child's first step into his discovery of the natural world, and very likely it was the essence of Leonardo's vision of his own infancy.

<div style="text-align:center">⁕</div>

Practically every drawing or painting of an infant made during the 14th, 15th, and 16th centuries was related to an Infant Jesus—only rarely to another ordinary baby—and of course that identification guided me to Leonardo and his contemporaries. I investigated other possible artists, including Leonardo's much younger contemporary and rival Michelangelo, whom I had considered earlier, and Raphael, Peruzzi, Andrea del Sarto, and of course Verrocchio, but mainly I focused on Leonardo's gifted students and contemporaries who were stylistically influenced by him. I examined the paintings and drawings, many exceedingly rare, of others in Verrocchio's workshop, including Lorenzo di Credi and Perugino; and then on with Franceso Melzi (Leonardo's close companion and pupil who copied some of Leonardo's drawings); Bernardino Luini (Leonardo's pupil); Giovanni Antonio Boltraffio (Leonardo's pupil); Andrea Solario (Leonardo's Milan Circle); Agostino da Lodi (Leonardo's Milan Circle); Giovanni Pietro Rizzoli, called "Il Giampietrino" (Leonardo's

Milan assistant); and many others in a widening circle through the late 15th century and the 16th century in Italy and elsewhere, and casting an even wider net into the 17th century—I always cast a wide net, but this was large even for me. Within a few of Leonardo's early circle, I found some encouragement but not enough to redirect my idea to any one of them. Stylistically many had been influenced by Leonardo, but under our microscope none of their drawings or paintings compared to the rare quality of *Holy Child*. And so it went as we wandered through the Italian Renaissance.

Some years later, in 2003, I learned that the Louvre had a little-known drawing of a baby's head by Leonardo that was closely comparative to *Holy Child*; almost an identical twin! Titled *Head of a Child in Three-Quarter View*, it was considered Leonardo's only known preparatory drawing for the head of the Infant St. John in *The Virgin of the Rocks*.

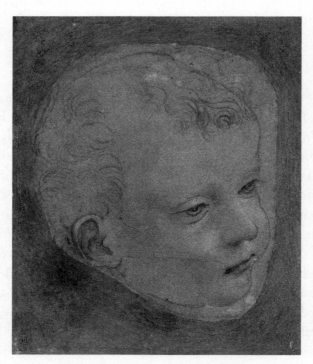

Leonardo and Studio, *Child in Three-Quarter View*, Louvre

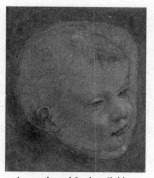

Leonardo and Studio, *Child in Three-Quarter View*, Louvre

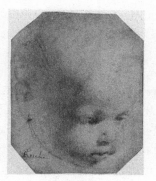

Holy Child

I had never seen the drawing before its rare publication in 2003 in the beautiful and scholarly (and weighty, at 8 pounds!) Metropolitan Museum of Art exhibition catalogue of Leonardo's drawings, *Leonardo da Vinci: Master Draftsman*, organized and edited by Leonardo scholar Carmen Bambach, who always referred to Leonardo in her essays with the godlike term "the Master." I later saw the Louvre drawing in person when I made a literal pilgrimage from Santa Fe to the New York exhibition, a once-in-a-lifetime opportunity to see the largest gathering of Leonardo's drawings ever assembled. A legion of viewers packed the museum.

The Louvre Child, rendered in black and white and gray wash, seemed like a ghostly memory of *Holy Child*, yet unmistakably and intimately related. Both drawings of the child suggested the meditative expression of Infant St. John in *Virgin of the Rocks*, but *Holy Child* was without question the more finished and more sensitively drawn of the two—the two differing much like a lifelike portrait compared to the face of a statue or a mannequin. *The Louvre Child* was in fact a made-over sketch, presumably altered by Leonardo's studio assistants, possibly Giovanni Boltraffio, whose style it reflected, and it was oddly and extremely overworked. It was like stone to flesh when compared to the painting and to *Holy Child*. Why would it have been so overworked and distorted? The Louvre thought it might be a rare piece cut away from a larger cartoon (as large preparatory drawings were called), but that did not explain its awkward makeover. I couldn't figure it out.

Leonardo's sole authorship of the drawing seemed questionable, but both the Louvre and the Met had accepted it as mostly Leonardo's work and that was worth considering. Traces of underdrawing, called *pentimenti*, had been found and that was always a good clue, which spoke of originality and in this case Leonardo's hand. I could still see that *Holy Child* and *The Louvre Child* were both convincing as preparatory studies for the same painting, still practically twins in spite of their contrasting sanguine and pale faces. But something else was not quite right. There was a difference, other than the made-over quality, and that needed to be understood.

The Louvre Child was made over to appear somewhat older than *Holy Child*. The older baby now had a head of hair, a less chubby face, a slightly more developed nose and chin, and more opened eyes, but the eyes were oddly blank of any intention. The mouth was very awkwardly resolved, and then I recognized an immediate correlation to *Holy Child*. It was obvious that whoever reworked the drawing did not know how to change the mouth in copying it from the original: the eccentric angled perspective of *Holy Child*'s mouth, a unique and perfectly rendered optical distortion in Leonardo's hands but a failure in the case of *The Louvre Child*. What was going on? The very awkward revising of the mouth was blatant and clearly referred back to an effort to remodel *Holy Child*'s delicate and unusual perspective. *Holy Child* had to be the model; that now seemed a certainty.

The Louvre Child had been transformed with overworking into an empty generic shell out of a copybook. The child's intention shown in the Louvre drawing simply did not fit Infant St. John in the final painting. It was night and day. Unlike the Louvre drawing, the painted head of Infant St. John was richly alive and younger, infinitely more related in age and general demeanor to *Holy Child*. Why then was *The Louvre Child* so badly made over? There had to be more to it, but there was no need to overly speculate. I would think the Louvre drawing was simply a related copy of *Holy Child*, reworked several times by Leonardo's assistants who were assigned to account for an older and slightly different child, which would then transform into the painted Infant St. John. If that were the case, the Louvre drawing would then represent a failed assignment—or, more fairly, merely a rough draft, or a cartoon as the Louvre had thought.

Then an eye-opening piece of evidence appeared in the Louvre's research. Both *Holy Child* and *The Louvre Child* were close to exactly comparative in size, if not in quality. Size takes on special importance because the Louvre had measured their drawing against Infant St. John's painted head and it compared close to exactly to their drawing—and to the size of *Holy Child*, within millimeters of difference! This was an unexpected match and a major correlation, again suggesting *The Louvre Child* as a copy of *Holy Child*—certainly not the other way around.

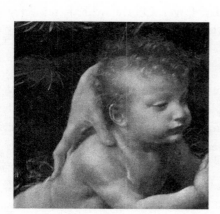

Detail: Leonardo, Infant St. John, *Virgin of the Rocks*

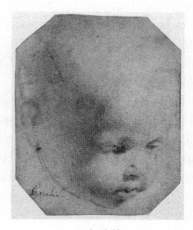

Holy Child

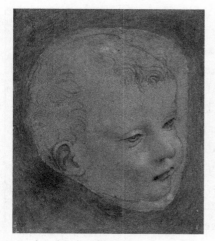

Leonardo and Studio, *Child in Three-Quarter View,*
Louvre

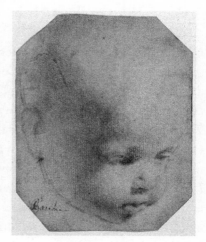

Holy Child

Finally, there was a big and vital difference in *Holy Child*'s favor: it was the original unadulterated drawing. *The Louvre Child* was acknowledged to be so reworked that, as long ago as 1903, Renaissance scholar and connoisseur Bernard Berenson wrote succinctly after his examination: "The Louvre head for St. John has preserved little of da Vinci's own work." To underscore Berenson's opinion, Louvre curator Francoise Viatte wrote candidly in the published evaluation of their drawing that there was "little of the original left: in the outlines of the head, the eyes, the nose, the mouth, the ear, and the hair." What else is there? Clearly, the Louvre had a second-generation copy that had been very fussed over. On the other hand, *Holy Child* had not been reworked at all and appeared entirely persuasive as the original lifelike model for *The Louvre Child* and the prayerful Infant St. John in *Virgin of the Rocks*.

Widening my perspective, I then found, to my continuing astonishment, that among recorded drawings in public or private collections, attributed to Leonardo or to his circle or even to just followers, there was just one other drawing which related to the specific head of Infant St. John in the painting. It was in the renowned Chatsworth collection, and it was clearly a copy of the Louvre's drawing, already itself worked over, and this one, too, by an unknown hand, clearly not Leonardo, and likely made by the same studio assistant, Boltraffio.

Could *Holy Child* possibly be accepted as the original study, more readily than *The Louvre Child*? That was an easy *yes*. Still, *The Louvre Child*, even in its rough and altered state, can be appreciated as a singular and rare production of Leonardo and his workshop. After all, drawings evolve into a painting, and they can look quite different in the transformation, especially with Leonardo guiding the brush. Yet *The Louvre Child* did have a close relationship to Leonardo and to *Holy Child*, and that fact left me with a vital and thrilling piece of affirmative evidence: both drawings obviously related to each other, and to *Virgin of the Rocks*, and there could be little question that *Holy Child* had served as the original model and that pointed back to Leonardo's hand. "Look again," I reminded myself. "Leonardo always gives you a puzzle to be solved."

Time was passing in months and years, and *Holy Child* was secure in its frame on a sun-shielded wall, still gazing down the centuries, a small sanguine icon of a baby quietly hanging above a writing desk at our gallery and giving no small pleasure to Jann and me. We resisted many offers, but it was not for sale. *Holy Child* had become a necessary part of the interior decoration of our lives, as the Peruzzi had been in the past for Jann. It was our private Leonardo. There was no urgency to do anything but enjoy it.

Browsing one afternoon in Collected Works, a superb bookstore across the street from our Santa Fe gallery, I spotted *Renaissance Florence: The Art of the 1470s*, a large illustrated catalogue that had accompanied an exhibition at the London National Gallery. And there I was, magically transported in a time machine back to young Leonardo's Florence, to exactly where I needed to be. I love the serendipity of bookstores.

Leafing through the book, I quickly came upon an illustrated head of a baby from the Uffizi Museum in Florence that, again, I had never seen—a drawing attributed to Leonardo's teacher Andrea del Verrocchio. It, too, like *The Louvre Child*, looked related to *Holy Child*. I was stunned by the recognition. In spite of the fact that babies tend to look alike, I was as sure as a parent that this was the same baby as *Holy Child*. The Uffizi *Bambino* was a three-quarter-length sketch of a baby looking to the left in the image (the image is my normal directional orientation). The drawing was a rapid sketch made from life with black chalk and shows the baby distracted and looking down while holding a stemmed flower or plant. It is carefully observed but without the polish of *Holy Child*, yet this *Bambino* also had a distinctively inquisitive character.

Holy Child was also three-quarter view and of course red chalk and drawn from life, a more finished reprised portrait of only the head, but with brilliantly added shadowing. *Holy Child*'s head was turned to the right, in a different direction. He was not holding anything but was distracted by *something* and also looking down with that pensive intention.

(Attributed to) Andrea del Verrocchio, *Study of a Baby*, Uffizi

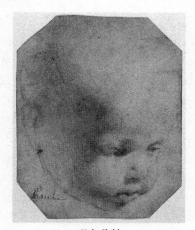

Uffizi, *Bambino* *Holy Child*

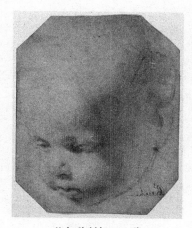

Holy Child (reversed)

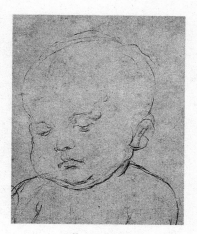

Uffizi, *Bambino*

Verrocchio, well known as Leonardo's mentor, seemed off the mark as the author, but then I would have to have a fresh look at his drawings before making any firm conclusions. I promptly bought the book and in a state of anxious elation went back to the gallery to compare it face to face with *Holy Child*. It was the same child and exactly comparative even with the minor differences. However, when compared to other Verrocchio drawings in the book it didn't make sense. Verrocchio's drawings are exceedingly rare, and I found practically his entire small oeuvre in other published examples, including quick sketches of babies, and they were not recognizably by the same hand as the Uffizi *Bambino*, nor were they of the same child.

Uffizi, *Bambino*

Verrocchio, *Studies of Five Infants*, Louvre

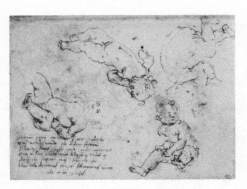

Verrocchio, *Studies of Four Infants*, Louvre

Verrocchio became a troubling question. I looked at many examples of his paintings and sculpture and found no correspondences there either. At this point, I knew with certainty that the Uffizi *Bambino* was not a drawing by Verrocchio. Who then but Leonardo? Who then but the author of *Holy Child*?

The essay in the book tried to support Verrocchio's authorship of the *Bambino* with the illustrated example of Infant Jesus in Verrocchio's Pistoia altarpiece, which I felt related but off the mark. Then in the next sentence, the curator also hinted at a relationship to Leonardo's *Benois Madonna* but dropped the idea quickly. The *Benois Madonna* is of course one of the early paintings relating to *Holy Child*, but the Uffizi *Bambino* is even closer as a model for that painting. The *Bambino* was clearly related as well, like *Holy Child*, to Leonardo's earlier *Madonna of the Carnation*, which oddly the curator did not even mention. I could now see what was happening. The dots could not be connected to Leonardo because no early drawings existed which suggested Leonardo may have worked in the style of the *Bambino*, thus the curator left that question safely unasked. And here I was asking it, and now I was studying two drawings that were intimately related to each other and to Leonardo's two early Madonna paintings, but with no traditional support.

But why would the Uffizi give authorship of the drawing to Verrocchio? This was something that needed to ferment. I knew *Holy Child* was not by Verrocchio and there was only one other answer as I saw it, and that was Leonardo as well. In order to prove Leonardo had made *Holy Child*, I would have to also disprove the Uffizi *Bambino* was by Verrocchio and

reattribute it as Leonardo. That was the only way it made sense. Verrocchio could not have made either the *Bambino* or *Holy Child*. It was the same baby and both were drawn from life and very close to the same moment. Apparently, the Uffizi *Bambino* was a quick first sketch and *Holy Child* was a more planned and finished second return to the baby, probably during the same session and now with a first use of Leonardo's stick of innovative red chalk. Both drawings had an intimate connection to both of Leonardo's first two Madonna paintings; there could be no mistake in perceiving that. Altered angles, turned heads, even an image in reverse—all are perfectly justifiable comparatives when studying drawings, and in Leonardo's case, he usually tested a figurative idea with a variety of poses. Finally, the evident conclusion clicked resoundingly into place: both drawings could only be by Leonardo.

What now? All of a sudden, *Holy Child* had led to the Uffizi *Bambino*, and before that *Holy Child* had led to *The Louvre Child*, all exact supportive visual connections in themselves, but the bull's-eye of a universally recognized, and hopefully relational, red chalk drawing by Leonardo as conclusive comparative evidence was still evading me. Was I stuck on a short and thin red line?

My elated confusion continued on a more or less permanent basis. It was a daunting project to piece together, and I left it simmering with the delicious aroma of discovery in the air and the anticipation of further review of Leonardo's works. More immediate projects were pulling me away, and I felt like the rope in a tug-of-war. There was the pressing matter of making a living. There was always that.

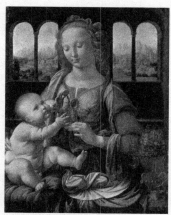

Madonna of the Carnation, Munich

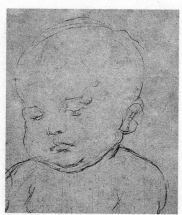

Bambino, Uffizi

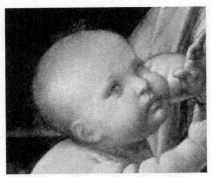

Infant Jesus, detail, *Madonna of the Carnation,*
Munich

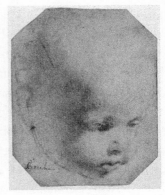

Holy Child

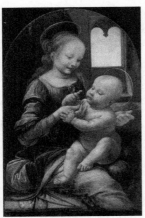

Leonardo, *Benois Madonna*, St. Petersburg

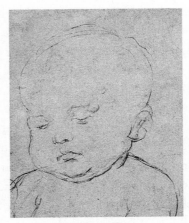

Bambino, Uffizi

Infant Jesus, *Benois* detail, St. Petersburg

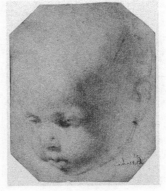

Holy Child (reversed)

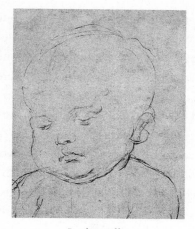

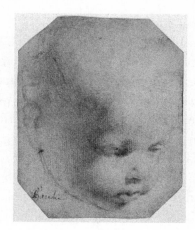

Bambino, Uffizi

Holy Child

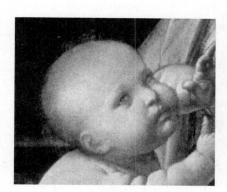

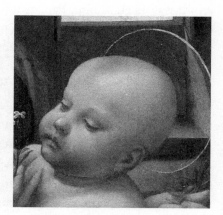

Infant Jesus, Leonardo, *Madonna of the Carnation*

Infant Jesus, Leonardo, *Benois Madonna*

Finally, I reached a boiling point when I could no longer ignore dealing with "the Leonardo Project" and decided it was time to figure it all out and push everything else aside and write down what I had discovered into a proper study. I recalled helpful advice from the novelist E. M. Forster, who famously asked himself, "How do I know what I think until I see what I say?" Indeed, it was time to get a grip on it all. It was time to climb the sacred mountain.

To begin with, I had to understand the Uffizi *Bambino*. I made contact with the Uffizi and they kindly emailed the illustrated page from the

museum's official catalogue. I was surprised to see the Uffizi was now calling the Bambino "School of Verrocchio," not the authorial "Verrocchio" as in the London exhibition catalogue, and it was not a stand-alone drawing, which the London curator had also failed to mention. There was in fact another more primary drawing on the verso which was understandably by Verrocchio—an unfinished head of an angel which reappears in a finished Verrocchio drawing of the same subject, also in the Uffizi. The angel's clear relationship to Verrocchio had too easily crossed over to the drawing of the Bambino on the other side. Here certainly was the answer: Leonardo drew the Bambino on the back of his teacher's discarded sketch—in Verrocchio's studio. That would explain it. Verrocchio didn't need his sketch anymore; he had used the sketch already to make another finished version on another sheet, and probably Leonardo had asked for it or it was given to him. Paper was much too precious and costly to waste during that period; it was logically given to the best students who coveted paper to test their drawing skills, and Leonardo was first in line, as Verrocchio had recognized.

In the Uffizi footnotes to the Bambino, Leonardo was again referenced but without enthusiasm. Again, the dots had not been connected and no doubt for the same old reasons. Based on the traditional canon on Leonardo, even in the literal face of the Uffizi *Bambino* being closely comparative to Infant Jesus in the two early Madonna paintings, the too cautious scholars feared making a leap of the imagination to claim the obvious connection. Now, understanding the rest of the story of the Uffizi *Bambino*, and seeing clearly the mistaken attribution to Verrocchio, I knew my path to Leonardo had again been supported. What I had discovered was even better than I first realized, and continuing good news came as a huge second wave of perception rolled over me and then into revelation upon revelation.

The most astonishing discovery with the Uffizi Bambino came in the form, of all things, a facial abnormality known as a congenital mole. I had at first barely noticed it by the Bambino's right eye and had too quickly moved on since it was not discernibly carried over to *Holy Child*. In my excitement, I was moving too fast. Then it dawned on me: look again. If *Holy Child* and the Uffizi *Bambino* were indeed the same baby,

Holy Child should have the mole too. I went searching for the mole and with a triumphant *eureka*! I found it again, now a diminished vestige by the right eye of *Holy Child*. The mole was not a blatant growth on *Holy Child*, as it was by the *Bambino*'s eyebrow (a mole which even had tiny hairs growing on it), but now it was camouflaged. Under magnification, I could see that it had been hidden yet not originally ignored. A soft red chalk detail denoting and outlining the mole had been muted with a deft touch of white. And because *Holy Child*'s head had been differently posed or turned in a very unusual and brilliantly contrived perspective, the mole was very cleverly angled almost out of the picture. Almost, but not entirely. It was definitely there, an odd but actual detail that in drawing from life Leonardo could not ignore. Ignoring it would be like lying about what he saw. He clearly did not ignore it in the Uffizi *Bambino*, where he encountered the mole head-on for the first time.

 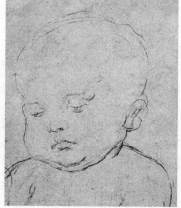

Holy Child, diminished mole, at right by eyebrow *Bambino*, large mole, at right by eyebrow, Uffizi

I realized that with the manipulation of the pose and the unusual perspective of *Holy Child*, Leonardo had challenged himself to create an optical distortion. It appeared that Leonardo had made the discovery of red chalk drawing and optical distortion at the same moment. Optical distortion is an aspect within the field of optics, which is a well-documented area of investigation for Leonardo, thought to have first come years later. His

goal with *Holy Child* was obviously to create a more ideal child, a child to represent Infant Jesus with a less conspicuous mole. I noted in *Holy Child* the ingeniously widened angle from the ear to the eye, and the very unusual rendering of the baby's mouth uncommonly close to the chin. A cutting-edge perspective on a portrait, as sharp and precise as *Holy Child*'s, had never been done so well. This was the exact angle needed to push the mole out of the picture and preserve as much of the face as possible, preserving especially both eyes. The child's sensitive gaze was imperative; it would show his intention, a developing technique in Leonardo's portraiture. The perfection of this eccentric perspective as well as the observational acuity was extraordinary. Clark had called it "inhuman," which always made me chuckle. The minimal use of the drawn line and the precision of the shadowing also seemed avant-garde and groundbreaking. But then, these advances in technique can be found everywhere in Leonardo's confirmed drawings.

I studied *Holy Child* again for a long time and realized I had never seen anything like it. My perceived importance of the drawing and its virtuosity left me astonished in disbelief. Leonardo had unquestionably recognized *Holy Child*'s inventive and innovative properties and of course would have kept it with him since it documented a successful visual experiment and many other discoveries including the use of red chalk in drawing.

The mole should not be lied about in the Uffizi *Bambino* nor in *Holy Child*, since both were drawn from life and must reflect the actual face, as Leonardo, always the scientist, observed. However, with a creative revision by changing the angle, the mole could be rendered innocuous. Other artists might have disposed of it entirely without a second thought, but Leonardo, the keen and rigorous observer, could not let it entirely vanish. At least, not at the beginning, in these two drawings from life. In the paintings, however, which were imagined and fictional creations, the mole could easily disappear from the faces of Infant Jesus and Infant St. John.

I quickly returned to the Louvre drawing of Infant St. John in search of the mole. The drawing was of course adulterated, yet still intimately close to *Holy Child*, and clearly a copy of it, but it could not be counted on to

carry forward original details like the mole. The mole was indeed absent from the drawing, but quite conspicuously absent. Exactly in its place, a bizarre and incongruous thorn-like eyelash was sticking out; the funny mouth and now the funny eyelash. Apparently both odd and unsuccessful adjustments had developed in the revision process of making over a copy of *Holy Child* to accommodate the painted Infant St. John in the *Virgin of the Rocks*, where the mole was of course absent. This rough state of the drawing had obviously been set aside and ignored in the painting of *Virgin of the Rocks*.

Now, aware of what I was looking for, I could speculate that under x-ray or infrared, a copy of *Holy Child* might appear buried under the makeover of *The Louvre Child*, probably showing that the residual mole had been painted over and the original mouth painted over as well. Why else would the weird little wire of an eyelash have been so exactly noted? And the mouth so awkwardly bungled? *The Louvre Child* would very likely prove to be a copy made in some fashion from the original model of *Holy Child*. These were tantalizing questions only the Louvre could address via an x-ray or infrared copy of *The Louvre Child*, but thetelltale mole presented a new dimension to my *Holy Child* investigation.

I went searching for this telltale mole in established drawings by Leonardo as if I were a driven character in a tale by Edgar Allan Poe. There was only one other possibility to explore. I returned to *Studies of the Christ Child* (Venice Accademy, ca. 1508–1510), which, according to the Leonardo canon, was a much later sheet of red chalk drawings. The *Venice Christ Child* had always presented a confusing question to me, due to its being traditionally dated and connected to a painting, *Virgin and Child with St. Anne and a Lamb* (Louvre, ca. 1508–1510), a painting which had been made some forty years later than I had imagined for *Holy Child*. I had obediently let the canon direct me away from it in the past, away from the consideration of any relationship with *Holy Child* and the newly recognized Uffizi *Bambino*. On the Venice sheet, oddly juxtaposed, was a small and carefully drawn head of Infant Jesus in red chalk. I had seen it before and now I would look again with a reopened mind.

Leonardo da Vinci, *Studies for the Christ Child*, here dated 1472–1510, Venice Academy

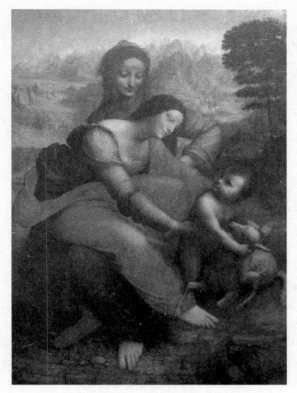

Virgin and Child with St. Anne with a Lamb, ca. 1510, Louvre

Venice sheet with studies applied to *Virgin and Child with St. Anne with a Lamb*, ca. 1510, Louvre

Venice Christ Child (with diminished mole at right eye)

There, as I hoped, was the mole.

"I found it!" At my shout, Woogie and Loola began barking and Jann rushed to my study.

Now, looking more critically at *Studies of the Christ Child*, I could also recognize *Holy Child* and the Uffizi *Bambino*. With my eyes wide open, I had found the mole again. I was incredulous and ecstatic at the same time.

The same odd mole, looking in this evolution more like a spot than a protuberance, had appeared on the drawing, on the same baby I was certain, in an unquestioned red chalk drawing by Leonardo, a drawing that clearly had to be part of a series of the linked infant's heads made during the 1470s: the Uffizi *Bambino*, *Holy Child*, and now the *Venice Christ Child*. How could I not think this was a positive identification linking the three drawings definitively to Leonardo? It was a dream come true.

Soon the inquisitor's imperative questions came. Was the mole really there? Could this really be the smoking gun? Could this just be the coincidence of what actually might be an accidental small spot on the drawing? It was hard to believe what I was seeing. I looked at it a hundred times, questioning my eye. Was I seeing what I wished to see? Was it just an odd dot, an ironic coincidence? If it were a mirage, Jann would see it clearly and

tell me so. Sitting down with a powerful magnifying glass, Jann looked hard at the good photograph in serious silence.

"It's there," she said. "You found it."

My questions poured out to her. "How can I be sure without seeing the actual drawing in Venice? Couldn't it be a flaw in the reproduction? Or just a fly speck. How can I expect to stand on a spot of ink and argue my case?"

"It's just like *Holy Child*," Jann said. "It's another study of the same child. The mole looks something like a beauty spot now. I remember a time when all the girls had one, copying Elizabeth Taylor. Including me."

A beauty spot, on a baby? When I looked again, the spot seemed to be on top of the mole, distracting me once again.

I soon found there was even more to Jann's revelation. We looked into the history of beauty marks and found that the mole, as a beauty mark, was prominently featured in the historical review. Moles—whether biological or created by women as a beauty mark, and generally as a well-placed dark accent-spot—have been associated with beauty and good luck since the time of the Renaissance in Europe, and before then in ancient China. So a baby with a natural beauty mark was special. If it originally appeared too obtrusive, like the large mole on *Holy Child*, it could be cosmetically corrected (certainly by an artist), perhaps even surgically reduced during Leonardo's time. Ladies born without beauty marks created false ones to make themselves more attractive, some going as far as a permanently tattooed spot. Leonardo, in his drawings of the baby, had presumably, and probably with amusement, created a permanent beauty mark on top of the mole as a distraction. Much ado about a mole! It was hysterical.

<div align="center">⧈</div>

After repeated study and working through doubt again and again, I felt that the mole—or later the beauty mark—was emphatically there on the *Venice Christ Child*. And it was, without question, the same baby as *Holy Child* and the Uffizi *Bambino*: a smaller and more studied version and not drawn from life but still the same child with the enduring mole now touched with a beauty mark. The mole was still there, but the addition of a beauty mark over the larger spot distracted and tricked the eye, a

trompe l'oeil, as the French say. The *Venice Christ Child*'s physical correlation with the Uffizi *Bambino* and *Holy Child* offered a perfect synthesis of the two related drawings. The mole was yet carried over by Leonardo, connecting his "dots" and genetically linking the three studies; this time, with the *Venice Christ Child* offering the most thrilling confirmation for me of their genetic relatedness. We now had for comparison a universally established red chalk drawing by Leonardo with a traditional date that needed revision.

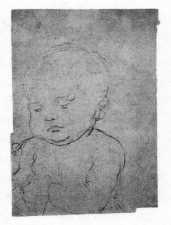

Uffizi *Bambino*, large mole at right eye

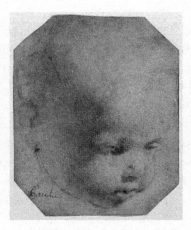

Holy Child, diminished mole at right eye

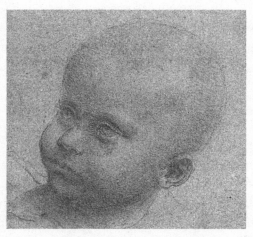

The *Venice Christ Child* showing distinct mole and spot at right eye.
For a comparison with red chalk, see the image insert.

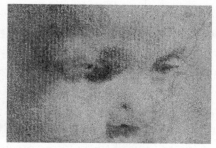

Holy Child showing diminished mole without beauty mark at right eye

The *Venice Christ Child*'s smaller head, in a pose slightly altered from *Holy Child* and the Uffizi *Bambino*, and less than half the size of either of them, was awkwardly positioned within diverse red chalk figurative studies, yet the entire sheet was connected with a much later Leonardo painting, *Virgin and Child with St. Anne and a Lamb*. That connection was traditionally accepted, and I could see its justification with the figure studies but not for the head of the *Venice Christ Child*, which appeared out of place. The head of the *Venice Christ Child* had seemed from the beginning of my studies a surprising stretch of the dated canon and had actually encouraged my comparative thinking at first, yet I had allowed a traditional idea to block my further progress. I rationalized, trying not to be too hard on myself for not seizing on the idea. No doubt it had been too early in the game to pull it all together. It is not unusual with investigations to follow a hanging thread once more and look again. In fact, it is imperative in the pursuit of connoisseurship to *always* look again and again, like a scientist conducting multiple tests of the same thing or writers constantly revising their words. Now there was nothing else in the canon to choose from, and here it was, or appeared to be, the head of the Christ Child oddly juxtaposed on the Venice sheet which was connected to later figurative studies which also had made chronological sense with a connection to the Louvre painting *Virgin and Child with St. Anne and a Lamb*.

At this point, of course, the clues made better sense because I could now recognize that the *Venice Christ Child* was also an early model drawing that Leonardo had continued to use along with the Uffizi *Bambino* and *Holy Child*. Suddenly, the *Venice Christ Child*, along with the companion figures of a baby on the same sheet, began to connect to Leonardo's earliest

paintings as well. It had now become obvious that in the Venice sheet, the head of the Christ Child and two studies of an infant's anatomical parts linked very closely to figurative aspects of Leonardo's two earliest Madonna paintings: *Madonna of the Carnation* and *Benois Madonna*, both from the 1470s. The partial leg and foot drawing at lower right was the same, with slight adjustment, as that of Infant Jesus in *Madonna of the Carnation*. In the *Benois Madonna* (a small painting, 19 x 12 in.), the small head of Infant Jesus in the painting precisely echoes the small head of the drawn *Venice Christ Child*; and the drawing of a infant's clutching hand at lower left was precisely the hand (in reverse) of Infant Jesus gripping a flower in the same *Benois Madonna* (see following illustrations). The locked door of the Venice sheet had needed the magical appearance of Holy Child to open it.

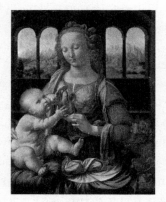

Venice sheet: Application of leg and foot study in *Madonna of the Carnation*

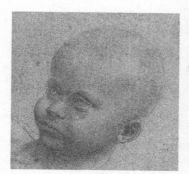

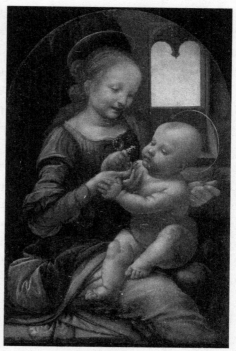

Venice sheet: Application of head of Christ Child and clutching hand (reversed) in *Benois Madonna*

The Venice sheet was a common miscellany of drawings for Leonardo, with new ideas consistently appearing surprisingly next to old ideas, and often they were related. In this case, the *Venice Christ Child* and two of the figure studies linked to Leonardo's two earliest independent paintings from the 1470s, while all six studies again connect to 1508–1510 and *Virgin and Child with St. Anne and a Lamb*. Leonardo had used the sheet twice, some forty years apart. Now we could see the *Venice Christ Child*'s head with firm assurance dated to the 1470s and in all likelihood the two anatomical studies as well.

The *Venice Christ Child*, evidently made not long after *Holy Child* and the Uffizi *Bambino*, offered important new stylistic evidence related to Leonard's largely undocumented First Florentine Period. The *Venice Christ Child* had unquestionably linked-up in a concurrent series to the twins, no doubt as a third reprise that had at first begun with the quickly sketched Uffizi *Bambino*, closely followed by *Holy Child*. Now we had triplets.

Leonardo had indeed found the ideal model for Infant Jesus and Infant St. John with *Holy Child*, and its application continued on. Now I could see what was logically coming: I should consider the connection of the three related infant studies to *all* the paintings by Leonardo that included Infant Jesus. There was nothing else to compare. Important revisions of the Leonardo canon were at hand. Our evidence had suddenly become rooted.

Holy Child had truly become a Leonardo Codex of one amazing sheet.

Yet I continued to be nagged by the question of whether the mole on the *Venice Christ Child* was an accident or placed there on purpose. I was certain no one had ever recognized the mole, and now it seemed to leave a question in the air. How could I possibly resolve it and dispel a question I could hear being raised by skeptics? In any case, I knew my evidence was conclusive enough without another appearance of the mole. I was content to relax, but I still kept looking.

Many months later, a truly remarkable confirmation of the mole did appear again—now for the fourth time—thanks to the research of Carmen Bambach in her Met catalogue of Leonardo's drawings. In the entry Bambach wrote for the *Venice Christ Child*, there were two different illustrations of the same sheet of drawings, the original Venice sheet and another, an almost exact copy in the collection of the Musee Conde in Chantilly, France, a red chalk replica of the entire sheet but not in Leonardo's hand. In the Chantilly copy, exactly depicting the *Venice Christ Child* but with the more determined emphasis of a copyist, the mole reappeared (see opposite and Leonardo da Vinci: Master Draftsman; fig. 195). Someone else had made this copy, but the mole had dutifully and clearly carried over exactly in its spot size from the original Venice sheet, while some of the same figurative elements and an additional few had been freely rearranged to make the assortment less congested. My question of the artist's identity was soon answered by a remarkable surprise as I read Bambach's essay.

The Chantilly sheet wasn't just an ordinary copy. It was in fact linked in another stunning way to Leonardo. Bambach reliably attributed the drawing to none other than Leonardo's esteemed assistant and life companion, Francesco Melzi. It could not get any better. This was wonderfully

clear evidence of the copy's integrity, the integrity of the original, and finally of the mole's integrity. If it was just an accidental spot or something that tarnished the drawing later, it would not have been in Melzi's copy. The mole was not an accident. Melzi had carefully copied the *Venice Christ Child*—in his own recognizable and meticulous style—clearly from Leonardo's own folio of drawings, either at Leonardo's request or after Leonardo's death when Melzi made known copies of Leonardo's drawings. At this point, with four moles, I was shouting *Holy moley!* and laughing. The *dots* had been connected thanks to *Holy Child*, the Uffizi *Bambino*, and the exacting Francesco Melzi, Leonardo's loyal companion.

What a wondrous irony to see the transformation of the real mole, which grew ever smaller into a dot, which then added a definite period to this long and difficult investigation after so many years of question marks. But more revelations were to come.

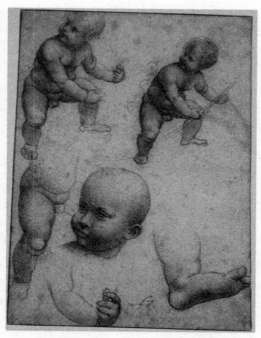

Francesco Melzi, copy of Leonardo Venice sheet, red chalk,
Musee Conde, Chantilly

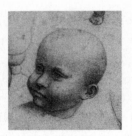

Melzi, copy of Leonardo detail of Christ Child

The attribution of *Holy Child* to Leonardo was now rooted and ironclad. The Leonardo train was moving on down the line, on a mysterious track that had suddenly materialized, right before our eyes.

In all the related portrait drawings of the baby that sat still for Leonardo da Vinci—in the Uffizi *Bambino*, in *Holy Child*, and in the *Venice Christ Child* (and the Melzi copy of it)—the mole was consistently at the right eye, progressively softened but not ignored. I could not help but speculate there was a good chance Leonardo's observant eye initially focused on this highly unusual and rare anatomical detail and that the mole drew him to the infant, first as an ever-curious scientist and then as an artist seeking a model for Infant Jesus. Leonardo may have associated the child to his own youth when he stood out as being singular and even ridiculed for being different, as the baby would be, and as Jesus might have been. Why else would he have made this eccentric and mischievously playful choice for a model?

After endless comparative studies, I was convinced, beyond a reasonable doubt, that all three drawings were depicting the same baby at close to the same time: differently posed, the same age, with the same congenital mole. Further, the drawings were made in three different styles that related clearly to Leonardo: a rapid sketch from life in black chalk (Uffizi); a more finished second rapid study from life in the new medium of red chalk (*Holy Child*); and a smaller, more formal and refined red chalk study based on study of the first two (Venice)—comprising a series of three distinct but closely related complimentary poses. And to dispel any question of an accidental "dot," the mole quite emphatically continued in its hereditary evolution with Melzi's devoted copy. The mole unquestionably was not a

misreading of an odd wrinkle or a careless inkdrop, nor was I reading tea leaves. Mere coincidence? Merely miraculous, I would say.

It was clear that the two larger heads, the Uffizi *Bambino* and *Holy Child*, were drawn from life and that both were used as preparatory studies for the larger head of Infant Jesus in *Madonna of the Carnation* and again as preparatory studies for the "Benois Madonna," while the smaller *Venice Christ Child* synthesized the two into a more studied format that was probably first used as a later scaled-down preparatory study for the similarly smaller *Benois Madonna*. As these preparatory drawings evolved and were revised into the paintings, the heads tilt and turn and the eyes change direction, as ideas imbued with life and movement. A child does not sit still for very long. This embodiment of life and movement was Leonardo's style if anything was. Suddenly the mist had lifted and questions regarding Leonardo's process, and two new drawings stood clear and perceivable as additions to his body of work. In the dawning light, *Holy Child* was awakening and with him, the Uffizi *Bambino* and the *Venice Christ Child* with its two figurative studies, had come alive into sharper and truer focus. There they were, back in Leonardo's ever-present folio of drawings, and they were doubtless with him until the end came, in France. Then *Holy Child* went to the four winds.

With the mole now established as an actual genetic link between four drawings, I rested well with my evidence. Before long, I went back to look again and to make sure my eyes were not playing tricks. In a way they were.

Discovery, I have learned, is by its nature always a concentric process of expanding discoveries. With discoveries, chance and accident favor the prepared mind. There is an exploratory route I have always found helpful, a map for thinking, that the poet W. H. Auden described simply as "Making, Knowing, and Judging," a practice that must come into play for poetry and connoisseurship, and really for anything to work at its best. There is always more to come after the first blink of the eye. In other words, it often takes time for the eye and the brain to understand the deeper quality of something and work things out. It takes looking again—and again with curiosity—as many times as it takes to see

everything you need to see, to see everything that is *there*. It is as simple and as complicated as that. In the case of Holy Child, I had been looking again for years and staring bright truth in the face. Judging, for certain, takes the most time.

<center>✸</center>

I now continued to study the five drawings to see if there were additional comparative qualities. Side by side by side, I laid out good reproductions of all the closely related heads of Infant Jesus: the drawings of the Uffizi *Bambino*, *Holy Child*, the *Venice Christ Child*, and the Melzi copy of it, as well as *The Louvre Child*. I enlarged details of the painted heads of the holy infants from *Madonna of the Carnation*, *Benois Madonna*, *Madonna of the Rocks*—the first paintings into which the drawings were applied. From face to face to face among the images, they all echoed one another with clear resonance. They were surely the same baby, all related nuances from the life sketches of the Uffizi *Bambino* and *Holy Child*, from whence they originally came.

Unexpectedly, as if I switched to a different power on a microscope, I began to see that the noses of the infants were close to exactly comparative and offered yet another proof of positive identification. How could I have missed the nose? The distinctive, tiny, curved hook at the end of the cute baby-nose was carefully rendered and repeated in all four drawings and closely reprised in three paintings. Some were more obvious where the angle of the pose made it a clear distinction, like *Holy Child* and the Uffizi *Bambino* compared with Infant Jesus in *Madonna of the Carnation* and *Benois Madonna*; it was a little less obvious in the others with a slightly changed pose, but plainly there. As telling as the mole, the same cute hooked nose was specifically repeated and reappearing. It was remarkable. Of course, it was the same child, so why shouldn't the nose be the same? A mole and a nose? It was hilariously wonderful. Incredibly, yet another genetic connection had fallen into place. If this were a horse race, I could say we had won by a mole and a nose.

Then another surprise came with the distinguishing nose detail in the made-over Louvre drawing of Infant St. John, the most likely drawing

where the nose would understandably have been changed, and where the mole had already disappeared. But on the contrary, I could see an emphasis on the design of the nose, although the nose is larger in the now-older child, obviously no longer a very young infant as in the original drawings. It appeared that the little hooked shade of difference in the Louvre infant might have been a missed detail in its early makeover because now, surprisingly, I noticed the end of the child's nose was clearly and precisely reinforced with emphasis, implying that the little hook was important and not to be missed. Who else but Leonardo would have cared about that detail? Leonardo had meant for that fine distinction to be there. This would show, as I suspected, that the Louvre drawing of a somewhat older child was probably modeled and copied from the earlier model of *Holy Child* and the Uffizi *Bambino*, where the detail was unmistakable. Perhaps in the process Leonardo had strolled by the assistant and made a quick lighthearted revision to the nose.

Not content to stop with the seven good examples, where the comparisons were strongest, I continued to look into his later paintings, and a significant observation developed. The hooked nose was like a common denominator from the beginning, but grew larger as Leonardo took into account a maturing child. Leonardo was taking into account the passage of time by way of the nose as he evolved Infant Jesus and Infant St. John. What a wonderfully curious detail. I reminded myself that *Holy Child* and the Uffizi *Bambino* were modeled on a very young infant who was probably sitting up for the first time when Leonardo caught that fleeting, spellbound moment of first awareness. The nose does grow quickly in an infant, and even the holy noses of Infant Jesus and Infant St. John would grow proportionately over time. With his scientist's eye for anatomy, Leonardo would carefully take the nose into account as it would become one of the most significant features to change and "age" as the child grew. In the later paintings, the noses of the holy infants were subtly becoming a distinctive Italianate nose. Leonardo paid affectionate attention to the delicate noses of his holy children. (Conversely, in a number of later drawings, Leonardo, with a sardonic sense of humor, caricatured adult noses in an ongoing series of grotesque faces jokingly known as "nutcrackers.")

Leonardo: Comparative Noses of Infants in Leonardo's Drawings & Paintings

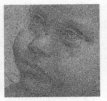
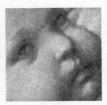

| Holy Child | Uffizi *Bambino* | Venice Christ Child | Infant Jesus, *Madonna of the Carnation* |

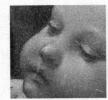
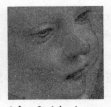
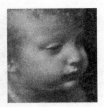

| Infant Jesus, *Benois Madonna* | Infant St. John, Louvre cartoon | Infant St. John, *Madonna of the Rocks*, Louvre |

Red chalk, like the telltale mole and the telltale nose, had become another unifying and identifying detail that needed to be understood as I examined *Holy Child* alongside the four other drawings. Greatly encouraged by the evidence I had already discovered, I went looking further into Leonardo's drawings and found significant additional proof that he drew with red chalk during the 1470s—and importantly, he drew children with red chalk specifically connected to the early Madonna paintings. This long-ignored linkage added vital support to the early creation of *Holy Child* and the *Venice Christ Child*—both now unified red chalk studies. This evidence can also revise a small milestone in art history. We can now accept, a decade earlier than supposed, Leonardo's pioneering use of red chalk, an innovative medium that played an early role in his creative life and in the works of many artists in following centuries.

Before red chalk (made from red clay) became the drawing medium of choice for Leonardo—the accepted "pioneer" of the medium—the Renaissance artist's drawing-tool box consisted of charcoal or black chalk, white chalk, sepia ink (known since ancient Roman times), iron gall ink (used

primarily for writing since the 5th century), graphite (pencil), and silver-point or metalpoint (using a soft metal rod in a stylus for drawing a finer line on a prepared surface, which Leonardo also favored). Leonardo often chose red (or "sanguine") chalk for drawing because he liked its flesh-like color, its indelible quality, and its hard solidity which enabled a sharp and finely drawn line. Leonardo always drew on paper but never on vellum or parchment, which was nevertheless readily available and had been since ancient times, but its surface was too reactive and unstable under damp conditions, resulting in blurring and losses. Finally, red chalk was a stylistic choice for artists (and collectors) who loved the liveliness of its red color, which came in many shades.

<div align="center">❦</div>

My additional red chalk discovery came about with study of two sheets of closely related sketches of babies, one in red chalk and the other in silverpoint, both illustrated with assorted anatomical parts. Although still unrecognized as works from the 1470s, the two sheets are visibly connected to Leonardo's lost First Florentine Period and to his first two independent Madonna and Child paintings. The sheets, in the illustrious collection of Leonardo da Vinci drawings at Windsor Castle, owned by the Queen of England, were acquired centuries ago by her royal predecessors.

Of the two sheets, the sheet in red chalk with five modeling studies of an infant's anatomy in alternate positioning contained a very clear preparatory study for the leg, abdomen, outstretched hand, of Infant Jesus in *Madonna of the Carnation*, by all accounts his first independent Madonna during the 1470s. The comparison was unmistakable. This linkage tied neatly with a red ribbon, almost too easily, and proved again his early 1470s use of the elusive sanguine medium and again reinforced *Holy Child*'s and the *Venice Christ Child*'s interrelated early creation. It was another breakthrough in the mystery, but it seemed too obvious as I thought about it. Why didn't Leonardo scholars see the unmistakable association with the two early paintings? It had clearly been misjudged.

Leonardo, *Studies of a Child*, Red Chalk,
London, Royal Collection

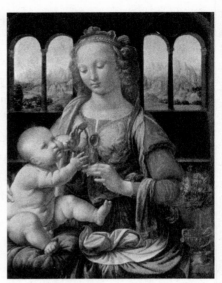

Madonna of the Carnation, Munich

The sheet in silverpoint, rich with twelve diverse figurative ideas, pointed with clarity to five studies used a little later in the *Benois Madonna*. The sheet also incorporates two studies that repeat poses from *Madonna of the Carnation*. Another important, straightforward connection had gone unrecognized.

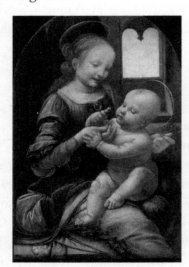

Leonardo, *Benois Madonna*

Leonardo, *Studies of a Child*, silverpoint,
London Royal Collection

114

Was I being naïve in thinking I was the first to connect them securely as drawings from Leonardo's First Florentine Period? After studying the published canon, that apparently was the case. The drawings, although long published as images, had been sequestered at Windsor Castle for hundreds of years. Quite excellent research on the paintings and drawings had been carried out more than half a century ago by longtime royal curator Sir Kenneth Clark and A. E. Popham of the British Museum, both of whom wrote classic studies, Clark on Leonardo's paintings and Popham on the drawings. However, to be fair, we now had the long-hidden example of *Holy Child* and the reconsidered Venice sheet offering the missing red chalk links in the chain of understanding Leonardo's development that neither Clark nor Popham had access to. The Leonardo canon had been stuck on a very short line of red chalk. The catalyst of *Holy Child* and the *Venice Christ Child* had reappeared, and now we can see that Leonardo was working with red chalk from his earliest days as an artist. Solid evidence had grown from a seed of red chalk, and *Holy Child*'s roots had continued to grow into Leonardo's First Florentine Period.

<p style="text-align:center">⁘</p>

Quite unexpectedly, another exciting discovery brought new light to the expanding universe of *Holy Child*. With *Holy Child* and the other reassessed drawings to guide me, I returned to study *Leda and Her Children*, an eccentric and delightful painting closely associated with Leonardo in the collection of a little-known museum, Staatliche Kunstsammlungen in Kassel, Germany.

Leda has been traditionally attributed to Gianpietrino (Giovan Pietro Rizzoli, died ca. 1540), a talented young artist, little known today, who was part of Leonardo's Milan studio around 1510. Leonardo's assistance with *Leda* was widely accepted, but no documentary evidence in the form of preliminary drawings had appeared from either artist.

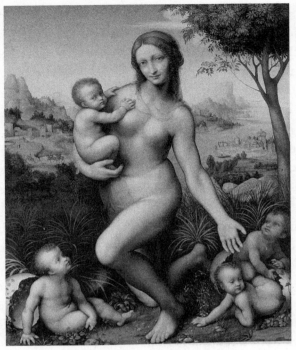

(Traditionally attributed) Gianpietrino, assisted by Leonardo
(here attributed)
Gianpietrino and Leonardo
Leda and Her Children
Staatliche Kunstsammlungen, Kassel

According to the Leonardo canon, the *Leda* painting was possibly made with the aid of a now-lost cartoon by Leonardo and possibly under his guidance, and I could see from Gianpietrino's very rare comparative works that his style was influenced by Leonardo. But *Leda* was a satire, an eccentric and humorous entertainment, completely comic, much like a burlesque act. It might have been a contemporary work from the 21st century, not a painting with a circa date of 1510. But then, as an invention of Leonardo's, I was ready to believe it. *Leda*'s eccentric subjectivity was very unlike Leonardo's other paintings, or Gianpietrino's, or any other painting depicting the Leda myth. In fact, as I considered it, *Leda* stood out as a groundbreaking painting

within the entire Italian Renaissance where satire in art was unheard of, whether religious or mythological.

Leda had always struck me as a zany mythological metaphor that could have been poking fun at the Immaculate Conception myth. Under that same veil, I could see another revelation that lay hidden in Leonardo's personal history. Because Leonardo was an illegitimate child, Leonardo's birth mother was generally hidden outside of the immediate family. But there was much more than that. Leonardo's earliest memory of childhood had inferred that he was in fact a hatchling tended by a mother bird (specifically a kite); and understandably, he would then have been hatched from an egg. Leonardo recorded the experience in his Notebooks as a remembered dream while "still in the cradle"; he also acknowledged that birds (and their flight) had become his destiny.

Cruel taunts like "odd bird" and no doubt "bastard" surely echoed from Leonardo's childhood. "Maverick" was 500 years away from being added to the lexicon, but he was indeed a weird left-handed maverick and an odd-bird bastard as well. Leonardo had flown away from the flock of ordinary people early on, surely an "odd bird" in his own mind, a curious kid with strange ideas and a cloudy origin. Sigmund Freud gave a complex sexual interpretation of the dream in his famous essay on Leonardo but did not take into account the dream's relationship to *Leda* as he was unaware of the painting. In Freud's psychoanalytic study of Leonardo, he also suggests an insight often overlooked which surely pertains to *Leda* and somewhat explains its creation: "Indeed, the great Leonardo remained like a child for the whole of his life in more than one way. . . . Even as an adult he continued to play, and this was another reason why he often appeared uncanny and incomprehensible to his contemporaries."

As the popular myth went, Leda, the beautiful daughter of a king, was married to another king. She was lusted after by Zeus, the supreme god of Greek mythology, who then transformed himself into a swan and seduced her. Leda subsequently gave birth to a number of famous children who were hatched from eggs, including Helen of Troy and other mythic characters. This odd erotic fantasy had become a popular and amusing idea floating around in Leonardo's day, and the drawings he made of Leda attest to his interest.

I had seen Leda-themed paintings by other artists of the period and a few may be copies of Leonardo's original lost painting. Those paintings were all very different, showing a standing Leda and always with the traditional amorous swan. The sexually motivated Zeus-swan, which appeared in virtually all the other Leda paintings, was notably missing in the Kassel painting. Leda's hatchling children were here unusually characterized as distinct individuals. And Leda was portrayed here as if she had just completed an odd dramatic role—naked, sexy, and unashamed—she boldly and proudly presented her brood, kneeling to an audience at the end of a play. Brava! Everyone knew what had happened with the big swan and this was the result: godly children miraculously hatched from eggs. However, with the swan absent from the picture, a questionable parentage could also be cleverly suggested.

As I examined *Leda*, a bigger question kept interrupting. Was Leda actually directing the applause to one of her hatchlings, that distracted and curious little fellow looking at a flower? This was very peculiar. Why was he so important? In the painting we find four human-like hatchlings just awakened and come out of their large eggs, yet something was very different and possibly important about the preoccupied baby. In Leda's elaborate presentation of her brood she had singled out the exploring baby by placing her hand directly over his head. A focused sense of humor seemed to be at play, much like a political cartoon with someone's well-known face put on the baby, and Leda saying, "He did it, he's the one." If she had been pointing to "Mr. Swan" it would not be hard to guess why she was singling him out. But why single out the baby?

When I saw the face of Holy Child materialize on the curious hatchling, and obviously not as Infant Jesus, I thought that Leonardo may have used the Holy Child to represent himself—an Infant Leonardo! With all the documentary connections in support, it was again a perfect metaphor. This playful alchemy of the mind was very much like him. The Holy Child had changed, in a final transformation, into a surrogate for Leonardo. Leda was saying it all along and pointing it out: "That's Leonardo, the odd bird hatched from an egg, as many have suggested . . . and he's also responsible for this crazy painting."

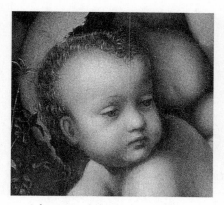

Infant Leonardo hatchling, *Leda*, Kassel

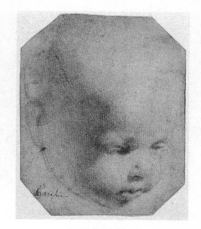

Holy Child

I gathered images of the three "holy" children around a good clear image of *Leda* and looked again. There was no mistaking it. Holy Child was almost exactly comparative to the head of the inquisitive hatchling. Then I recognized that all three related drawings—*Holy Child*, Uffizi *Bambino*, *Venice Christ Child*—were all referenced as preparatory studies for the hatchling babies, including one of the figurative poses on the Venice sheet. Leonardo and his folio of drawings were right there and his direct participation could not be missed. With no reasonable doubt, the evidence now supported Leonardo as co-author of *Leda* with Gianpietrino.

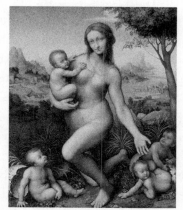

Here attributed: Gianpietrino and Leonardo,
Leda, Kassel

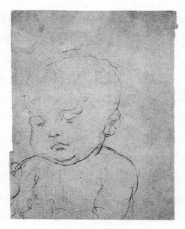

Bambino, Uffizi

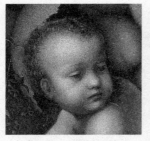
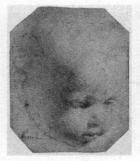
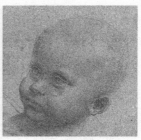

"Infant Leonardo" hatchling,
Leda, Kassel

Holy Child

Venice Christ Child

Comparison of three Leonardo's drawings and a painted St. John with hatchlings on the ground in Leda

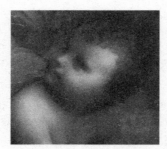

Infant St. John, *Virgin and Child
with St. Ann and a Lamb*, Louvre

And let us not forget Gianpietrino. Doubtless Leonardo conceived the painting and further veiled his identity by assigning the job of painting the figure of Leda to Gianpietrino. Gianpietrino, in all likelihood, is in the painting looking at us in the guise of the hatchling with a notably different face, looking like an impish clinging monkey and claiming Leda with both hands. After all, Gianpietrino painted Leda, with his own hands; that honor was his and his skill had been recognized by the great Leonardo. The baby's face is in all likelihood a caricatured self-portrait of and by Gianpietrino; it has no relatedness to any drawing by Leonardo.

The overall painting was a marvelous practical joke, an inscrutable riddle, and no doubt carried a vow of secrecy among Leonardo's studio assistants. I can't imagine it was kept a secret, but the archives have remained silent. For Gianpietrino, whose work is rare and questionably

documented, this reconsideration of *Leda* only enriches his claim for immortality in art history. He and Leonardo must have been good friends.

Under Leonardo's direction, his special effects permeated the painting. Along with the placement of *Holy Child*, they surely include (1) Leda's very large and gesturing arm, obviously an overstated perspective, an optical distortion, appearing to reach out from the scene to present the little odd-bird inventor of the painting, and (2) Leda's projected leg, which again appears to be coming out of the painting, inviting a distracting touch. Even Leda's cocked head seems to have just moved as she directs her arm in response to applause and calls of "Autore! Autore!" I had to think that above all else the Leda fantasy was a wonderful amusement for Leonardo, and Gianpietrino. Leonardo was going all the way with this frolic; he was definitely into it.

<p style="text-align:center;">∽</p>

Both physically and in attitude, the singled-out hatchling resembled *Holy Child* and the hidden Leonardo. The Infant Leonardo hatchling was looking at a flower, the Uffizi *Bambino* was distracted by a flower, and a flower also held the attention of Infant Jesus in *Madonna of the Carnation* and again in *Benois Madonna*. That same flower was almost certainly there but out of the picture and distracting, *Holy Child* in the drawing. In *Leda*, Infant Leonardo crawled away from his mother and his siblings into nature, where he would find intellectual and spiritual nourishment.

The three hatchlings on the ground had suddenly echoed the three holy children: *Holy Child*, the Uffizi *Bambino*, and the *Venice Christ Child*. It was like fireworks going off. It unified the inherent connection of the three drawings and documented their application more than thirty years after they were first made. Now, Leonardo's unmistakable direct influence and his hand had suddenly been revealed in *Leda*.

Thus encouraged, I went back to my study of Leonardo's infant noses and found a resounding exact comparison with the noses in Holy Child and Leda's Infant Leonardo.

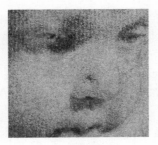

Holy Child

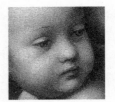

Leda, Infant Leonardo

More support for Leonardo's principal authorship of *Leda* was on its way. A recent study financed by the Kassel museum directed an x-ray analysis of their *Leda* and the wood panel upon which it was painted. X-ray had revealed a long-hidden secret. First of all, it appeared that some figurative elements of *Leda* were drawn by Leonardo on the wood panel.

Secondly, underneath that, another astonishing surprise: there was a preliminary study of none other than Leonardo's painting of the same period, *Madonna and Child with St. Anne and the Lamb*, a smaller first version (a larger version is in the Louvre). Now the evidence for Leonardo's direct participation in *Leda* was extraordinarily supported, as if he had signed his name. More investigation suggests the smaller version hidden within the panel was very likely in Leonardo's studio at the same time as *Leda*. This left the wood panel with the smaller *Madonna and Child with St. Anne and the Lamb* in the studio and avail-able for the new *Leda* to be drawn and painted over it to be used again by Leonardo and a favored student, Gianpietrino, who was obviously invited to participate. True to what was advertised, *Leda* was as much a riddle as it was a painting.

With *Leda*, I came full circle in an investigation filled with revela-tions, arriving at an epiphany at the end of a riddle. Finally, hidden within *Holy Child*, this lost and homeless red chalk drawing of a baby, an ancient poem of hidden rhymes had appeared. The drawing of *Holy Child*, which began life in a serious way as Leonardo's personification of Infant Jesus, had ironically ended up reinvented as a satirical personification of Infant Leonardo himself.

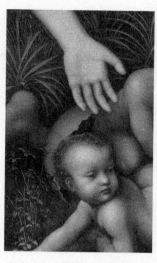

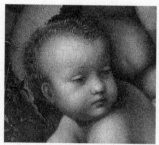

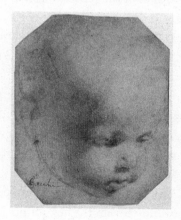

Infant Leonardo Hatchling and *Holy Child*
(Hatchling detail, *Leda*, Kassel)

CHAPTER 4

Leonardo's Codex of One Sheet

eonardo, the great Magus of the Renaissance, had shown us that things are not as they seem, and his instruction is clear: *Look again*. Until I began to look again with *Holy Child*, the discoveries and connections I made with Leonardo's body of artistic works could not have been recognized or supported without the conclusive evidence I needed.

Holy Child was the missing link to the fuller understanding of Leonardo da Vinci, much like the fabled Rosetta Stone provided the key to unlocking Egyptian hieroglyphs. The connections had the wondrous eureka quality of discovery, and they would never have come to light without *Holy Child* leading me to them.

Indeed, Jann and I also recognized the deeply personal, even mythological quality of this adventure from the beginning, and this put our hearts more deeply into the quest. What was once a drawing of a lost child nobody wanted had step by step led us all the way home to Leonardo da Vinci.

And in the end, *Holy Child* had transformed into what actually became *Leonardo's Codex of One Sheet*.

I could not deny the magic and the poetry of *Holy Child*, nor could I deny my consideration of it as the most beautiful drawing of an infant and of the image of Infant Jesus made during the Italian Renaissance. Yet ironically, as fate would have it, *Holy Child* had been invisible for 500 years.

In the beginning, I had a theory that *Holy Child* might be a masterpiece by Leonardo da Vinci. The first big question was: Could I disqualify it as an autograph work by Leonardo? The second big question was: If I could not disqualify the drawing, then could I prove it was Leonardo beyond a reasonable doubt? I was understandably anxious and aware that the discovery of an integral lost work of art by Leonardo would be equivalent to finding the mythical Holy Grail, and this certainly would be a holy grail of lost art. It was a bold challenge which some would even call brazen, but I was drawn inexorably to the light of *Holy Child*, which I followed and found impossible to resist. And so I began a serious study of Leonardo da Vinci, whose canon lay before me.

In writing this memoir, the actual story demanded that it be no less suspenseful and with no fewer pivotal clues than a Sherlock Holmes "Case of the Lost Leonardo," an investigation of a very cold case of a missing person and of a missing treasure from the Italian Renaissance. It would necessarily have to develop into nothing less than the astonishing chronicle that it actually became: true to life as it plays out for all of us, which in its actual development is as unlikely in its twists and turns as the most surprising plot of imaginative fiction.

In the pursuit of connoisseurship, and with a good deal of amazing grace, the question of Leonardo's authorship was answered: step by cautious step in a continual attempt to disqualify it; then piece by surprising piece to qualify it in its many astonishing details. As we looked deeper and fit the pieces together, the picture of Holy Child began to appear like a radiant puzzle. With the work finished, I would stand back, truly overwhelmed as I was by the experience, and wonder if I should be bold enough to say that *Holy Child* had materialized as nothing less than Leonardo da Vinci's most precious drawing; most precious only because, as it appears from the

evidence, Leonardo himself thought so by his continued use of *Holy Child* as a model drawing for Infant Jesus and finally for himself.

We may have resolved the question of *Holy Child*—and of its lost twin the Uffizi *Bambino*, the *Venice Christ Child*, the Kassel *Leda*, and other questions—but the larger mystery of Leonardo's art has just deepened and remains ever challenging. What other works of Leonardo's are still wandering lost and unrecognized, even in the dark drawers and storerooms of museums, especially there, where the pursuit of connoisseurship deserves a chance to make a discovery. Surprisingly few discoveries have come to pass within the established museum culture.

Of course it was imperative that my theory be richly illustrated with essential comparative images and concrete examples, without which even a patient scholar might walk away mystified by my conclusions, asking, "How do I know what to think until I have seen what he is talking about?" Obviously, without the illustrations, comparative and side by side, and as good as my eidetic memory is, I too would have lacked essential visual help to think clearly about what I had to say. Comparative analysis—the eye's judgment of the "signature comparative detail"—is of course the key to the pursuit of connoisseurship in art and in everything else in life that can be enhanced by qualitative judgment.

In the exacting process of connoisseurship I was delighted, all the more, to have seen once again the metaphysics of chance acting its part in the play of things in the poem of the world. For me, this whimsically profound thought was somehow inspiring—perhaps too Romantic and mystical for many—but it pleased me to think I could trust its wisdom and the good luck that came my way. After 76 years, I believed I was lucky, and long ago discarded cynically thinking life was all chaos and surrendering to the mundane. A term like "serendipity" can also be applied, but first of all there is everyday toil, as Emily Dickinson summarized in her succinct gem of a poem:

> *Luck is not chance—*
> *It's Toil—*
> *Fortune's expensive smile*
> *Is earned—*

Leonardo was the ultimate examiner of life. He was a committed humanist, and yet he was paradoxically, in his private way, extremely interested in the mystical development of the Church-sanctified subject of the Madonna and Child. I think for good reason. There is every indication that he was deeply touched, no doubt playfully in *Leda*, by the romantic and holy ideal of the mother-and-child relationship. I believe Leonardo chose over and over to develop masterpieces within the Madonna-and-Child theme, which in all likelihood he recognized as symbolic of his brief and sweet relationship with his own mother. His always beautiful Virgin Mary was the archetype of his mother, and her Holy Child became the archetype for himself. It could be said that with the aid of religious mythology in his works of art, Leonardo mischievously created his own mythology, much like Picasso.

There remains the unanswered question of *Holy Child*'s whereabouts for the last 500 years. Based on the evidence, it is clear that *Holy Child*, from its inception, was a precious object for Leonardo, served as an inspirational model drawing throughout his life as an artist, and became the archetype of his holy children in his paintings. He obviously took great care of it during his lifetime, and this care was carried forward after his death.

Many suggestions arise concerning provenance. *Holy Child* may have been hidden away in France from the time of Leonardo's death there. On the other hand, perhaps the drawing first went back to Italy with Leonardo's devoted entourage, all of whom inherited his paintings and drawings. Through a twist of fate, which should never be neglected, *Holy Child* may actually have been stuck away in a book in a protected library somewhere, and through the ages the book may have found its way to someone who simply flipped the pages, found it, and sent it to auction. Its guardians in any case deserve gratitude. The metaphysics of chance could suggest a journey of a thousand possibilities. Lost art, miraculous survivals, and unanswered questions have always been part of the romance and the mystery of art history, with Old Master paintings but especially with Old Master drawings. The hidden provenance of *Holy Child* may long remain a tantalizing question, joining the multitude of vague and unknown provenances of many masterpieces in museums everywhere. At this point,

however, while interesting, the matter of provenance is of small importance in relation to the authenticity and actual survival of *Holy Child*. Provenance can gild the lily with a pedigree, which may or may not represent verifiable facts, but the true lily must first be there.

Old Master drawings are precious objects, and as they are made on paper, they are vulnerable to a variety of misfortune. At once they are as close to an artist as a whisper of intimate thought and yet distant in time as light from an echoing star.

Old drawings, even modern drawings, are rarely signed or dated, so they are for the most part attributed or unattributed and subject to diverse and changing opinions. Often comparative evidence of authorship in drawings, and in paintings as well, is veiled in seemingly insignificant or surprising details, but the signature comparative details must finally come together with the eye as a genetic reality—in a mole, a nose, an ear, or a mouth; the gaze of an eye; the curls of hair; the characteristics of a line or brushstroke; the choice of subject; the structure of a figure; a gesture or intention; a facial expression; a choice of color; the design of a leaf or stone or branches in a grove of trees. Wherever care has been applied. Disparate clues either come together and light up in a candle of perception, or they do not. A drawing may survive merely by being beautiful, or just as fortunately by suggesting itself as a study for an established painting. It may evolve as a related insight into the artist's thinking, an evolving first or second idea, or even a false start with nothing else in support. A drawing exists for some reason, and even Leonardo doodled and daydreamed. Mistakes of attribution are made and perhaps in a hundred years corrected, or 500 years in the case of Leonardo's *Holy Child*. This state of affairs is common and inherent in the nature of Old Master drawings. Many lost drawings lead a charmed life and manage to survive for centuries as decorative and symbolic icons. Many pass on to collectors from generation to generation and then possibly into a museum's permanent collection and into a wider appreciation. While art may be eternal, life, however, is short, and patient study of drawings, like the love affair it is, has its limits. Countless drawings fly away to parts unknown with an insecure identity and forgotten history.

As always with most new discoveries in art and other disciplines, doubt and disagreement is inevitable. As an art historian, as an art explorer who

has played a leading role in many discoveries, I am gratefully aware that a simple *no* is not an acceptable or valid argument, nor should it be a stop sign for further thinking. *Yes* does not imply perfection either, but then, it can be a life-affirming recognition and lead to deeper perception. In the end, we only see what we know. Leonardo said it best when he wrote:

THOSE THAT SEE.

THOSE THAT SEE WHEN SHOWN.

THOSE THAT DO NOT SEE.

In the land of Leonardo, hand in hand with Holy Child, we became explorers on a quest into a masterpiece that had been sleeping for 500 years. We entered into a mystery and sailed away with it and years later in this odyssey arrived back home laden with answers that, ironically, the great artist had not hidden at all. Leonardo just asked that we become acute observers and engage our curiosity and imagination to evolve the truth of what can be seen, as was his practice. In the pursuit of connoisseurship and in the thrall of discovery, I hoped my investigation into Leonardo da Vinci and his *Holy Child* would clearly and accurately present what I had found—with skepticism and enthusiasm entwined. If, in the end, the discovery of *Holy Child* has come together as a poem of logical and imaginative ideas, and finally as a theory supported with the evidence of objective facts and with essential subjective interpretation, I will be well pleased. And I am certain Leonardo would approve. No doubt the drawing will be tested again and again over time, but as it stands, *Holy Child*'s time is now, and it stands tested here in this book. Connoisseurship and poetry walk hand in hand; the poet imagines, the connoisseur refines.

Leonardo's *Holy Child* and the story of its discovery appears here for the first time. The drawing has never been shown publicly, only in a quiet

corner of our Santa Fe gallery where it hung for years and where few people noticed, yet Jann and I enjoyed its presence every day.

My theory of this unprecedented drawing—and my research proving it—has been some fifteen years in development. I have not sought the standard peer-group review, which no doubt will develop in time now that I have put my research into the drawing into publication with this book. It is an unconventional approach appropriate for a masterpiece that has been lost and unrecognized by many peers for 500 years. The reading public is entitled to the first look and thus will render the first judgment.

In effect, this is the virtual opening of *Holy Child*'s first exhibition, between the covers of a book—a traveling exhibition opening here, there, and everywhere. Enter when you like, stay as long as you like, return any-time. There is no question that *Holy Child* ultimately belongs in a museum collection, where the drawing will be permanently cared for and presented in protected exhibitions, where people can actually see it and appreciate its alluring reality. That will come about in time, but for the present, I find it difficult to part with a work of art that Jann and I loved and lived with for so many years. For the time being, *Holy Child* remains safe and secure in my private collection, as it has since the summer of 2000.

<div align="center">◄</div>

A deep sadness shrouds the end of this long journey. My wife Jann died before the work on *Holy Child* was completed and before this book was published; she was 66 and had been in declining health. Her contributions were significant, and the work always profited from her insights. One night in her sleep, on October 21, 2011, she peacefully floated back to the stars. We had been married and worked together for three decades, a bond of love that began in our youth and spanned half a century. There will always be the joy of that miracle.

ANNOTATED RECORD

ARTIST: Leonardo da Vinci (b. Vinci, Italy, 1452; d. Cloux, near Amboise, France, 1519)

TITLE: *Holy Child (Head of a Pensive Child in Three-Quarter View)*

SIZE: 5¼ x 4¼ in. / 13.3 x 10.8 cm / 133 x 108 mm

DATE: Circa 1472–1476, Florence, Italy

MEDIUM: Red chalk and white chalk on uncoated laid paper with corners later cropped; traces of sepia ink framing around the drawing; sepia ink notations at lower left; sepia ink spotting. Verso blank.

WATERMARK: A partial cut-off sun or star symbol.

INSCRIPTION: Lower left recto, in dark gray ink in antique script, "Barache," a later-added and mistaken French attribution to Federico Barocci (1535–1612). In sepia ink, underlying the attribution, an unreadable notation. Mingled within and above the inscribed "Barache," small details in sepia ink suggesting an ampersand and a curved fingertip.

CONDITION: The drawing was received in very good condition, its two backings glued to an antique hand-decorated French-style mat (probably late 19th c.). Conservation by Marjorie Shelley, Metropolitan Museum of Art: several backings removed; minor repairs by M.S. of an old previously repaired small hole at upper right in the forehead area and at a smaller unrepaired hole lower right in the margin; no reworking

of the image was undertaken. Note: Underlying the small missing area at upper right and pasted as a rough repair to it, there was an antique handwritten fragment, apparently an odd scrap torn from a letter in faded dark gray ink retrieved by M.S. that said only ". . . Giovanni. . ." (see Provenance note below).

PROVENANCE

1. Speculating from the evidence on the drawing: French or Italian collection or collections, from ca. 1519 to ca. 1815 (possibly attributed in France to Barocci in 17th or late 18th c. and then possibly by descent in the same or another French collection up to May 2000.

2. Christie's East Auction, New York: "Old Masters, Frames, Etc.," May 23, 2000, Lot 34, "Attributed to Annibale Carracci." No provenance offered.

3. Purchased by Fred R. Kline, Christie's East Auction, May 23, 2000.

4. Fred R. Kline Gallery, Santa Fe, 2000–2006.

5. Private Collection, Santa Fe, 2006–present.

Provenance note: The antique "Giovanni" fragment used in an old repair and found by Marjorie Shelley may possibly suggest Italian ownership at some earlier period, but it is not considered in the provenance. However, the Giovanni fragment could suggest an association with the *Codex Atlanticus*, a twelve-volume bound set of drawings and writings by Leonardo, comprising 1,119 leaves dating from 1478 to 1519. The *Codex Atlanticus* was gathered in Milan in the late 16th century by the Italian sculptor Pompeo Leoni (Milan 1533–Madrid 1608). The folios had originated from the estate of Leonardo's direct heir Francesco Melzi (d. 1570 near Milan), and some folios were later sold and scattered in Milan by Melzi's descendants.

Leoni dismembered some of Leonardo's notebooks in the formation of the *Codex* and some of the sheets were scattered and sold over time as well. Finally, one of Leoni's heirs sold the *Codex* to Marquis Galeazzo Arconati who in 1637 donated the *Codex Atlanticus* to Biblioteca Ambrosiana in Milan. During the conquest of Milan by Napoleon Bonaparte in 1796, the *Codex* was stolen by the French and kept in the Louvre for 17 years. Then in 1815, the Congress of Vienna directed the return of the *Codex* to the rightful owner, Biblioteca Ambrosiana in Milan, where it is preserved.

EXHIBITIONS

Fred R. Kline Gallery, Santa Fe, NM: "Selected Old Master Drawings" (#3, attributed to Leonardo da Vinci), winter and spring 2006. Not for sale.

CATALOGUE OF COMPARATIVE PAINTINGS AND DRAWINGS BY LEONARDO DA VINCI RELATING TO *HOLY CHILD*

Comparative Paintings (chronological)

1. Leonardo da Vinci, *Madonna of the Carnation*, ca. 1472–1476, tempera (?) and oil on poplar, 62.3 x 48.5 cm (24½ x 19 in.). Munich, Alte Pinakothek.

2. Leonardo da Vinci, *Benois Madonna*, ca. 1476–1478, oil on wood transferred to canvas in 1824, 49.5 x 31.5 cm (19.4 x 12.4 in.). St. Petersburg, Hermitage.

3. Leonardo da Vinci, *Ginevra d'Benci*, ca. 1474, oil on wood panel, 42.7 x 37 cm (17 x 14.5 in.). National Gallery of Art, Washington.

4. Leonardo da Vinci, *Adoration of the Magi*, ca. 1481–1482, oil on wood panels, 243 x 246 cm (approx. 8 x 8 ft). Florence, Uffizi.

5. Leonardo da Vinci, *Virgin of the Rocks*, ca. 1482–1485, oil on wood transferred to canvas, 197.3 x 1220 cm (77½ x 47 in.). Paris, Louvre.

6. Leonardo da Vinci and assistants, *Virgin of the Rocks*—second version, ca. 1495–1499, oil on poplar, 189.5 x 120 cm (74½ x 47 in.). London, National Gallery.

7. Leonardo da Vinci, *Virgin and Child with St. Anne and a Lamb*, ca. 1502–1513, oil on poplar, 168.5 x 130 cm (66 x 51 in.). Paris, Louvre.

8. Here attributed: Gianpietrino and Leonardo (originally Gianpietrino after a design by Leonardo), *Leda and Her Children*, ca. 1508–1513, oil and tempera (?) on alder, 128 x 105.5 cm (50 x 41½ in.). Kassel, Staatliche Kunstsammlungen.

Comparative Drawings (chronological)

1. Here attributed to Leonardo da Vinci—originally "School of Verrocchio," *Study of a Baby*, ca. 1472–1476; 11 x 7.8 in. (279 x 198 mm), black

chalk on uncoated laid paper; traditionally considered a verso drawing with the recto *Study of an Angel* firmly attributed to Verrocchio. Florence, Uffizi.

2. Here attributed to Leonardo da Vinci, *Holy Child*, ca. 1472–1476, 5¼ x 4¼ in. (133 x 108 mm), red chalk with white heightening. Santa Fe, private collection of Fred & Jann Kline.

3. Leonardo da Vinci, *Studies of the Christ Child*: the head of the Christ Child and other figure studies in this sheet here dated ca. 1472–1476 with other figure studies on the sheet dated as late as ca. 1502, 11 x 8 in. (285 x 198 mm), red chalk on reddish prepared paper. Venice, Accademia.

4. Leonardo da Vinci, *Studies of a Naked Child*; two sheets similarly titled and both here dated circa 1472–1476. London, Windsor Castle Royal Library.
 1. *Studies of a Naked Child*, red chalk, 5½ x 7½ in. (139.7 x 190.5 mm), #12,568.
 2. *Studies of a Naked Child*, silverpoint and pen, 6½ x 8½ in. (165.1 x 215.9 mm), #12,569.

5. Leonardo da Vinci, *Study of the Angel's Head in Virgin of the Rocks*, ca. 1482–1483, 7 x 6.25 in. (182 x 159 mm), metalpoint heightened with white. Turin, Royal Library.

6. Leonardo da Vinci and studio, *Head of a Child in Three-Quarter View*, ca. 1472–1482, 5¼ x 4¾ in. (134 x 119 mm), metalpoint highlighted in white gouache; extensive studio reworking in all parts with pen, brush, brown wash. Paris, Louvre.

7. Leonardo da Vinci, *Virgin and Child with Saints Anne and John the Baptist* (*The Burlington House Cartoon*), ca. 1499–1508, mixed media: including charcoal and black and white chalk on light brown tinted paper mounted to canvas, 1415 x 1060 mm (55.7 x 41.7 in.). London, National Gallery.

A BRIEF REPORT REGARDING THE DISCOVERY OF LEONARDO DA VINCI'S DRAWING
HOLY CHILD AND SUBSEQUENT REVISION OF OTHER WORKS

By Fred R. Kline, M.A., Independent Art Historian
Kline Art Research Associates

With the recent discovery of a small and beautiful red chalk drawing of an infant's head held in a Santa Fe private collection, we can now recognize a significant missing link in Leonardo da Vinci's early development as an artist. Titled *Holy Child (Head of a Pensive Child in Three-Quarter View)* and here attributed to Leonardo da Vinci (1452–1519), the drawing offers rare graphic evidence of Leonardo's precocious genius from his first Florentine period of circa 1472–1476 while associated with Verrocchio's workshop, a period from which very few drawings and sketches related to Leonardo's paintings have survived. *Holy Child*'s notable importance lies in its key role as a preparatory study for Leonardo's paintings of Infant Jesus and Infant St. John in his two earliest independent paintings and in later works. We can now establish the drawing in a previously unrecognized series of Leonardo's early drawings of infant models and additionally bring to light *Holy Child* as an unrecognized ideal model in many of his paintings, specifically in those paintings which feature the Madonna and Child subjects. Leonardo's masterful creation of an exceptionally innovative and lifelike portrait drawn from life of an infant forecasts in *Holy Child* the artist's penetrating observational genius and displays his incomparable draftsmanship, qualities already in full blossom during his First Florentine Period. *Holy Child*, in all likelihood, was created as a very quick sketch from life while a flower was held as a distraction to the baby, as seen in other works from the 1470s listed below.

Once captured in *Holy Child*, the perfect "intention of mind" of a newly awakened, inquisitive infant became a precious reference for Leonardo and a clear inspiration for later works. The new understanding offered with Leonardo's early and continued use of *Holy Child* as a model preparatory study, offers a revised insight into the great artist's entire oeuvre, with suggested additions and revisions as follows:

1. Attribution to Leonardo da Vinci of *Holy Child* (Private Collection, Santa Fe), a recently discovered drawing relating to his First Florentine Period of the 1470s.

2. Attribution to Leonardo da Vinci of a Verrocchio school drawing *Study of a Baby* (Florence, Uffizi) relating to his First Florentine Period and to *Holy Child*.

3. Revision of three other sheets of drawings by Leonardo to his First Florentine Period, to include the head of the Christ Child and various figurative studies in *Studies for the Christ Child* (Venice, Accademia), and two related and similarly titled sheets of figurative studies, *Studies of a Naked Child* (Windsor Castle Royal Collection).

4. Application of *Holy Child* and *Study of a Baby* (Uffizi) and *Venice Christ Child* as preparatory drawings from Leonardo's First Florentine Period into his two earliest independent paintings, *Madonna of the Carnation* (Munich, Alte Pinakothek) and *Benois Madonna* (St. Petersburg, Hermitage), and in additional paintings and one cartoon by Leonardo, and another painting shared by Gianpietrino, as follows: Leonardo da Vinci, *Adoration of the Magi* (Florence, Uffizi); Leonardo da Vinci, *Virgin of the Rocks* (Paris, Louvre); Leonardo da Vinci with studio assistants, *Virgin of the Rocks* (London, National Gallery); Leonardo da Vinci, *Virgin and Child with Saints Anne and John the Baptist* (*The Burlington House Cartoon*, London, National Gallery); Leonardo da Vinci, *Virgin and Child with St. Anne and a Lamb* (Paris, Louvre); Gianpietrino and Leonardo da Vinci, *Leda and Her Children* (Kassel, Staatliche Kunstsammlungen).

5. Attribution of *Leda and Her Children* (Kassel, Staatliche Kunstsammlungen) to Gianpietrino and Leonardo da Vinci.

SELECTED BIBLIOGRAPHY
(ARRANGED CHRONOLOGICIALLY)

Bernard Berenson. *The Drawings of the Florentine Painters*, 2 vols. London, 1903.

Sigmund Freud. *Leonardo da Vinci: A Memory of His Childhood* (Trans. Alan Dyson). London, 1910.

Kenneth Clark. *Leonardo da Vinci*. Cambridge, 1939.

A. E. Popham. *The Drawings of Leonardo da Vinci*. New York, 1945.

Jane Roberts. *A Dictionary of Michelangelo's Watermarks*. Milan, 1988.

Martin Kemp. *Leonardo da Vinci: The Marvelous Works of Nature and Man*. London, 1989.

David Alan Brown. *Leonardo da Vinci: Origins of a Genius*. New Haven, CT, 1998.

Patricia Lee Rubin, Alison Wright, and Nicholas Penny. *Renaissance Florence: The Art of the 1470s*. Catalogue associated with the exhibition. National Gallery, London, 1999.

Leo Steinberg. *Leonardo's Incessant Last Supper*. New York, 2001.

Carmen C. Bambach, editor. *Leonardo da Vinci, Master Draftsman*. Exhibition Catalogue with numerous essays. Metropolitan Museum of Art. New York, 2003.

Frank Zollner. *Leonardo da Vinci 1452–1519: The Complete Paintings and Drawings*. Cologne, 2003.

Charles Nicholl. *Leonardo da Vinci, Flights of Mind*. New York, 2004.

Dario Covi and L. S. Olschki. *Andrea del Verrocchio: Life and Work*. Florence, 2005.

Fred R. Kline. *Leonardo's Holy Child*. New York, 2016.

PART II

A Search for Lost Art in America

Until you are committed to your quest, there is hesitancy, the chance to draw back. But the moment you definitely commit yourself, then Providence moves with you. Unexpected helpful things occur to help you that would not otherwise have occurred. A whole stream of events begins to flow from the decision, raising in your favor all manner of unforeseen things—incidents, meetings with remarkable people, material assistance—which no one could have dreamed would come their way. Whatever you can do or dream you can do, begin it! Boldness has genius, power, and magic in it! Begin it now!

—Johann Wolfgang von Goethe (German writer, philosopher, scientist, 1749–1832; *Maxims and Reflections*)

Romantic quality and classic quality together may be called the mystic.

—Lao Tzu (Chinese philosopher and poet, 571–531 B.C., author, *Tao Te Ching*, as interpreted by Robert M. Pirsig in *Zen and the Art of Motorcycle Maintenance*, p. 253)

CHAPTER 1

The Lost Virgin of the New World

The defeat of their gods left the Indians in a spiritual orphanhood that we moderns can scarcely imagine. This is the source of the truly visceral nature of the cult of the Virgin of Guadalupe. The new religion, then—and this I consider decisive—offered a *mysterious bridge* connecting the new with the ancient faith.

—Octavio Paz, on the Conquest of Mexico

La Virgencita del Nuevo Mundo, Mexico, ca. 1521–1540, cantera stone, 15 in. high,
Private Collection, Courtesy, Kline Art Research Library

I

Jann and I would often burn a devotional candle that came in a tall glass with an illustration of the Virgin of Guadalupe on it. A candle to Guadalupe always brought with it the optimistic idea that everything was going to be all right, and we often lit her flame with some hope in mind. This was not a religious act but more on the order of following a popular ritual. Although Jann was raised Catholic and I was raised Jewish, neither of us had participated in organized religion since our youth. I preferred to think mythology explained all religions perfectly, and so we practiced a sort of agnostic spiritualism.

The candle was a $1 purchase at the grocery store and had much more personality than a lottery ticket. It even offered a 50-50 chance of being a winner. In Santa Fe, New Mexico, affection for Guadalupe came easily. Her

spirit had manifested for years in T-shirts, tattoos, statuettes, devotional candles, paintings, earrings, and even a bumper sticker that said "In Guad We Trust." Over the centuries, La Guadalupana had become the spiritual symbol of Old Mexico, and her persona had evolved into nothing less than a goddess cult across the United States and Latin America. Guadalupe the goddess gave freely of her compassion and forgiveness and grace, with no strings attached. A simple "Gracias, Senora" when she came through for you might even be published anonymously in *The New Mexican*, Santa Fe's daily newspaper.

<div align="center">⌀</div>

It was December 12, 1995, the Day of Guadalupe and a day of widespread celebration in the city. We were then private dealers, and I had an appointment that morning at our home. The appointment in question already had a curious history and was surrounded by unusual circumstances. How could I not light the Guadalupe candle for good luck in advance?

During this time, I would sometimes cast out a line for lost art through a classified ad: "We Buy Old Paintings, Drawings, Sculpture. Any Condition, Any Subject."

A month after the ad had expired, a man called citing the ad and said he had heard I was interested in religious art and that he had "some stuff" left over from his uncle's estate, some religious statues, maybe old, and other odds and ends. He wanted to bring them over right away. I was very busy that day, but interested, and I encouraged him to try me another time. He said he would call back in a few days. I asked for his phone number and name and made a note. Two weeks passed with no call from "Diego Lopez," not that I was waiting. I saw the note floating on my desk with "religious statues" underlined and I called him. No answer. I called again in a few days. Diego was there but couldn't come that day but he would try soon. Another week or so passed and he called. He was getting some things together for a local flea market and wondered if he could come over before he went. He still had those religious statues. A remarkable turn of events, I thought.

After all this time and chance, with delay after delay, there was Diego Lopez in my doorway at long last, a personable and dignified man in his

late forties, standing at the front door of Hillcrest, as we referred to our hilltop home. He was holding a well-used cardboard box piled high with old clothing.

It was a beautiful crisp morning, and we stayed outside under the clear blue sky as he unpacked the box on a stone bench in the bright sunlight, my preferred examining light. The light of truth, if you will. The statues were wrapped in old shirts. He handed me a carved wood Virgin Mary in the pose of the Immaculate Conception, circa 1930s, with "Nuestra Senora de San Juan" and "Mexico" and the maker's name carved on the base. Her praying hands had broken off. I handed it back to him, silent and disappointed. Was that his best shot at a sale? Diego then handed me the second statue, which surprised me.

"What's this?" I asked. It was another Virgin in the same pose of the Immaculate Conception, beautifully carved from one piece of pinkish stone with bizarre details that I had never seen on a religious work. What in the world? I put the strange sculpture down on the flagstone and walked around it. At first I was mystified, then intrigued, then infatuated. I began to see the beauty of the object and the unusual innocence of the Virgin's face, which looked like a young Indian girl. She appeared to be speaking—unusual for the Immaculate Conception motif.

I began to ask Diego questions about the Indian Virgin. He told me she had belonged to his uncle, who had kept it on an altar in his room. When his uncle died, about thirty years ago, Diego's mother, who considered the stone Virgin "weird," had stored it in this same box in the garage, and for decades nobody bothered with it. He had no idea where she had come from in the first place. "It wasn't the kind of Virgin that looked good in the house; it was kind of weird, you know," Diego said. I learned that Diego's family had lived in a small northern New Mexico village since the 19th century and he was pretty sure some of his family had come from Mexico City and Spain before that. He alluded to possible conquistador ancestors and his Spanish heritage with some pride, a not uncommon genealogy claimed by Spanish-speaking northern New Mexicans whose Spanish ancestors first settled New Mexico late in the 16th century.

One unfortunate and stressful characteristic of my early days of searching for lost art was a very small budget for purchases. My reserve of dollars was usually in the hundreds, from time to time one or two thousand. With five teenaged children between me and Jann (two for me and three for her), along with a house big enough to fit us all, there was rarely ready cash available for art speculations. So I had to make our little money go a long way and buy and sell with some urgency. My romantic dream of exploring for lost art was still struggling to become a livelihood, but remarkably, little by little, it was succeeding enough for me to continue. Typically, we would be months behind in everything, then a sale would happen, debts would be paid, and variations of the cycle would start all over again. Obviously, we had good reason to burn devotional candles to the Virgin of Guadalupe, the ever-generous goddess. So there I was, master of Hillcrest, with only $200 in the bank that day.

I decided that I had to buy this weird and wondrous Virgin even if I had to look high and low for the money. I looked at her praying and speaking to me in the sunlight, an orphan child pleading to be rescued, and I couldn't let her go. Jann at that very moment was spending $100 at the grocery store. I decided to take the offensive and I offered $100, the best price I could afford. Diego had priced everything for Trader Jack's Flea Market, the next stop, and so he said okay with only a little hesitation. With further embarrassment, I discovered that I only had a few dollars in cash but he graciously took my check, an unusual courtesy for a transaction like this. I felt he deserved at least $200, and wished I could have offered it—after all, it was the Day of Guadalupe. I told him I would buy the other souvenir Virgin for $100, easily five times its value, if he would bring it back in a week, which he did, and this time I gave him cash.

Then Diego Lopez disappeared. He never called me again, and when I tried his number some time later, it was no longer in service. We both had been directed by an uncanny intuition to seek each other out. Both of us had waited patiently for the right moment to meet, and then finally after time and circumstance luckily converged, when our little bit of business was finished, he was gone and the two Virgins remained, and I would remind myself, *the play of things in the poem of the world*, coming round and making another turn. Of course there could be many reasons for his sudden arrival

and equally abrupt disappearance, but it seemed magical then and more like a miracle today in light of what transpired, as the stone Virgin slowly materialized into the rarest of New World treasures. The metaphysics of chance was holding true.

By the time Jann returned from the grocery store, I had placed the statuette on a low shelf by the front door. "Oh, she's beautiful!" Jann said with instant recognition and great enthusiasm. I was taken aback. She put the groceries down and sat enthralled in front of her. What a wonderful beginning! As soon as we put away a ton of groceries—out-of-town family was coming soon for Christmas—Jann took the little Virgin and placed her above the fireplace. Then, for the rest of the morning, she constructed a grand altar around her, decorating the three tiers of shelves above the fireplace with votive candles, flowers, decorative plants, pine cones, and branches—and the already-burning Guadalupe candle with its flame that lasted for days. It was an installation worthy of a pilgrimage. Thus began our amazing adventure with *La Virgencita* [*veer-hen-cita*, "little Virgin"], as I affectionately began to call the exotic stone idol. From the moment of Jann's response and her creation of the altar, *Virgencita* became for me not just a mysterious artifact, but a sacred object.

"If this isn't just a strange fake, it could be the rarest thing we have ever found," I told Jann.

"She is not a fake," Jann said in her quiet and knowing way.

Jann would later recall that first encounter. "Every image I knew in art history, every work of art that I had examined firsthand, seen personally, studied in libraries, thought about, loved, admired, criticized, evaluated—it all went around in my mind when I first saw *La Virgencita*, and I couldn't place her, but I knew she had deep spiritual and humanistic significance. Of this I was sure."

That Christmas it was family and friends and the admired presence of *Virgencita* on Jann's altar. Amidst the sentimental joys of our traditional Santa Fe *feliz Navidad*, the prayerful and natural innocence of Virgencita made me weep when on a number of occasions I stood alone with her. I remembered Jann as a young girl—as young as the Virgencita must have been when she received her incredible pronouncement from God—then she was gone, lost for twenty-two years, and I too was lost. She had found

me, as *Virgencita* had. The coincidence seemed profound and fated and I was eagerly awaiting what might come next.

<center>⋈</center>

During the next three months, because of a wonderful and unexpected sale of a painting early in the new year, I was able to devote my full time to researching *Virgencita*. The candles burned every day without fail on her altar. Jann saw to it. I was hypnotized by this astonishing object. I took detailed photographs and gathered books. In the entire history of sculpture, I could find nothing to compare. *Virgencita* presented a very odd mixture of Baroque styles and iconography: an unprecedented hybrid of Spanish, European, and, most amazingly, Precolumbian Mexican-Indian. Who had ever heard of that mix in art? Yet the history of the New World had evolved in Mexico from that very same eclectic assimilation.

It seemed logical to go back to the Conquest of Mexico in my research, to the violent beginning of that integration of cultures, but where were the sculptural examples from 16th century Mexico? It seemed to be one of art history's darkest rooms. The only study I could find which began to answer the question was an excellent pioneering effort published in 1950 by Elizabeth Wilder Weismann, *Mexico in Sculpture, 1521–1821*, and it lighted the way. It was a short road since there seemed little else to go on. After searching in all the libraries in Santa Fe and Albuquerque, I finally located the classic work on the subject, written in Spanish, hiding in the library of the Museum of International Folk Art in Santa Fe: *Arte Indocristiano: Escultura del Siglo XVI en Mexico* (Indo-Christian Art: Sculpture of the 16th Century in Mexico) by Constantino Reyes-Valerio, the world's leading scholar on the subject, published in 1978 in Mexico City, almost thirty years after Weismann. From Reyes-Valerio's book, I could see, for the first time, comparative relationships to *Virgencita* in carved stone reliefs on churches in Mexico, architectural decoration made in a 16th century New World style he called Indo-Christian, sometimes classified with the further stylistic nuance of the Aztec word *Tequitqui* (*ta-key-key*), as in Indo-Christian-*Tequitqui*. *Tequitqui* was the earliest and most Aztec-influenced Indo-Christian style. While Indo-Christian is a general term covering the

<center>147</center>

Indian-Spanish style of 16th century Mexico, *Tequitqui* designates a rare and short-lived post-Conquest style that still carried untainted vestiges of the Precolumbian past. Although I didn't find an exact correspondence to *Virgencita*, some examples of Aztec sculpture offered clearly related iconographic details, like floral discs, spear points, feathers, tassels. But no free-standing, carved stone (or wood) saints from this Indo-Christian period could be found anywhere. This was most surprising.

I showed *Virgencita* to several art historians in Santa Fe associated with the Museum of New Mexico, specialists in Mexican and New Mexican art history, and I stated my hypothesis of 16th century Mexico. Disappointingly, I could find no enthusiasm or aesthetic appreciation, only a vague direction to the Mexican art historian Constantino Reyes-Valerio. Inquiries over many weeks to other specialists in Mexican art history at museums and universities across the United States uniformly responded: there was only one person in the world who could possibly authenticate Virgencita and that was Constantino Reyes-Valerio in Mexico City. I began my search for Reyes-Valerio, and since my Spanish was very rusty, I stumbled along slowly, *poco a poco*.

What exactly did I have? *Virgencita* stood 15 inches high and weighed 15 pounds. Her condition was near perfect, with several very old skillfully glued repairs on the radiating aura called the nimbus. The stone, called cantera, was masterfully carved from a hard volcanic material found in Mexico. Stone is tricky to date, being ancient to start with, so the surface patina and the carving technique must be carefully examined. The aged patina on stone, as I had seen over the years, could even be cleverly faked on so-called antiquities, with added grime baked in or surface mineralization achieved by a chemical bath—and always a little too perfect to an experienced eye. I was suspicious but reassured of the stone's natural aging after studying every inch of the surface under magnification and in sunlight. With great relief, I concluded that nothing about its patina was contrived. It had an honest surface, whether carved with a stone or iron chisel—both were extant after the Conquest—and in the skilled hands of an artisan close to impossible to distinguish. I didn't know what to make of the eccentric iconography carved all over her front: the flower disks, the phallic tassels, the feathered dress, the blade points. She seemed naïve and sophisticated

at the same time. Her back was without details except for rather surprising strands of her hair spread thinly across the shoulders of the cape. The base was Renaissance-style, no less, an appropriate style for late 15th century to early 16th century Spain. Clearly, Virgencita was a pastiche of styles, a very strange invention indeed.

Virgencita details: Face and praying hands, back showing hair, floral disks with blade points and feathered robe, phallic tassels. Courtesy, Kline Art Research Library

Virgencita's face had the appearance of a young Indian girl, and her mouth was open—as if speaking or even singing. Both qualities were startling and unique in an image of the Virgin Mary. Nowhere in the historic iconography of Christian art is the Virgin Mary depicted as speaking or singing. Or as a young Indian girl.

So what exactly did I think about *Virgencita*, besides the fact that I was amazed by how unusual she was? My initial interpretation of *Virgencita* was that she was a unique cult object relating to the Virgin of Guadalupe's earliest 16th century following among the Indians. I approached the idea cautiously, but I couldn't ignore the evidence. A few rare documents from this early period, cited in Weismann's book, hinted at the existence of an early Marian cult among the Indians, which some Spanish priests found threatening and sermonized against, very likely because of Mary's newly acquired assimilation of "pagan" attributes. With growing excitement I realized that *Virgencita*'s Indian face and her open mouth recalled precisely those key details of the 1531 apparition of the Virgin of Guadalupe. As the legend is related, the Virgin appeared to the Aztec convert Juan Diego as a young Indian girl who spoke Nahuatl, and she directed him to deliver her wish to the bishop to build a cathedral on the very site where they stood. As evidence of her appearance she left her image imprinted on Juan Diego's cloak. (It should be noted that Juan Diego was canonized in March 2002 as Saint Juan Diego by Pope John Paul II.) The tradition places Juan Diego's vision at Tepeyac Hill, the former temple site of the ancient Aztec earth goddess Tonantzin, today the location of the grand Basilica de Guadalupe in Mexico City.

Her unique physical appearance as a young Indian girl who was speaking dramatically suggested *Virgencita*'s possible early connection to the emerging legend of Guadalupe, which would place *Virgencita* historically at the moment of cultural first contact. Could our *Virgencita* reflect the earliest recognition by the converted Aztecs of a new goddess, the Virgin Mary, who in the next century would come to be known as the Virgin of Guadalupe? Was this possible?

Octavio Paz, the late Nobel Prize–winning poet and Mexican philosopher, writes of this moment of first contact: "The defeat of their gods left the Indians in a spiritual orphanhood that we moderns can scarcely imagine. This is the source of the truly visceral nature of the cult of the Virgin of Guadalupe. The new religion, then—and this I consider decisive—offered a *mysterious bridge* connecting the new with the ancient faith. The basis of Mesoamerican religion, its founding myth and the core of its cosmogonies and ethics, was sacrifice. The gods sacrifice themselves

to save the world, and men pay for that divine sacrifice with their lives. The central mystery of Christianity is similarly sacrifice . . . In turn, the Indians saw in the Eucharist the supreme mystery of Christianity, a miraculous if sublimated confirmation of their own beliefs. In truth, it was something more than substitution or sublimation: it was a consecration.

Like a phoenix, *Virgencita* seemed to rise from those fires of sacrifice. Could *Virgencita* be the connective link on Paz's "mysterious bridge"?

During the 16th century, documents (cited in Weismann) show that the infamous Spanish Inquisition proclaimed that all Christian religious art in Mexico showing "pagan" Indian influences be either altered or destroyed. Before long, some Inquisitional directives forbade Indians from making Christian devotional objects at all. I had begun to imagine *Virgencita* as a vestige of the Aztec's early indoctrination into Christianity, without then realizing that she was, judging from the absence of other known examples, a unique survivor of the Inquisition's purge of Indian "paganism" in Mexico during the 16th century. The possibility was breathtaking.

I tried to gather my thoughts. If Virgencita were authentic, she would have to be from the earliest days of New World colonization and still have a connection with Precolumbian culture. I still felt this was an audacious possibility, yet the evidence, especially the mixture of Christian and Precolumbian symbols, seemed to be strongly suggesting it. Feverish with anticipation, I searched for guideposts. I had studied Precolumbian art in the past, and I could identify most of the cultures, but my knowledge was far from specialized and needed a focused review.

Gradually, the New World identity of *Virgencita* began to evolve as a surreal mosaic of Mexican religious and cultural history, much like Mexico herself. *Virgencita* suggested collectively a complex symbolic relationship to a number of significant Precolumbian gods, like Tonantzin and Chicomecoatl, and to a variety of once dominant Precolumbian cultures, including Maya and Teotihuacan, a synthesis historically compatible with Aztec culture and cosmogony, but here, freshly configured within a recently introduced Christian saint. A definite Indian influence was overlaid, integrated, and writ in stone. With deep excitement, I could now perceive that *Virgencita*'s syncretic style was unknown to art history, and that she led to a trail lost since the dawn of the New World.

◊

The more I researched, the more pieces of the Precolumbian puzzle started to fall into place, but the shapes kept shifting and turning into another puzzle.

Virgencita's Indian face closely echoed the features of Teotihuacan goddess figurines, which depicted a similar Indian face but without an open mouth as in *Virgencita*. Her unusually dramatic nimbus suggested a symbolic relationship to the elaborate feathered headdress of Teotihuacan's Great Goddess, an earth diety whose attributes include the owl—a disguised and integrated symbol that encompassed all of *Virgencita*, which later developed importantly in *Virgencita*'s iconography. The phallic tassels or bells, certainly fertility symbols, hanging from the collar of *Virgencita*'s cape, echoed the phallic-pendant details of a Maya sun god pectoral and as well Aztec phallic-shaped symbols for blood and raindrops. These fertility symbols hang appropriately above and almost touch the two elaborate flower disks on her cape, which are clearly attributes of the important Corn Goddess, Chicomecoatl, who herself is a manifestation of the great Mother Earth goddess Tonantzin, who lacks a figurative image. Octavio Paz and others felt that Tonantzin evolved as a resurrected goddess in the Virgin of Guadalupe—a goddess of primary importance, who, today in the entwined Catholic-native Mesoamerican religion of Mexico, stood above all the other deities in the pantheon. I was wandering through a hundred degrees of separation in a hall of mirrors and trying to get my bearings.

At heart level, in the hollow between Virgencita's praying hands, she likely once held an inlay of jadeite or obsidian, suggested by many Precolumbian works depicting gods who held just that. Evidence that *Virgencita* was once further enhanced with jewels—possibly with pearls, gemstones, or beads—appeared now as empty concavities around the inner nimbus, on the crown, and on the crescent moon. Aztec calendrical numerology may yet offer an interpretation for the number-suggestive details of *Virgencita*.

Connections were everywhere! The zigzag pattern of the brocade and the fringe on *Virgencita*'s cape, and her feathered dress, repeat accurately Aztec royal costume motifs, as seen in various codices. The attempted

continuation of *Virgencita*'s hair onto the back of her cape, a generally unseen detail, suggests the Aztec practice of often adding carved symbols to the back and even to the hidden underside of a sculpture. This seemed like a fading, half-hearted last vestige of that theme, as Aztec practices were quickly being overcome by the influx of the Spanish.

As I kept examining *Virgencita*, the god Quetzalcoatl emerged! The feathered pattern on *Virgencita*'s dress recreates the sculptural motif found on numerous images of Quetzalcoatl, the feathered-serpent deity who is the most meaningful of all Aztec gods and who is considered a powerful benefactor of humanity, similar to Prometheus in Greek mythology. Thus, a primary Aztec god is subtly assimilated into *Virgencita*, adding immensely to the importance of her New World character. Like Quetzalcoatl, the Virgin is a benefactor to mankind. Every aspect of Aztec life was motivated and controlled by their extremely complex religion, which comprised more than a hundred gods—many of dual gender, dual personality, and of immaculate conception like Quetzalcoatl—gods from whom piety was required in everything from social behavior to art to human sacrifice.

Attached to the two floral disks—which appear to be like spellbinding eyes staring out of *Virgencita*'s cape—there are two Aztec sacrificial flint blades, or directional spear points, both pointing south. To me, the blades suggested war-inspired protective symbols relating to the god Tezcatlipoca, which may explain their presence on the renowned Aztec calendar stone. Tezcatlipoca, representing matter, and Quetzalcoatl, representing spirit, coexisted in the Aztec religion as closely related rival deities. And they still coexisted in Virgencita.

Amazingly, all the vital gods had converged in this tiny *Virgencita*. Could she be a type of Indo-Christian Rosetta Stone that allowed us to see the transfer of the Mesoamerican gods after the Conquest into Christian symbols? Suddenly, I could see that *Virgencita* held a hidden truth underlying Mexican Christianity, a truth that is invisible in the image of the traditional Virgin of Guadalupe we see today. For almost 500 years, this fact has been swept under the table. The Mexican Virgin Mary—is now, and was in the beginning—an Indian!

Here, in *Virgencita*, was the proof of the Virgin Mary's transformation from a pantheon of Aztec deities and her resurrection into something

new. The Catholic Church hides the fact that the Virgin of Guadalupe had evolved and had been resurrected from an Indian goddess. It can be argued that in the deepest hearts of the Mexican people, the Virgin of Guadalupe still lives as the Indian goddess, far removed from Church dogma yet now commingled with it. *Virgencita* and the Guadalupana were one, and the ancient gods of Mesoamerica were there from the beginning. The Church had, with its normal opportunistic intention, clearly tried to erase the ancient mythology of Mexico and replace it with the mythology of Christianity, but had not wholly succeeded. The evidence was in my hands!

Research continued with *Virgencita*-like models of the Virgin Mary appearing in European and Spanish religious art of the Middle Ages and into the Renaissance period, yet the bell-shaped winged cape of the Virgin proved to be unique to Spanish art. European and Spanish Virgins of the Immaculate Conception coordinated with *Virgencita*'s design: the large spiked nimbus, the crown and cross, tassels on her robe, the prayerful position of her hands, the crescent moon she stood upon. Here and there, those Virgins had the rare and wonderful feature, as in *Virgencita*, of one bare foot peeking from the hem of her gown. This was a Virgin of the Apocalypse, interpreted from the book of Revelation, chapter 12: "And there appeared a great wonder in heaven, a woman clothed with the sun, and the moon under her feet, and upon her head a crown of twelve stars." I was convinced *Virgencita* was based on an amalgam of details found in sculptures of European-influenced Spanish Virgins circa 1492. "Steady as she goes," Columbus cautioned, making his first appearance. "There is something out there."

༄

The Aztec Empire, a militaristic-agrarian culture of syncretic richness in their art and severe piety in their religion, was the last surviving power base of many in ancient Mesoamerica's political evolution, after perhaps 3,000 years of civilization. When the Spanish arrived, the Aztec leader was the fabled Montezuma, who foresaw their coming in a dream. In the years 1519 to 1521, the incomparable and merciless adventurer Hernan Cortes with

a small troop of some 400 armored and horsed Spanish "conquistadors" with firearms, steel blades, and new germs in their lungs accomplished what seems impossible. Spurred on by a fanatical fervor for "gold, glory, and God," and vitally assisted by thousands of Indians oppressed by Aztec imperialism, Cortés's army accomplished the Conquest of Mexico, one of the most remarkable military feats in all recorded history. Horses, steel armor, firearms, and steel blades were first introduced into the New World, as well as the sight of humans with dark beards.

Tenochtitlan, the Aztec capital, one of the architectural gems of Mesoamerican civilization and a wonder of the ancient world, was totally destroyed by the conquistadors, assisted by a multitude of Indian volunteers. The ruins of Tenochtitlan lie beneath what is today Mexico City. Out of this destruction arose a transformed consciousness for conqueror and conquered alike, a consciousness which was first and foremost religious in nature—religious with a complexity very much like *Virgencita*!

In reconstructing *Virgencita*'s creation, it seemed probable that a recently "converted" Aztec, a Nahua-speaking Indian artisan, was commissioned by a Catholic friar—or even plausibly, records suggest, by a conquistador—to make a Virgin for placement in an early outdoor chapel, or in a Spanish hacienda, possibly in the 1520s to 1540s. A legal document from the period uncovered by Weismann cites a complaint against Cortes for displaying Indian-style idols at his grand hacienda in Cuernavaca. In all probability, a very small Spanish woodcut print of the Immaculate Conception from a 15th century or early 16th century prayer book served as the model for *Virgencita*. The small size of the print would have made the image difficult to read, thus leaving many decorative details to the Aztec artist's imagination. Possibly a friar attempted to translate from Revelation. Here the Indian artist would likely have recognized an amazing kinship with his defeated Aztec religion, which, like the new religion of Christianity, was also filled with fabulous mythology. He could now perceive how his recently defeated religion had changed and could now be reborn from fire and death into the religion of the conqueror. A way of paying tribute to what had been lost.

In *Virgencita*'s classic pose, known as the Immaculate Conception, a healing and protective Virgin had long been embraced with cultlike

devotion by the Old World Spanish, a devotion that was carried into the New World by the conquistadors. She was called La Virgen de los Remedios (the Healing Virgin), and she was specifically called upon for protection and healing. A devotional sculpture of the Remedios Virgin was brought to Mexico by the conquistadors in 1519, and, we are told, this painted image of the Virgin Mary was emblazoned the flag Cortes carried into battle with the Aztecs. It would have probably resembled *Virgencita*, at least in the pose of an Immaculate Conception. This was the first Christian image that the Indians had ever seen. Today, one of the battle flags is enshrined in Mexico City at the Museo Nacional de Historia–Castillo de Chapultepec. In *Virgencita*, we can plausibly see this first image of the Virgin Mary recreated, but now transformed with a passionate and intuitive Indian subjectivity and filled with allusions to Aztec culture.

My startling conclusion from this comparative study was that *Virgencita* was indeed of unprecedented transitional importance. The evidence could support that she was a first Virgin Mary of the Americas, a first new deity of the New World. She symbolized the first Indians baptized into a transformed Christianity, and a first Remedios Virgin of the New World, offering a healing transformation of the now merged Christian and Indian religion. There was no doubt about it: the ancient religion of the Mexican Indians was still alive and "Christianized" in *Virgencita*!

Much insight is offered by the vast body of work by Octavio Paz, who sadly died while my letter to him about *Virgencita* was in flight. He writes of the Virgin of Guadalupe's genesis in Mexico: "Like all conversions, that of the Mexican Indians entailed not only a change of their beliefs but the transformation of the beliefs they adopted. The phenomenon was similar to the change from Mediterranean [Greco-Roman] polytheism to Christian monotheism that had taken place a thousand years earlier. That is, there was a conversion to Christianity and a conversion of Christianity, the supreme expression of which was, and is, the Virgin of Guadalupe, in whom the attributes of the ancient goddesses are fused with those of Christian virgins. It is natural that Indians should still call the Virgin by one of the names of the earth goddess: Tonantzin, Our Mother."

The first published image of the Virgin of Guadalupe, which was a woodblock print, and the first published story of the Virgin of Guadalupe, the story which we know today, appeared in Mexico City in 1648 in a booklet by the priest Miguel Sanchez. The print depicted *Our Lady of Guadalupe* as the apparitional image that was miraculously imprinted onto the cloak (called *La Tilma*) of Juan Diego in 1531. Today *La Tilma* is enshrined as that actual sacred relic at the Basilica de Guadalupe in Mexico City. Thus the legend, the sanctified vision we know today, began to be disseminated in Mexico City for the first time, almost 120 years after the Conquest of Mexico. In all likelihood, a related visionary story of the Virgin's appearance was by that time an oral tradition submerged within the Mexican consciousness. *Virgencita* seemed to provide the evidence.

Guadalupe's image, in spite of the Aztec qualities she still retained in the legend, was then, in the 1648 woodcut, as is now devoid of any visually distinguishable Indian characteristics or iconography. Since Indians were the lowest social class, it seems that the Church could not allow the ascendency and transformation of the Virgin Mary as a recognizable Indian. It was a magician's trick. The dark-skinned Indian Virgin had further transformed into a white Anglo-European Virgin, the Virgin of Guadalupe we see today. Remarkably, the Virgencita carries forward in her Indian symbols and her Indian visage in what can plausibly be seen as the memory of Tonantzin. Virgencita, it can be argued, would then represent the most intact memory of the early Aztec Remedios Virgin, which—quite apart from the published 1648 Guadalupe legend—probably began, as a few early documents suggest, with a goddess cult among the Indian-Christian converts not long after the Conquest of Mexico in 1521.

One can easily suppose that the present-day Virgin of Guadalupe, now permanently attached to the Catholic mythos of the miraculous 1531 vision of the Aztec witness St. Juan Diego, quite plausibly evolved from the early cult. And the only known vestige of this early cult, could I dare believe, was the statuette I had saved from the flea market and named *La Virgencita del Nuevo Mundo*—The Little Virgin of the New World.

When I recognized the suggestion of two spellbinding eye-like designs on Virgencita's cape, my perception of her transformed and she acquired a shamanic dual nature that I sought to understand. Surprisingly, two similar eyes appeared in Precolumbian artifacts I had located in my small library of books, which I had begun to acquire, as well as in Reyes-Valerio's cornerstone work, *Arte Indocristiano*. In the eyes of an owl found in a Veracruz Culture stone yoke used in a ritualistic ballgame, a ballgame that used a stone ball and within its rules decreed that the captain of the winning team be decapitated! And again, I found owl eyes in an Aztec relief, and yet again in owl imagery on the Great Goddess of Teotihuacan. The idea of the owl integrated into *Virgencita* haunted me. The owl symbolized death throughout ancient Mesoamerica, so why was it integrated into *Virgencita*?

The combined evidence, although ambiguous—ambiguity fittingly being integral to Mesoamerican mythology—was suggestive. *Virgencita*'s feathered gown could also relate to the the owl, as well as to Quetzalcoatl. The two blades—looking very much like beaks— added to owl-like imagery. The traditional Spanish winged shape of her cape hinted of owl. And of course, the vestiges of large owl eyes on her cape, although also linked to the Corn Goddess, could, through the pluralistic nature of Aztec symbols, clearly complete the owl suggestion. An altogether fantastic ambiguity infuses Aztec art and religious thinking. A multilayered subtext is always present in Aztec representation and to my thinking a subtext as surreal as anything in Greco-Roman mythology.

The owl is first noted in the New World by Columbus, as appearing among the Taino Indians of the West Indies. Columbus reported "the Devil being embroidered on the dresses of Indians in the likeness of an owl." The Tainos were likely invoking shamanic protection from the strange, hairy demons that had appeared in fantastic ships by their shore. Among the first Indian words used by missionaries in Mexico, in the process of their Christian instruction, was the Aztec/Nahuatl word *tlacatecolotl* (owl man), which became a word the missionaries used for their concept of demon or devil. An additional clue to owl usage is found in the *Codex Ixtlilxochitl* depiction of the Aztec ruler Nezahualcoyotl

dressed for battle in a costume suggesting a horned owl; again showing owl imagery as a threatening symbol of protection.

I was beginning to understand the dual nature of *Virgencita* now that I was looking for her "owl" quality. The owl was protecting *Virgencita*. The owl was *Virgencita's tonal* and her *nagual*, her shadow spirit and her animal totem. Still today, belief in the *tonal* and *nagual* co-essence is pervasive among indigenous peoples of the Americas. Owl's protection threatened death to any evil approaching *Virgencita*; and *Virgencita*, in turn, protected the faithful. She was their owl in turn.

The Aztec convert who made *Virgencita*, no doubt still aware of the dualistic nature of his defeated gods, also could have remembered that under the banner of the Virgin, Cortes and his army had brought death to thousands of his people. The banner of the Virgin with her image emblazoned upon it, hovering on a pike above the fray of battle, was reputed to have been regarded as a terrifying apparition-like image to the Indians fighting the conquistadors. The Aztec maker of *Virgencita* certainly understood that the Virgin had the power of death as well as life; hence, the death threat of the owl was infused as part of the new god's power.

The owl idea lingered in my mind. One evening, votive candles burned below *Virgencita* on her altar in our living room. Ready to retire, Jann and I turned out all the lights. The candles still burned. A draft flew through the room and the candles flickered as we walked past the altar. Suddenly, I saw a large shadow moving on the wall behind *Virgencita*. It was the owl himself!

"Look!" I cried out, electrified. My heart must have stopped and I grabbed Jann. Then she saw it and audibly caught her breath. *Virgencita*was casting the large shadow of an owl! It shimmered in the candlelight as if alive. I almost fell to my knees. Tears welled up in our amazed eyes. We held each other, stunned and speechless, and looked at the apparition of a ghostly owl. This went beyond accident, far back in time to the living spirit of ancient Mesoamerican ritual, to shadows and mysteries, to the birth of mythology and religion.

The owl was there, and now there was no question in my mind, nor would there ever be.

Virgencita and owl shadow. Courtesy, Kline Art Research Library

Jann and I sat down, calmed somewhat, and watched the phenomenon continue. The owl's head had always been there, but we did not see it until tonight. It was the nimbus, with feathers spiking out like the rays of the sun. And the owl's two eyes were there, formed by the crescent spaces within the nimbus. The winged cape completed the bird's shape. As the candlelight played on the surface of the carved stone, I noticed that the round owl eyes on the cape were glimmering back at me, feathers were ruffling, *Virgencita*'s face became animated. Needless to say, we didn't sleep much that night.

Now that I felt I understood *Virgencita*, I sent my hypothesis and photographs to several U.S. museum curators of important Spanish Colonial and Precolumbian collections. After prolonged periods of waiting, I received pallid and disappointing responses, robotic and zombie-like with no enthusiasm. It would have been the perfect opportunity for them to acquire *Virgencita*. No leap of faith, not even a step, not even a glimmer of recognition from the institutionalized authorities, not even aesthetic appreciation. Conventional thinking—my nemesis dressed in academic robes— even in the face of good evidence, continued in its blind march against any

evolution of established dogma and traditional thinking. It was depressing, but I had not lost hope.

I still had not made contact with Constantino Reyes-Valerio, and it seemed that none of the curators had a clue to his whereabouts. Finally, I spoke to a librarian in Mexico City at the Instituto Nacional de Antropologia e Historia, the publishers of his book. The librarian spoke some English, and she said she knew him and promised to deliver a message from me when she saw him again. I solemnly told her that I would pray for good things in her life and promised room and board and a job if she wanted to emigrate to Santa Fe. I wasn't kidding.

Meanwhile, continuing along the way for peer review and some agreement, I continued to find no recognition of *Virgencita*, no enthusiasm, no suggestions, no help or encouragement. I felt riddled with arrows of discouragement, and often I gave in to anger and despair. I was sure I wasn't crazy! Jann and I went over and over the developing evidence in front of us. Slowly my hypothesis began to emerge and stabilize, which I had to trust, in spite of all logic and experience cautioning against this unlikely and unprecedented direction.

Then, from out of the blue, a phone call came from the now-legendary Constantino Reyes-Valerio. He called one morning, thanks to the blessed librarian. He was a charming man in his seventies who spoke English and he asked me to send my research and transparencies, which I did on the angel wings of FedEx. Within days Reyes-Valerio called back. He liked what he saw and what I had written; in fact he called *Virgencita* by name and called her "amazing and unique." We were quickly on a first-name basis. Constantino said that my hypothesis, with some minor adjustments, appeared to be correct. I could barely speak and just managed to whisper "Wonderful!" Of course, he said, he would have to examine *Virgencita* in person at some point. He suggested that we commission a scientific analysis first.

I had already anticipated the need for a scientific study and had some months before commissioned Dr. M. Susan Barger of the University of New Mexico, a noted materials scientist who specialized in art object analysis, to undertake the study. Soon after Constantino's directive, the study was completed—and would later win some acclaim. Dr. Barger's

paper, "*La Virgencita*: Technical Study of an Indo-Christian Statue"—co-authored with Dr. Weiliang Gong—was delivered at the annual Materials Research Society symposium and published in *Material Issues in Art and Archeology* in 1997. Barger and Gong's research found conclusively that *Virgencita*'s cantera stone medium came from Mexico's Los Humeros volcanic field, the very area from which quarried stone was taken during the early post-Conquest period for the rebuilding of Mexico City. An amazing correlation! Additionally, in the examination by Dr. Barger, nothing was found in a deep microscopic study of the surfaces and chiseled areas of Virgencita to contradict the dates of 1521–1540 that Reyes-Valerio was suggesting.

I reported back to Constantino with the results, and we made arrangements for his firsthand study in Santa Fe. After the Barger-Gong study, Barger's further study, my study, and Constantino's study of the detailed transparencies and my research, Jann and I felt assured that there would not be any question of its authenticity. We planned to celebrate in Santa Fe.

Fortunately, we were able to offer Constantino and his wife, Carolina, an all-expenses-paid trip along with a wonderful surprise for their lodging. My friend and sometime art partner Rutgers Barclay had just finished remodeling and refurnishing one of the grandest historic residences in Santa Fe, at 418 Canyon Road, and he graciously allowed us to offer it to our guests. As we awaited Constantino's and Carolina's imminent arrival, Jann filled the kitchen with food and drink and spread spring flowers in the rooms. We had classical music playing and the aroma of cinnamon bark simmering in a little pot on the stove. It was early April 1996, Holy Week preceding Easter and Passover.

Soon after Constantino and Carolina arrived, Constantino met with Susan Barger and discussed her findings. Following his hands-on examination, he pronounced *La Virgencita del Nuevo Mundo*—now her formal title—to be an authentic Indo-Christian sculpture with a unique overlay of Precolumbian iconography, adding a new style to this first new post-Conquest art genre. It was an historic and joyous moment for all of us, including *Virgencita*, who in that moment was officially reborn into the late 20th century.

Constantino Reyes-Valerio and Susan Barger examining *La Virgencita*,
Courtesy, Kline Art Research Library

Constantino Reyes-Valerio examining *La Virgencita*,
Courtesy, Kline Art Research Library

Jann and I decided to make a great occasion out of the discovery and
Constantino's visit. We notified art reporter Hollis Walker at the *New
Mexican*, wrote a press release, and created a classy handout with a color
photograph of *Virgencita*, and then planned an unveiling at Hillcrest:
collectors, scholars, several former Latin American ambassadors, museum

directors, prominent professionals, writers, artists, and assorted friends were all in attendence. Jann spread a feast on the dining room table. Constantino and I gave short speeches. *Virgencita*, above the fray on her altar, had an admiring crowd gazing at her all evening. Hollis, who was covering the story and the reception, said the front page of the Easter Sunday paper would be ours.

But we awoke Sunday morning to a sad front page. The renowned actress Greer Garson, a beloved Santa Fean for decades and a regal benefactor to education and the arts, had died on Saturday at her Forked Lightning Ranch in nearby Pecos. The entire front section of the paper became an elegant farewell to her and a celebration of her rich and glamorous life. On the front page of the following section, *La Virgencita del Nuevo Mundo* appeared in print for the first time and seemed to offer continued tribute and added reverence to Greer Garson's memory.

⚬∞⚬

In the course of Constantino's stay, we learned that his ancestry was Aztec and that he also spoke Nahuatl, the still-living language of his ancestors. One evening, we gathered by *Virgencita*'s altar with my stated intention of recreating *Virgencita*'s owl for Constantino and Carolina. We lit the candles, opened a door to let a breeze pass through, and then turned out the lights. The shadow of the owl appeared in all its mystery as the flickering lights played across *Virgencita*.

"Oh, my God!" Constantino exclaimed, and then whispered a phrase so strange sounding it could only have been in Nahuatl. We did not analyze the phenomenon, we did not discuss it. We looked at the living shadows of *Virgencita*'s ancient past and sat for a long time in silence and reverence. Constantino wiped tears from his eyes. We all did.

⚬∞⚬

The museum exhibitions began in September 1996, just six months after *Virgencita*'s authentication, and continued into January 1998, which encompassed the first public viewing of *Virgencita*. Our goal was to make her increasingly famous, and therefore valuable, through exhibitions, published scholarly

studies, and popular journalism. *Virgencita* was not for sale, but she could be at some time in the future. For now, we—and any commercial interest—had to stand aside. This process was a time-honored and proven strategy and easier said than done. Realistically, we knew this process could take years, but the creation of an exhibition and publication pedigree, its provenance, was imperative. We asked the first two museums to insure her for $500,000, which is what we thought we might ask if the time came, and they readily agreed.

At Davenport Museum of Art in Iowa (the first exhibition venue available), *Virgencita* was the sole sculpture in their exhibition "The Baroque Vision from Europe to New Spain"—essentially their own recently donated collection of Mexican Colonial Old Master paintings. At Meadows Museum of Art in Dallas, director Jon Lunsford created a striking one-object exhibition, "La Virgencita," among their collection of Spanish Old Master paintings. Third, and most prominent, San Antonio Museum of Art would be *Virgencita's* regal debut, and her inclusion had been planned for a year. The exhibition was called "Folk Art of Spain and the Americas: El Alma del Pueblo [The Soul of the Town]," and it would travel to many additional museum venues from October 1997 through the summer of 1999; however, *Virgencita's* sole exhibition would be in San Antonio since we did not want the risks of travel that we could not be on hand to supervise.

Jann and I looked forward to visiting our old hometown on this glorious occasion. On the flight to San Antonio, I picked up a copy of *Spirit*, Southwest Airlines' monthly magazine, and opened it at random. There, like a vision, was *Virgencita*, full page in color, leading the parade of objects in the article about the show. Within minutes of landing, we sailed gaily into the museum before lunch, in the midst of last-minute preparations before the opening that night. *Virgencita* was exhibited in a beautifully crafted glass-enclosed niche that would have done justice to the Louvre's exquisite 14th century Gothic ivory *Virgin and Child*. It was perfect and wonderful. The opening that evening was a crowded and glittering Tex-Mex fiesta in the grand San Antonio tradition. *Virgencita's* glorious presentation generated a veritable pilgrimage of viewers all evening. During the three-month run of the show in San Antonio, notices and reviews appeared in the national press and magazines, and often *Virgencita* was the only object illustrated. It was uncanny. Time after time, there she

was in the spotlight, in all her glory, representing the entire exhibition. I could swear she was in control. Three months later, after the show closed in San Antonio, we had *Virgencita* back and henceforth she would be on exhibition at our gallery in downtown Santa Fe.

It was wonderful to have her back. Rarely has the presence of an object brought us more joy. As time passed, more scholarly recognition and a variety of publications began to develop. Mary Miller, the eminent Yale Mesoamericanist, became fascinated with *Virgencita*, and she put me in touch with Louise Burkhart at SUNY–Albany, an anthropologist and scholar of Marian devotion in 16th century Mexico. Burkhart was writing a book called *Before Guadalupe: The Virgin Mary in Early Colonial Nahuatl Literature*, and she wanted *Virgencita* for the cover. Mary Miller's referral was a perfect fit. Then Linda Hall, a University of New Mexico historian and Latin Americanist, learned of *Virgencita* and also wanted her for the cover of her book-in-progress dealing with the Virgin in Spain and the Americas (later published as *Mary, Mother and Warrior*). *Virgencita* was included in Marion Wheeler's book, *Her Face: Images of the Virgin Mary in Art*. Harrison Fletcher wrote an award-winning story in *New Times*, "Virgin Rebirth," which investigated the Guadalupe/Virgencita connection, and his piece was featured in newspapers across the country during the 1998 Christmas season. Professor Khristaan Villela of the College of Santa Fe featured *Virgencita* in a popular lecture that placed her within a broad art historical context. The Santa Fe daguerreotypist Robert Shlaer made several images of *Virgencita* in that rare medium. And so her fame continued to grow.

Jann and I kept *Virgencita* at our gallery, which was a flight up from busy West San Francisco Street in downtown Santa Fe and our home away from home for almost ten years. It was an intimate space and included a research library of several thousand art books. It was unique in Santa Fe with its artistic mix of Old Masters, 19th and 20th century American and European art, Mexican and Spanish Colonial works of the 16th to 20th centuries, and a contemporary area for working Santa Fe artists we knew and admired. All of these areas were reflected in the works we exhibited. There was no doubt we were generalists. Into our quiet corner of downtown came many scholars and collectors, and increasingly many people came specifically to see *Virgencita*. We began to imagine that someday she might even have her

own chapel. Then, from an unlikely place, it seemed the chapel idea might become a reality. A Native American prep school was being organized near the Black Hills in South Dakota by Delphine Red Shirt, an extraordinary Oglala Lakota woman, who was a noted author and a teacher.

We had recently met Delphine quite appropriately through two friends, the writer Harvey Arden, my former colleague at *National Geographic*, and Keith Rabin, a benefactor of Indian causes, both of whom had important and dedicated ties to the American Indian world. Harvey's book *Wisdom Keepers*, his first in what is now a long list, profiled Native American elders and has already become a contemporary classic, as would his later book *Travels in a Stone Canoe* (both books were co-authored with photographer and writer Steve Wall). I was honored to have had a supporting role in both books. My principal contribution had been a Seminole shaman's cane I purchased at an Indian art show and had given to Harvey at the outset of *Wisdom Keepers* with the bold prediction that it would open the way for his explorations. With its rough magic, it may have. Harvey later returned the cane in a formal ceremony at the Seminole's Ah-Tah-Thi-Ki Museum at Big Cypress Reservation in Florida, where it acquired the provenance of having been made in the 1850s during the time of Osceola by the powerful shaman Wildcat. A Seminole elder, Buffalo Joe, who first examined the wood cane with its carved alligator handle, said the powers of Wildcat's cane were such that we were lucky it didn't kill us.

☙

Delphine Red Shirt was a tall, thin woman who looked to be in her late thirties, with classic Indian features and an aura of deep calm and serious purpose. She smiled very little, but attractively when she did, and while she listened attentively and did not waste words, another part of her seemed detached and dreaming in another place. She was remarkably centered and self-assured and no doubt physically strong like the long-distance runner she was—in her youth she had been in the Marine Corps, as I had. I characterized her in my mind as a medicine woman and a warrior. Jann and I enjoyed her from the start, and so our friendship began. On one occasion when she was visiting Santa Fe, Delphine came by the gallery and we showed her *Virgencita*

for the first time. There was no one else in the gallery. I described *Virgencita* in terms of her being a first New World Indian Madonna and as the symbol of the first Indian baptized into a transformed Christianity.

"Look, " I said, and pointed up to *Virgencita*. "She appears as a young Indian girl and she is speaking. In the whole world, no other image of the Virgin Mary has these attributes."

Almost at once, Delphine became visibly shaken, her body shuddered, and blood drained from her face, which now had changed from brown to gray. She stood transfixed and silent, staring up at the statue in a trance-like state. Jann and I slowly eased away and left her in deep meditation with *Virgencita*. Their spiritual connection flowed like an electric current, deep and palpable and unquestionable. It was like they had claimed each other right there in that spot and in that moment. Jann and I went over to the conference table and sat down and waited for Delphine to join us.

"I am greatly affected by *La Virgencita*," Delphine said, coming over and sitting down. "Is she for sale? Do you think we could have her at the new prep school? She would be wonderful there." Jann and I both liked the idea. It seemed a perfect fit. Delphine spoke quietly. "I have a friend who has promised a big donation to get the school going. I'll talk to him about *La Virgencita*. She is so beautiful. I was very moved in her presence."

"Maybe she can lead the way," Jann added softly.

"You'll hear from us before long," Delphine said.

In a few weeks a man called, soft-spoken and friendly, and asked about *Virgencita*. It was Delphine's backer. He asked the price and I told him. He then asked if we would take a lesser amount, which he quoted. I asked if he was going to donate *Virgencita* to Delphine's school. Yes, he said, he would be donating it. I said we would in effect donate what we deducted from our asking price and accept his offer. He agreed that our names would appear on the donation plaque along with his. And so it came to pass that *Virgencita* was sold for an astonishing amount—and a good reason to give thanks! What a wonder she had been in our lives.

With the money from the sale of *Virgencita*, we bought our wonderful home, 7th Heaven Ranch, in the Pecos River Valley. Shortly after the sale, we had found the property advertised for sale by owner, and on a Sunday morning after breakfast Jann and I drove out to see it. It was farther than

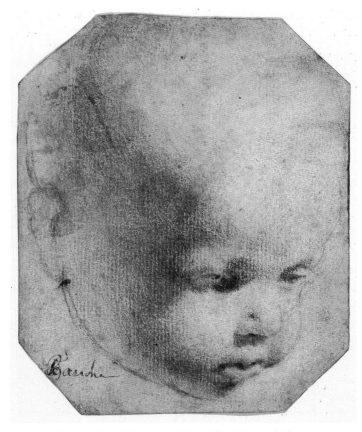

Figure 1. *Holy Child*, Leonardo da Vinci, Kline Art Research Library.

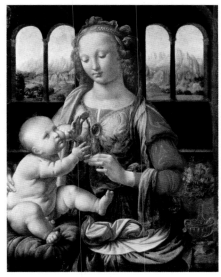

Figure 2. *The Madonna of the Carnation,*
Leonardo da Vinci, Alte Pinakothek, Munich.

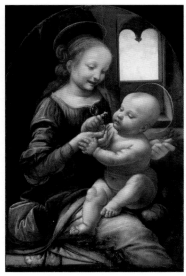

Figure 3. *Benois Madonna*, Leonardo da Vinci,
The Hermitage Museum, St. Petersburg.

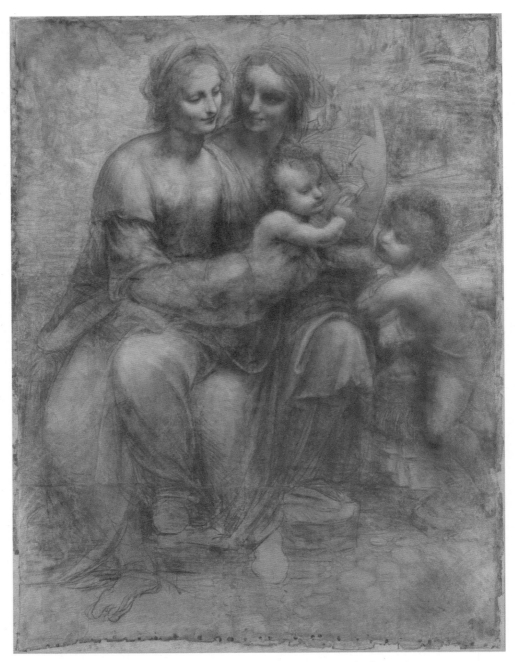

Figure 4. The *Burlington House Cartoon*, Leonardo da Vinci, National Gallery, London.

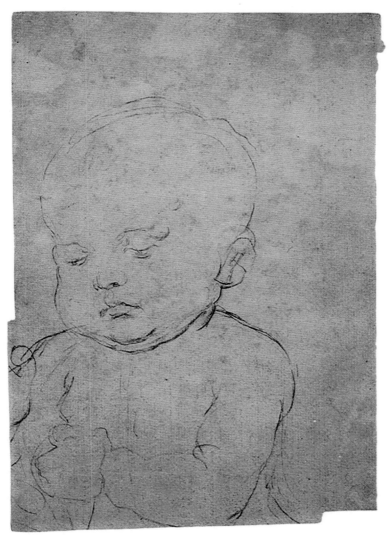

Figure 5. *Study of a Baby*, attributed to Andrea del Verrocchio, Uffizi Gallery, Florence; here attributed to Leonardo da Vinci.

Figure 6. *Studies for Christ Child*, Leonardo da Vinci, Venice Academy.

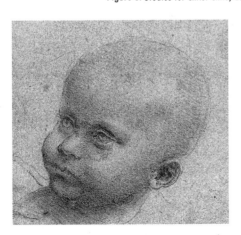 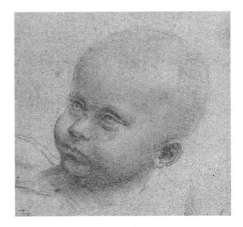

Figures 7. and 8. At left in black and white, *Venice Christ Child* showing distinct mole and spot at right eye.
At right in original red chalk, *Venice Christ Child* showing a less distinct mole and spot at right eye.

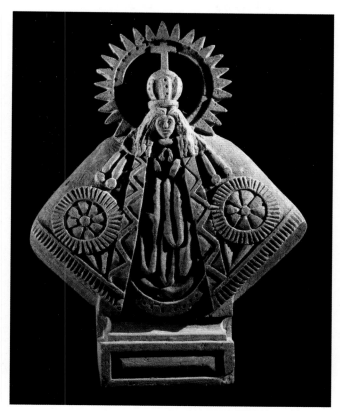

Figure 9. *Virgencita del Nuevo Mundo,* Private Collection.

Figure 10. *Virgencita* and the owl shadow

Figure 11. *The Horse Thief*, George Caleb Bingham, Private Collection. Courtesy, Rachael Cozad Fine Art.

Figure 12. Back of canvas of *The Horse Thief*

Figure 13. Detail of the Goupil stencil on the back
of *The Horse Thief*

Figure 14. *Sarah Helen Rollins* by George Caleb Bingham (1837, oil on canvas, 60 x 32 in. Private Collection. Courtesy, Rachael Cozad Fine Art.). Bingham's transition from portraiture to Western genre began with this early masterpiece of a 12-year-old girl on the American Western frontier dressed in her Sunday best and holding her favorite book.

Figure 15. *The Emigration of Daniel Boone*, George Caleb Bingham, Mildred Lane Kemper Art Museum, Washington University St. Louis, Gift of Nathaniel Phillips.

Figure 16 (LEFT). Cover for *George Caleb Bingham Catalogue Raisonne Supplement*. **Figure 17 (RIGHT).** *Baiting the Hook* (1841 Virginia, oil on canvas, 28 x 23 in. Private collection. Courtesy, Rachael Cozad Fine Art)

Figure 18. *Young Fisherman, Hudson River Palisades,* George Caleb Bingham (1855, oil on canvas, 27.75 x 30 in. Collection of Renée duPont Harrison and Mason H. Drake Chicago, IL. Courtesy, Kline Art Research Associates.) Integral additions to Bingham's series of "River" paintings were *Baiting the Hook*—Bingham's first river-themed painting and *Young Fisherman: Hudson River Palisades*—Bingham's last river-themed work and his only known Hudson River School painting.

Figure 19. *Colin Dunlop and His Dog,* George Caleb Bingham, Collection of
Virginia Governor's Mansion and State of Virginia, Richmond.

Figure 20. *Fanny Smith Crenshaw* and *Lewis Allen Dicken Crenshaw,* George Caleb Bingham,
Springfield Art Museum, Springfield, MO.

Figure 21 (ABOVE). *Orpheus Charming the Animals*, Jan Brueghel the Elder, with Hendrick van Balen and Denis van Alsloot, Private Collection.

Figure 22 (BELOW). *Allegory of Hearing*, Jan Brueghel the Elder and Peter Paul Rubens, Museo del Prado, Madrid.

Figure 23 (ABOVE). Wild Bill Hickok tintype and poem, Private Collection, used with permission from Heritage Auctions.

Figure 24 (BELOW). *Bernese Oberland Landscape with Women Working*, Joseph Anton Koch, Thaw Collection, The Morgan Library.

Figure 25 (ABOVE). *Allegory of the Divine Beauty of Nature*, Gottlieb Schick, Lehman Loeb Art Center, Vassar College.

Figure 26 (BELOW). *Decorative Landscape and Barn*, Lawren Harris, Private Collection.

Figure 27. *The Arrival of General Grant at San Francisco*, William A. Coulter, Private Collection.

Figure 28. *Aaron, Holy to the Lord*, Pier Francesco Mola, Private Collection.

Figure 29. *Barbary Pirate*, Pier Francesco Mola, Louvre Museum, Paris.

Figure 30. *La Cruz de Las Cuatro Flores,* Indo-Christian (Post-Conquest Yucatec Maya), Kline Art Research Library.

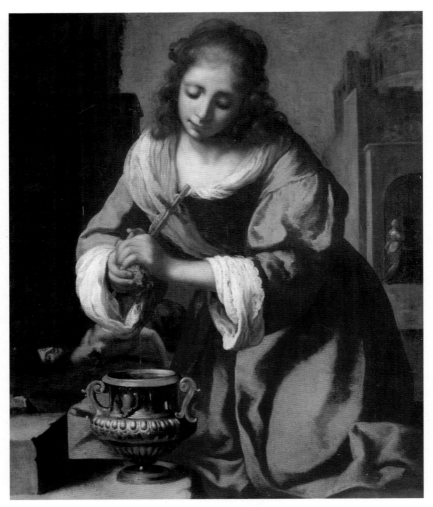

Figure 31. *St. Praxedis*, Johannes Vermeer, Private Collection.

Figure 32. Fred and Jann Kline, San Antonio, Texas, 1985.

practical for a daily commute to Santa Fe, an eighty-mile round trip, but the landscape was spellbinding and the house was splendid, and within a few minutes we changed our ideas about commuting. It was a dream and a romance waiting for us to inhabit. A vast sea of thousands of pinyon and juniper trees spread across twenty acres surrounding the house with its 50-mile view of nearby highlands, the Pecos Valley, and distant mountains. Sculpted rocky bluffs on the ranch rose 700 feet above the nearby Pecos River. The country life beckoned! All we could say was "this is 7th heaven . . . this is 7th heaven . . ." and so we named it. *Gracias, Senora!*

POSTSCRIPT

The earliest recorded Remedios Virgin made in Mexico is *Nuestra Senora de la Salud de Patzcuaro*, commissioned by Bishop Quiroga in 1540 for the Patzcuaro Basilica in Michoacan, and it is in the pose of the Immaculate Conception. Still extant, periodically redressed like a doll, and still venerated in the basilica, all possible Indian qualities have vanished from this traditionally called "Indian Madonna," which in its original incarnation was made from cornstalk paste, an indigenous material used by the Indians. Undoubtedly, the most important relationship to *Virgencita* found in Mexico today is the closely related *Nuestra Senora de San Juan de los Lagos*, a fabled healing Virgin, originating also in Michoacan, whose documented origins in Mexico are earlier than Guadalupe's.

The Virgin of San Juan is also presented in the pose of the Immaculate Conception, but with no Indian qualities. Her popularity in Mexico is second only to the Virgin of Guadalupe.

Our Lady of San Juan de los Lagos, Basilica of San Juan de los Lagos, Jalisco, Mexico

FURTHER DISCUSSION
LA VIRGENCITA DEL NUEVO MUNDO

SYNOPSIS

This record documents the discovery in 1995 and the ongoing research of a unique New World Marian sculpture of unprecedented transitional importance: an interpretive Aztec-made Virgin of the Immaculate Conception, circa 1521–1540, Mexico (New Spain); now called *La Virgencita del Nuevo Mundo* (*VNM*). The stone sculpture has been judged by leading scholars to be virtually unique in its overlay of symbols representing ancient Mesoamerican-Aztec gods here integrated into a Christian devotional sculpture of the Virgin Mary. These qualities suggest that *VNM* might be studied as a type of Indo-Christian Rosetta Stone that could offer insight into the transformation of religious consciousness in the New World. In all probability, *VNM* can be considered a first Virgin Mary of the Americas, as well as a first New World Indian Madonna. This evidence warrants consideration of *VNM* in relationship to the 16th century origins of the cult of the Virgin of Guadalupe in Mexico, a subject of wide research traditionally based on an apparitional legend, a painted textile image of problematic origin, and sparse(but expanding) 16th century documentation. VNM symbolizes within religious history the first new deity of the New World; the first Native American baptized into (a transformed) Christianity. Within art history, *VNM* represents a singular and ephemeral Indo-Christian genre—the first art genre of the post-Columbian New World. The implications of this discovery suggest fresh insight into many areas of New World studies.

RECORD

Mexico (The Viceroyalty of New Spain), circa 1521–1540
Unknown Aztec artisan
Immaculate Conception (*La Virgencita del Nuevo Mundo*)
Cantera stone
14¾ in. high x 11 in. wide x 4½ in. deep
(37.5 x 28 x 11.5 cm)
 Original condition: nimbus fractured in three places and repaired long ago, no losses; old minor losses at back of head and base. No restoration.

PROVENANCE

Collection and private estate, New Mexico; 18th–19th century to 1995. Family history traces to Mexico and possibly Spain before New Mexico. (as unidentified object)

Collection, Fred and Jann Kline, Santa Fe, NM: December 1995–January 2000 (here first researched and identified by Fred R. Kline)

Private Collection: 2000–present

DISCOVERY, AUTHENTICATION, AND EXPERTISE

Discovery December 1995: Purchased (as unidentified Virgin) from a New Mexico estate by art historian Fred R. Kline, who first identified, attributed, and began interpretation of *VNM*, December 1995–March 1996.

Authentication and expertise April 1996: Constantino Reyes-Valerio, Instituto Nacional de Antropologia e Historia, Mexico City. The late Reyes-Valerio was the world's leading scholar of 16th-century Indo-Christian sculpture in Mexico and author of the foundation work on the subject: *Arte Indocristiano, Escultura del Siglo XVI en Mexico*, 1978, Mexico City. (CRV written expertise on request.)

SCHOLARS SUPPORTIVE OF VNM'S AUTHENTICITY

Dr. M. Susan Barger, University of New Mexico, Albuquerque, NM (Material science: relating to fine art)

Dr. Marcus Burke, The Hispanic Society of America, New York, NY (Spanish colonial art history)

Dr. Louise M. Burkhart, University of Albany/State University of New York, Albany, NY (New World anthropology/Nahua-Aztec Christianity)

Dr. Linda B. Hall, University of New Mexico, Albuquerque, NM (Latin American history/Marian studies)

Dr. Jon Lunsford, Director of Meadows Museum, Dallas, Texas (Spanish Art history, Spanish Colonial art history)

Dr. Mary Miller, Yale University, New Haven, CT (Mesoamerican art history/iconographic studies in the art of ancient Mexico)

Dr. Marion Oettinger Jr., Senior Curator of San Antonio Museum of Art, San Antonio, Texas (Spanish and Mexican folk art)

Dr. Constantino Reyes-Valerio, INAH, Mexico, DF (16th c. Mexican colonial Indo-Christian sculpture)

Dr. Khristaan D. Villela, Director of Thaw Art History Center, College of Santa Fe, Santa Fe, NM (Mesoamerican art history)

MUSEUM EXHIBITIONS (ON LOAN 1996–1998)

Davenport Museum of Art, Davenport, IA: "The Baroque Vision from Europe to New Spain," Sept. 29, 1996, to Feb. 16, 1997 (Notably, the only sculpture in the exhibition.)

Meadows Museum of Art, Dallas, TX: "La Virgencita," March 1, 1997, to May 31, 1997 (A single object exhibition.)

San Antonio Museum of Art, San Antonio, TX: "El Alma del Pueblo: Folk Art of Spain and the Americas", Oct. 17, 1997, to Jan. 1998. (Exhibition reviews with illustration of *VNM* in various publications.)

PUBLICATIONS (ARRANGED CHRONOLOGICALLY)

Hollis Walker. "Sculpture of Virgin Might Be Rare Discovery" (*VNM* illustrated). *Santa Fe New Mexican*, April 7, 1996.

M. Susan Barger and Weiliang Gong. "La Virgencita: Technical Study of an Indo-Christian Statue" (*VNM* illustrated). *Material Issues in Art and Archeology V.* Pittsburgh, 1997.

Texas Catholic newspaper, April 1997 (*VNM* illustrated, see above, review of Meadows Museum exhibition).

D. J. Williams. Southwest Airlines *Spirit* magazine, October 1997 (*VNM* illustrated, see above, review of San Antonio Museum of Art/SAMA exhibition).

Kristin Bucher. *Southwest Art* magazine, October 1997 (*VNM* illustrated, see above, review of SAMA exhibition).

Avis Berman. *Art and Antiques* magazine, December 1997 (*VNM* illustrated, see above, review of SAMA exhibition).

"Devotion to Our Lady of Guadalupe," *Vista* magazine, an Hispanic national Sunday newspaper supplement. December 1997 (*VNM* illustrated and featured).

Marion Wheeler. *Her Face: Images of the Virgin Mary in Art* (*VNM* Illustrated, p. 10.). First Glance Books, Cobb, California, 1998.

Harrison Fletcher. "Virgin Rebirth" and "Like a Virgin," *New Times* newspaper (*VNM* illustrated, lead story in Denver, Dallas, Los Angeles, and St. Louis editions), December 10–30, 1998.

Rachel Maurer. "Cult of the Virgin Mary" (*VNM* illustrated, p. 31; regarding UNM history professor Linda B. Hall's forthcoming new book—see below)

Quantum: Research, Scholarship, and Creative Works at the University of New Mexico. Albuquerque. Fall 1999.

Louise M. Burkhart. *Before Guadalupe: The Virgin Mary in Early Colonial Nahuatl Literature* (*VNM* illustrated and text references). Institute for Mesoamerican Studies/Monograph 13. Albany, October 2001.

Linda B. Hall. *Mary, Mother and Warrior* [*VNM* illustrated and text references]. University of Texas Press, 2004.

LECTURES

Dr. Khristaan D. Villela (College of Santa Fe). "Mexican Art and Architecture in the Sixteenth Century: European Mannerism and Indochristian Tequitqui" (*VNM* featured in slide presentation). Southwest Seminars, Santa Fe, July 29, 2000.

RESEARCH NOTES

1. The Aztec deities merged into *VNM* suggest the great god Quetzalcoatl (represented by feathers overlaid on the area of the dress) and the significant Earth/Corn Goddess Chicomecoatl (who may merge collectively with the generic Mother Goddess Tonantzin in the two floral disks, four phallic-like tassels, and two flint blades). The Virgin's face, echoing the naturalistic style of Teotihuacan masks and figurines, depicts a young Indian girl who appears to be speaking (a Mesoamerican sign of authority). It should be noted that nowhere in the historic iconography of Christian art is the Virgin Mary depicted as speaking.

2. *VNM* is modeled on a Spanish Virgin of the Immaculate Conception, circa late 15th–early 16th century, and is likely based on a print or painted miniature, but possibly from direct observation of a sculptural Virgin. The Aztec maker was probably directed by a missionary, or conceivably by a conquistador, for placement in a niche in a private

or an open-air chapel. The Aztec artisan was allowed to interpret the Virgin's imagery through the bias of his still fresh religious tradition. During the later 16th century, however, images like *VNM* which bore "pagan" influences were ordered to be destroyed or altered by the Spanish Inquisition. *VNM* stands as the unique survivor of that purge. Evidence that *VNM* was once enhanced with a decorative inlay on the apocalyptic symbols of the crescent moon, solar rays of the nimbus, and the crown appears as now empty seed-pearl size concavities (Aztec calendrical numerology may yet offer an interpretation of the number-suggestive details of *VNM*).

3. In *VNM*'s pose of the Immaculate Conception, the Virgin was embraced by the Old World Spanish and venerated by the conquistadores as La Virgen de los Remedios (remedies). A devotional sculpture of the Remedios Virgin is known to have been brought to Mexico by the conquistadores in 1519. The earliest recorded Remedios Virgin made in Mexico is *Nuestra Senora de la Salud de Patzcuaro*, commissioned by Bishop Quiroga in 1540 for the Patzcuaro basilica, Michoacan. Still extant, periodically redressed, and venerated in the Basilica, all possible Indo-Christian qualities of this traditionally called "Indian Madonna" (originally made from cornstalk paste) have been erased. The *Patzcuaro* Virgin retains an overall design, which is probably traditional, that closely resembles *VNM*. The most notable stylistic affinity to *VNM* found in Mexico today is *Nuestra Senora de San Juan de los Lagos*, a Remedios Virgin whose popularity is second only to La Virgen de Guadalupe.

4. Research conducted on *VNM* by materials scientists at the University of New Mexico (using scanning electron microscopy, transmission electron microscopy, and electron microprobe analysis) and later published (see Publications) found conclusively that the sculpture's cantera stone medium came from Los Humeros volcanic field, which is consistent with historic Mexican localities of Indo-Christian stonework. The finding of remnants of a green paint ground is an indication supporting the probability that the statue was once polychromed in a documented traditional color. Nothing was found to contradict the circa dates of 1521–1540.

SELECTED SOURCES

Germain Bazin. *The History of World Sculpture*. Greenwich, CT, 1968.

Louise M. Burkhart. *The Slippery Earth: Nahua-Christian Moral Dialogue in Sixteenth Century Mexico*. Tucson, 1989.

Bernal Diaz de Castillo. *The Discovery and Conquest of Mexico*. New York, 1956.

Serge Gruzinski. *Painting the Conquest: The Mexican Indians and the European Conquest*. Paris, 1992.

George Kubler. *Mexican Architecture of the Sixteenth Century*. New Haven, CT, 1948.

———. *The Art and Architecture of Ancient America*. New Haven, CT, 1962.

Jacques Lafaye. *Quetzalcoatl and Guadalupe: The Formation of Mexican National Consciousness,1531–1813*. Chicago, 1976.

Metropolitan Museum of Art. *Mexico: Splendors of Thirty Centuries*. Exh. cat. with essays by Octavio Paz, Marcus Burke, Johanna Hecht, Donna Pierce, and others. New York, 1990.

Mary Miller and Karl Taube. *An Illustrated Dictionary of the Gods and Symbols of Ancient Mexico and the Maya*. New York and London, 1993.

National Gallery of Art. *Circa 1492: Art in the Age of Exploration*. Exh. cat. with essays by Michael D. Coe and others. Washington, DC, 1991.

Lee A. Parsons. *Pre-Columbian Art: The Morton D. May and the Saint Louis Art Museum Collections*. New York, 1980.

Esther Pasztory. *Aztec Art*. New York, 1983.

Jeanette Favrot Peterson. "The Virgin of Guadalupe: Symbol of Conquest or Liberation." *Art Journal*, 1992.

Stafford Poole. *Our Lady of Guadalupe*. Tucson, 1995.

William H. Prescott. *The Conquest of Mexico*. Boston, 1843.

Constantino Reyes-Valerio. *Arte Indocristiano: Escultura del Siglo XVI en Mexico*. Mexico City, 1978.

B. de Sahagun. *General History of the Things of New Spain*. Santa Fe, 1950–1975.

Hugh Thomas. *Conquest*. New York, 1993.

Manuel Toussaint. *Colonial Art in Mexico*. Austin, 1967.

Pamela B. Vandiver, James R. Druzik, et al., editors. *Material Issues in Art and Archeology V* (including Barger and Gong, "La Virgencita: Technical Study of an Indo-Christian Statue"). Pittsburgh, 1997.

Elizabeth Wilder Weismann. *Mexico in Sculpture*. Cambridge, MA, 1950.

CHAPTER 2

Wandering Paintings in Search of an Author

George Caleb Bingham, *Horse Thief*, ca. 1851, 30 x 36 in., oil on canvas,
©2015 Kline Art Research Associates and Private Collection

George Caleb Bingham, *Self-Portrait, Age 24*, ca. 1834–1835, St. Louis Art Museum

I

The Painting in a Dark Corner

L ost art exists in a world of its own, and the search for it requires that
you embrace the miraculous and the chaos of chance. Sometimes, as
is the case with this painting, it seemed like a fairy tale.

*Once upon a time there was a strange painting exiled to live in
a dark corner of a shop. It was an outcast and did not fit into
the decorations of the shop, and besides, no one could understand
its veiled language. It was a mystery. Actually it was a beautiful
painting but it spoke symbolically, like a riddle, and it confused
people. The painting was an orphan without a name or family and
no friends, and the shopkeeper could not even remember where it
had come from. It just wandered in one day and had no other place
to go. The shop owner allowed it to have a dark corner where no*

one would see it because he was at heart a kind man who liked art and he couldn't bring himself to throw it in the trash. He hoped someone as strange as the painting would adopt it and take it off his hands. So the unloved painting spent all its days sleeping and no one ever disturbed it. Years passed. All the while, unknown to the shopkeeper, the painting was dreaming of a time when its story would be discovered and it would hang brightly on a wall and be welcomed by everyone who saw it. And the painting thought, "Just love me enough, and I will reveal my secrets."

We had escaped the oppressive heat and brutal traffic of the Dallas afternoon. It was 1999. Jann and I were now inside an air-conditioned oasis of civilization, an opulent antique gallery with rooms of museum-quality art and antiques that could have decorated a French chateau of the 18th century or a Dallas mansion at the end of the 20th century. As we ambled around the gallery and took it all in, I could see that many paintings required a second look. I intended to spend more time examining them. I saw a first-rate copy of van Dyke's famous self-portrait that could easily be accepted on the wall of a museum, but there were also many paintings of originality and quality, and they posed tantalizing questions.

Detouring from the glittering main show and in no hurry, Jann and I went into a dark side room and noticed a painting with its face leaning against the wall. It was an old landscape painting of surprisingly high quality, evident even in the ambient light from a hallway. The painting looked intriguing, and we took it outside into the sunlight. It was a masterfully painted 19th century landscape with a Western theme, oddly populated with three very small figures on horseback with a man on foot looking like a prisoner with his hands tied. With some creases and minor paint loss around the edges, it was in good original condition with a relatively clean picture surface. The back of the canvas was also in original condition with only a small patch covering a tear. The back dramatically showed its age with a pervasive spider-web of underlying cracks, which did not carry through to the front picture surface except with the normal craquelure found in 100-year-old paintings. It had been well cared for. A

routine repair of the tear and a cleaning by our painting conservator in Santa Fe would bring it back to its original condition. Also on the back was a readable inked stencil and another blurred one, and I quickly read "New York" on the good one, but there was more to be deciphered later. It was not signed, and no artist came to mind.

Verso of *Horse Thief*, pre-conservation, showing spider-webbing of cracked gesso, stencils, and patch

We thought the painting was probably American and made around 1850, or perhaps it could have been a European artist working in America. Jann and I were very impressed by the high quality of its craftsmanship. A master painter was hiding here, no doubt, and I knew we had to have it and at some point solve the mystery. I had an inventory of mysteries waiting for me back in Santa Fe and wanted this one as well.

I knew by its quality it had to be a noted artist of record, either American or European. We bought five paintings at the antique gallery that day, including another unsigned masterpiece, which we put at the head of our line of lost-art projects (and which eventually succeeded with our attribution and a celebratory museum sale). I asked the antique dealer to put a firm hold on the landscape painting, promising to buy it when my project load was lessened, and he graciously promised to hold it for me. We made a very relaxed and informal agreement. It was only $3,500, but one straw too many that day, and we were already over our budget.

Three years passed.

In an unlikely sequence of events, after these years of its being held safely in storage and with yearly promises that I was going to buy it and with no money down, word was kept and we finally closed the deal. I had realistically expected that this landscape painting would evaporate in the way of any stalled promise, but miraculously it had finally wandered back into our hands, an event more far-fetched than fiction would dare. A favorite quote came to mind with ironic timing, from the great trailblazer Daniel Boone: "I never got lost, but I was bewildered once for three days." Three years had passed instead, and I had to admit that I was still bewildered by the painting but very happy at the prospect of a new adventure.

Even before we bought it, the painting had languished in suspended animation for years in a dark corner of this classy antique shop. The dealer said it just never fit in. The painting came without an artist's name, without a title or provenance, and with only a superficial understanding of what it was all about except for its quality, recognizable if you could judge quality. Quality was always the first reason to investigate lost art.

In the many months of research that followed, the painting would transform almost alchemically and reveal an undreamed-of story. Amazingly, it became a masterpiece called *Horse Thief* by the 19th century artist George Caleb Bingham (1811–1879), an American Old Master. Bingham was generally considered to be among the foremost artists of the early American West, but, as I quickly learned, most of his paintings are not signed; hence it is not unusual for many to have become lost and unnoticed.

The Trail to Bingham

At first we referred to the painting as *The Prisoner* and began looking comparatively at the works of Thomas Cole (1801–1848), a brilliant Englishman who moved to America in his teens and later became the first of the Hudson River School masters and inspired a landscape tradition that influenced a generation of artists even after his early death. *The Prisoner* was a strong Cole-influenced narrative landscape, which typically depicted a vast landscape with tiny figures symbolically representing a spiritual, philosophical, or historical allegory, but I did not see Cole's hand, only

his stylistic influence. There were many artists to consider as Jann and I trekked through the Hudson River school. Both of us had been busy going through our library, our net of inquiry always spread wide at first, then one by one removing unlikely artists. Along the way, with this pleasurable and time-consuming style of research we became more educated as generalists in art history, which was always my goal and a happy by-product of trying to solve art mysteries, even if the result does not pan out as we originally hoped. As I was about to turn to the work of Cole's great pupil Frederick Edwin Church, Jann walked over to my chair.

"I want to look at Bingham again," Jann said in her soft way. "I keep thinking there's a certain Bingham-like handling in our painting. It reminds me of his early self-portrait we saw at the St. Louis Museum."

Our only book on George Caleb Bingham (Michael Edward Shapiro, *George Caleb Bingham*, 1992, Abrams) had the self-portrait in color. We looked together, and it didn't take long for our experienced eyes to see the affinities. Jann appeared to be right! *The Prisoner* did indeed echo Bingham's self-portrait in the use of vibrant brown tones and especially the smooth creamy texture of the paint. It was a brilliant out-of-the-box association on Jann's part—a giant leap from a self-portrait to a landscape. In the book with Bingham's landscape paintings reproduced in excellent color we could see that many of the same carefully drawn landscape details in *The Prisoner* corresponded almost exactly. With a magnifying loupe, we began to compare rock formations and textures, the lichen on rocks, the overall structure of landscapes, groups of trees and the figuration of branches and leaves, small plants, architectonics of rock formations, the surface of water, deadwood, clouds and skies, small figures of people and animals—all showed close to exact similarities in what I call signature comparative details: seeing the artist's hand when you compare an unidentified painting with one of established identity. Jann's bright idea kept lighting up.

There was no painting illustrated exactly comparable to *The Prisoner*. It was unique in its subject as far as we could see within the book's selected works, but we believed we were right on target with Bingham stylistically. With Jann's direction we had now successfully evolved a working attribution to Bingham. The standard works would come along shortly: E. Maurice

Bloch's *The Paintings of George Caleb Bingham: A Catalogue Raisonne* and *The Drawings of George Caleb Bingham*. Both were illustrated with all the known paintings and drawings.

Bingham's compositional formula for landscapes was noted succinctly by Bloch: ". . . the spectator is led gradually into the distance through an opening in the right foreground which has been built up, in a stage-like fashion, by rocks and enframing trees. In the background, distant hills are visible . . . the play of darks against lights in a carefully organized pattern of receding planes is effectively demonstrated. . . ." This perfectly described the landscape construction of what was to soon become the retitled *Horse Thief*. Matthew Baigell had also noted in his *Dictionary of American Art*, a book we had at hand, that Bingham's compositional designs were the "most geometrically structured and the most consciously composed of any 19th century American artist," a compositional style drawn from Bingham's study of Old Master paintings, which he studied in books of instructional prints. Bingham had taught himself how to paint by his early study of standard instructional guidebooks for artists and by very brief mentoring in 1821 at age 10 by Chester Harding, a noted American portraitist who had stayed at the inn owned by Bingham's father in Franklin, Missouri, while finishing a portrait recently made of the aged Daniel Boone. Bingham was always independently minded and not an artist the established academies could have readily indoctrinated. *Horse Thief*—with its carefully balanced division of space, pyramidal constructions, and interlocking symmetries— repeats Bingham's structural signature from which he rarely deviated. I began to see this conscious construction throughout Bingham's paintings; picture after picture proved the point.

I sensed again and again that Jann was right. We saw it clearly now. The comparative details continued to connect with each closer look. But in order to make a case, we would repeatedly have to keep comparing signature details, testing the truth of Bingham's hand in our painting, and continue seeing it and testing it with rigorous certainty and prove it with stylistic and documentary evidence with rigorous certainty. Rigorous certainty and an educated eye were the keys. Most importantly, we had to eliminate or reconsider all other possible artists by studying at least a good selection of their complete published works. A great commitment of time faced us. The

painting's mysterious beauty, its hidden story, its flawless craftsmanship, and the allure of treasure drew us on. Bingham was a great prize and very rare. A Western-themed genre painting of his could be valued at several million dollars. The clock went ticking along its merry way. On the research road, years can pass in the blink of an eye.

Our research associate and sometime art investment partner Rutgers Barclay, who, before he retired to Santa Fe, had been a New York art dealer with a well-known gallery, Portraits, Inc., had come aboard to help. Unfortunately, Santa Fe lacked a public art research library, so expensive art books at bookstores were our only resource. Barclay persevered and quickly had located Bloch's catalogue raisonne of Bingham's paintings at an out-of-state bookstore. In it he found a list of Bingham's lost paintings, where he discovered the prize: the list contained the title *Horse Thief.* This appeared to be a perfect match, and it was a cause for celebration, yet it was not illustrated nor had it ever been described.

After an extensive search of mid-19th century exhibition lists in other available books, *Horse Thief* was the only title we ever found that linked even remotely to our painting. Apparently no 19th century artist had attempted to depict a horse thief as a subject. Bloch's book quickly became a treasured resource with its illustrations (most of them, alas, in black and white) of practically every known Bingham painting and with its deeply researched historical and provenance information. Color reproductions were of course best, and we found most of Bingham's paintings in color scattered in other books, but black-and-white images still had an undeniable and worthy usefulness. Bingham typically painted scenes of fully realized people engaged in everyday activities on the Missouri River and in Missouri towns. However, with Bloch to guide us, many "untypical" Bingham works materialized in his book and reinforced our direction with *Horse Thief.* Since an artist's style and subject matter often change over the course of a career, I like to look at a wide range of the artist's complete works, not just a few paintings, and this had to be done through books. For the needs of my art research, books were as essential as food. Over the years, with every old and new project and with the anticipation of future ones, armloads of this nourishment were carried or sent from bookstores to my library. The art book, really a work of art in itself, with its fine color reproductions, awaits

contemplation anywhere and anytime like a portable museum. Today, we also have advanced to high-definition digital images of art works offered online by a few generous museums and other Internet sources. Digital images provide an invaluable and often imperative substitute for seeing and studying the actual works of art which are impossibly scattered to the four corners of the earth. Fortunately, in our computer age, the ability to magnify a digital photograph of a work of art into ever-closer details for close-up scholarly study transcends even the trained naked eye in normal circumstances. The 19th century art historian's notion of having to actually see the work of art in the flesh before you could speak about it or define its qualities or utilize it for scholarly attributions is as old-fashioned as reading by candlelight. With responsive and reliable sources like museum or auction or scholar specialists able to correctly describe the actual work at hand, and with my further study through high-definition digital images and relevant comparative information, accurate attributions and even authentications are achievable. I have successfully discovered many works of lost art using this modern method.

Small Clues Develop the Big Picture

The printed stencil on the back of the canvas, which I now made out as "Goupil and Co, Artist's Colourmen, 289 Broadway, New York," was an important documentary clue. Goupil was a famous French dealer with a vast network of worldwide galleries during the 19th century, including one in New York, and they sold a wide variety of paintings and art supplies. I could not find information to date the stencil, an essential clue that would lead to the circa dates for the painting. I had volume 2 of Katlan's reference guide to American 19th century art materials, but the stencil was not listed (*American Artists' Materials, Vol. II : A Guide to Stretchers, Panels, Millboards, and Stencil Marks*, Sound View Press, 1992.). Volume 1, the *Suppliers' Directory*, probably held the answer, but it was nowhere to be found, used or new. In fact, it was the rarest of the rare among art reference books, in high demand and very expensively priced. After spending hours calling around the country looking for it—at a time before Google could have found it in seconds—I decided to call Peter Falk, owner and editor-in-chief of Sound View Press, the book's publisher, and fortunately an old colleague. Many

years before, when Peter's best-selling reference book *Who Was Who in American Art* first came out, I called him and asked if I could stock the book in my Santa Fe gallery—on consignment no less. It was not available in bookstores. Graciously, he made a rare exception and sent me several boxes, all of which I sold. When I found Peter again, he graciously went right to the missing book and found the answer. Goupil had been in New York at 289 Broadway only from 1851 to 1853 and then moved on to two other addresses on Broadway, which would have been noted with revised stencils on the canvas. This was vital information. Now I knew that the painting could not have been made earlier than 1851, and in all likelihood was made during the 1851–1853 period, by an American artist probably working in New York who was no doubt at the top of his form. With the specific dates for the Goupil stencil, I recognized that Cole and other possible artists had died before the canvas was stamped. However, the Goupil dates coordinated with Bingham's presence in New York City when he was painting *The Emigration of Daniel Boone*—and *repainting* it after its shocking rejection by his dealer, the American Art Union, with whom he had been successful and long affiliated (their bankruptcy soon afterward may have ultimately caused the rejection). Bingham had quickly found a new dealer—none other than Goupil & Co! I saw the artist's footprints now added to his fingerprints on *Horse Thief*.

Goupil had given Bingham renewed hope and vitality. In 1851, he received commissions from Goupil to paint two subjects of "Western character" which would then be published as lithographs for a popular market. We know that these were *In a Quandary* (depicting riverboatmen playing cards) and *Canvassing for a Vote* (which continued his series of "political paintings.") Bingham was always thinking about the democratic process and had an entire series devoted to political themes, including *Country Politician* and *The Verdict of the People*. At the same time, Goupil also contracted with Bingham to publish a popular lithograph of his painting *The Emigration of Daniel Boone*, the rejected masterpiece which no doubt had been a bitter disappointment to Bingham, both personally and financially. In the process of making a lithograph of *Daniel Boone*, Bingham revised the painting, opening up the landscape into a more spacious middle ground, much like *Horse Thief*. The circumstance suggested that *Horse*

Thief, another painting of "Western character," could plausibly have been a fourth painting commissioned by Goupil or—just as likely—independently made on a Goupil canvas during this period of protean creativity. No Goupil or Bingham record of the creation of *Horse Thief* was found, but the stencil added an importantly convincing document to our Bingham attribution and supported a plausible Goupil provenance and a persuasive time period for the picture.

There were actually two stenciled supplier's marks on the back of the canvas: the *Goupil & Co.* and a very faint one that was at first indecipherable: *G. Rowney & Co., Manufacturers, 51 Rathbone Place, London.* Further research in our Katlan reference showed that Goupil was considered the supplier or retailer, and London-based Rowney represented the manufacturer. Both were known to appear together on American canvases, and and Rowney's dating coordinated with the 1851–1853 period we had for Goupil. Bloch had noted that at least one of Bingham's paintings had a Rowney stencil. Both stencils were preserved in the relining we commissioned. "Relining" is the stabilizing process which adhered new canvas to the back of the old canvas. Our Santa Fe conservator, John Andolsek, skillfully created clear plastic windows so that the stencils and areas of original canvas were still visible after relining.

Unfortunately, because of the pervasive relined condition among virtually all Bingham's paintings in museum collections, it was extremely rare for Bloch to make note of any stencil marks or inscriptions on original canvas because the original canvases were entirely covered over by an archaic glue relining process, which was close to impossible to remove. The heavily cracked condition of the gesso so evident on the back of *Horse Thief* had apparently been a common problem among Bingham's paintings, according to a few rare old conservation reports I had dug up. As it turned out, we learned the majority of Bingham's paintings in museum collections had long ago been badly and irretrievably relined and their surfaces flattened to an extreme extent during the dark ages of the conservation arts and museum practices. Sadly, as heat was involved in this relining process, many paintings, including *Daniel Boone*, which we examined closely at Washington University in St. Louis, had the wove texture of the new canvas backing pressed and imprinted into the paint. Thus retextured, the original

surface of the painting was altered and its surface appearance became adulterated. Few notes had been handed down from the Washington University conservator. *Daniel Boone* was as flat as a pancake with a tweedy texture, definitely a surface not intended by Bingham, who covered his entire canvases with a smooth, invisible brushstroke. *Horse Thief*, on the other hand, was relined with great care by Andolsek and offered a rare pristine surface for further study.

The size of *Horse Thief* was typical for Bingham, as were other details. Bingham's known use over his career included at least nine paintings having our approximately 30 x 36 inches size. This is also consistent with a standard size used by the American Art Union, Bingham's dealer from 1845 to 1851. Oil on canvas was Bingham's usual medium outside of pencil on paper for drawings; he never made a recorded watercolor, gouache, or pastel. A lack of signature was typical for almost 95% of Bingham's paintings. Although he had signed some paintings, he appeared to make random choices. His landscapes, his genre, his portraits, and his history paintings are for the most part unsigned. Famous paintings like *Fur Traders Descending the Missouri, Daniel Boone, The County Election, Jolly Flatboatmen in Port, Washington Crossing the Delaware*, and both versions of *Martial Law* were among those not signed. Who knows why? It certainly was not from lack of pride in his work or lack of artistic ambition or even from absentmindedness. The only reason I can come up with is that Bingham may have taken this fashion from the Old Masters, who rarely signed their work, and whose compositional and drawing practices were a strong guide and inspiration for him. By his 200th birthday in 2011, Bingham himself had become an American Old Master.

According to Bloch's catalogue raisonne, *Horse Thief* had first been mentioned by name in a letter written by artist Matt Hastings to May Simmonds, an early Bingham scholar. Hastings recalled that in a letter to him, Bingham had noted: "the Horse-thief excited much attention in Boston." Matthew Hastings (1834–1919) was an eminent and colorful St. Louis artist and old friend of Bingham, and he was considered by Bloch to be a reliable source. However, no other evidence had ever been found, no reviews or exhibition listings, and no description or image existed. *Horse Thief* was like a ghost painting in the artist's body of work, but Bloch had

held on to its attribution and probable existence throughout two editions of his catalogue of paintings.

The Boston connection to *Horse Thief* was the only supported appearance of the painting. But where in Boston had it been exhibited? From this Boston lead, continuing with Bloch's encyclopedic research, I found evidence that the most probable provenance of *Horse Thief* pointed to Nathaniel Phillips, originally a piano merchant in St. Louis who later moved to Boston. In 1853 Bingham consigned *The Emigration of Daniel Boone* to Philips for the purpose of raffling it off, but instead it was purchased by Philips, who moved his piano business to Boston, where he no doubt exhibited it. In 1890, still living in Boston, Phillips donated *Daniel Boone* to Washington University in St. Louis. The evidence clearly suggested Phillips was also the exhibitor of *Horse Thief* and his Boston piano store was in all likelihood the hidden venue. I later found that *Daniel Boone* and *Horse Thief* had a paired relationship of subject and a similar date of creation, which suggests Bingham and Phillips kept the paintings together. Unfortunately, Bingham did not keep any record of his paintings and both were unsigned. Phillips no doubt hung *Horse Thief* in his piano store in Boston, probably along with *Daniel Boone*, where among his sophisticated trade "the Horse-thief excited much attention." Phillips then would have passed on this news to Bingham in a letter, hence Bingham's comment in an apparently lost letter to Matt Hastings. Bingham was keeping up with *Horse Thief*, and I thought it likely that Phillips returned *Horse Thief* to him. The painting would later prove to have a special importance to Bingham.

❧

Where did *Horse Thief* go after Boston? In all likelihood, it went back to Bingham for a time, but then how did it end up in Dallas? Bloch's research revealed a strong Texas connection, and of course I had found the painting in Dallas. Bingham's daughter and her descendants, and his brother, had lived and homesteaded in Texas during the artist's lifetime. The antiques dealer in Dallas would not give me any information, repeatedly insisting he "could not remember" where he had bought it and then saying he never

disclosed where he bought things. The history of ownership, or provenance, can offer helpful evidence in developing and supporting both the attribution and the authentication of an unsigned painting, but I had to live with this protective veil which was common among art dealers and auctions who, like journalists, most often refused to disclose their sources. The Texas clues suggested by Bloch were the logical trail to follow.

Bloch had discovered that Bingham had actually been in Texas in 1861, 1873, and 1878, and I could assume that he may have brought *Horse Thief* with him as a gift to his family or to sell. Travel to the wild west of Texas or anywhere was never an easy trip, but Bingham was a hardened and very determined traveler with the grit of a Missouri pioneer. Most of the time, leaving his wife and children at home in Missouri, and with a load of canvas and paint, he traveled by stagecoach, boat, horseback, and train from Missouri to Virginia, from Washington to New York, and many cities in between on an endless quest for portrait commissions and opportunities for sales, and he managed to make a decent living.

Bingham's older brother, Matthias Amend Bingham, went to Texas in 1835 and fought as an officer with Sam Houston at the Battle of San Jacinto; he became quartermaster general of the Texas Republic, stayed in close touch with his Missouri family, and later died in Houston in 1861, leaving no recorded family. Bingham went to Houston in 1861 to settle his brother's estate, and again in 1873 to Houston, and then to Austin. He no doubt visited his daughter Clara, who lived in Stephenville, near Dallas, during this period, and he again visited Clara and her family in 1878, a year before his death. Clara Bingham King (Mrs. Thomas Benton King) died at Stephenville, Texas, in 1901, after many years in residence, and she was survived by her husband and eight children, some of whom, according to Bloch, had Bingham's paintings in their possession until 1967. George Bingham King of Stephenville, grandson of the artist, had paintings; Clara King Bowdry, Bingham's granddaughter, also had paintings, and she was living in Fort Worth in 1945 when she shared the Bingham family genealogy with Bloch, who was then just beginning his research on Bingham. And of course I had purchased *Horse Thief* in 1999 from an antiques dealer in the Dallas/Fort Worth metroplex—within 100 miles of Stephenville! No further reliable provenance was uncovered,

but Bingham's Texas family certainly made their previous ownership of *Horse Thief* convincingly circumstantial, even probable. If at some later point the painting descended in the family, then the lack of a signature on *Horse Thief* and no identifying inscription and its untypical subject would not have given a later generation any clue to Bingham's authorship and it probably would have been sold as "unknown artist," as I received it. In my experience, this circumstance is not unusual. Connoisseurship of art, particularly in regard to a family member, is not automatically carried forward like a genetic trait. In fact it is common to find family paintings without any inscriptions or documentation, and especially with family portraits the identity of the sitter and the artist is very often unrecorded and a mystery. Few old paintings carry identifying inscriptions of any kind into the future. Provenance to Bingham's Texas family was the best educated guess. Another important piece of the puzzle had drifted into place.

∾

We were off and running with the early evidence pointing squarely at Bingham, but it remained to be seen if Bingham's authorship could be corroborated with additional documentary evidence that could make his authorship conclusive. I still could not understand what the painting was all about. All the details offered unmistakable genetic clues to Bingham's style, yet the tiny scene depicting the capture of a horse thief seemed just too simple to accept. Why such a sharp step back to the style of Thomas Cole? There had to be a deeper story, a more serious purpose, that could further support Bingham's authorship and bring everything together.

Horse Thief was Bingham's most extravagant landscape, and he was definitely not a frivolous painter. Nor would he have wasted great effort on a very finished work of minor importance. He did paint a number of small facile landscapes of little distinction, which were offered for low prices at the request of the American Art Union, and, as he said, "to keep the pot boiling." *Horse Thief* was definitely not a potboiler. Bingham needed first of all to make a living, but he was also an artist who had steadfast principles and a true and serious belief in American democracy. He could even be classified a Whig politician, a patriot, a no-nonsense Constitutionalist with

an almost religious devotion to the law and high moral principles. He often ran for office and once held an elected position as a Missouri state legislator. Throughout his career, he juggled and managed deep commitments to both art and politics. Why, in *Horse Thief,* would Bingham go to so much trouble painting a masterful landscape and then juxtapose a tiny confusing scene of a prisoner on his way to being hanged, presumably by vigilantes, for stealing horses?

The Horse Thief Who Was Jesus

When I finally sat down to study *Horse Thief*—and it took many months trying to *read* it—I began to fit the surprising pieces together and decipher its coded message. When my eyes did open, the tale of the painting became nothing less than astonishing. An allegorical work of true genius.

⌘

Horse Thief could be an opening scene right out of a John Ford Western movie. It opens with a dramatic landscape of towering rock features, three distant small-scale horsemen with a prisoner on foot traveling through a desolate pass, dark storm clouds threatening, mountains looming in the distance. The scene is unfolding from a high bluff not too far away. You hear thunder rumble, hear the flow of wind, sense the dynamic forces of nature working. Why are these people in the middle of nowhere, and what on earth is going on? The circumstances are a mystery.

Then the camera—in this case our eyes—slowly zooms in for a closer look at the men. The horsemen are bearded and dressed in wide-brimmed hats that sport jaunty blue and white feathers. Two of the men are carrying rifles. They are dressed in a pseudo-military style, wearing red and blue flannel garb commonly found in the Western frontier of late 18th and early 19th century America. They could be vigilantes or bounty hunters or even militia from a frontier town. The horsemen have a captive in tow—hands bound, hatless, and dressed more or less like them. A very close look reveals that the prisoner's head is bleeding. He walks beside them, a slow progress that ominously suggests that they may not go much further with him. Has he walked his last mile? The prisoner's crime is a mystery.

Whether he is guilty or innocent, whatever his crime, he is nevertheless a prisoner. Why is he a prisoner? You start searching for a reason.

Symbolic clues begin to appear. A few steps in front of the prisoner, by the lead horseman, who has stopped, we see a large claw-like piece of deadwood. It clearly resembles a crown of thorns. You wonder if this pitiable man is suggesting a Jesus-like figure? His forehead is bloodstained. Behind him, within the large rock outcropping, a tombstone-like monolith suggests an opened burial vault. Now the symbolism becomes clear and you get it: the prisoner, the horse thief, is meant to suggest Jesus Christ resurrected and on his way to Calvary to be crucified yet again. That's it! The execution of an innocent man is about to be repeated. Presumed horse thieves were routinely hung without trial by jury, with prejudice, and without compassion. Jesus was crucified without a trial for preaching a new religion of compassion. Here, the narrative seems to pause.

Bingham, *Horse Thief*, detail: horsemen, prisoner, crown of thorns, burial cave, Mosaic stone

The horsemen have ridden into a fierce wind. A hat brim bends back, the riders' scarves flutter behind them, small trees sway violently. The wind and the rumbling thunder are the only suggested sounds. The lead horseman has paused and leans forward in his saddle. Nearby, a small quiet pond and a grove of trees come into sharper view. The peaceful oasis with its still

water offers a place for rest and meditation, a possible reflective moment amidst the gathering storm. Is a life-or-death decision about to be made with swift frontier justice? That seems to be the question.

Light from an opening in the clouds puts the leader in sharp focus. The wind is coming right at them. A solitary branch juts out of a dark tree in the grove, into the sight-line of the leader. A possible hanging tree? The prisoner's fate seems to weigh in the balance. The threatening tempest overhead leaves little doubt that a thunderstorm may quickly come on. An observer might think that they are surely going to hang him. All seems to be lost. Is that it? Is this the story?

Bingham, *Horse Thief*, detail: jutting branch, pond, oasis of trees

A Rock That Was Moses

Then another surprising clue appears. Immediately above the lead rider, and also caught in the passing light, an imposing figurative stone rises hauntingly from a mound of earth. Is a vague presence watching them, perhaps overseeing or even judging the events taking place? Suddenly, you realize that the veiled sculpture is standing in judgment of the events about to unfold, a symbolic judgment stone. Then, like a revelation, you see it is more than that. You recognize the iconic figure of Moses holding the stone tablets of the Ten Commandments, a familiar depiction

recognizable to most anyone from biblical prints and paintings. A moral judgment of the situation is clearly being suggested by this looming symbolic presence.

Horse Thief: Burial cave and Mosaic judgment stone

Then the story starts to come together. The Mosaic law and the example of Jesus must apply to the prisoner. You begin to see the implication. Those ancient moral codes represented by Moses and Jesus are the cornerstones of the American code of law, the Constitution, and of course Judeo-Christian morality. And altogether they will offer, or should offer, the final judgment of the prisoner's fate. Guilty or innocent, the prisoner is entitled to a trial by jury. What laws did he break? What laws are in question? Two commandments come to mind. "Thou shalt not kill" reminds the captors not to take a life, and the law, into their own hands. "Thou shalt not steal" could speak to the captive's presumed crime; perhaps he is a horse thief. And fittingly, as the two ideas come together, you might think: *Two wrongs don't make a right.* Even if the prisoner was guilty, he was entitled to justice and a trial, the Constitutional right of every American. Jesus never had a chance to defend himself. Of course! This is clearly an allegory and much more than it seems. Old Testament and New Testament mingle dreamlike and the lessons of Jesus and Moses rise up to guide the viewer into realizing that the United States and the Constitution have incorporated that moral guidance into law.

My eyes keep searching for more clues. I looked to the sky, searching for another sign of hope, and I was taken aback. There in the fantastic storm

cloud at upper right were two distinctly white eye-like puffs looking out by an opening of blue sky, clearly suggesting that the celestial presence of God may be looking down on the men. The two "eyes" are also noticeably reflected on the Mosaic stone—a reminder that the Ten Commandments came from God. And then, continuing to scan the sky, a shocking specter materialized in the cloud. Hard to believe but there it was, another sign, unmistakably—an evocation in the dark clouds of the slain Beast of the Apocalypse. It lay vanquished on its back. The slain beast was forecasting that justice will prevail over injustice, good over evil.

Horse Thief, detail: eyes of God

Horse Thief, detail: slain Beast of Apocalypse on its back

The action has stopped at the oasis. Bingham is doubtless encouraging the viewer—and the men on horseback—to pause and think about the situation, to act judiciously and not too quickly. The future remains a question, but the prisoner is still alive and does not yet have a noose around his neck. He is still on his feet. There is still hope that justice will prevail, that the prisoner will live to offer a defense for his accused crime. A divine edict was unfolding in *Horse Thief*, calling for moral vigilance in that circa-1850 moment and in America's future.

Was this a time of crisis? On America's expanding Western frontier at mid-19th century there was a crisis of lawlessness versus civilization, vigilante justice versus Constitutional justice. The questions, after some reflection, become clear: Would the nation accept lynch law or trial by jury and uphold the Constitution supported by the Judeo-Christian moral code handed down by God, Moses, and Jesus? This was something Bingham held close to his heart. Can lawlessness and morality exist side by side in the United States? What will be the fate of American democracy as the United States expands westward into the untamed wilderness? The questions were all asked in Bingham's painting. Nature in all its divine power hosts—and is even sensitive to—the unfolding events in *Horse Thief*, but human affairs hold the spotlight at center stage. The choice is ours.

I began to see *Horse Thief* as a masterpiece of allegory, of poetic storytelling. The painting's symbolic message artfully alluded to America as a nation of law and democratic process guided by Judeo-Christian moral principles. Yet the painting itself, in spite of the depiction of a tense situation, was not melodramatic; it urged contemplation. The message was veiled and thoughtful and quietly very American in its biblically toned patriotism. It was among the most remarkable paintings I had ever studied, an unparalleled tour de force of storytelling through the brilliant and subtle use of visual metaphor.

This was the story waiting to be recognized in this painted poem, very much a product of the 19th century Romantic period and the idea of the nation's God-sanctioned Manifest Destiny. It required a quiet reading, but once grasped, you had to catch your breath, awed by the masterful achievement. In the 19th century people had the time to think about a painting and a poem, but *Horse Thief* took too much time to understand in the 20th century and

so the painting and its story were missed. Its high quality as a lost work of art and the mystery it presented had urged me to go back and dig deeper.

It was then that I made a commitment to George Caleb Bingham: to continue building his tower of artistic achievement and search for more of his lost paintings. Important evidence continued to develop, pointing to Bingham's artistic motivation to create *Horse Thief*, and I was excited by what else might be discovered.

A Dream of Daniel Boone and a Wrathful Painting by Asher Durand

Bingham used in *Horse Thief* the same unchronological mix of biblical metaphor, the same sense of poetic license as he had first used in *The Emigration of Daniel Boone*—freely mingling in both paintings Old Testament and New Testament, Moses and Jesus, as if in a dream. Audaciously symbolical, *Daniel Boone* alludes to the Old Testament book of "Exodus," to the New Testament flight into Egypt, to Daniel Boone and his wife as the frontier Moses carrying a rifle and the pregnant Virgin Mary on a white horse, to the American pioneers as the reborn Israelites trekking out of the wilderness to the promised land which God has blasted open, parting mountains and forests like a green sea. Judeo-Christian civilization will also be coming along in the West with the help of vigilant hunting dogs and rifles to uphold law and order. Again, Bingham's poetic genius enthralls us.

Bingham, *The Emigration of Daniel Boone*, Washington University, St. Louis

Not only was it clear then that *Daniel Boone* was the allegorical precedent for *Horse Thief,* but it was obvious that the two paintings were very likely linked as intentional and interacting ideas with a related theme and that they were made very close to the same time. In *Daniel Boone* Bingham depicts Boone leading a band of pioneers to the Promised Land of the West. In *Horse Thief,* an allegory necessary to complete the history lesson of Boone's exploration, Bingham reminds us that America's Promised Land has appeared, but being the imperfect beings that we are, it will require a code of law as the first order of a democratic civilization.

Both *Horse Thief* and *Daniel Boone* connect thematically yet again in the early 1850s with Bingham's ongoing series of political paintings which refer to his recurring subject of America as a nation of laws: *The Country Election, Canvassing for a Vote, Stump Speaking,* and *The Voice of the People.* He continued with his political paintings after the Civil War, with *Martial Law*—again with vivid biblical symbolism, now protesting an actual occurrence during the Civil War: the lawlessness of military justice in the lack of compassion and mercy toward civilians on the part of the Union army, in spite of the fact that the civilian was solidly with the Union cause. And with *The Puzzled Witness,* suggesting ironically that the law in its complexity has become too confusing for ordinary people to understand. I could now appreciate that *Horse Thief* was a lost cornerstone in Bingham's dedicated series of related political paintings that merged his Western-themed paintings with his political ones.

Some years later a significant new clue appeared that probably motivated the creation of *Horse Thief.* The clue unexpectedly emerged with a shockingly untypical painting that I noticed by Bingham's contemporary Asher B. Durand, *God's Judgment upon Gog* (Chrysler Museum of Art). *God's Judgment* was an all-out melodramatic Old Testament allegory with many relationships to *Horse Thief,* including the fact that both paintings were strikingly unique for each artist. With Durand's *God's Judgment* as evidence coming from the same time and place, I could imagine that in all likelihood it had been an additional catalyst to the making of *Horse Thief.* Since Bingham was in New York during the same time period that Durand's *God's Judgment* was exhibited, I can assume that Bingham had heard about and seen the painting at some point and felt it personally

imperative to respond in kind. Durand was one of the most successful painters in America and an influential and powerful presence in New York as president of the National Academy of Design.

Asher B. Durand, *God's Judgment upon Gog*

Durand's painting, officially exhibited in 1852 in New York at the National Academy of Design, was probably seen by Bingham at some point during the revision of *Daniel Boone*, when he was reworking the rejected painting and had begun painting new works. The artists were probably acquainted through their shared representation by the American Art Union. If Durand, the esteemed artist, dared to paint a biblical allegory (his only one, as it turned out) which closely imitated Thomas Cole, there was nothing holding Bingham back from doing likewise but with a superior idea. The Bible was a book Bingham had deeply studied, and Durand's *God's Judgment* would not only have been an obvious challenge to surpass but would have brought strong disagreement with Bingham's deeply

humanistic beliefs. The point-counterpoint comparativeness of the two uncharacteristic paintings—with their sharply contrasting biblical and Cole-like allegories—strongly suggests that Durand's painting spurred a competitive spirit of one-upmanship in Bingham. In addition, Bingham had first used biblical symbolism before Durand in *Daniel Boone*. Durand's painting pointed to God's vengeful rage at its worst while Bingham's theme in "Horse Thief" suggested God's and man's higher judgment. For Bingham, the wrath of God represented vigilantism and that lawless message had to be countered with one of judgment representing the rule of law. The tiny figure of Durand's God would be replaced almost exactly by Bingham's Mosaic judgment stone. *Horse Thief* had not just come out of the blue as a pendant to *Daniel Boone*. While Durand chose the wrath of God as his message and histrionic literalness on a large scale as his approach, Bingham took a more subtle, intellectual, and symbolic approach on a smaller scale and transformed *Horse Thief* into a moralistic and patriotic statement of much greater artistry. The United States was a nation of laws and not a theocracy, as Durand appeared to be preaching. That idea was antithetical in the extreme to Bingham's philosophy and he would not allow it to stand unopposed. Ironically, *Horse Thief* was a letter Bingham never sent: to the Academy, to Durand, or to the public.

Another painting by Durand had made an early appearance in the *Horse Thief* story. One of the first things I had to do was to understand what I was looking at, which took months of back and forth, and then to question its logic as a Bingham. Where to begin? Along the way for a period of time, the scene in *Horse Thief* had suggested a well-known Revolutionary War incident, the capture of Major Andre by three militia men, and Asher Durand's famous 1845 painting *The Capture of Major Andre* and the widely distributed print of it. Andre was an aristocratic spy for the British, based in Washington as a diplomat, but he was in league with the traitorous American general Benedict Arnold. Andre was caught, tried by a military court, and hanged. Durand's print, which Bingham probably saw because they both had the American Art Union as their publisher, depicted Andre with his boots off to prevent escape and guarded by three militiamen; the barefoot Andre was a key detail that people recognized from the widely circulated

story. The prisoner in *Horse Thief* was not bootless, a clear distinction. Although a close idea, the Major Andre subject and Durand as the artist were eliminated, yet I still suspected its influence on our painting.

The theft of horses and vigilantism was another influence on the painting of *Horse Thief*. Both were major problems on America's Western frontier in Bingham's time and particularly in his home state of Missouri. Bingham had always been guided by a strong moral code, ideals carried forward from his youth in Arrow Rock, when he considered careers as a preacher and as a lawyer while apprenticing in the workshops of several nearby furniture craftsmen. I can readily theorize that the exacting wood craftsmanship required of Bingham in his formative years transformed into his meticulous style of painting seen in the geometric construction of landscape and the sculptural figuration generally found in his body of work.

Bingham was probably aware of the Anti Horse Thief Association—a developing vigilante group that was officially founded by pioneer farmer David McKee in Luray, Missouri in 1854, and later spread to Kansas and the Indian Territories. McKee declared that his organization differed from lawless vigilantes who too quickly resorted to lynch law, stating that the purpose of the Anti Horse Thief Association was "not to hang thieves, but to prevent criminality." Records of the AHTA show that one of the Mosaic Ten Commandments, "Thou shalt not steal," was a motto used under the masthead of their official newspaper as late as 1901. The Anti Horse Thief Association was generally known for effective law enforcement and for following a moralistic and legal path to justice. Responding to this crisis in law and order, *Horse Thief* poses one of the important questions of the early 1850s in Missouri: lynch law or trail by jury?

<div align="center">⚬∞⚬</div>

A treasure of comparative details awaited with Block's catalogue raisonne of Bingham's drawings. With Bingham's drawings to support *Horse Thief*, the case for his authorship became doubly assured: signed, sealed, and delivered. It was astonishing to see his genius for modeling at work.

Bloch's book reproduced the drawings exactly to scale, which demonstrated Bingham's ingenuity in their brilliant and evolved transference or tracing close to exactly into *Horse Thief*. It was not a lesson in copying but a course in Bingham's creative imagination: a small mounted horseman in a drawing became three small vigilantes in the painting; two drawings of Jesus became the prisoner; a drawing of an overcoat changed into the Mosaic stone with the Ten Commandments; a drawing with a group of rocks developed into the architecture of a rocky bluff. The signature comparative detail of a drawing can be the parent of an offspring in the painting, and, like a child, it is not always exactly what you expect as it matures. When I first reviewed Bingham's drawings, only the horseman suggested I was on the right track. Then, encouraged to look again, my imagination began the secondary process of going beyond the literalness of tunnel vision.

⁓

Bingham's standard practice, which Bloch discovered, was the transference of model drawings into his paintings. Bloch's catalogue illustrated all the artist's known drawings, which were primarily figurative, and the figures were reproduced in the book in the actual size of their reappearance in the paintings, about 10 x 8 inches. Bingham had used the majority of his drawings as perfectly scaled models, which he transferred and maneuvered using different techniques and imaginative skill into his paintings. The effectiveness of this clever reorganization of the drawings was astonishing. Almost no drawing effort was wasted. It was rare to find the figurative model for a painting that was not used, and sometimes they were used more than once. There were men of many types: men sitting and standing and reclining; men smoking a pipe or playing cards or whittling; men with moody expressions. There were a few boys in the mix but no women to speak of. Here and there we find a sketchy nonspecific landscape, a dog, a cow, a female nude, a religious subject. Bingham was all business and wasted little effort on idle drawing pursuits. His method was to utilize and cobble with great craftsmanship what he had among his repertory of drawings. His drawings were like blueprints, probably much like the model drawings he made and used as an apprentice for crafting

furniture. Unless the drawings for *Horse Thief* were lost, I felt something would materialize, but they were not easy to discover.

Bingham's Drawings Authenticate the Painting

Finally, after several reviews of all the drawings, five seemingly minor drawings lit up which suggested models for major details of *Horse Thief*: the mounted horsemen, the Mosaic judgment stone, the captive (two drawings), the rock towers. Before I could be certain, however, the drawings required interpretation. Would it have made sense for Bingham to use them as I imagined? Could they really have been used as model drawings?

A small drawing of a single horse and rider was the first and most logical consideration. It was wedged into a larger sheet of drawings and close to identical in size to the painted figures of horsemen in *Horse Thief*. The close relationship to the three diminutive riders and their horses was suddenly apparent.

Bingham: drawing of horse and rider

Bingham, *Horse Thief*: detail horses and riders

The drawing depicts a bearded man wearing a wide-brimmed hat riding a horse wearing an unusual breast collar, a detail commonly used by Bingham in his rendering of horses. All of the details in the drawing are repeated in the three riders in *Horse Thief*, and the lead horse clearly repeats the breast collar, with its sketchy suggestion in the other two horses. Slight differences in poses of the men and horses and small added details like hat feathers, rifles, and scarves would have developed imaginatively to fit the movement and characterization of the horsemen in the painting. None of the painted horsemen exactly copied the pose of the model drawing but instead were slightly innovative variations of it. The horsemen in *Horse Thief*, in both scale and figurative details, were the most closely related use of this small drawing in *any* painting by Bingham. The drawing stands as the unique example among Bingham's drawings of a man on horseback or even a single horse, both subjects treated many times in varying scale in his paintings. The small size itself matched Bloch's studied calculations for the comparative differences in Bingham's drawing-to-painting transference. There could be little doubt we had our first connection among the drawings, a signature comparative detail.

In a eureka moment, the next drawing that came into view was, of all things, an overcoat hanging on a peg. An astonishing connection, but there it was. Bingham had cleverly transformed the coat, folds and all, into the Mosaic judgment stone. The comparison was remarkably clear.

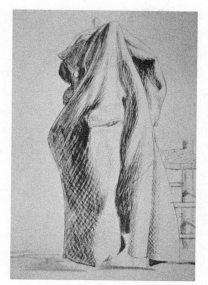

Bingham drawing: *Overcoat*

Horse Thief: Mosaic judgment stone

This evocative drawing of an overcoat or greatcoat is the most abstract of all Bingham's drawings and his only drawing of so-called drapery, and it had found only token realization as a coat in the dark background of *County Politician* (ca. 1849), where Bloch had noted its only application. Transferred into *Horse Thief*, the mysterious shrouded shape clearly found its fated and more important use as the symbolic figure of Moses holding the Ten Commandments. The highly innovative experiment Bingham carried out in *Horse Thief* was exemplified by this drawing and helped me to gain valuable insight into his creative process. Bingham's imagination was on fire here, and he would fill the painting with symbolic imagery, a metaphorical tour de force that, once recognized, would show his full genius as an artist. The drawing's abstract figurative shape, its rock-like fissures, its surface shadowplay, had been recycled and evolved incredibly as a mysteriously shaped stone that evoked Judeo-Christian morality. In one of several cogent details, the draped jutting knob which holds the hanging coat finds its transference in the unusual head rising on the shoulders of the stone.

As if appearing out of the fog, two more drawings suddenly connected to the painting: Bingham's large sketch, *Preliminary Study of Christ*, and another much smaller sketch of the identical study of Christ in another

sheet. They closely related figuratively and subjectively to each other and to the Christ-like prisoner in *Horse Thief* and proportionately with the smaller drawing, and finally to the further development of Judeo-Christian iconography in the picture. The figurative shape of Christ in both drawings clearly pointed to their transformation into the prisoner in the painting. The association was undeniable. The horse thief was meant to represent Jesus Christ on his path to being crucified or, as Bingham hoped, to a fair trial.

Horse Thief: prisoner

Bingham: small drawing of Christ as a prisoner

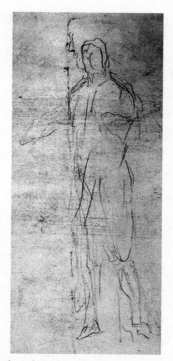

Bingham: large drawing of Christ as a prisoner

The one-inch variation between the small Christ sketch and *Horse Thief*'s prisoner was compatible with Bingham's standard practice, and the prisoner's Christ-like persona offered an appropriate idea and image for the moralistic narrative of *Horse Thief*. My conclusion was that the prisoner depicted in *Horse Thief* was the only plausible use in a painting by Bingham of his model drawings of Christ. The larger one may have come first, probably held in reserve for future use, then came the smaller figure once *Horse Thief* was materializing. The thematic connection to *Horse Thief* was perfect. Nothing else in Bingham's oeuvre came close.

Finally, a finished landscape detail, unique in Bingham's drawings, became apparent and its integration into *Horse Thief* yet another instance of Bingham's inspired use of his model drawings. An area of carefully drawn and cleanly fractured large rocks is depicted with a reclining figure in the drawing *Fisherman Waiting for a Bite*, a study for the painting *Fishing in the Mississippi*, which coincidentally shared with *Horse Thief*

its circa 1851 date and canvas size. While the rocks in the drawing clearly conform to a grouping in the *Fishing* painting, an advanced use of the drawing became obvious in the closely related building-block architectonic quality of the rock towers in *Horse Thief*. The varied rocks in the drawing replicated the proportional size and shape of various sections of the rock towers and other large rock features in *Horse Thief*. In support of this modeling practice in Bingham's additional mountainous landscapes, the exact same type of rock building blocks appear in many Bingham paintings. It was astonishing to see the artist's economy of means put to such brilliant, inventive practice. It fit Bingham perfectly.

Bingham drawing: fisherman & rocks

Horse Thief: rock towers detail

With Bingham's preparatory drawings for *Horse Thief* so conclusively connected to the painting, no further evidence was needed to prove Bingham's authorship.

To prove or to disprove authorship of a lost work of art with evidence of signature comparative details: that was the quest in the pursuit of connoisseurship in art. And here now was *Horse Thief,* hidden away and long asleep like a sleeping beauty fairy tale, a work of art awakened by an embracing response to its splendid artistic quality and its mystery. But my search for the lost art of George Caleb Bingham was far from over.

The Bingham Catalogue Raisonne Supplement Is Established

I believed more lost works by Bingham would probably come to light. No one had stepped up to the job of discovery, which had been vacant since Bloch's death in 1989. There was no process of authentication and no one to judge.

If I could accept Bloch's scholarship and, when necessary, question it or add my own, and *if* I could equal Bloch's connoisseurship and add new discoveries, and *if* I were willing to accept the responsibility of authenticating lost works by Bingham, then, and only then, might I consider stepping into Bloch's shoes and continuing his work. I gave that challenging question serious consideration and finally answered affirmatively. My study of *Horse Thief* had brought the entirety of Bingham scholarship and his body of work into an intimate association. I was ready.

Thus I began to establish the *George Caleb Bingham Catalogue Raisonne Supplement of Paintings and Drawings,* with the confidence of my long experience successfully identifying lost art and most importantly having faith in my eye, which was now sensitized to Bingham's styles and to his thinking. Bingham scholar and biographer Paul Nagel urged me on. He was the first to serve on the advisory board, which would judge my (hopefully) future discoveries. Soon Nagel was joined by an amazing generalist scholar, a man named William Kloss, a distinguished Washington, DC, art historian, connoisseur, and author, who has anchored the Bingham advisory board from its beginning to the present day.

Bloch's catalogues of Bingham's paintings and drawings had laid out a clear course of study using the skill of a dedicated scholar immersed in his life's work. His catalogues were exceptional teaching tools in their expository clarity of description and detail. Bloch had built such a solid scholarly edifice for Bingham that could only be added to and rarely needed revision. Thanks to Bloch's eye and scholarship, Bingham's genius now had a golden frame around it. Bloch had done all the ground work, and any further expansion of his catalogue raisonne had to be built on his shoulders. Alas, now departed, Professor Bloch could not supply the essential expert "eye" needed for authenticating new discoveries, but with his books and the actual paintings to be studied in museums, Bloch and Bingham could still teach a willing and enthusiastic student.

Bloch had already described an astonishing 460 Bingham portraits in existence, and he had located some 240, most of them illustrated in his catalogue. The illustrated genre and landscape paintings came to 55, with many more hinted at and unlocated. I determined 50 to 100 additional lost works may still be hiding. Many more portraits than genre scenes could be expected.

Bingham's body of portraits traditionally stood secondary to his genre—narratives—and there had been no exclusive exhibitions for them, though many were outstanding examples of 19th century American portraiture. The combined portraits, as they stood, offered an extraordinary if not singular view of 19th century Missouri pioneers, many of them coming through time with genealogies and stories of human interest. No other state had an artist like Bingham, whose democratic eye included so many people from every level of society, including President John Quincy Adams and Senator Daniel Webster, as well as a uniquely illustrative gathering of anonymous Western pioneers. Bingham had compiled an historic regional biography that quietly waited in the wings to be written. No wonder in his own lifetime Bingham was famous as "the Missouri Artist."

Bloch's own pioneering work was magnificently executed, but I could see there was still more to be accomplished. I gathered all the published books on Bingham and traveled to museums to see the actual paintings with the goal of becoming a Bingham specialist, a connoisseur of his body of work.

In 2005, I began the publicly accessible online Bingham catalogue raisonne supplement with the first addition of *Horse Thief.* I launched the catalogue with the enthusiastic encouragement from my dear friend and Bingham biographer, the late American historian Paul Nagel, who, during his incredible life, had written biographies of John Quincy Adams, Robert E. Lee, and the notable women of the Adams family. On the occasion of the publication of Nagel's biography—he himself a native Missourian—*George Caleb Bingham: Missouri's Famed Painter and Forgotten Politician* (University of Missouri Press, 2005), which prominently included the discovery of *Horse Thief,* the painting was exhibited at the State Historical Society of Missouri in the company of their rich collection of Bingham's paintings, and I was invited to speak about its discovery.

Ten years later, I would look with some pride at our addition of twenty-six paintings to Bingham's achievement, an unprecedented addition to the body of work of a major American artist: four genre and landscape; two portrait genre (portraits that characterize the sitter within a distinctive category); and twenty portraits of men and women, most of them Missourians. Surprisingly, none of the paintings were known to Bloch nor specifically recorded and, as expected, none were signed. As I anticipated, a fresh new direction to Bingham had opened up, and I knew that still more undiscovered works were still floating by on the river of art.

Fred R. Kline, Director & Editor

GEORGE CALEB BINGHAM
Catalogue Raisonné Supplement of Paintings & Drawings

November 2012

Cover of *Bingham Catalogue Raisonne Supplement,* in progress

I initiated public awareness by advertising the new Bingham catalogue project; I think it was the first online catalogue raisonne for any artist, and it offered free public access to anyone, straightforward inquires and replies, and the ongoing development of new works. Little by little inquiries were emailed to me; most were merely hopeful attributions, but reassuringly a smaller number would prove authentic. Some of the portraits had remained in the families of the sitters or had come from dealer's inventories, most with a hint at Bingham's authorship—and all awaited authentication.

Other Bingham portraits and genre would appear here and there at public auction vaguely identified as "unknown artist" or "American school," and I discovered them by chance, and luckily I was able to purchase them. I saw this as nothing less than a miraculous opportunity. This may raise a question among academics about the mingling of scholarship and commerce, but the answer is simply one of common sense, and clearly my answer is: if you have the expertise to recognize a lost art treasure and could fairly buy it, it would be foolish and irresponsible to let it go back to its wandering journey as an unknown and worthless orphan.

One case in point, a purchase of mine at auction, involved a major museum's ill-advised deaccession of Bingham's rare early portrait of Missouri riverboat captain Joseph Kinney. It was offered carelessly as simply "American school," yet it had been in the museum's storehouse for years—remarkably with Bloch's attribution to Bingham! Bingham's authorship of the portrait was undeniable. My normal procedure, after many hours of further research and development—including in every case an investment in conservation—was straightforward: I hoped to sell the painting to a collector or museum, and possibly make a profit. Common sense. In the case of the Kinney portrait, it succeeded particularly well on all counts, going back to Missouri to a historically minded collector who would hang in it his grand Antebellum family home in Missouri near Capt. Kinney's restored estate in New Franklin, where it had originally hung. Bingham's portraits tend to have a homing instinct, and I remained sensitive to it.

Riverboat Captain Joseph Kinney (1810–1892) was portrayed by Bingham in 1839 as a young man poised for a bright future ahead.

George Caleb Bingham, *Capt. Joseph Kinney*, 1839. Collection of Blaine and Stephanie McBurney

In his career, Joseph Kinney built, captained, and operated eleven classic steamboats on the Missouri and Mississippi Rivers. A close associate described him as "The most daring, the most resourceful, and the most successful of all Missouri river captains." As I mentioned, I had recognized and purchased the portrait in an auction knowing it was Bingham from my study of his portraits in Bloch's catalogue, and then I went searching in the catalogue for something comparative to doubly confirm the point and to help date it. I knew Bingham often painted the same person twice with intervals of many years. The exact portrait I had was amazingly there in the catalogue but cautiously identified as *Portrait of a Man* (possibly Capt. Joseph Kinney)." This was a little confusing, because another Bingham portrait of Kinney was in the catalogue, fully identified as Kinney but made about thirty-five years later, when his face had obviously changed somewhat with aging. I carefully compared the facial structure in both portraits and in several photographs of Kinney, which were probably unavailable to Bloch. It was the same Joseph Kinney without a doubt. Bloch had somehow felt unsure about the positive identification of the younger Kinney, but he left intact the best suggestion and he was right.

As both an art dealer and an art historian, I might offer further insight and justification of my Bingham purchases and of my purchases of lost art in general—a conflict of interest only if dishonesty in one form or another rears its ugly head. Art joined to commerce is not a secret marriage. The pursuit of art at its best is a labor of love, but, any way you look at it, it is also a business. Without the business end, art will fall short and break down as a cultural force. The phenomenally inflated prices we see today across the art market, particularly in the area of contemporary art, may serve to commodify art to a point beyond rare and beautiful to mere fashion. In any case, I prefer the historic areas of art where the ideas of "rare and beautiful" will, I hope, continue to support the larger idea of quality and where time has told a more reliable story. Judgment of the present is difficult.

Scientists, entrepreneurs developing new ideas, writers and poets and artists of all kinds, inventors, explorers of every known and unknown subject, all creative people working away on research and experimental ventures of one kind or another strive for new discoveries in their quests. Often they have twin goals: a dream of progress that will advance civilization, and hope and intention to profit in myriad ways—including financially—if their work proves successful. Many creative people work independently, and I was no exception. No museum or university was paying me or covering my expenses to study Bingham. I had chosen to be an independent thinker, to work without being stymied by Machiavellian art politics and "correct" thinking. The process and progress of the Bingham catalogue continued.

As the years passed, Bingham masterpieces emerged. In 2011, a knowledgeable collector suggested that a genre scene in her collection, *Young Fisherman, Hudson River Palisades*, (as I later titled it), could be a Bingham—it was not for sale but awaiting authentication—which I provided at no charge, avoiding a conflict of interest when I believe a work to be by Bingham. In 2012, another genre scene, *Baiting the Hook*, appeared at auction as "American school," with a tepid suggestion of Bingham, and I purchased it. Both works were added the *Catalogue Raisonne Supplement*, and they became integral and indispensable additions to Bingham's series of River paintings: *Baiting the Hook*—Bingham's first river-themed

painting, and *Young Fisherman, Hudson River Palisades*—Bingham's last river-themed work and his only known Hudson River school painting. I was astonished.

George Caleb Bingham, *Baiting the Hook* (Colin Dunlop), 1841. Private Collection

George Caleb Bingham, *Young Fisherman, Hudson River Palisades*, 1855, Collection, Renee duPont Harrison and Mason H. Drake, Chicago

The two portrait genres that appeared in 2008 and 2010 were also masterpieces. *Portrait of Lt. Col. Levi Pritchard*, a full length, life-size depiction of a heroic Missouri Civil War officer in full dress uniform painted during the war, was also Bingham's largest portrait (79 x 32 inches). It came to me with the sitter identified and with Bingham suggested by the collector, who was also a happened to be war hero, a U. S. Marine who had been seriously wounded in action in Vietnam rescuing his comrades and ultimately won the Silver Star. He had purchased it in a New Jersey antique shop and awaited authentication.

George Caleb Bingham, *Lt. Col. Levi Pritchard*, 1862. Private Collection, New Jersey

Colin Dunlap and His Dog came along in 2010 from the Commonwealth of Virginia. It had hung misattributed for decades in the governor's mansion, with only a recent suggestion that it may be Bingham. It was a

stunning addition to the classic "boy and his dog" genre, destined to become an iconic example in American art history. A dedicated group in Virginia has yet to discover the name of Colin's unforgettable dog.

George Caleb Bingham, *Colin Dunlop and His Dog*, 1841, State of Virginia

Bingham painted in Petersburg, Virginia, for six months in 1841, and there he twice painted young Colin (see *Baiting the Hook*), a boy of five or six from an established family whose presence he captured in a tranquil summer of the antebellum South. With both paintings of Colin, I was reminded of Twain's Tom Sawyer. The paintings forecast scenes of rural life that might have stepped from Twain's book, published decades after Bingham's portraits. Dunlop was a year younger than Mark Twain, both children of the time in different states sharing many similar experiences. For 175 years, the two paintings of Colin, which were now in the new catalogue, had not been credited to Bingham and thus were lost to the visual treasury of art history.

Colin Dunlop (1836–1864) grew up and went to Texas as young man to become a cowboy. During the Civil War he joined the Texas 6th Infantry, allied with the Confederacy. In 1863, he was taken captive by Union forces, then

paroled because of illness. He later rejoined the Texas 6th and was with them at the Battle of Jonesboro, where he was killed. He is buried in the Confederate cemetery in Jonesboro, Georgia, in one of a thousand unmarked graves.

❧

Now familiar with Bingham's life and work, I saw again a striking portrait of a man in a small auction I was reviewing on the Internet. I purchased it. It was not signed, in good condition, and credited to the "American school." I immediately recognized the painting as one of Bingham's earliest portraits, circa 1834–1835, the period when the artist was just starting his Missouri career in Arrow Rock and Columbia and when his self-taught style of portraiture was being developed—carefully crafted like carved wood and modeled somewhat sculpturally yet aware and alive to the moment. The early portraits were dramatic and memorable, and they stood out as brilliantly innovative and unique among American artists, whose work he hardly knew. The early portraits were a giant step up from the naïve folk artists of the period. Bingham's youthful years as an apprentice to furniture makers translated seamlessly into his careful and geometric crafting of oil on canvas, into genre scenes as well as portraits. After reviewing the comparative portraits from the 1834–1835 period in Bloch's illustrated catalogue, I could see I had discovered a rare example of Bingham's early genius. I felt the man's identity would be coming along soon, with more research.

It was at this point in time that Bingham had first met and painted a portrait of his lifelong friend and benefactor attorney James Rollins of Columbia, who would go on to become one of the most distinguished lawyers and politicians of 19th century Missouri. At the beginning of Bingham's career in 1834, Rollins graciously introduced the young artist to a wide circle of his influential family and friends, who in turn commissioned portraits and spread the word about the phenomenal 24-year-old Bingham. He was off and running with a big push from Rollins, who first recognized Bingham's genius as an artist.

In 1837, Bingham painted his first genre portrait, a life-sized depiction of Rollins's 12-year-old sister, Sarah Helen Rollins, who was visiting from Kentucky. No doubt eager to impress his best friend and patron, who insisted on the commission, Bingham pushed his talent into a new realm of

distinctive characterization and created a classic image, a masterpiece depicting a fashionable girl of the early Western frontier dressed head to toe in her Sunday best carrying a favorite book, itself symbolic of the importance of education. The portrait led directly into Bingham's genre classics of the American scene for which he best known. *Portrait of Sarah Helen Rollins*, age 12, became a significant turning point in Bingham's career.

Bloch had seen "Miss Sarah" only in an old black-and-white photograph, but he could see its quality and knew its provenance with the Rollins family and catalogued it without hesitation. Sometimes these black-and-white reproductions were all that he was given to work with. With the blessings of Sarah's descendants, we took on the mission to have it conserved after 175 years and were able to publish it, cleaned and in color, and finally to develop its transitional importance as a milestone in Bingham's career for the first time. The painting still has not been publicly exhibited in a museum and is now in a private collection.

George Caleb Bingham, *Sarah Helen Rollins*, 1837
Private Collection, Courtesy Rachael Cozad Fine Art, Kansas City

Now I was back to thinking about the unknown man in the 1834–1835 portrait I happened upon in the auction. He was likely also affiliated with Columbia and a friend of James Rollins. I set about trying to identify him, using a photograph of the painting for easy desktop reference with the real picture hanging nearby. I was drawn to the man, noticeably so to his intense eyes, which had an unusually alert and intelligent appearance. There was something special about him. He was posed with his head slightly turned to the right, yet his eyes were oddly, nervously, looking left as if distracted and planning his next move. He was in a hurry. In all of Bingham's early portraits, this anomaly never reoccurred. It was an unusually skillful and innovative characterization using just a slight movement of the eyes that suggested the man's restless energy. Since he probably would not sit still and look straight ahead like most people would when sitting for a portrait, Bingham decided not to fake a calm the man did not have.

I knew from working with the portrait of Capt. Joseph Kinney that Bingham often painted the same person twice, and I searched through Bloch's catalogue for a resemblance in later portraits. Finally, I found him—in the same pose twenty years later! In the blink of an eye, like Kinney, he had first appeared young and then older. The comparative study left no doubt it was the same man, but now his eyes had a steady gaze. The match-up was a circa 1855–1856 portrait of Frederick Moss Prewitt (1799–1871) in the collection of the Nelson-Atkins Museum in Kansas City.

George Caleb Bingham, *Frederick Moss Prewitt*, 1834– 1835. Collection, family of Frederick Moss Prewitt

George Caleb Bingham, *Frederick Moss Prewitt*, ca. 1855–1856. Nelson-Atkins Museum of Art, Kansas City

I now knew the man to be Moss Prewitt, and he had come a long way since the early portrait. By the time of the later portrait, Prewitt had pioneered Missouri's first national bank and become one of the richest men in the state, and, like Rollins, he became one of the founders of the University of Missouri, among a multitude of other accomplishments. After conservation, this younger portrait of Prewitt was in museum-quality condition. This was my standard procedure for all old paintings. I wanted them hanging at long last identified, in their best suit, and never again to be a lost and impoverished orphan. This was a wonderfully ironic twist of fate in the case of Prewitt, a millionaire banker, who actually had humble frontier origins, close to the time of the early portrait, as an enterprising hatter in Franklin, Missouri, supplying the first wave of traders embarking on the Santa Fe Trail.

Using the clues at hand, I was thrilled to discover, after a bit of research, a group of identified Prewitt descendants, alumni of the University of Missouri, who were featured in a photograph at an annual alumni gathering. My mission was clear: I had to return the portrait to the family. I located one of Prewitt's great-great-granddaughters, Christie Koonse, a journalist and fundraiser in Denver, Colorado, who was elated to hear about the portrait, and she offered a wealth of genealogical information. Unfortunately, she was not in the market to buy a fairly priced, but still relatively expensive, family portrait. I urged her to pull together a group of Prewitt relatives to pool their resources and purchase the portrait, which she accomplished by and by. Besides Christie, the group included her sister Julie Koonse Sturm, a pastry chef in Overland Park, Kansas; her brother Randy Koonse, an English teacher and actor working at a U.S. Army base in South Korea; and Missouri cousins Susie Koonse Fiegel and Steven Koonse. Together they formed a consortium and bought the portrait with dedicated enthusiasm and made me feel like an honorary member of the family. They would later proudly organize many exhibitions of the portrait around Missouri. Years after the sale, Randy Koonse, who was acting in A. R. Gurney's play *Love Letters* at Yongsan Army base in South Korea, wrote to inform me: "We needed something on the wall of the set that looked old and family, so Moss Prewitt was the perfect choice." Perfect indeed: Randy had a haunting

resemblance to his great-great grandfather, which he had not realized before the portrait came into his life.

Actor Randy Koonse on the set of *Love Letters* with a copy of the family's Prewitt portrait
(courtesy, Randy Koonse)

With the Koonse family experience, the meaning and rewards of art gained a depth I had not suspected. The lost portrait of Moss Prewitt, their legendary patriarch, had come back to the bosom of his family, and it was evident that he had been missed. It was a double reward for me. This experience and more to come with Bingham's lost portraits brought with their appearance an unsuspected epiphany. Suddenly another human face was added to a family's history and, in this case, to Missouri's early history as well. Bingham's portraits had become amazing catalysts for celebration. I could only wonder at some people who may think art is a frivolous pursuit with benefit only to the privileged, or that a lost portrait of someone's lost ancestor spoke little truth in the more important run of things. And I wonder at myself that I didn't expect to see, and probably Bingham did not expect to see, such poetry manifest among his hundreds of portraits generations later.

For two other long-separated Bingham portraits, there was a love story of a handsome man and a beautiful woman: Lewis Allen Dicken ("LAD") Crenshaw (1820–1884) and his wife, Fanny Smith Crenshaw (1841–1919), both pioneer-citizens of historical importance to Springfield, Missouri. Both portraits were exquisite examples of Bingham's portraiture that could shine alongside the best of his era: Samuel F. B. Morse, Chester Harding, Charles Loring Elliot, and Daniel Huntington among them.

News came first of LAD's portrait being offered for sale by a great-great-grandson, and I took the painting on consignment, agreeing to put broken frame and tattered painting into museum-quality condition, necessarily at my expense. They informed me that Fanny's portrait had been donated to the Springfield Museum of Art many years before by Clara Crenshaw Early, Fanny's daughter. In a gifting note to Clara, Fanny had said that the portrait was painted by their friend, Bingham. Then I was shocked to learn that *Fanny* had always been locked away in storage with questioned Bingham authorship. Once I saw it, my authentication came quickly.

When I realized there were two magnificent Bingham portraits of a husband and wife that had been painted to celebrate their marriage, and then the bride and groom had subsequently been separated for more than a hundred years, Jann and I were emotionally affected, I must admit.

Again I felt compelled to be a matchmaker. You might think I should have had more important things to be concerned with, but you would be wrong. What is a knight errant good for if romantic ideals cannot be part of his wandering quest in search of a chivalrous adventure? For me, the search for lost art in America has always been wrapped in the romance of personal mythology, and I am not above putting chivalry above profit and following my heart. Jann never said I was being irresponsible putting more urgent things aside and neglecting business. She had an unshakable romantic spirit and of course loved my suggestion of reuniting the lovers' portraits, since the two of us had also been lovers reunited after twenty-two years. The poetic echo was too personal to ignore.

In a practical sense, we spent time and money on what was to become a relatively expensive project offering a small return, and it took thirteen years before we were successful. It was not about money really. Bingham's great portrait of LAD and its magnificent original frame—exactly like

Fanny's—needed expensive restoration, and it was imperative that we go ahead with it. Come hell or high water, they *would* be reunited. Art and romance and commerce had to come together. The museum would have to buy LAD's portrait, since a donation from the owners was not possible nor could they afford the necessary restorations before the painting could in fact be sold or exhibited. So I took it on, as befitting my new role as guardian of Bingham's legacy.

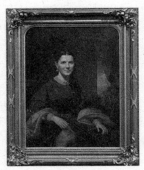

George Caleb Bingham, *Fanny Smith Crenshaw*, 1867–1869,
Springfield Museum of Art, Springfield, Missouri

The Springfield museum director—now long gone—told me that historical art really didn't have a place in their museum, and he preferred exhibitions of a more general community interest, like contemporary watercolors and school art projects. I was speechless except for politely questioning his competence as a museum director who had no interest in either Bingham, whom he had vaguely recollected, or American art history, and history specifically in relation to Springfield to boot. Fanny's portrait, he informed me, would remain stored away for the foreseeable future. Good grief, these portraits could have hung with no apology in the Metropolitan Museum of Art!

It was a pity that neither the Springfield museum nor the newspaper found the story of reuniting the couple as compelling as I did. LAD's obituary from the 19th century *Springfield Daily Herald* reads like the summary of a fascinating novel: "L.A.D. Crenshaw, one of Greene County's oldest and most honored citizens, spent his early youth in Tennessee and was known to have been a quite young Deputy Constable. Son of William

Tate Crenshaw and Susannah Ward Crenshaw. Early settler of Greene County MO and Springfield ca. 1841–1843. Mississippi River trader with his father. Based in New Orleans 1843–1844. Second Clerk on steamer 'Republic' between New Orleans and Shreveport in the Red River trade on the Mississippi. Clerk on the 'Hunter' for nine months in the Mississippi River trade. Began dealing in mules and livestock in Springfield ca. 1845–1850. In 1849 at the outset of the California Gold Rush, he led 27 men to California with a wagon train carrying provisions, mules, livestock, and merchandise of all kinds, one of several trips as guide-merchant but not for gold prospecting. Returned to Springfield around Cape Horn with mules and wagons on the boat. In the stock business, 1851–1861. During the Civil War, although a Southerner, like many Missourians [including Bingham] he was a Whig and did not believe in secession. He courageously freed his slaves and supported the Union and became an effective civilian spy. He notified Union General Frans Sigel of Confederate plans to take Springfield and convinced him to come to Springfield to defeat these plans and he then guided the Union troops under Sigel and General Fremont to surround Springfield and thwart the attack. Founded Crenshaw Hardware Co. on South Avenue, Springfield, wholesaler in hardware. Farmed successfully until the end of his life; had one of the largest and finest farms in Green County. Known as an authority on the Mule Market. Land investor. One of the principal developers of the Springfield and Western Railroad ('The Gulf Line'). Married twice: first to his cousin Mary Louisa Crenshaw who died. Second marriage to Fanny Smith, 1867, lasted until his death. They had eight children. LAD Crenshaw was characterized by Fanny at his death: 'Small and wiry, seemed to never tire if he could get to sleep from 2 til 8 but was fresh and good-natured all the balance of the 24 hours, and was the best husband I have ever known. A warm friend and a fearless enemy. A sharp, quick, decisive man of generous impulses & open heart, yet the last person it would be safe to attempt an imposition upon. A lover of law and order and in the early history of his county no name was more a terror to the lawless than his.'"

Here was a man among men.

George Caleb Bingham, *Lewis Allen Dicken Crenshaw*, 1867–1869.
Springfield Museum of Art, Springfield, Missouri

Though I was not to receive the response I had hoped for from the Springfield Museum, I was pleased that the portrait of LAD was now in its best suit, beautifully cleaned and free of abrasions and the valuable period-frame as good as new after months of tedious conservation. The portrait hung in my gallery for several years, looking all dressed up with nowhere to go.

In the meantime, in 2012, I started a business association with Rachael Cozad Fine Art in Kansas City, and I forwarded to Rachael all the Bingham paintings I had discovered and others that I managed to get consigned to me, including the portrait of LAD. I would acquire the paintings and she would be in charge of selling them, which was not my strong suit. Rachael also agreed to become the sponsor of the Bingham Catalogue Raisonne Supplement project, which would handle publication of a book when the time came. I hoped that this new partnership would help LAD find the home he deserved, and ideally be united with Fanny at long last.

Kansas City was Bingham's home and the perfect place to exhibit his paintings and Rachael was the perfect representative. Her private gallery

was a section of the beautiful home where she lived with her husband, Kanon, a corporate executive. Their home was an architectural gem and practically next door to the park setting of the old Union cemetery where, in a wondrous coincidence, Bingham was buried and where she often left flowers on his grave when walking her two dogs.

Rachael Cozad was a career professional in the art world; when we met, she had just declared her independence after fourteen years as the director and CEO of the Kemper Museum in Kansas City. Prior to that, she had been curator of the Iris and B. Gerald Cantor Foundation collection of Rodin sculpture. Rachael quickly took on the project of reuniting LAD and Fanny. By this point, there was a new young director and a bright new curator at the Springfield Museum, who immediately took to Rachael's presentation of the idea, and over some months the museum raised the funds and purchased LAD. Voilà! A gala opening followed, and it can be imagined that Fanny and LAD will live happily ever after gracing a wall of the museum, where they will remain in a permanent exhibition. With the ship being captained by Rachael Cozad, I personally felt that LAD and I had returned safely from a treacherous passage round Cape Horn to find Fanny patiently waiting to celebrate with us.

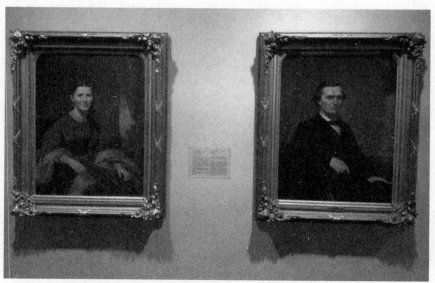

George Caleb Bingham, Portraits of Fanny & LAD Crenshaw, 1867–1869, Springfield Museum of Art

CHAPTER 3

Paradise Brueghel and the French Spider

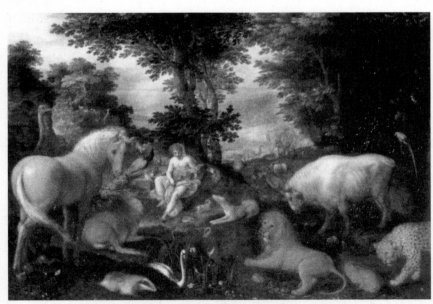

Jan Brueghel the Elder with Hendrick van Balen and Dennis Alsloot,
Orpheus Charming the Animals, ca. 1605. Oil on wood 13.5 x 18.5 in.,
Private Collection. Photo courtesy of Kline Art Research Associates

I

W e were both looking at the same wall of paintings in a consign-
ment shop and the stranger standing next to me asked, "What are
you looking for? Anything in particular?" I saw a somber bearded fellow
wearing a suit and tie and I blithely answered, "lost art." He laughed and
said he was looking for that too. We were amused at the coincidence. Then,
before we had introduced ourselves, he told me about four old paintings he
had just bought at a local office liquidation auction for $800. He described
a painting that had forty exotic animals in it. It sounded like he had found
his own Garden of Eden. Who was this person?

It was early in the game, around 1986, the time of the Peruzzi, and soon
after Jann and I were married. We were looking around Austin antique
galleries and consignment shops when I met the one and only Harold
Henderson. We both were dealers and worked by appointment, and neither
of us had a formal gallery. When I expressed great interest in the menagerie
painting, Harold kindly invited me to come take a look. At his rented
room in a friend's house I looked at the painting, which had not yet been
restored, and immediately thought it was a masterpiece—late 16th to early
17th century, pretty good condition, Italianate-Flemish, worth $100,000
to $200,000, in my opinion, and I told Harold so with honest enthusiasm.
"Then $3,000 for half interest should be a very appealing price," Harold
said, in his slow and studied way, somewhat amused. He probably thought
I was nuts with my wide-eyed estimate. The quality of the painting was
overwhelming. I had no inkling of the artist's identity, but I was confident
I could find out and I began to consider Harold's offer, which seemed too
good to be true.

Harold was a homespun Texan, an old-fashioned man in his forties with
a naïve and trusting nature and always ready with an amused laugh that was
most endearing. I found him delightfully fresh and eccentric. He seemed
strangely like Christian, reincarnated out of the pages of *The Pilgrim's
Progress*. Harold was a bachelor when Jann and I met him. He admitted, as
we got to know him, that he had accepted a self-imposed vow of celibacy in
his quest for a soul mate. An awesome, even heroic, achievement, I thought.
Harold, in his pilgrim's progress, had been an apple picker for many years,
going from apple orchard to apple orchard all over the United States with

migrant workers. This was no less than a spiritual quest for him, his own wandering in the wilderness waiting for the call, which at one time, he inferred, was closely related to Jesus Christ and the Second Coming. He certainly seemed as pure and as naïve as a saint might have been. Harold had attained a high ranking and a top-of-the-ladder pay scale among the apple pickers, so he told me, because of his ability to pluck the fruit quickly and delicately from the tree with his long orangutan-like arms and large hands. I began to like him almost immediately because he seemed to be a totally true and amazing character, however eccentric. I swear, Harold made me blink in disbelief. Call me a shameless opportunist, but I'm always looking for great characters for my book of life, and Harold was one of a kind.

<center>☙</center>

The year was 1986, and Jann and I had limited experience with Old Master paintings at this point. The menagerie painting had conservation problems as we looked at it together for the first time. The wood panel was broken in two and cracked in another place, but the paint was miraculously intact. Preserved under the rock-hard amber varnish was a beautifully crafted mythological scene depicting a nude man in a lush landscape playing a violoncello to a rapt audience of peaceful animals, including a jaguar, lion, swan, fox, peacock, horse, parrot, dogs, badger, deer, bull, ostrich, and no less than an elephant coming over the hill to join them. I knew that a good conservator could clean and restore the painting. But what was it?

Using our loupe to magnify details, Jann and I looked slowly and carefully. "Ah, you're using a loupe, good idea," Harold said. "I haven't gotten around to doing that." Harold had not been at the lost art pursuit for very long. Rarely have I felt the need or obligation to be teacher to another dealer from whom I might purchase an unnoticed treasure, but dealing with Harold was different. I felt a protective kinship with him and didn't wish to take advantage of his lack of experience in art dealing or his limited knowledge of art history. The simple truth is that I thought we might continue to work together since, most of all, I thought he could see

quality in a painting, and he seemed as honest and sincere as anyone could be. An intuitive trust began when Harold, the innocent pilgrim, very openly told me about the menagerie painting and then right off invited me into a partnership. Otherwise, I would have certainly pushed my resources to buy the painting from him for $6,000. This painting was going to provide a big number down the line if I ever saw one.

As Jann and I looked with the loupe, clues began to materialize. First a tiny signature comprised of odd letters. Then a date, semi-readable as 1683. The signature, after a lengthy study by all of us, seemed like secret code. The clues were revelations to Harold. "You certainly seem to know what you are doing," he said, somewhat embarrassed that he hadn't noticed. At this point, I asked Harold point-blank if he still wanted to sell us half interest and he said yes, and he even suggested that we take the painting and continue with our research. And so we did. That Harold was amazing. I was ready to nominate him for sainthood.

＊

Jann and I dove into art books looking for comparative paintings, and tried for days and nights to decipher the signature, and line up the 1683 date to artists working at that period. We commissioned a photographic study, blowing up close-up details of the signature, which contained perhaps nine or maybe twelve characters. We struggled with wonderous names like *F Kivrbnlr* (or *Aeurbnclte*), *F Peirrb ae, FphbohnrbHez, Feur-Herte, Dihr B Herte, Fm Clor b Heve*. We sought possible signature affinities within our now-agreed-upon category of Dutch-Flemish artists. All to no avail. Nothing made any sense, especially the gibberish we were working with.

Then we asked our conservator in San Antonio, Richard White, to try a light cleaning, hoping the signature would become more legible. Jann and I arrived in late morning at Richard's studio in a charming old quarter called King William, a late 19th century neighborhood that included some shabby and some refurbished Victorian mansions, a scattering of quaint Texas bungalows, many towering pecan trees, and the flavor of the San Antonio River right there in many backyards. The neighborhood's southern

ambience fit Richard's quiet personality. His studio was an old white stucco long-ago store, wonderfully stark with crumbling walls and stained cement floors, and outside grew a large banana tree.

The big moment arrived. We nervously watched Richard work . Slowly, gently, deftly, he moved a prepared cotton swab in a circular motion across the signature. Wait a minute! What was going on? The signature was not becoming clearer, it was quickly disappearing! "Wait a minute! Goddamn it!" I fairly shouted. I stood paralyzed, feeling like I was watching all at once the mutilation of an art treasure under my care, the loss of my $3,000, and the cancellation of a dream check for $200,000. Sweat poured off Richard White like someone who had seriously fucked up. I was on the verge of knocking the cotton swab out of his hand and choking him. "Stop! Halt!" I finally managed to shout, with the deadly seriousness of a Marine Corps sentry ready to shoot. "What have you done?" I said with disbelief, my face red with anger, my heart pounding. I almost had a heart attack on the spot. I thought that if I killed him, I could claim temporary insanity and get off with involuntary manslaughter. Richard normally stammered but now he began to stutter loudly and emphatically like the engine of a car trying to start and make a getaway. Only a whisper remained of the signature!

"The-the-the-the-the-the sig-the sig-the sig-sig-sig the signature, the signature wa-wa-wa-wa-wa-was-was-ad-ad-ad-ad-ad-added, the signature was added, la-la-la-la-la-later, later, la-later," he sputtered. "The signature was added later," he said in a burst of articulation. "The signature was added later; it was ca-ca-ca-ca-counterfeit."

I relaxed, distracted by his stuttering and realizing the probable truth of what he was trying to say. Of course! No wonder the signature came off so easily; it was added on top of the varnish. The date also came off. Now I was feeling grateful: the picture was still there and it was going to be okay and I didn't have to decipher the vanished gibberish any more. I had survived my Old Masters Club initiation! All of us had tears in our eyes. I embraced Richard and apologized for almost killing him. He forgave me, gentleman that he was. Jann was shaking and weeping, her face in her hands, and I hugged her and then we began to laugh. Then Richard poured a few drinks and we all went out to nearby El Mirador for a great Mexican lunch that lasted the rest of the day. What does not kill you makes you stronger. Yes, I paid for lunch.

We were now liberated from false clues and guided misdirection, and it was a good lesson never to be forgotten. Our minds and our eyes now opened to what we had before us: a lost and dirty masterpiece with no signature or date. Really, not an unusual predicament when dealing with Old Masters.

Jann and I rushed back to the books, to the art libraries at the McNay Art Museum and Trinity University, with a good photograph of our painting in hand. At the McNay library, among the twenty books on our table, I began to turn the pages in *Allegorie Dei Sensi di Jan Breughel* by Fabrizio Clerici, a very rare book published in 1946 in a limited edition of 500. Our book, number 469, illustrated a series of paintings depicting allegories of the senses by the Flemish Old Master Jan Brueghel the Elder (1568–1625)—all of which were in the collection of the Prado Museum in Madrid.

Suddenly there was our painting! A very close version of it. "I found it!" I whispered loudly to Jann across the table. The librarian looked up and smiled, putting a finger to her lips. I was trembling. There it was: our painting was hanging on the wall inside another painting! There it was! In the decorative background of *Allegory of Hearing*, a painting by two of the greatest Flemish Old Masters, Jan (pronounced *Yan*) Brueghel the Elder and Peter Paul Rubens (1577–1640).

Brueghel and Rubens, *Allegory of Hearing*, Prado Museum

Detail, upper right: *Allegory of Hearing*

Our picture, I soon discovered, depicted Orpheus, the wondrous poet-musician of Greek mythology, playing music to the varied animals of the world in a setting akin to the Garden of Eden, known as a Paradise landscape. Further comparative study suggested that our picture had a dual authorship as well. As in the Prado painting, our landscape and animals looked like they were painted by Brueghel. The finely articulated figure of Orpheus strongly suggested Rubens, or someone influenced by Rubens. We were ecstatic and dove into every book on Brueghel and Rubens we could find.

Jan Brueghel the Elder (called "the elder" because he had a son with the same name) was the youngest son of the legendary Pieter Brueghel the Elder (1525–1569), the greatest Flemish painter and draftsman of the 16th century, who died when Jan was just a year old. Jan became famous in his own right, and remains so, in a variety of genres: small-scale religious history paintings on copper, exquisite flower paintings, allegorical and mythological scenes, and richly varied landscapes with perhaps hunters chasing a deer. Among his colorful nicknames were Velvet Brueghel for his masterful skill at rendering delicate textures, Flower Brueghel for his exquisite floral still-lifes, and Paradise Brueghel for his exotic and Edenic landscapes with animals. Jan worked in his own original style, developing a miniaturist idiom entirely different in spirit from his father's robust pictures. The father's extremely rare paintings could climb to the stratospheric vicinity of $100 million if one appeared at auction. Jan's paintings, which

are more readily available, have brought steadily climbing but much lesser millions in the 21st century art market.

The Paradise landscape subject, as ours obviously was, formed an important part of Jan's total oeuvre of some 500 securely attributed paintings. Of those, a hundred or so were Paradise landscapes. Considering that more than 3,000 paintings were once attributed to him, a number decidedly reduced and refined by art historians over time, our picture would certainly require support from a specialist scholar. However, the thrill of our possible discovery and its obvious quality overcame a more sober wait-and-see attitude and we optimistically celebrated.

At this point, I called Harold and told him about our breakthrough discovery. We were now calling it "Studio of Jan Breughel the Elder."

"That sounds mighty good," Harold said. "My-tee my-tee good. What will you do next?"

We then turned to Dr. Alfred Bader, the now well-known art dealer and connoisseur, with whom we had recently become friendly, for advice. Bader, a German émigré chemist, was then chairman of Sigma-Aldrich in Milwaukee, the largest supplier of research chemicals in the world. His company would later be sold for a reputed $400 million. Bader was also a scholarly collector and experienced in the international art scene. Jann and I had met him some months earlier in San Antonio when he came to our home-gallery and rather whimsically purchased several small and inexpensive American portraits. His serious collecting focused on 17th century Dutch paintings with an emphasis on the Rembrandt circle. Bader's passion for art made him interesting to us in spite of the fact that he had an imperious manner that could be hard to take.

Bader had come to San Antonio to give a lecture at Trinity University on the conservation of paintings. This was a special interest of his, being a chemist. A seriously addicted collector, which he never failed to mention, he also made sure that we knew he bought about three hundred paintings a year. Bader made the rounds to galleries wherever he was. "It's a disease," he would often proudly say. But here he was, with his millions of dollars to spend. In a way, he was like Jann and me, searching for dirty unsigned works to bring into the light of day, albeit with deeper pockets! This time, he spent $2,000 for two unsigned portraits.

I called Bader about our possible Brueghel because I thought he would know where to turn. I sent him photographs and he liked the picture, suggesting we contact a dealer in New York, the imported French wunderkind Christophe Janet.

Janet, in his mid-twenties, was already famous, hailed by the press as the "eye" of his generation. He was always finding lost art treasures that the *New York Times* often featured: a Gainsborough, a Watteau, even forgotten murals by Thomas Hart Benton. *Vanity Fair* reported that he had many enemies among New York's art trade, competitors who did not appreciate his youthful—and very French—arrogance, and likely also were jealous of his meteoric rise. An Old Masters specialist at Christie's disliked the fact that he always made "a big deal about his discoveries," remarking rather smugly that one couldn't be a successful dealer in Old Masters *without* making discoveries. Janet added fuel to the fire by saying things like, "Spotting the Gainsborough at auction wasn't really a coup. Actually, anyone who knows his work *would* have noticed. It's just that no one in this country knows Gainsborough." True enough, but Christophe Janet did lack grace and politesse when it came to dealing with his success. Nevertheless, I must admit that I was a bit star-struck and certainly appreciative of Janet's talent and discoveries, and I welcomed the opportunity to work with him. In fact, in my new career as an art explorer, studying the competition firsthand offered a rare opportunity. Janet had grown up in Paris in an art-dealing family. From an early age, he was a precocious student of art history. On the other hand, I had a lot of homework to do as an adult, but happily, I could not think of a more pleasant course of study than art history.

Janet enthusiastically agreed with my Brueghel attribution and was eager to sign on as dealer for the picture. Harold was greatly impressed with the fact that I got Janet on board and before long, Janet had flown to Texas, picked up the painting, and had deposited it with his New York conservator Simon Parkes for its precarious cleaning and repairs. This took three months. In the meantime, Harold had found his soulmate, became engaged, and returned to UT–Austin to finish up a BA in Spanish. I wondered why not art history, and Harold said Spanish would come in handy if he ever had to find a real job as a teacher. He had a good point.

In the interim, Jann and I found several Old Master paintings at estate sales and we partnered them with Janet. Suddenly, serious problems developed with his credibility. We would buy a painting, then receive a check for half the cost from him, then the check would bounce . . . once, twice–three times. Then he would apologize and send another check, and it could happen all over again, with Janet all the while lying and saying the money was being deposited and not to worry. Finally the checks would go through after we had lived with the extremely annoying problem for weeks, and worrying over our own credit, which was jeopardized by the repeated bounced checks. I was ready to break the scoundrel's legs.

Harold—acting like a devoted acolyte and willing lamb to the slaughter—refused to question his religious-like faith in Janet and take the Brueghel painting away from him, as I now wanted. With his calm and forgiving, Harold now seemed like an idiot to me, and I told him so in my frustration. He counseled me not to get so upset.

By and by, after some serious travail, a given problem would straighten out, but Christophe Janet the con man was becoming a migraine headache with a French twist every time we turned around. His apologies were always elegant and good-natured and so we moved on, and the Brueghel remained with him thanks to Harold's insistence, although not without my growing trepidation.

Once the conservator Parkes had completed his work, I informed Janet that I would send my hypothesis and pictures of the cleaned painting to Klaus Ertz, the world expert on Jan Brueghel, who lived in Freren, West Germany. I could sense his disappointment at missing the honor of being the first to suggest the attribution to Ertz, the Brueghel "pope," but at this point he was grateful to still have the painting consigned to him.

Ertz's wonderful reply came in two weeks: "I am 90 % convinced that the painting has to do with Jan Brueghel . . . I would like to reserve judgment until I see the original. . . . If you would like more extensive expertise with comparative material, you must first satisfy 3 requirements:

1. I must see the original in Freren.
2. Before delivery or writing of the expertise, I would expect a check for the customary 5,000 marks ($2,500).
3. For the expertise, I require 2 black and white photographs."

Janet, with a noblesse oblige attitude and a bravado designed to compensate us for the anguish he had caused, offered to advance the expertise fee and take the painting under his arm to Germany. Soon afterward, on May 26, 1987, we had the written expertise from Ertz. In his opinion, the circa 1605 painting had three authors. Jan Breughel the Elder, the primary artist, did the landscape and smaller animals. Hendrick van Balen (1575–1632), an important and frequent collaborator with Jan Breughel, did the figure of Orpheus. And the rather rare Denis van Alsloot did the larger animals. This was the only painting Ertz knew that had this particular three-part authorship. Collaboration during this circa 1600 period of Flemish art was not unusual for two artists, especially for Jan Breughel, who often invited his friend Rubens to participate by painting figures—they made about twenty paintings together. Ertz mentioned that our painting was very close to the painting within a painting I had found in the Prado's *Allegory of Hearing*. And he intended to publish it in his catalogue raisonne supplement. Our attribution to Jan Breughel the Elder had held up.

Jann and I were basically in charge of the painting, and we flew twice to New York, once with Harold, to check on Janet and the conservator's progress. It was obvious that Harold had now become a true believer in the Frenchman, and neither hell nor high water nor a dark night of the soul could convince him that our misgivings about Janet had any validity. Harold the country boy wanted the big time, and we were not it. Jann and I watched in amazement as Harold acquired an awkward self-importance.

Out of the blue, I received a registered letter from a lawyer in New York informing us that in order to settle a long-overdue debt of Christophe Janet's, the Brueghel painting would have to be sold in a private sale the next day. Janet had signed the painting over as collateral, citing his future commission as 30% ownership. What a con! This guy rated the guillotine. No, too merciful.

It was now crystal clear to me that we were in the clutches of a sociopath and a thief and that the painting must be taken out of his hands. We had lawyers working quickly and stopped the sale. Harold, still Janet's apologist, flew to New York with my directive to take the painting away from him. Of course that didn't happen. Instead, with Harold's permission, Janet took

the picture to Paris, where he said he had a certain sale for $300,000 to $400,000! Of course that didn't happen. I told Harold that I was holding him personally responsible for the painting and Jann and I tried to go about our business.

Then a letter came from Dr. Ertz saying that Christophe Janet's $2,500 check for the expertise, written months earlier, had bounced and bounced after Janet had repeatedly assured him that all he had to do was wait and put it through again. Now Ertz had put his own lawyer after Janet. I was at my wits' end with Janet and with Harold. I had to get the painting back from Paris.

Again, Janet had a ready answer, calling from Paris to say that he had paid Ertz and pompously informing me that he of course had a buyer for the Brueghel and would without question sell it soon for $400,000. Absolutely and positively a done deal; we would have our money soon and put all the past problems behind us. Harold assured us as well that Janet had a buyer. Not to worry. It was definitely a done deal.

In the midst of all this, Jann and I had decided to move to Santa Fe. I was moving back after initially settling there in 1980. Jann and I took a holiday in Santa Fe first, at precisely the time that Janet had said the sale would happen. In the face of all adversity with Janet and Harold, we would be optimistic and plan on having at least $100,000 for a down payment on a house. The hour came for us to call Janet in Paris and give him an address in Santa Fe to FedEx the check. Of course the sale didn't happen. I hate to admit it, but even after all Janet's lies and cons, which should have taught us a lesson by now, this last dashed hope left us devastated. We were counting on this sale, which, alas, we had left in the hands of a crook and our goofy partner, the all-forgiving Harold Henderson, who clearly felt that he was following yet another newly arisen Christ in Christophe Janet.

It was time for me to make a bold move to get the painting back. I called Eugene Thaw, who I knew by reputation as a powerful mover and shaker in international art circles. Gene, now semi-retired, had just moved from New York City to Santa Fe and we were new friends. It was like asking the Godfather for help, in a way. But I had to take the chance.

"Just tell Janet you filled me in and that I'm watching what's going on, and to send your painting back," Thaw said. And so I did. The mention

of Thaw knocked Janet for a loop. He implored me, he begged me. "Tell Thaw that I am sending the painting back immediately. Please promise me you won't say bad things about me. Just tell him I'm doing the right thing, okay, everything will be fine, tell him I'm sending the painting tomorrow, okay, you don't have to tell him our problems." The man was panicked. It seemed death was at his door.

"Of course," I lied to Janet, "I wouldn't think of telling anyone about our private business." I wanted to see his head on a plate! At every opportunity, I told everyone that Janet was a crook and, funny thing, they already knew it.

Miraculously, I got the painting back in a few days. "Thank you, Thaw!" I repeated, like a mantra. I told Harold that I wanted to sell my share in the Brueghel and before long, at Janet's suggestion (according to Harold), they had Jack Tanzer buy me out. Tanzer, a dealer and a well-known charmer in the New York art scene, was formerly head of Old Master paintings at Knoedler and had worked as a gallery director for the charismatic Armand Hammer, the billionaire oilman and art collector. Tanzer must have had his own charisma because Andy Warhol had made an orange portrait of him, in his art dealer series. I only spoke briefly to Tanzer and cashed his substantial check, which did not bounce. I can tell you it was not enough to pay for the Janet ordeal. As the sunset curtain closed on my initiation into the world of Old Master paintings, there was Tanzer looking at me, a garish Warhol portrait shimmering in the spotlight. I wonder how Janet screwed him, and Harold for that matter. Twenty years later, a large photographic reproduction of Orpheus charming the animals hangs on the wall of our gallery room at 7th Heaven Ranch. I look at it every day, remembering the beauty of the painting, and enjoying its mythic ambience. Harold has died and so has Tanzer. Christophe Janet, as far as I know, is still at large; I keep checking but have not found a trace. He is no longer the wunderkind of the art world.

At our ranch in the forested heights above the Pecos River, I am Orpheus and those are my animals. When I start remembering, a refrain from Walt Whitman always passes through my mind: "I think I could turn and live with animals, they're so placid and self contain'd, I stand and look at them long and long."

CHAPTER 4

Wild Bill Hickok, Gunfighter and Poet

Few people have ever heard of Wild Bill Hickok's only known poem. Well, I found it. There it was, in all its deathless greeting-card sincerity, written in pencil and signed, on a small scrap of paper, tear-stained and whiskey-stained, stuffed behind a tintype photograph of Wild Bill, all lovingly packaged and preserved in a small and well-worn leather case and hidden away at the back of someone's drawer. The bard of the mythic Old West had come to light.

Here's the poem, exactly as the lines played out on the small page, an indulgence for the sake of literary historians of the Old West and all the cowboy poets out there:

> *Do I love thee go ask*
> *The flowers if they*
> *Love Sweet refreshing*
> *Showers*
(and a little off to the side)
> *Sadia*

As I see it, this is a Valentine to Miss Sadia, one of Wild Bill's girlfriends, doubtless one of the exotic ladies of the night he tended to favor. Below this, Wild Bill drew a line of five delightfully simple flowers—as far as I can tell, his only known drawing.

And then, boldly:

> *James B. Hickok*
> *Springfield*
> *MO*

Wild Bill was traveling back and forth to Springfield during the years 1865–1876 in various guises: a professional gambler, man about town, and even a provost marshal after honorable duty as a scout and spy for the Union army, before he turned to less reputable pursuits. It was also here in July 1865 that Wild Bill and one Dave Tutt (reportedly late of the Confederate army and a barfly compadre of Wild Bill) engaged in what is reputed to be the first public gunfight of the Old West. I don't know why for sure, but it's told that Tutt made off with Wild Bill's old family pocket watch after a hand of poker and wouldn't give it back. Who knows, maybe Tutt insulted Wild Bill's girlfriend Sadia and he was also defending her honor. Anyway, Tutt, who was probably drunk, quickly drew his pistol, shot first, and missed. Then Wild Bill shot him dead. It should also be noted that soon afterward, in September 1865, Wild Bill ran for marshal of Springfield, among a field of five candidates, and came in second. There is no record of who won, but he was not a legend of the Old West.

I actually felt I was going to discover something that day in 1986 when Wild Bill found me. On a cheery morning of good omen, my sidekick Jann and I ventured out into Austin, Texas, with a few thousand dollars to spend. Many hours later, at the end of that hot and tiring day and after passing up a lot of junk, I stood in the doorway of a last-chance shop on South Congress. The store was cluttered with Western "antiques": used saddles and saddle blankets, historic tack, branding irons, a buffalo skull, rusty tobacco signs, Mexican spurs, ranch furniture, Indian artifacts, even a sweat-stained moth-eaten cowboy hat or two. My attention was quickly turning to a Mexican food dinner and a drink with sweet Jann. The

owner, a likable trader, asked if there was anything he could help me find. I cut to the chase and told him straight out that I'd like to see the most interesting and valuable rarity he had in the shop. He thought a moment, asked if I liked old photographs, to which I said yes, then pulled out an old leather case from a drawer. "This might qualify," he said, "something I've had for twenty years, came from an old Austin estate." He showed me an encased tintype photograph, which I recognized immediately as Wild Bill Hickok because I had studied photos of him when I was a kid (and I never forget a face), and he said he believed it was Wild Bill Hickok. I shook my head understandingly. It was surprising to see him dressed in a flashy checkerboard-patterned dude's outfit. The tintype was $1,200, and by the way, came with a poem that was "stuck in the case behind it." A poem? He carefully lifted it out, and there it was, as previously mentioned. Whoa, hoss!

Wild Bill Hickok tintype and poem. Private Collection, Courtesy Heritage Auctions

I instinctively felt it was authentic, and *wonderful*, and rare as hen's teeth, but $1,200 was nothing to fool around with, so I asked if he had an expert opinion to support it or if he would guarantee it. He said no to both questions and ventured that was why he hadn't sold it in lo these twenty years. Jann looked and didn't say a word, then nodded at me with a twinkle

in her eye, and I could tell it was *Go, cowboy!* After a few more minutes of deliberation, I said I would take it. "Sold," he said, and we shook hands, he made out a bill of sale, and I promised to deliver the cash he requested in the morning. I took another long look with my loupe and he put the tintype back in the drawer. It was closing time, and I was wishing I could have studied it overnight.

That evening, when I was excitedly discussing the discovery with Jann, the phone rang. It was old Moody Anderson, the owner of Wild Bill. He said he and his partner had decided not to sell it!

"Hell, Moody," I said, "a deal's a damn deal, we shook hands, you made out a bill of sale, I gave you my word that I would come in with the money tomorrow. I've gone high and low to scrape it up, and I'm holding it in my hand right now. I just don't think it's right since you gave me your word and a written bill of sale and I gave you my word, so come on, a man's word is his bond and a matter of honor." (I stopped short of threatening legal action.)

"A deal's a damn deal, Moody," I said again, "and this is about trust and integrity here, so we've got a deal as I see it—and I took it without a guarantee at that! Did you just get it authenticated after twenty years, or what?" No, Moody said, I was right, and we would go ahead with the sale. He only thought I might want the chance to back out of it but now he guessed I didn't. "A deal's a damn deal, you know that," I repeated in friendly Texas talk. I said I would see him in the morning. "And another thing," I said, "I won't be wearing my twin six-guns for a shoot-out on South Congress." We laughed. Seller's remorse can give you high blood pressure! But thankfully, the code of the West held true.

<center>⌒∞⌒</center>

After picking up the tintype the following morning, I began to delve into the life and times of James Butler "Wild Bill" Hickok, a fascinating story that ends at a Deadwood poker table with Wild Bill shot dead in the back while holding his famous two pair, aces and eights, the "deadman's hand." The rest of his story can be found in books by the leading Wild Bill specialist, Joseph Rosa. It was Rosa I got in touch with first for authentication,

sending him professional photographs of the tintype and autograph poem, and he agreed 100 percent all around. Of all things, he lived in London and worked as a risk manager for Lloyds, of London.

During the last half of the 19th century, the tintype photograph—a unique image without a negative, printed on a thin iron plate—became popular in the United States, competing with the pioneering daguerreotype and ambrotype, while the albumen photograph on paper would soon become the standard choice for a commercial photograph. Tintype photographs were easy to produce by itinerant photographers working out of covered wagons, and many tintypes offer historic documents of the Civil War and the early days of the Wild West. Wild Bill, due to his fame, had many photographs made, but the combination of this encased tintype image of him as a gentleman and the accompanying love poem with his full signature was extremely rare and more than hinted at an unknown, serious romance.

I cherished my Wild Bill icon for many weeks, then offered it to Joe Rosa for a charitable $3,000, and he very regrettably didn't have the money. Then I offered it at $5,000 to one of the scions of the King Ranch, B. Johnson, whom I knew, and he stared skeptically into the headlights of a golden opportunity. Finally, I offered my Wild Bill treasure, poem and tintype, to the autograph specialist at Swann Auction Galleries in New York, who was overjoyed at the opportunity. It sold for $18,700 and appeared in its own *New York Times* article the next day, which quoted the poem in its entirety. Wild Bill's Valentine and his little drawings of flowers and his checkerboard suit are now a part of the mythology of the Wild West, adding, as it should, a little bit of tenderness.

CHAPTER 5

A Masterpiece for My Brother

Chance furnishes me what I need. I am like a man who stumbles along; my foot strikes something. I bend over and it is exactly what I want.

—James Joyce (1882–1941, Irish novelist)

Joseph Anton Koch (Germany, 1768–1839); *Bernese Oberland Landscape with Women Working*, ca. 1792–1794; 8 ¼ x 11 ⅛ in. (209 x 280 mm); Pen, black ink, brush and brown wash, white heightening, pencil. Thaw Collection, The Morgan Library

I

Queenie's Antiques in San Antonio, Texas, occupied a unique 1930s building that had originally been a gas station and garage with two large entrance doors for cars that allowed access from a main street and exit to a side street. Now the sliding doors were open only to people, and there was a spread of furniture, antiques, and potted plants in front that you had to navigate when entering. The building itself was a folksy work of art, handcrafted entirely from smooth river stones that stuck out on all sides like big knobs and made it seem like a compact 19th century fort with a late 20th century forest that grew up around it. I remembered this building from childhood and I couldn't help delighting in it every time I drove past but I never had a reason to venture inside until antiques appeared. The shop was dusty and laid back—one big room that contained old furniture, some hanging from the walls, and a grab bag of antiques scattered on every available surface.

When I walked in that afternoon, the first thing I did was kick over a small framed picture on the floor that had been leaning against an old dresser. The glass and the frame were very dusty and I held it up to catch the light, trying to discern if it was a drawing or a reproduction.

"What did you find?" A conspiratorial voice whispered in my ear. It was my brother, Allen.

"Not sure yet," I said, and he quietly moved past me. I walked around with the framed picture, wiping the glass and trying to see it in a better light. It had a dirty price sticker pasted to the glass that said $65.

In addition to my younger brother, Jann and Allen's fourth or fifth wife, Marilyn, were also with me. It was November 1997. We had closed our gallery in Santa Fe for a few days and were visiting Allen in San Antonio soon after he had received a life-saving liver transplant that was a year in the waiting. We were out on a "treasure hunt"—an idea, that as I hoped, had noticeably lifted his spirits.

Allen loved to go through antique shops hoping to find something of value, and he was always buying things with the soaring hope of treasure. His mind, however, was not cluttered with knowledge of art and antiques and nothing had ever turned up. Yet, Allen was one who never gave up his optimism about anything, including women, as evidenced by his persistence

in marriages and girlfriends. He had the spirit of a born gambler and was fond of saying "You never know." He would bet on just about anything and had often succeeded in speculating with stocks about as often as he failed, too. Of course over the years I had told him about some of our finds (as he liked to call them), encouraging his optimism, and I was pleased that this gave him a brotherly pride as well as a competitive spirit.

Before we went out to the antique shops this day, I had boldly raised Allen's hopes about finding an art treasure and promised him that if Jann or I found something we would share future profits with him. It was clear that maybe two or three antique shops would be the maximum he could handle. The liver transplant had weakened him considerably, and he was now pale and gaunt (as a kid he had the endless energy of a Labrador Retriever anxious to chase a ball until he dropped), but his enthusiasm, as always, was high. Queenie's was convenient, and I had always loved the old building, so I pulled in.

<div align="center">⌘</div>

The drawing was waiting for me just as I had been bold enough to hope. Its quality was radiant, its condition perfect, its discovery nothing less than dumbfounding. Babe Ruth must have felt something like this same elation when he pointed to a far fence in Chicago in 1932 and then hit his legendary "called shot" home run. The Babe had just promised a sick kid in the hospital he would hit a home run for him. Strike One! Strike Two! You could feel the wind. Then *Crack!* I could hear it flying through the air. *Whoosh!* And the radio announcer's excitement, knowing the Babe's promise, *It's going, going, it's gone! He did it! He did it for the kid!* Well, this one was for my kid brother. And on the first pitch! Can you imagine?

I was immediately convinced of the rare-treasure quality of the drawing, but I had no idea whose work it was. It was not signed, and I did not recognize the style except that it was somewhat Neoclassical and it seemed to be set in the Swiss Alps. I just knew it was a home run. I was a crowd of one and my cheering sounded more like a long silent *Yesssssss!*

The dealer saw me studying the drawing and spoke up. "That's a nice print, don't you think?" I nodded and said I liked it.

"It's 65 dollars?" I asked.

"Okay, you can have it for $50."

I had my loupe out and was examining it closely, making sure that my eyes were not playing tricks. I had seen enough and told her that I would take it.

"I haven't had it out of the frame," she said loudly, "but I could take it out. Do you think it could be an original? Did I miss a good one? Don't tell me. Maybe I should take it out of the frame."

I mentioned that I liked it, which was certainly true. "No need to take it out of the frame, I'll buy it *as is*."

"Sold!" she announced to the world.

A closer examination would come later, not in situ, but I felt my excitement growing. I tucked the drawing under my arm and kept looking around. What I didn't tell the happy-go-lucky dealer, of course, was that I recognized that it was a late 18th century master drawing of the finest quality in remarkably pristine condition. A circa date of 1776 suggested itself particularly in the fashion and activity of the subjects. This idyllic alpine genre scene, set in a lush valley below vast snow-covered mountains and a nearby glacier, was drawn with great skill in brown and black ink. A group of four nicely dressed young women and a girl appeared to be ironing laundry and doing chores outside by a substantial log house, probably an inn. No doubt it was a summer's day, and judging from an old framer's label on the backing it was quite possibly depicting an area near Bern, in the Swiss Alps. I felt certain the author would by and by be revealed through my research. And I failed to inform Queenie that my quick estimate of its value was in the range of at least $20,000, probably more, maybe $50,000 to $100,000 if the artist were renowned. It was a masterpiece and there was plenty of time to think about it. Quality first; names and numbers later.

As I continued to browse this funky garden of delights, I also found a delightful Mexican painting by the famous Mexican-Indian folk artist Marcial Camillo, whom I had actually been acquainted with years before in Santa Fe. I remembered him fondly. Marcial had originally been "discovered" in a little village near Cuernavaca by Eddie and Carol Rabkin, old friends of mine in Santa Fe, who eventually developed a renowned school of folk painting around Marcial's family and his village. The

painting was irresistible, and I bought it for our collection of contemporary art. What a morning! Eddie later told me that Marcial had become a revolutionary leader in the then active Zapatista grass roots movement for Indian civil rights and that he was living in constant danger from the Mexican government. The *Federales* were after him, and he had a price on his head!

Later that day, back at Allen's house when we were examining the drawing, I told him it could possibly be worth $20,000-plus. I could see that he really wanted—and needed—the money in his current state (he was unemployed and receiving a monthly disability check), so I impulsively gave the drawing to him. He was elated and said he was feeling lucky. We left the drawing with him and returned to Santa Fe. I thought that the research, under my direction, would give him a bright project that would take his mind off his dire health problems, which had been ongoing for many years in a number of areas. His liver transplant was a result of contracting hepatitis C from an unscreened blood transfusion during a protracted series of hip operations. He was now 57 and still walked with a limp and had to use a cane. Somehow, with it all, my brother was a cheery soul. In a small way, I thought this little treasure of a drawing was a welcome bit of good luck for Allen. He loved having it on his wall, and he sought to learn everything he could about it. Alas, before long the responsibility of researching and caring for the drawing along with his painful convalescence proved too daunting and he returned it to me to carry on. We would talk on the phone almost every day and always discuss the progress of the drawing. He devoured every nuance of my research, which was consuming many days of my time. Now Allen was really enjoying it, loving the vicarious "detective work," as he called it, and the imagined spoils of the treasure hunt.

II

A study of Swiss artists turned up nothing, except for the fact that studies in the field of Swiss art history were woefully sparse. The drawing had a French quality, and this took me to Jean-Baptiste Oudry (1686–1755), and then to Hal Opperman, the leading Oudry scholar. Opperman required $300 in advance for a yes or no decision, a standard procedure with many scholars but with varying fees. After a few days he informed me that it

was not Oudry; however, he said it was better than Oudry, superb in fact, but he had no idea. That buoyed my spirits, having a connoisseur like Opperman support its quality. It would come to be a beacon among many scholarly pessimists.

Back to the books. German art and Northern European art generally of the late 18th and early 19th centuries began to make sense. I had a few books and found a few more in bookstores. Many of the books I needed were written in German, which I don't read, and they were very hard to find, particularly in New Mexico libraries. The interlibrary loan system was my best bet, but this process often took four to six weeks to get a book. I was not yet using the Internet to find books, so I was still in the dark ages of the book search.

There were several possible approaches to solving the problem of identifying the artist. Certainly, I felt, a given art historian whose expertise touched on the northern European Alpine regions of the late 18th to early 19th centuries could help me. The drawing had a spirit of place that suggested that it could have been one of many landscape drawings and paintings the artist had done in the vicinity of Basel, Switzerland. Before the Internet and email, finding scholars and communicating with them was daunting and very time-consuming, but by and by, with persistence and luck, I was able to write and telephone and send a transparency to many specialists and curators in Germany, Austria, Switzerland, and the United States. Most, to my great disappointment, suggested minor Swiss artists or had no idea. The drought of connoisseurship I encountered could parch the soul. Inquiries sent to Christie's and Sotheby's Old Master drawings departments produced a few weak and disinterested suggestions that were, when I found examples of their suggested attributions, ridiculously far from the mark. With rare exceptions, research and attribution, I have learned over and over, are generally not strong suits of the auction houses. I was invited to put the drawing in a forthcoming sale at Sotheby's with an estimate of $1,500–$2,500, at a reserve of $1,000. No, thank you. I would have to first find the answer and then seek its confirmation.

Months and months passed. My brother was hanging on every development, and I had to hold out hope to him. All the while his liver transplant required taking this and that serious or dangerous medicine, like

Interferon, and we could both hear the clock ticking. His hepatitis C was coming back and slowly attacking the new liver, and cancer was beginning.

The possible curatives were poisoning him. Undaunted, Allen laughed it off and spurred me on.

In a desperate move, pressed for time, needing to concentrate more on cash flow and business than on research, I consigned the drawing to Mia Weiner, an Old Master drawings dealer on the East Coast. She felt she could sell it for $25,000 as Swiss/German school, less her commission of approximately 30%. I thought this was a high estimate for what she considered a "school" drawing and was both pleased and surprised. However, I wasn't happy about her being satisfied with the vague attribution. Soon I sent her my researched list of artists which I felt were strong possibilities: German, Austrian, and Swiss artists which I had gathered from my studies of the Oskar Reinhardt Collection in Wintertur, Switzerland (one of the world's great art collections), and the Winterstein Collection, based in Munich. Richly illustrated exhibition catalogues of the Reinhardt and Winterstein collections helped with my thinking. When I contacted Heinrich Sieveking, curator-author of the Winterstein catalogue, in spite of the excellent transparency I had sent, he imperiously brushed the drawing off without even a suggestion. Mia Weiner also brushed my suggestions aside. I despised her superior attitude, but I had to get on with pressing other business and I let it go. She thought a sale would be forthcoming from a big show she was doing in New York, but she failed to sell it. Months passed, again with no progress on the drawing, and Weiner was becoming a nemesis with her obnoxious attitude and egotistical refusal to investigate or even address any of my suggestions, which would surely help with a potential sale. I plotted ways to escape from this relationship that had quickly turned sour and get my brother's drawing back. The consignment period I had agreed to was nine months (six months were already used up), and it was in essence a signed contact. However, between dealers, I thought it would not be too difficult to ask that it be returned after six months of no sale and no prospects in sight.

I finally decided, after more research, to show a good image to Eugene Thaw, the world-renowned collector and connoisseur of Old Master drawings who lived in Tesuque, a village near Santa Fe. Gene and I were

friends, but I had never sold him a drawing. I had gone through a long period of study before calling Thaw at this point and had narrowed my list of possibilities to six artists, all of whom were represented in the Reinhardt catalogue: Caspar Wolf, Adam-Wolfgang Toffer, Jacques-Laurent Agasse, Caspar David Friedrich, Joseph Anton Koch, and Ferdinand Olivier. I was still apprehensive: after all, a score of experts had declared that the drawing was a minor artist of the Swiss school, yet I felt they were certainly wrong. Now was the time to test my judgment. Gene came to my gallery in downtown Santa Fe and together we studied a photograph of the drawing. He liked it very much. He was all smiles. I brought out the Reinhardt catalogue and directed his attention to the ones I had marked. After only a few pages, Gene said, "This looks very close. The style, the house, the similar landscape, the finished quality. See if you can find a book on Koch."

III

Joseph Anton Koch (1768–1839), practically unknown in United States museum collections, was a highly esteemed European master, an Austrian landscape painter who worked most of his life in Rome in a French-influenced classical-romantic style that evolved from the 17th century master Claude Lorrain. (Claude was, I add for a note of optimism, trained as a pastry cook and was probably working for a bakery when he decided to move to Rome and try his hand at painting, where he lived for the rest of his life with enormous success.) Koch's landscape paintings and related drawings have also come to be rare and highly prized, but this only recently developed during the late 20th century. Less than a handful of his works, and only a few minor drawings, were in United States museums at this time. German museums held most of his important work. Thaw and I had seen only one drawing in the catalogue, and after I found a few more examples in other books, I was convinced that Koch was worth a major effort. Gene wanted to see the actual drawing, and I assured him that I would have it soon. Expediency has always proved to be a bad idea for me in art dealing, and I knew that I had once more become trapped by my own need to hurry things along, thanks to the combination of money and family. When I politely requested that the drawing be returned, Mia Weiner informed me that she wouldn't return it unless I paid her a $5,000 fee for a cancelled

consignment—an unprecedented reprimand. I quickly instructed my lawyer to write her one of his best controlled threats and out it went overnight. Weiner surrendered quickly, and before long I had the drawing returned, but clearly in a vindictive fashion—poorly and unsafely wrapped and slowly sent via U.S. Mail—both outrageously cavalier methods for any responsible dealer. This war was short, but stressful, and the lesson cynical. But all's well that ends well, I gleefully and simplistically repeated as a mantra, and I gave my lawyer a beautiful work of art as a gift.

It took a month to get the catalogue raisonne on Koch from interlibrary loan. Here was literally the illustrated bible of all the artist's works. I was wonderfully surprised to see that it was sent from, of all places, the library at Trinity University in San Antonio—the very place where Jann and I had begun our art research together on Brueghel a decade earlier; the very place where we had first met and only a block away from our first home. And if those coincidences were not enough, Trinity was just a few blocks from Queenie's antique shop. I naturally took all this as a good omen as I began to turn the pages of the book that would reinforce or disqualify the drawing as Koch. After looking at Koch's complete paintings and drawings, I was convinced that he was without question the author of the drawing and a superb artist as well. Thaw had spotted the relationship in just a few seconds! I finally knew firsthand, from this quick master class, that his legendary "eye" was indeed amazing.

⌒∞⌒

Koch, as a young man, having fled from what he felt were the boring requisites of an academic art education at the Vienna Academy, settled in the Swiss Alps near Bern during the 1790s, where he primarily made and sold highly finished landscape drawings to his several patrons and to print publishers. From comparatively studying the drawings in the catalogue raisonne with ours, I could identify with dead-on certainty not only Koch's particular style, but also the landscape in our drawing as the Bernese Oberland, and the period as 1792–1795. I had it! And just possibly, one of the lovely women in the drawing was Koch's future wife, whom he had met at a similar Alpine inn owned by her father. I could sense that

this drawing represented a beautiful moment in Koch's life, perhaps that romantic summer day in the Alps two hundred years ago when he first saw her. I thought of Jann and echoes from my life continued to lift my spirits.

Now another search began, faxing and phoning all over Europe for the whereabouts of Christian von Holst, the German art historian who was the author of the Koch catalogue raisonne. He was the "pope" of Koch, as my first mentor in Old Master drawings Rudolph S. Joseph would have said. On von Holst's opinion rested the "blessing" of anything presumed to be by Koch and the future of my entire case. Two weeks after I had faxed an inquiry to the Stattsgalerie Stuttgart—one of many museums in my pre-Google search for von Holst—a fax came back with an apology for the delay, noting that Dr. von Holst was in fact the director of that museum.

Before I sent my Koch hypothesis to von Holst, I showed Thaw the actual drawing for the first time, along with the evidence from the catalogue raisonne. Gene loved the drawing and agreed with the evidence and said that if von Holst authenticated it he wanted the Koch for his world famous collection of Old Master drawings at the Morgan Library in New York. And how much did I want for it? We agreed on a price, and I knew from my research, particularly with dealers in Germany, that it was a justified high-water mark for a Koch drawing and probably a world record; it was, as we both recognized, a masterpiece. A Koch painting had sold at auction in the early 1990s for over $1 million, and I was very pleased that a respectable percentage of that for one of his greatest drawings might be forthcoming. *Pleased* is putting it mildly. It was a stipend for a comfortable year-long sabbatical for me and a dream cruise around the world and a great deal more for my brother.

༜

Off went my FedEx to von Holst: with a color transparency, a black-and-white photograph, and my research. I was not overly nervous because I knew that I had correctly judged the evidence. It was like submitting newly gathered DNA that you could see agreed with an established DNA, and I had no doubt von Holst would see it. Within a week, I received a phone call

from him. His voice was deep, authoritative, and loud; his English perfect; his mood cheerful and elated. I had to hold the phone away from my ear.

"Congratulations, Mr. Kline!" von Holst trumpeted. "You have discovered a rare and unknown drawing by Koch. It is very beautiful. I am calling you from a meeting of German museum directors, and they are all sitting here and they too send their congratulations."

I could just get out a "thank you," as von Holst's voice boomed, projecting like a Shakespearean actor. He then asked totally out of the blue if I knew his friend, an art historian at Trinity University in San Antonio. Another amazing Trinity convergence! In fact, I actually did know him.

"Small world," I said, reeling at the coincidence.

"We all agree," said von Holst, "all the museum directors sitting here, that we must purchase this drawing for a German museum. Would you tell me how much you are asking for it?"

I couldn't believe it. All the German museums were after my drawing. What a riot! I paused, catching my breath and savoring a rare moment, and wondering in my glee if I could possibly sell it twice. Then I cleared my throat and told him that the drawing was already sold, and to whom, and where it was going. Silence! Seconds passed. I could sense that von Holst was turning either beet red or ghostly white. I finally spoke up and apologized and said how regrettable it was that I couldn't sell it to him, but on a positive note, we now have at least one great Koch drawing in America whereas Germany has many. Von Holst then boldly asked what Thaw had paid for the drawing and so I boldly told him. I must have been on a speaker phone because there were exclamations in the background. I heard "Mein Gott, mein Gott" echoing in the background and Thaw's name mumbled around. In spite of his disappointment at losing the drawing in front of his colleagues, von Holst composed himself and politely congratulated me on the sale and agreed in front of everyone to write the expertise that I then requested. I sent him a generous check immediately, although he had not requested it, as a "contribution toward his future research" and as insurance for the expertise I needed. It was quickly deposited. When I told Thaw of von Holst's acceptance, he paid me the next day, far in advance of receiving the written expertise, and he directed me to send the drawing straight away to the Morgan Library.

(I have to add a word about Gene Thaw's integrity in dealing with me, because in my experience it was a rare occurrence, even among friends. When Gene first saw a photograph of the drawing, he had asked me where I had found it and if it came with a provenance. I told him the true story of the discovery exactly as it happened, including the $50 I had paid for it and its lack of provenance beyond Queenie's—a later inquiry I made turned up the original owners, a Swiss family and their descendants in San Antonio. We bargained a little when I named my price, but he never once referred to the absurdly low price I had paid.)

I called Allen and told him the good news and that I would overnight a jackpot of a check to him. He was ecstatic—he had won the lottery! He wanted Jann and me to join him going around the world, and bring the kids. For a brief and exciting period I honestly think my brother forgot about his cancer and concentrated on enjoying his good fortune. Increasingly debilitated in the months to come, though, he never made it around the world. On many days thereafter, when he felt strong enough, up to several months before his death, he called to tell me that he had been out looking for treasure.

Allen was 58 years old when he died, and his memory still gives me inspiration for dealing with the difficulties in life, much as he had motivated me with the Koch project. Our adventure with the lost Koch was the most fun we ever had together. With that twist of fate, we had truly become brothers at last. We were both transformed by the experience, and so was that little lost drawing on the floor at Queenie's.

CHAPTER 6

The Divine Beauty of Nature

Gottlieb Schick (1776–1812); *Allegory of the Divine Beauty of Nature.*
©Kline Art Research Associates and ©Lehman Loeb Art Center, Vassar College

I

had become a very interested student of 19th century German art after the wonderful sale to Eugene Thaw of the Joseph Anton Koch drawing in 1999. Amazingly, paintings and drawings of this hidden school began to materialize in the market at this time. Thanks to the research I had done on the Koch project, I was increasingly able to recognize styles and subject matter and names of notable 18th and 19th century German and Austrian artists—including, surprisingly, drawings by the great German writer Johann Wolfgang von Goethe, as well as works by Friedrich Overbeck and Julius Schnorr von Carolsfeld of the little-known Nazarene school. Armed with this somewhat esoteric knowledge, I was a rare bird among art historians and dealers in the United States, and even among U.S. museum curators, whose institutions generally held meager inventories of German art. Suddenly it seemed that German works were as drawn to me as I to them. It seemed like Providence, having recognized that my commitment was helping me succeed, as Goethe once noted. Magical thinking, no doubt, but I was willing to believe in that magic and ready for favorable winds. Which is not to say that that Providence hands you a map to follow, but I was ready for favorable winds. Those providential winds would soon blow me toward a magnificent lost masterpiece of 19th century German art.

A phone call came to us, out of the blue, from a country auctioneer in Dallas inviting us to the liquidation of the Joseph Sartor Gallery, a once thriving early 20th century gallery of quality art. The promise of dusty paintings from forgotten storage held an irresistible promise. Off to Dallas Jann and I went, closing the gallery in Santa Fe for a long weekend.

We arrived as the doors opened for the morning inspection of paintings in the auction. Over a hundred were hanging on the walls. Since we were coming from so far, the auctioneer had promised that we could quietly inspect a large group of paintings, still in storage, destined for a later auction. The paintings on display were second-rate at best and we passed through them several times, with barely a comment. We moved on to the storage area, guided by the cordial auctioneer. We made our way through a gray-walled labyrinth of dimly lit passageways and long abandoned nooks with cobweb-covered gallery artifacts. Luckily, I had remembered a flashlight. I was given a ladder to get up to the second and third storage

tiers. Jann and I were left to ourselves, excited by the expectation of finding lost art in this dark and forgotten cavern. I expected bats to fly past my head, but they never appeared and, fortunately, neither did black widow spiders, who love places like this. It was very hot and very dusty and doubtless I should have worn work clothes. As I climbed, Jann held the ladder and then helped lower the paintings to the floor as I climbed down with the flashlight for us to take a closer look. And then back up the ladder and down again. One after the other, there was nothing but junk. If nothing else, I rationalized, this was good exercise. Verily, another hundred paintings did we inspect: calendar art, dirty and torn works on paper, motel art, awkward copies of Old Masters, Sunday painter art, airport art. Soon we were working quickly, but still it took two hours and several hundred climbs to see everything. I would call it seventy years of mistakes, accidents, and charity. It was so bad, it was funny. Exhausted and hungry, we washed up and went to lunch.

We found a popular French restaurant and ate outside on the shaded patio, near an entertaining birthday party attended by twenty chic Dallas women. Their gaiety put us in a good mood, as did the delicious food, and we celebrated our release, after hard labor, from the mediocrity of the auction. I can still remember my delicious beef bourguignon and Jann's irresistible escargot, the wonderful sauces to be soaked up with the oven-fresh bread and butter, and a ruby Cabernet. The Texas women sitting next to us were having a jolly time and they knew how to laugh. For no reason I can recall, they raised their glasses to us as we left. Okay, we were acting like honeymooners.

We decided not to go back for the auction for a last look, happily liberating ourselves from the first plan of a tedious two-day auction. Now of course we could explore the vast art and antiques scene in the Dallas–Fort Worth megalopolis, the fine restaurants, the world-class museums, and await the hidden and inevitable serendipity of the big city. We were still explorers in search of some lost treasure, even though the auction that day held no prizes. I dreamed on, and why not. As we searched in the chaos of Dallas, we stumbled onto an uncharted island, a small oasis of classy antique shops on the edge of a funky but resurrecting old neighborhood. We pulled in.

One particularly enticing shop had every wall, floor space, table, pedestal, cabinet, and corner filled with a celestial array of paintings and rare antiques.

Most of the paintings were unsigned and of good quality, and all were beautifully framed. We entertained visions of lost masterworks with many of them. The owner told us that he bought at small auctions and estate sales all over the country, staying away from the New York scene. He had an unusually good eye for quality, and this suggested a serious opportunity for a discovery. Perhaps it was the lunch hours that kept people away, but the dreamlike privacy we found was as if he had put a sign on the door that read "Closed while the Klines are shopping."

I finally focused on a large and exquisite Neoclassical painting by an unknown artist: it depicted a bare-breasted classical goddess who seemed to materialize suddenly from a tree to confront a startled woodcutter in a toga—a baffling subject, to be sure. I quickly requested a hold on it. It filled a wall that was not well lighted. My surprise, when I first saw it, echoed that of the agape young man in the painting. The coincidence was highly amusing as I mimicked the pose for Jann and pretended to lift her blouse *(Hello! What's this?)*.

Goddess and Woodcutter measured a whopping 5 x 6 feet in its original gilt frame and at $16,000 was the most expensive painting in the shop and the largest. It was a masterpiece to both our eyes. My first thought was 19th century, possibly German, with French a very strong second. I asked to examine it, and two men carefully extracted the heavy painting from the wall, leaving an immense blank space. It must have weighed a hundred pounds.

"If you buy it, would you please let me keep it here for our Thanksgiving party?" the owner pleaded, seeing that I was hooked. "I've only had it for a week! I've decorated the whole room around it. It would throw everything off."

"Of course," I said, with an exaggerated bow. "The show must go on!"

"And please don't tell me if you sell it for a fortune!" he said. "You look like you know what you're doing. Just don't tell me."

I just smiled. I was far from having all the answers he thought I had, but I knew intuitively that I would understand this painting before I was

finished with it. He, on the other hand, had chosen to be finished with it quickly, before he understood it.

After examining every inch of the painting, even taking it out of its antique frame and black-lighting it for camouflaged overpaint, we determined that it was indeed very old, relatively untouched, and in surprisingly good condition. It was also unsigned, with no inscriptions anywhere. Who had done it? What was the peculiar subject? When and where was it painted? How much is it worth? In spite of all the unanswered questions, we were totally enthralled by its quality, and I felt that pinning a name on it would be only a matter of time and persistence. It was clearly museum quality. The price was lowered to $14,000, and we bought it. He later sent photographs of his sumptuous Thanksgiving table set before our masterpiece.

II

I had been researching from photographs of *Goddess and Woodcutter* for a month before the painting finally arrived at our gallery in Santa Fe. Although Neoclassical in style and certainly of a romantic French inspiration, I instinctively felt that the painting was German. I had only one reason for thinking so. The initial clue, the woodcutter's head, suggested a striking Caspar David Friedrich portrait drawing, no doubt a visual memory from my research of Koch, but I quickly found that Friedrich, perhaps the greatest 19th century German artist, was clearly not the author of our painting. Clues for me often come in odd details. No other name came to mind and no artist rose up as I studied the few books I had with possibly comparative 19th century German works. I found that Neoclassical German paintings were rare and didn't appear on conventional maps, but I continued to follow my intuition until I could find that I was mistaken.

I was also browsing in used bookstores and quickly found a rare 1936 catalogue of 15th–20th century German art, a loaned exhibition from Germany organized by Philadelphia Museum of Art. This was the first broad survey of German art ever held in the United States, with major works from German museums. The Foreword ironically noted that ". . . these troubled times . . . prevent exchange of ideas as if war had closed the frontiers." In a

few years, of course, World War II and the Nazi plague descended upon us all. Little wonder that German art had been ignored.

One painting in that prophetic catalogue, by Gottlieb Schick (1776–1812), stopped me, a portrait, *Frau Heinrike Dannecker*—a seated woman posing outside, rendered in Neoclassical style (Alte Nationalgalerie, Staatliche Museen zu Berlin). A small area of distant landscape, at Frau Dannecker's left, immediately caught my eye, and then the particular pose of her hand by her chin, and then her beautifully rendered arm. These details closely echoed a small vignette of distant landscape, at right, in our picture, as well as the outstretched hand and arm of the woodcutter. I knew nothing of Schick, but I liked the clues. You have to start somewhere, and here were the first comparative echoes, strong and clear. Two seemingly insignificant details in this very different painting were urging me to Schick, and I could already sense, with some anticipation, that I was on the right track.

Within my library, I found no additional examples of paintings by Schick and only scant biographical information in the Benezit dictionary. The remarkable 35-volume Grove Dictionary of Art had recently been published at $5,000, and the library at the New Mexico Museum of Art, just around the corner from my gallery, had a set. Today, I access this invaluable tool online for an annual fee. Here I found a learned biographical essay on Schick by Dr. Ingrid Satel Bernardini, complete with a bibliography. To my amazement, the bibliography listed Christian von Holst, whom I had dealt with as the Koch specialist and director of the Statsgalerie Stuttgart. Von Holst was co-author of a 1973 exhibition catalogue for a major retrospective on Schick in Stuttgart, Schick's hometown. As coincidental as this was, it very much remained to be seen if we indeed had a Schick and if von Holst remained enough of a specialist in Schick to authenticate. Phone calls all over the country finally found the Schick catalogue. Now the best available illustrated source was at the gallery for research but, alas, it was in German, which I could not read. The paintings, happily, did not need to be translated.

When I first began my research, I had only observed a very compelling comparative relationship to small details of landscape and anatomy in the one and only painting I had ever seen by Schick. Then, one after another,

three paintings in the Schick catalogue began to make comparative sense with *Goddess and Woodcutter*, ringing bell after bell both in signature comparative details, anatomical and landscape, notably in *Eva* (Cologne, Wallraf-Richartz-Museum) and *Apollo unter den Hirten* (State Museum, Stuttgart). Pieces of visual DNA in Schick's portraits and allegories were leading me to a strong comparative sense of Schick's hand in our painting. The mostly biblical and mythological themes of Schick's paintings—a small body of work, numbering around forty paintings, due to his early death—suggested a further relationship to the scene in our painting. Everything was falling into place. It was uncanny. I was again as awestruck as the woodcutter seeing the naked goddess appear before him. An exciting moment! I knew it was Schick and felt this was a rare and valuable painting with a good place in German art history.

From Bernardini's essay I learned, with growing excitement, that Schick had been a favorite student of the great French master Jacques-Louis David (1748–1825), the leading artist of the Neoclassical movement. Now the French influence was wonderfully reinforced. He could not have had a more important teacher. Schick had studied with David in Paris from 1799 to 1802, in the recent aftermath of the French Revolution, blood and smoke still in the streets, Napoleon appearing here and there. After Paris, Schick went to Rome, where he became a good friend of none other than Joseph Anton Koch, which again made me catch my breath. In Rome, he had only brief success, joined with bouts of depression, before he died from tuberculosis at thirty-six.

∽

We hung *Goddess and Woodcutter* in the gallery, rather eccentrically, with a tantalizing wall sticker that stated *UNDER RESEARCH / not for sale.* Most dealers keep "whodunnit" paintings under wraps until an appropriate christening, but Jann and I liked to live with our discoveries out in the open and even to discuss them with clients and visitors. Such were the pleasures and excitement of a small gallery, that our research was at hand and often the catalyst for fascinating discussions and unexpected revelations. I might ask someone to try and suggest the story told by the painting or who they

thought had painted it or when and where they thought it was made, and since I did not have all the answers myself, these discussions helped me to think about possibilities.

I had occasion to fax Eugene Thaw, who lived only 15 minutes down the road from the gallery, in regard to the Koch drawing he had purchased and, in a wave of confidence, I mentioned the new painting and my attribution to Schick. Gene came in before long and liked the picture and suggested that I run it by Robert Rosenblum, the famous art historian and 19th century specialist at New York University's Institute of Fine Art. I was quite anxious to show it to a Schick specialist, and I went ahead and sent it first, with my attribution and research, to von Holst in Stuttgart, thinking he was sure to recognize it. He didn't reply for five months.

The subject of the painting had baffled everyone. My ideas kept changing as I tried to interpret the subject from a list of Schick's lost works, all the while trying to relate it to "the divine origin of poetry," an engaging theme of divine origins suggested by Schick himself. The quote directly related to Schick's *Apollo* painting, which I had seen in photographs. I thought, on the lighter side, that seeing a naked nymph appear from a tree would, in itself, be enough to change a woodcutter into a poet. In any case, as I worked on the elusive subject, I stuck firmly with Schick as I began to see more of his paintings.

I finally wrote to Robert Rosenblum with the always helpful preface "at the suggestion of Eugene Thaw," and I sent images and mentioned that I had done some research and would be pleased to share it. At Thaw's sagacious suggestion, I did not offer an attribution, allowing Rosenblum to make up his own mind first. This procedure is, of course, the traditional high-mannered courtesy given with a courtly bow by the art courtiers to the professorial art royals. The courtier should not tell the royal what to think. However, I must admit, that this was an etiquette that my ego did not always allow after I had worked hard on a discovery and wished to claim it.

After a week of waiting, I called Rosenblum. He admitted being stymied, then I told him I was thinking Schick. "A Schick in Santa Fe?" he exclaimed with lighthearted amazement. "You know, I think you're right on. I've been thinking German and Rome, which is exactly Schick." He

urged me to find Dr. Gisold Lammel, who had curated the most recent Schick exhibition in 1984 at Staatliche Kunstsammlungen, Dresden. Before long, I had Lammel's address and sent off a letter and then another and then another to various updated addresses. He had finally signed the FedEx receipt, but no response ever came. First, no response from von Holst, and now the same with Lammel. I sensed a conspiracy of silence. I had put forth a daring hypothesis to von Holst, pointing out the clear stylistic comparatives I had found with the other Schick paintings. I suggested that our picture completed a previously undetected trilogy which would link three paintings together with the idea of "divine origins" and the idea of "poetry." Later, after much pondering, Jann and I refined the idea into its final transformation as *Allegory of the Divine Beauty of Nature*.

Schick himself had interpreted *Apollo* as being "a symbol of the divine origin of poetry and its first manifestation to human beings." What a wonderful clue! I further saw *Apollo* as the key to also understanding *Eva* and then extending to and explaining *Allegory of the Divine Beauty of Nature*. In *Eva*, which was chronologically and conceptually the first of Schick's "divine origin of poetry" ideas, the biblical Eve of Genesis is pointedly sticking her toe into a cold stream, and with this wonderfully innocent and brilliantly imagined act, Schick created an allegory of the sense of touch in the first awakened being. Now that the senses had been awakened in *Eva*, ultimately poetry is born with *Apollo*, the principal Greek god of culture. With *Allegory of the Divine Beauty of Nature*, my hypothesis suggested that it could very well be the first manifestation to a human being—a suddenly awakened Adam, a natural man—of the divine beauty of nature perceived as a goddess. What could be a more fitting development of the poetic ideal?

Finally, a letter arrived from von Holst, in German, which I had translated. Alas, he did not think it was Schick but reserved final judgment pending inspection of the original. He wondered if the work wasn't a Scandinavian artist rather than the work of a German.

Confident and relentless in my perception of Schick, I responded to von Holst, politely disagreeing with him. I suggested a symposium to determine authorship, a gathering of many opinions. That was to be his last word on the subject.

III

I had been trying for months to find an address for Dr. Ingrid Sattel Bernardini, and not a clue had turned up. Bernardini's stature as author of the Schick entry in the *Grove Art Dictionary*—which was quickly becoming the *Encyclopaedia Britannica* of art—would probably be sufficient to establish authentication of the painting and get me off my narrow track to von Holst and to Stuttgart's logical acquisition. I made a greater effort to find her. Now with a computer, I emailed a request to Jane Turner, the Grove editor-in-chief, and she pompously refused to send me Bernardini's address on grounds of privacy. She then proceeded to give me hints, acting like the director of an Easter egg hunt, suggesting I look here and there and follow logical clues offered by this and that publication. I said why not just give me her address since I was an art historian with important business relating to the very article she wrote for the *GAD*. So sorry, she said again, and I could see her nose in the air, which I dearly wanted to snap with a rubber band. What did she think I was, a goddamn bill collector? I should have offered her money. That would have pricked up her ears. I then called Rosenblum and asked him to please try calling the Mother Superior for the address and, what do you know, she readily gave it to him. Off went a package to Bernardini.

In the meantime, I faxed a translation of von Holst's letter to Rosenblum, saying I thought his objections were poorly supported. A fax soon came back from him. He strongly disagreed with von Holst's "grave doubts" about the Schick attribution and admitted to still being stymied about the subject and wished he could come up with a substitute. (I had held off sending him my new ideas.) Rosenblum's tacit support and his negation of von Holst's position was the first fair wind in a long while, and he agreed as well to allow me to cite him as a consulting scholar. Rosenblum's support was no small encouragement as I moved up the ladder toward the Schick authentication.

I had all but given up on Bernardini after a month or so of waiting, and after so much travail with the Germans, I was feeling quite depressed. Then a simple posted letter from Dr. Bernardini arrived in the mail. She was in Rome and it was very good news indeed. She agreed with my Schick attribution. She also suggested a remarkable and likely provenance to

Joaquin Murat—Joaquin Napoleon I, the "Dandy" King of Naples (1767–1815), Napoleon's brother-in-law and one of his greatest generals, who was also a known patron of Schick. She had in fact found evidence for the Murat provenance in Karl Simon's 1914 biography *Gottlieb Schick*, which I had not used due to my inability to read German. Here, great wonder of wonders, Bernardini discovered that there was a record of a lost commission from Murat, a commission Schick was "allowed to invent," and she suggested this could be it. I was ecstatic. Finally, she was as baffled by the subject as everyone else had been. I was then and there convinced that the subject of our painting had to have been invented! Of course, that's why it couldn't be pegged. There was no reference in literature or mythology to compare with it. Later, when I proposed the subject to her, she readily agreed.

Dr. Bernardini's letter was for me, as can be imagined, the rising sun of hope. It wonderfully offered support for my attribution, from a Schick specialist, and opened up a magnificent and totally unexpected avenue of provenance to Murat. Bernardini had done all this work, yet I had not sent a penny in advance for her time nor had she asked for any compensation. Soon afterward, I sent her a nice check for her research, and the most elegant thanks I could conceive. It is always difficult to know what to do in a case like this, with scholars of high integrity and talent and little thought of money, but it is a good bet that a thank you with an honorarium of cash is always appreciated. Later, she enthusiastically expressed her gratitude, as well as her surprise at the money. I hope to kiss her if we ever meet.

Remarkably, in the midst of the Schick project, I found and purchased an unsigned Nazarene school drawing I had seen in a Christie's Amsterdam catalogue. Both Koch and Schick were part of the circle of the Nazarene Brotherhood of artists in Rome, and, having studied them recently, I had acquired some expertise in their works. Believing in its high quality and seeking a top specialist, I asked Dr. Colin J. Bailey in Scotland, a leading specialist of 19th century German art, for assistance. Bailey, a refreshingly affable man with a wide knowledge of art history, who also did not request any money in advance for his work, found with some excitement that it was a lost drawing by Johann Evangelist Scheffer von Leonhardshoff (Austria, 1795–1822), a talented and very short-lived Nazarene artist and extremely rare. The masterpiece quality of the drawing, titled *Agnus Dei*, and Bailey's

authentication, quickly led to its purchase by Eugene Thaw, and it entered the Thaw Collection at the Morgan Library, in all likelihood the only Scheffer von Leonhardshoff in an American museum.

Evangelist Scheffer von Leonhardshoff, *Agnus Dei* (Thaw Collection, Morgan Library)

Coming as an afterthought, I asked Bailey if I could add the Schick onto his research, and he enthusiastically accepted, acknowledging a specialist's interest in the artist. A month later, I received a letter in the mail from Bailey. It was more good news. "I have absolutely no doubt," he wrote, "that this is by Schick. Documentary evidence aside, the style of the painting alone is sufficiently persuasive evidence of his hand, and you are right to make a comparison with other works completed by him around 1808–1809." It doesn't get any better than "absolutely no doubt," particularly from a careful scholar like Bailey. "The real problem," Bailey continued, "is the subject . . . I know of no classical or renaissance narrative in which two figures of the kind are depicted. . . ." The subject of the painting had become a greater mystery than I had ever supposed.

The time seemed right to offer the Schick. Now that authorship and at long last the subject had been established to my satisfaction, I did my due diligence and contacted the Art Loss Register in New York and asked them to carry out a search for lost paintings by Schick. To Jann's and my great relief, the Schick had not been registered as stolen or missing, nor was it listed among the losses from World War II. It was just wandering homeless and nameless in the world. From the evidence I gathered, the painting had probably begun its wandering journey after General Murat was captured and executed in 1815 by an Austrian firing squad during Napoleon's last campaign. The furnishings of his Palacio in Rome were probably auctioned off, and the painting flew away. Its provenance went no farther than the Dallas "art market," but whoever owned it had cared for it like a treasure for almost two hundred years.

Since the Schick was so rare, our best bet was to offer it through a major auction house and give it a worldwide audience. Sotheby's 19th Century European Paintings Department loved the painting and even invited me to submit copy for the catalogue description, which I did. It would go into their Important Sale of May 3, 2000 with Schick's firm authorship (not as "attributed"), and as *Allegory of the Divine Beauty of Nature*, with the Murat provenance, and of course with a significant bow to the excellent and indispensable Dr. Bernardini, supported as well by Bailey and Rosenblum. The estimate was $50,000–70,000, with the reserve at $50,000. Auction is always a gamble, with many variables, but in this case we won and set a world record at auction for a Schick painting at $137,750, sold to the Frances Lehman Loeb Art Center at Vassar College, and as far as I knew, the only painting by Schick in an American museum. But this experience was not over. The story suddenly changes.

I recently saw, some fifteen years later, that the Schick was strangely not featured in the Vassar collection. Then I found it. It was no longer Schick. Instead, a new author was suggested, the Slovene painter Franz Caucig (1755–1828), a practically unknown master of Neoclassical paintings. Had Vassar made an error in judgment? Had I and all the specialists who had accepted Schick been wrong? The comparative paintings of Caucig and Schick had an uncanny relationship—they appeared to have been made practically by the same hand! Caucig's paintings could easily be mistaken

for Schick. And, I also realized, Schick's paintings could easily be mistaken for Caucig. I would guess Vassar is happy with their "Caucig." I am happy with my Schick and stand with its supportive scholars. It is a masterpiece in any case.

This offered a good lesson in the pursuit of connoisseurship—be ready for changing winds! It is not my mystery anymore.

CHAPTER 7

The Master and the Monster

Ever tried. Ever failed. No matter. Try again. Fail again. Fail better.
—Samuel Beckett

Lawren Harris, *Decorative Landscape and Barn*, 1916–1918.
Private Collection, Canada. Courtesy, Kline Art Research Associates

Prologue

I t was right out of a dream. A flock of ravens, black feathers windblown and glistening purple, glided by our high balcony in the morning and occasionally, while I stood at the railing, one would fly by and turn his head and look right at me. Our eyes would meet. In my practiced raven voice I "caw-cawed" and held out my hand and they would often answer and circle back but not so close this time. The balcony was parallel to their airstream and I watched the birds passing like shadows coming and going morning and evening on the waves of wind.

I

A phone call came from an interesting young man I had recently met around town. He invited me to his private art sale and said he needed to raise money. He was a personable and intelligent artist-trader, recently moved to Santa Fe from Canada with his lovely wife. I wasn't in a mood for philanthropy, and I tried to beg off, telling him that I too was trying to raise money and didn't have much to spare at the moment. He informed me he had some old unsigned paintings he had picked up here and there and they were not expensive. "No junk," he said. On second thought, I decided to drive over.

They were house-sitting in a very expensive neighborhood in a fashionable adobe home that belonged to a friend of his parents. I was the first to arrive. Most of the things he was selling were high quality, small and precious objects d'art, and I was pleasantly surprised and tempted by many of them. I must have handled everything there.

I kept returning to a small and wildly colorful modernist landscape, a Fauvist tour de force—a pink-blue-orange-green-red barn, set among blue-purple-indigo spruce trees, with what appeared to be a yellow-green-violet-orange-blue-white field of flowers or rocks in the foreground, and with small patches of light blue-pink-violet-white sky filled in among the trees. Its rare and audacious color and painterly skill mesmerized me. I stuck it under my arm and kept browsing and finally just stopped to admire it and examine it more closely. I was dazzled! I was thinking, with some excitement, that it could be a rare and valuable painting by the American artist, Stanton Macdonald-Wright, the founder of an early 20th-century color-infused movement called Synchromism.

The painting was in an attractive, early 20th century gold-leaf frame with an original framer's sticker from Philadelphia still firmly glued to the crumbling paper backing. These decorative clues further suggested its age as circa 1910–1920. It was unsigned as far as I could tell. I purposely did not remove the backing or take it out of the frame yet, although invited to do so. I did not want the revelation of a signature to change the game and be confronted with seller's remorse. He was selling it "as is," and I would buy it "as is."

When I did remove the backing later, I saw a surprising inscription: "Gift from Lawren Harris." Lawren Harris, I remembered from past experience, was a Canadian member, and in fact the leader, of the Santa Fe-based Transcendental Painting Group during the late 1930s. The artists in the group were committed entirely to abstract painting, and exclusively to the development of the spiritual dimension in art. They were not painting landscapes, and I knew nothing beyond a few examples of Lawren Harris's abstract paintings. And so, the mystery of the painting deepened, with this tantalizing clue pointing to a Canadian artist—was it Harris's painting or a work by another artist he admired? There was much to investigate, including my first idea of Stanton Macdonald-Wright.

The picture was oil on composition board, 18 x 14 inches, and in wonderful condition. The broken brushstroke style reminded me of Van Gogh. It was in unusually pristine condition, so much so that tiny mineral crystals, as delicate as the morning dew, glistened on the heavy impasto surface—a sign that it had never been cleaned or varnished. Perhaps steam from a radiator or a tea kettle had accumulated on it year after year as it hung on a wall nearby. Early twentieth century seemed certain. I knew I had to have it. I loved its quality and I could sense the hand of a master. Lawren Harris seemed a far out idea.

I asked the owner where he had found it. He wasn't specific, but thought somewhere in his travels around Canada, possibly Toronto, maybe even Buffalo, New York. The asking price was $400, which I gladly would have paid but couldn't afford that day. I pressed for $300 and we settled on $350.

I bought it like an intoxicated lover, full of lust, smitten by its beauty, offering what little money I had to possess it. I was elated. I now owned

this glorious mystery, and I knew I wouldn't stop until I figured out the master who painted it.

I dismissed Stanton Macdonald-Wright as the author of the painting after studying his works in books I had in my library. He did not paint prismatic landscapes, and his abstract color details were consistently cubistic refractions of color, suggesting a musical quality in his brushstroke technique—nothing like the broken brushstroke style in my painting, which suggested puzzle pieces of color fitted together.

Now, with another good direction, I had both the inscription suggesting a Canadian artist and the Canadian clue tossed out by the seller. Thus encouraged, I began the fascinating study of 20th century Canadian art. I started searching for books on the subject, a challenging task anytime since few books had been published, but especially difficult before the Internet book sites would work their magic in seconds. I found a few books in Santa Fe at high prices and bought them. The investment in art books for a researching art historian is as essential as food, clothing, shelter.

After several months of research that spread across Canadian, European, and American modern art, I determined early 20th century Canadian art to be right on target. After close comparative analysis with my painting at hand, or a photograph of it, my focus narrowed with growing excitement to the Group of Seven, of which, resoundingly, Lawren Harris was a member. Everyone in Canada has heard of the Group of Seven. They are almost biblical in the reverence given to them. More reverence than scholarship, as I would find.

II

Jann and I were living at Hillcrest. Ours was a busy household. Mama Jann and Papa Fred, five teenage children from our previous marriages, many dogs and cats, and a huddle of used cars that accommodated a wide range of drivers. It was the summer of 1991, and Jann and I were working as private art dealers, "by appointment only," out of our unique Santa Fe home, looking wealthy but not. Profits from an art sale generally flew quickly away to serve the needs of our large household.

Our circumstances in this demi-paradise were challenging, to say the least. Very little money was available to buy art, and yet buying and

selling fine art was our business, concentrating on historical rather than contemporary works. What art we did find had to be cheap and "lost," and ultimately valuable if we were to make it. And equally important, we also then had to find someone to buy it, and often quickly. Consignments came in from time to time, from appraisals we had done or from collectors we knew or from other dealers, and they made up an important part of our inventory, pulling us through many a month. Such was our quixotic lifestyle. Santa Fe, I knew from art exploring experience dating back to 1980, was a haven for lost art.

Practically every Santa Fe art dealer and collector I knew was looking for Taos Colony Indian scene pictures, which had become the romantic icons of chic Santa Fe. These early 20th century paintings generally featured local Pueblo Indians or occasionally Hispanic villagers going about everyday life or following tribal ways. Only rarely was a whisper of the modernist or avant-garde to be found, and surprisingly few cowboys appeared in the Taos paintings. This was Indian country! The Taos painters were very competent academic realists and had great success even in their own day. Victor Higgins and Ernest Blumenschein, with their genius for color and design, were my favorites among the group. Once, during the Hillcrest period, I discovered and bought, at a Santa Fe moving and storage auction, an extremely dirty unsigned little Higgins, a so-called gem for $10, depicting a sweet little stand of aspens. It was later authenticated, and I sold it wholesale to a dealer for $7,500. But generally, Taos Colony paintings were too pricey and too obvious to allow for my kind of speculation. For some wise collectors, however, and especially some dealers like Forrest Fenn and Gerald Peters, speculation in the Taos painters proved that art can indeed be a great investment over the years, turning tens of thousands into hundreds of thousands of dollars, with no end in sight, particularly as their available works become scarce.

III

The Canadian Group of Seven's artistic vision, in the form of a patriotic manifesto published in Toronto in 1920, boldly proclaimed that the time had come to create a national Canadian art, an art inspired mainly by the Canadian landscape. Not exactly revolutionary thinking, but then

you have to understand Canada. The Group of Seven—although highly criticized for years by the ultra-conservative Canadian art establishment for their non-academic impressionistic approach—have, over the ensuing decades, become a legendary group of modern painters. Some of their works have sold for $1 million or more in the 21st century.

My little masterwork fit clearly into the Group of Seven landscape genre: small, oil on board, boldly designed, highly colorful, rich impasto. I explored three serious possibilities among the Seven: Tom Thomson (who died tragically and mysteriously in 1917, a few years before the Group actually formed, but remained a key inspiration to them), Lawren Harris, and J. E. H. MacDonald—all were close friends. My pleasure in landscape painting in general rose to a new level with this trio. I loved their work. They made poems in paint. Where had the Canadian masters—and their volume of work—been hiding?

⌒∞⌒

Suddenly one day, after weeks of deep and unending study of images in the handful of books I had gathered, there was no question. With great assurance I attributed the painting to Lawren Harris. I knew it was Harris as surely as I knew my own name. The comparatives were unmistakable, and to add further thrill, Harris was considered the greatest Canadian artist of the 20th century.

The evidence was overwhelming. Harris's painterly broken-brushstroke technique, the woodland subject, his tree shapes, the style of the barn, the architectural subject, his eccentric colors, his experimental bent, the small size and nature of the support, the patina of age, its probable Canadian origin, his occasional unsigned work—all qualities of style and documentation were closely and exactly comparative to Harris's paintings of the World War I period. This I knew from Jeremy Adamson's wonderfully comprehensive book *Lawren S. Harris: Urban Scenes and Wilderness Landscapes, 1906-1930*, what I would call my "Harris Bible." Adamson's monograph offered a hundred comparative examples and vivid insights. I had found the book in a Canadian bookstore after a day-long trek of long-distance calls.

Uncanny it was that I now owned what I believed to be a rare and beautiful painting by Lawren Harris. I was determined to establish it as a long-lost masterpiece. And not least, it was indeed miraculous to have the "Gift from Lawren Harris" inscription as well, which now implied correctly, that he had given his own painting as a gift. That evidence seemed to make my attribution even more certain.

I looked deeper into the amazing coincidence of Harris's Santa Fe connection. In spite of the painting's reputed provenance in Canada or New York state, a more complete provenance would have to include its appearance in Santa Fe—as if some magnetic attraction was at play. From 1938 to 1940, Lawren Harris and his wife, Bess, had lived in Santa Fe. He was invited to Santa Fe to be a founding member of the avant-garde Transcendental Painting Group, which had formed in Santa Fe and Taos around transplanted New Mexicans Raymond Jonson and Emil Bisttram. Harris, who had come to be known in both Canada and the United States as a talented and innovative painter not only of landscapes but of mystical abstraction as well, became the acknowledged leader and first president of the TPG. Harris was also a follower of Theosophy, a spiritual-philosophical movement that had materialized in the 1870s in New York City around the brilliant and charismatic Madame Helena Blavatsky (1831–1891). Since its inception, the teachings of Theosophy had generated wide interest among artists and intellectuals all over the world, notably W. B. Yeats and George Bernard Shaw in the early days. Not surprising, since Theosophy deftly synthesized the accumulated wisdom of theology and philosophy. During the 1930s, as it happened, the Theosophy movement also had a strong following among the New Mexico Transcendentalists. This pioneering group of American abstract painters in New Mexico—whose manifesto exalted spiritual, idealistic, non-objective abstraction—also included Ed Garman, Robert Gribbroek, William Lumpkins, Agnes Pelton, Florence Miller Pierce, Horace Towner Pierce, and Stuart Walker. Early on with my first contact with the TPG, I had seen a few of Harris's abstract paintings but had entirely missed his landscapes. The convergence and interrelatedness of Harris into my time and place mixed seamlessly into

the magic of the discovery. Call it what you will—magic, serendipity, miracle, synchronicity, coincidence, chance—I recognized early on that a certain *je ne sais quoi* was a necessary part of my romance with art. The great writer and wit Oscar Wilde hit the nail on the head when he wrote, "Art is the secret of life." Which is to say, with the poetic vision, life becomes wondrously transformed.

_∞

How could I be so sure and believe in the certainty of my Lawren Harris hypothesis? I didn't have the assurance of studying a roomful of actual Harris paintings. I had only one painting that I had attributed and a few books filled with reproductions of Harris paintings, some in color, most in black and white. I had to use what I had, and I also had a burning desire to closely study Harris's body of work—to see, compare, know, and judge—and begin connoisseurship of his oeuvre, combining that with my eye and intuition in order to establish an unquestionable attribution. And so I would begin my wide-ranging research, conditioned to take a creative leap and obedient finally to the writer's obsession with revision. Revision, I knew from my life as a writer, was the process of *yes-no-maybe-what if* and finally settling on *that's it!* This mantra would play over and over as I researched and pondered what steps to take next.

My repeated study of comparative images in Adamson's "Harris Bible" provided the answer. I had to make sure my eyes were not playing tricks, but finally it was undeniable. The painting was indeed by Lawren Harris, and it was also a "Gift from Lawren Harris"—to me!

IV

The last few months of 1992 were spent trying to find interest among several auctions in Canada. They were skeptical and wanted authentication and provenance, calling the painting "atypical" and "too experimental." I had hoped for an easy ride into auction and a brilliant sale, but apparently my Harris attribution wasn't obvious to them. For authentication and expertise, Dennis Reid was singled out and most often mentioned, and also Jeremy Adamson, the leading Harris specialist whose brilliant book

on Harris had been my primary reference, my "Harris Bible"—a 331-page exhibition catalogue, written when Adamson was curator of Canadian Art at the Art Gallery of Ontario. Reid was a Canadian museum curator—in Adamson's former position—and considered something like the pope of the Group of Seven. Adamson, who had moved away from Canada and was now an American museum curator, held a somewhat higher position on Harris because of his definitive study but had abandoned Canadian art and Canada for a variety of other art-related subjects in the United States. Clearly, I needed both Reid and Adamson to agree, and we would be home free.

I first sent transparencies to Jeremy Adamson, then a curator at the Smithsonian's Renwick Gallery in Washington, DC. I told him he would be indispensable to making my attribution. Judging from the examples in Adamson's book, I thought the painting fit stylistically in Harris's World War I period, from 1914 to 1918. When we spoke on the phone, I was elated to learn he more or less agreed with my attribution after looking at the transparency, and he liked the painting to boot. Needless to say, this was immensely gratifying to hear. Alas, the bad news: Adamson apologized that, even as the only Harris specialist in the United States, he couldn't write a formal letter of authentication because his museum job (operating under the Catch-22 guidelines of a U.S. government museum) forbade pronouncements of that kind. Additionally, he had to see the painting in person before he could authenticate it, and there again it was Catch-22 since the painting was not allowed to be sent to the museum except as a donation. Frustrating to say the least!

Finally, however, out of sympathy for the absurdity of the situation, Adamson kindly wrote a letter that spoke of a possible agreement with the Harris attribution and the circa dates I had suggested, but he carefully made it inconclusive. He said it might be the real thing, but stopped short of a firm answer. My situation was beyond words. I again approached Adamson, who with increasing empathy said I could speak of his informal acceptance to reassure a potential buyer. Doggedly I tried again, one last time for a more conclusive statement, and finally, after my best closing argument, he recognized my financial need to sell the Harris and he agreed to write a more positive note:

March 15, 1993

Dear Mr. Kline:

 In response to your letter of February 18th, the following is my statement in regard to your picture:

 "In my opinion, Field of Flowers and Barn bears many of the hallmarks of an experimental landscape picture executed by Lawren S. Harris during the period 1914 to 1917."

Yours sincerely,
Jeremy Adamson, Ph.D.
Associate Curator, Renwick Gallery of the National Museum of American Art

I was grateful for Adamson's statement but it still wasn't conclusive. It still said it *might be* a Lawren Harris, and that was as far as he could go. However, it would keep my interest in the painting alive and it was a great early boost.

I estimated the 1993 value of the Harris at $150,000, but I couldn't sell it without the clear blessing of Adamson or someone comparable, like Reid. I had no clients in Canada and I knew no Canadian dealers. My best chance was a Canadian auction or museum. The American market for Canadian pictures was virtually nonexistent, a shame given the wonderful work that was going unappreciated just across the border.

Following the lead with Canadian museums, I found Dennis Reid, entrenched in Adamson's old job, curator of Canadian Art at the Art Gallery of Ontario, and I told him of Adamson's encouraging comments. He asked me to send the painting, so I shipped it to Canada, where the museums did not have the same archaic restriction on sending outside art to be evaluated. After seeing it, he wrote back favorably about the painting itself but amazingly would not authenticate it. He quibbled about the size not being exactly equivalent to Harris's known works and he questioned the inscription on the back. "The size of the board, however, is not consistent with his early practice," Reid wrote. "The earliest works of this size painted on a solid support that I know date to 1934, and are on masonite. I also stop short of

attributing the painting unconditionally to Harris because the note on the back in pencil, 'gift from Lawren Harris,' appears to have been written many years after the varnish was applied, and long after the instructions to the Philadelphia framer had been pencilled on." Now what?

After a week, I sent Reid a long thoughtful reply, pointing out his irrelevant objections, but it elicited no further response. There was no getting around the fact that I could not sell an unsigned Harris at auction or privately in Canada without Dennis Reid's blessing. That appeared to be the bottom line. Everyone in Canada kept asking what Reid thought, and I was at another dead end. Then I came to a startling insight. Reid had seriously denied authentication on two absurdly perfectionistic points—a four inch difference in verticality and an inscription suggesting the actual truth of authorship! I was stymied.

I had also written to Lawren Harris's elderly son, himself an artist, asking his opinion. I sent slides and copies of the letters from Adamson and Reid and thought surely he could clear things up:

March 1, 1993

Dear Mr. Kline:

I truly wish that I could give you the answer which I feel certain that you would like to receive, but I can do no better than use the phrase you quoted in yours to me—namely "in all likelihood" it is an early work by my father, Lawren S. Harris. I feel unable to say either "yes" or "no" in a positive vein.

Yours truly, Lawren P. Harris
Copy: Dennis Reid

Again, no luck, but a decent encouragement. I had tried the experts and fell short of the result I needed.

I had left the painting with Reid at AGO so that other interested parties could examine it, Sotheby's Toronto among them. Frustrated and needing money, I irrationally accepted an "attributed" designation and a low reserve of C$3,500 from Sotheby's and agreed to auction (estimated

at C\$4,000–6,000), thinking quality will surely win the day. I could rationalize that paintings with low estimates often go sky high at auction. All it takes is two bidders recognizing the quality and then bidding it up. I agreed to do it in spite of the fact that Sotheby's Toronto gave small regard to the letters I had and even wrote that they had doubts that it was Harris.

A change of heart quickly came over me and I asked Sotheby's to send the Harris back, which they did. At least I still owned it and even in my despair felt the failures were a blessing in disguise. I could still try to sell it privately. Over many months, I offered it to Canadian dealers and collectors to some appreciation but with no success.

<p style="text-align:center">V</p>

As much as Jann and I loved this painting and believed in it, the necessities of life urged us to sell it. Cash flow was a big problem. As private dealers at that time, quite short of financial independence, we had to push our inventory and keep things moving. After all, we rationalized, turning \$350 into maybe \$5,000 in about 24 months is not such a bad thing. On the one hand this discovery looked like good news, but on the other hand, as was becoming evident, getting there was a trial by fire. Of course I hated to lose the dream of a \$150,000 treasure. That's the kind of thing that can keep you going, but it seemed that it just wasn't happening. I had other fish to fry and moved along with other business.

I returned to Sotheby's Toronto a year later in 1994 and they agreed to the same terms as the previous year when I withdrew. I importantly stipulated that this time I required a full-page color presentation in the catalogue (an expense that would be deducted from the sale) and they agreed. An important presentation would make a great difference and I, perhaps naïvely, hoped that this additional prominence in the catalogue would push them to seek out its probable authenticity to interested parties.

The catalogue arrived in October for the November 1994 sale and I eagerly searched for our picture. There it was, a full page—but in *black and white!* This painting was all about color and the color presentation was an integral and imperative part of my decision, and now, when it is too late

to correct, it comes to me exactly the way I did not want it to be. It was even in my contract. I went through the roof. A response from Sotheby's came by fax:

September 30, 1994

Dear Mr. Kline,

We were, unfortunately, not able to illustrate your painting attributed to Lawren Stewart Harris in colour in our auction catalogue, due to the number of higher valued pictures and a limited number of colour pages. Your painting is featured on its own page, however, as lot 166. We hope to do well for you, and look forward to a successful sale on your behalf.

Sincerely, Christina Orobetz

Fatalistically, I went forward and by an amazing grace the Lawren Harris failed to sell at the auction on November 16. Someone could have bought it for around US$3,000, but no one had dared to bid. The fear and ignorance of the Canadian audience took my breath away. But once I had calmed down, I had a sense of great relief that I still owned it. I must admit to having a clear feeling that the spirit of Lawren Harris was keeping it in my hands until the moment was right. But I felt cheated by Sotheby's. I waited almost a month to reply and demanded my painting back at no further expense, and it was quickly returned. Now what?

⌗

For the next three years we enjoyed living with this exquisite painting. I made a few offers to assorted collectors and dealers in Canada, and, as before, there was no real interest without Reid's blessing. In 1997, I wrote again to Dennis Reid asking if he had any new information and would reconsider and attribute the painting. Reid coolly wrote back, "Nothing has turned up since my last letter of February 1993 to cause me to shift my position."

In 2000, as the millenium turned, I located another Lawren Harris specialist in Canada, Peter Larisey, a Jesuit priest and art history professor who had written a pensive tome about the artist in 1993. After a great many emails and friendly repartee, Larisey agreed to pronounce on the Harris after extensive examination of transparencies. Alas, after months of soul searching he finally did not entirely like the "colour of the barn" and the "lack of provenance." As he wrote: "The most I could say about the painting is only that it is highly probable that it is a Harris." Onward through the fog with Peter Larisey's tiny flashlight.

VI

By 2002, a decade had rolled over this art mystery. It was no hardship living with this beautiful painting. In fact, it was a healing and teaching presence after all the disappointments. Now it was summer, and I felt some energy return to the authentication dilemma, not so much out of a financial imperative any more—we had some very successful sales in the meantime—but because I wanted to persevere and win the prize. It had to be done, and I knew I could do it. The picture deserved to have a place in Harris's oeuvre. This was not a dead issue with me, only resting, as with many of my authentication projects. Then a bright summer idea flew in the window: I would try again to find Jeremy Adamson anew, the foremost Harris expert who had been caught up in a museum Catch-22 in 1992, and see if he was free from his bureaucratic strictures. I prayed for his long and healthy life.

Thanks to the divine Google, he instantly appeared, alive and very well. Adamson had become, of all things, chief of the Prints and Photographs Division at the Library of Congress. I could not resist telling him that I had written a major article on the library for *National Geographic*, for their November 1975 issue, and he welcomed me as an old library hand. Jeremy said he could now, under different Library of Congress rules, authenticate the Lawren Harris and to send the painting for firsthand inspection. Before long, he readily agreed that the painting was indeed an authentic Lawren Harris and he wrote a glowing authentication. The magic wand of time had transformed everything.

September 8, 2002

Dear Mr. Kline:

Thank you for the opportunity to review the Lawren S. Harris painting Decorative Landscape with Barn, in my office for several weeks.

In my considered opinion, based on my own longtime interest and expertise in the subject, a review of scholarship on the artist published since 1978 (when my authoritative study of Harris' painting 1906–30 appeared), the response of experts in the field to my queries, and comparisons of your picture to photographs and reproductions of known early works by Harris, Decorative Landscape with Barn *is an authentic painting by Lawren S. Harris.*

Indeed, it represents an exciting new discovery and should attract significant attention from collectors, curators, and scholars interested in the early history of modernist art in Canada. In my view, argued below, Decorative Landscape with Barn was painted ca. 1916–17 and demonstrates the artist's keen interest at the time in exploring avant-garde color theory, particularly that of the Synchromists and other progressive American painters of the period.

In its decorative design, use of contrasting warm and cool hues, structured brush strokes, and impastoed surface, I believe the painting also reflects an influence closer to home—Tom Thomson's canvases painted in the winter of 1916–17: The Pointers, The West Wind, *and* The Jack Pine. *Whatever the degree of influence— and it certainly went both ways—Decorative Landscape with Barn clearly reflects shared interests on both artists' part and their commitment to defining a new mode of landscape representation in Canadian art.*

Yours sincerely,
Jeremy Adamson, Ph.D.

In addition to the wonderful authenticating letter, Jeremy then discussed the painting in an expertise that further developed its historical context.

After all the years of travail and blind eyes, this explanation of the paint-
ing's importance and place in art history was especially gratifying to receive:

Lawren S. Harris (1885–1970)
Decorative Landscape with Barn, ca. 1916–17
18 x 14 inches (45.5 x 35.5 cm) /Oil on pressed board / Excellent
original condition
Not signed / inscribed verso in pencil: "Gift from Lawren Harris"
Collection of Fred and Jann Kline, Santa Fe, New Mexico

*A new discovery, this unsigned and undated composition was
likely painted by Lawren S. Harris during 1916–17, a period in
which he experimented with vivid, artificial color schemes and
decorative arrangements of form. Examples of other similarly
high-toned, if less profusely colored, works from this time include
Building the Ice House, Hamilton, 1916, Decorative Landscape,
1917, and Snow VI (Winter Landscape with Pink House), 1917.*

*1916–17 proved a juncture in Harris' career. After a trip to Algon-
quin Park with Tom Thomson in early Spring, 1916, he returned to
Toronto and immediately enlisted in the Canadian Army, serving
from June 12 to May 1, 1918 as a Lieutenant in the 10th Royal
Grenadiers. Stationed in Toronto, he assisted in marksmanship
training at the Hart House rifle range by creatively devising targets.
Although the number of paintings he exhibited dropped dramatically
while in the Army, he was nonetheless able to continue painting in his
Rosedale studio in the evening, on weekends, and during periods of
leave, and to attend events at the Arts & Letters Club.*

*Given its atypical, vertical dimensions and the artificial nature
of its color scheme, Decorative Landscape with Barn is likely a
studio production, not a field sketch. The uncommon juxtaposition
and combination of contrasting warm and cool hues clearly demon-
strates the artist's concerted interest in exploring the use of heightened
color to create, through resultant optical sensations, dynamic, plastic
form. The chromatic brilliance of the picture appears to demonstrate
Harris' direct awareness of similar concerns among contemporary,
modernist American painters, especially the Synchromists.*

As Prof. Brian Foss points out in his article, "'Synchromism' in Canada," in a letter dated December, 1916, J.E.H. MacDonald informed Arthur Lismer in Halifax that, during a recent lively discussion at the Arts & Letters Club, Harris had been "strong & extreme" in supporting the avant-garde, Synchromist theory of color as expounded by the American art writer, Willard Huntington Wright, brother of the painter Stanton Macdonald-Wright, one of the founders of Synchromism.

Harris may actually have seen paintings by Macdonald-Wright and those by other American artists who experimented with color and form, such as Oscar Bluemner, Marsden Hartley, John Marin, and Alfred Maurer, for he owned a copy of the catalogue of the landmark show, The Forum Exhibition of Modern American Painters, held in New York March 13–25, 1916, organized by W. H. Wright in which their work was prominently displayed. Harris' pencilled annotations in the text-filled volume reveal his ardent interest in the artists' commentaries on the significance and use of heightened color. At the end of December, 1916, Harris made a documented, week-long trip to New York, doubtless to see recent American art.

Decorative Landscape with Barn is marked by a chromatic brilliance unusual in Harris' early work. The same exaggerated palette of yellow, blue, orange, mauve, and green that make up the foreground rocks and plants is not to be found in other known paintings of the period. But, in more limited combinations and juxtapositions, the exact same hues can be seen in his better-known canvases and sketches of 1916–17. The painterly strokes are also familiar—especially the brick-like brushstrokes in the barn roof and sky. It is the intensity and artificiality of the rich color scheme that remains uncommon. In this regard, the small painting's only peer is the artist's large and compelling canvas, Decorative Landscape, 1917, in the National Gallery of Canada. The short-lived context in which Decorative Landscape with Barn was painted was an international, not insular one: Synchromist and Post-Impressionist color as absorbed and promulgated by contemporary American artists and writers.

Dr. Jeremy Adamson, U. S. Library of Congress, September 8, 2002 (Main reference: Jeremy Adamson, Lawren Harris: Urban Scenes and Wilderness Landscapes, 1906-1930. Exhibition catalogue (331 pp.). Art Gallery of Ontario, 1978.)

The ten-year journey down the road to authentication had finally ended! I decided I would offer the Harris directly to the leading Canadian collector of practically everything, the late billionaire newspaper publisher Kenneth Thompson. Thompson had recently bought Peter Paul Rubens's long-lost 1611 masterpiece, *Massacre of the Innocents*, at Sotheby's auction for approximately $75 million. *Massacre* was a large painting depicting a gruesome massacre of children and their mothers at the hands of Herod's soldiers. (It is appropriate to note that in the 18th century the painting was in the Lichtenstein collection and miscataloged in a 1767 inventory of that collection and remained unrecognized as Rubens until its rediscovery in 2001, when it was hanging in a German monastery. It had been loaned to the monastery by the owner, a woman living on a government pension, who could not tolerate living with it because of its horrific subject. A relative took a snapshot to Sotheby's, where it was recognized, and the rest is history.) The Rubens ended up as a magnificent gift from Thompson to Art Gallery of Ontario, where our friend Dennis Reid was curator of historical Canadian art and, I later learned, consultant to Kenneth Thomson's substantial Group of Seven collection.

Concurrent with my offer to Thompson, not wanting to waste any more time, I queried leading Canadian auction houses with the precious Adamson documents in hand. Unbelievably, many reported back when I pressed them, that Reid, "the Harris expert," had vague reservations about the painting. This had stopped them from making an offer. Then I learned from Adamson that Reid's longstanding rivalry with him was likely one cause of Reid's aberrant behavior. I reckoned there was another cause as well: I, an American outsider, with no Harris credentials, had dared intrude into his specialty—and, adding insult to injury, I had in the beginning asked Adamson to authenticate the painting instead of Reid. I could rationalize Reid not agreeing with Adamson or questioning my belief in the fact that Harris was the artist, but it seemed as if he was actively taking

steps to undermine this new development—a major discovery—which he could not take credit for.

Ken Thompson, a happy man, right at his phone, could not have been a more delightful and courteous person. Alas, he passed up purchasing the Harris, saying it was not to his taste, graciously volunteering that he had only shown it to one person for an opinion, and that this was an absolutely confidential consultation with a top expert. Guess who?

◦◦◦

Undaunted, before too long I found a substantial auction house in Vancouver that loved the Harris and wanted to put it on the cover of an auction catalogue. Adamson's authoritative blessing, they informed me, made it as good as gold. I sensed my moment had come. I insisted on a guarantee of US$80,000 in advance, a very fair price knowing that it could now quite possibly reach $250,000. I drew up a contract, received $40,000 down, and sent them the painting. The contract stipulated that we were to split the proceeds after the auction deducted C$125,000 off the top of the sale of the painting—about 25% more than my advance. It was estimated at C$150,000–175,000. If it did not sell, the painting would, in effect, be sold to them. A month later, and a month before the auction, I received the last installment, another $40,000.

Finally, the big day came—and the painting did not sell! I really wasn't surprised. In my opinion, this was due to several not unexpected causes: a poor presentation by the auction house, which then allowed them to own the painting for a very low price, and the continued reluctance by Reid to support the painting. (A phone call from Adamson finally got Reid to relent and say he would support Adamson's authentication, but he then continued quietly to withhold his support.) In addition to all this, a whispering campaign by a rival auction house in Vancouver reminded potential bidders of the painting's problematic lack of sale ten years earlier at Sotheby's.

After an entire decade, this painting finally transformed from a wheel-spinning study in frustration to an ample treasure. Though the financial payout was of huge delight, what gave me the most contentment was that I had finally, with the vital assistance of Jeremy Adamson, successfully

established this work as a rare masterpiece by Lawren Harris. This was beyond a doubt. I loved this painting, and so did Lawren Harris—the joy he put into it was palpable. The painting is a veritable celebration of life!

Nevertheless, having been paid, and no longer owner of the painting, I remain confident that in time, the work's true worth and beauty will prevail. Someday, I predict, it will find a permanent home in a museum, and when that does happen, it will become one of Harris's best loved paintings.

Honor is due Jeremy Adamson, who helped save a great and rare painting by Lawren Harris. In serving the truth, and the art history of Canada, Adamson asked for nothing in return.

CHAPTER 8

Around the World Again with General Grant

William A. Coulter, *The Arrival of General Grant at San Francisco*, 1879.
Courtesy Fred R. Kline Gallery; Private Collection, San Francisco

Prologue: 1877–1879

I n May 1877, after two terms as president of the United States and twelve years after leading the Union to victory in the Civil War, General Ulysses S. Grant, with his wife, Julia, and two of their children, embarked on a journey worthy of the mythic Ulysses of Homer's *Odyssey*. The Grants sailed off on an around-the-world trip that lasted two and a half years and took them from Europe to the Middle East and to Asia. Accompanying Grant was veteran journalist and wartime correspondent John Russell Young of the *New York Herald*, who had first known Grant while reporting on the Civil War. At the end of this journey, he would publish a classic of travel writing, *Around the World with General Grant*. Young sent frequent dispatches home to eager readers in New York. His fascinating stories, which were quickly syndicated nationwide, were filled with exotic places, regal celebrities, and relaxed interviews with Grant. It was a play-by-play of the Grand Tour of the American century. Grant was still regarded worldwide as General Grant, the hero of the Civil War. He was celebrated by royalty, from Queen Victoria of England to King Chulalongkorn of Siam, and parades and grand festivities followed him everywhere. American readers put aside the scandals of Grant's administration and honored anew the victorious general of the Civil War, while vicariously enjoying the exotic sights and sounds of Grant's holiday. Close to the end of their world tour, the Grants spent two months in Japan, where they were received by Emperor Mutsuhito and Empress Haruko. It was widely reported that General Grant was the first person in the world to shake the hand of the emperor. From Japan, the Grants sailed for San Francisco aboard the *City of Tokio* [sic]. They arrived, home again, through the fabled Golden Gate passage, on September 20, 1879.

On September 21, 1879, the *San Francisco Alta* reported:

> We do not believe in the history of San Francisco, or we will say the history of California, there has ever been such a magnificent, unstinted, warm-hearted, enthusiastic reception tendered to any citizen of this country, than was that offered to General U. S. Grant yesterday. . . . At 5:37 the first gun from Fort Point boomed across the parapets and announced to

the expectant multitude that the long awaited welcome guest was entering the Golden Gate. . . . [It was noted in the article that the ships that sailed out to greet the *City of Tokio* included *China* firing her canon, *Ancon, Elder, St. Paul, Parthenius, McArthur, McPherson* carrying General Irwin McDowell, and the tug *Millen Griffith* carrying dignitaries among whom was U. S. Grant Jr.] The *Griffith* pulled alongside the *Tokio* and transferred passengers. The first person to board the *Tokio* was young Ulysses Grant, and as he reached the deck he was met by his brother Colonel Fred Grant who escorted him to the hurricane deck where stood General and Mrs. Grant.

Ship's Log: 1997–1998

It was mid-April 1997 and spring had just arrived in Santa Fe. The mountain winds were fresh and strong and steady, and reminded me of the ocean. Sometimes I can even smell the sea. The vast blue ocean of air above the New Mexican high desert can be as inviting as blue water, and if you are daydreaming it is a good substitute.

One April day, I left Jann to run our gallery in downtown Santa Fe and I went on a short "voyage of discovery" around town, no doubt hoping that the spring winds would blow something unique my way.

As I rummaged in a consignment shop, a beautiful wreck of a marine painting stopped me in my tracks. Its antique beauty, though badly neglected, still shined perceptibly and compelled me to stop and think about its qualities and admire its craftsmanship. The price on the sticker was a surprisingly high $900 for so damaged a painting, not the $200 I was expecting. A big price for me that day. Someone else had intimations of its quality, too.

As coincidence would have it, my thoughts of sailing the high seas converged into the seafaring scene in this painting now before me. Ships filled the picture plane. A large ship and escort ships were steaming into port at sunset and they were surrounded by tugboats and sailboats, perhaps fifteen vessels in all. Colorful flags were festooned on the masts of most of the ships, and it seemed to be the celebration of a grand event. The sunset sky reflected into the dark water and sent crimson waves rolling into the

foreground. Plumes of sooty steam and gray cannon smoke rose in the air. It seemed like a bonfire on the water. I noted the flags of Japan and the United States. It was a beautiful mystery and love at first sight.

The painting was large, 30 x 50 inches. Propped against silk pillows on a soft bed in the shop, it was displayed most incongruously, like a tattered and homeless waif. Imagery aside, on a superficial level it was actually unattractive. Across the painting's surface, I noted a litany of problems: it was creased, cracked, abraded, mildewed, filthy. It was partially hanging off its stretcher and had old water stains on the back of the canvas. At lower left there was either a signature or an inscription partially missing:—*S. Weber.* I didn't recognize an artist by that name and thought it might have been USS *Weber*, perhaps the name of the main ship. The small area at lower right where it was common for an artist to sign was totally abraded and devoid of paint. Adding insult to injury, the old gilt frame and the stretcher were moldy. Relining was imperative: a new piece of stabilizing canvas would have to be adhered to the original canvas, which was rotting and fragile. Inpainting (or retouching) was also imperative, but happily it was mostly in minor areas. Numerous tiny losses and paint separations were scattered: throughout the sky; throughout rigging, masts, and flags; in some smoke areas above ships; in the hull of the main ship; in the bow of a tug. I hoped it would not be more than 10 percent accumulated looses to the original paint, which was the general standard of acceptable loss; it may have been a little more as I took a hard look at the damaged spots, but all instances looked to be easily repaired. By and large, however, this neglected beauty had held herself together for what I knew had to be well over a hundred years. I could easily visualize its reincarnation. It was now ready for the emergency room, and not a moment too soon.

∽

My desire to rescue this seascape from oblivion was strong. I paid the asking price of $900 and decided to worry about my bills later. I was worried even more about the $2,000+ I would surely need for careful conservation of the entire painting, which had to be done. I was optimistic and felt instinctively

that I could identify the painting and resurrect it into a valuable treasure of some historic significance. I also knew I had to be patient. I estimated that the conservation would not be finished for at least two months, bringing me to about mid-June. Then, once photographed in its "best suit," I could begin sending images to institutions asking for help in identifying the event. In the meantime, I would carry on with my research and try to determine the author of the painting. The judgment of value would come along when I knew exactly what I had.

The next day at the gallery I dropped everything and began searching among our art library of several thousand books and auction catalogues for comparable paintings. The "S. Weber" inscription or signature did not materialize as either an artist or a ship. A Japanese flag and an American flag on the largest ship and the gently rolling coastline made me think of San Francisco and the Asian trade at that busy port. I used to live in San Francisco, and the recognition of the parallel coastlines and the sailboats made me think of the view to the west of San Francisco Bay toward the Golden Gate passage and beyond to the Pacific. Of course this scene was long before the Golden Gate Bridge was built, connecting San Francisco with Sausalito and Marin County, but I thought the convoy of ships in the painting could have been sailing right under the future bridge span.

Nevertheless, I wanted to exhaust all possibilities and scoured 19th century European marine paintings in addition to American marine artists and searched for the rare examples of Californians within that genre.

On a cluttered shelf in a bookcase, my eye suddenly caught sight of a booklet with a ship on its cover, lying on top of a stack of odd artist monographs. The booklet was titled *W.A. Coulter, Marine Artist*. I remembered purchasing it for a dollar at a St. John's College book sale about four years ago, thinking I might have an interest in California marine painters someday. I had only looked through it once since buying it. As I turned the pages now, I realized, catching my breath, that I had found the author of the mystery painting on the first day of my research—it had to be Coulter!

"I found it!" I shouted to Jann, who was at her desk at the other end of the gallery.

"The ship painting?"

"I just picked up a book and there it was." I showed her the Coulter monograph.

After she looked, she too was elated. We went over the comparative evidence together. The privately printed Coulter booklet, written by Elizabeth Muir Robinson and published in 1981 by the artist's son James V. Coulter and the Sausalito Historical Society, was a little gem of 28 pages, illustrated in color with Coulter's paintings on practically every page. The images were interspersed with a rich biographical sketch of the artist. At the time it was the definitive work on the artist and certainly a rare find in any library.

William Coulter (born 1849 in Ireland; died 1936 in Sausalito, California) had come to San Francisco at age 20 in 1869. As a result of an accident that badly injured his leg while delivering a boatload of lumber to Monterey down the coast, he stayed on. He turned to sail making in San Francisco for several years, but by the early 1870s he was a practicing artist, taking commissions for ship's "portraits," and he even traveled to Europe in 1876 to study art for several years. Today he is regarded among California's important pioneer marine artists.

Going through the little catalogue with Jann, we discussed the comparative details of Coulter's paintings with the disheveled painting in front of us. The signature comparative details included the distinctive way the ships and tugboats and sailboats were drawn, the overall use of color, the treatment of the water surface, the treatment of the sky and its reflections on the water; the depiction of shoreline around the Golden Gate, the treatment of steam and smoke coming from ships, and a common foreground motif of men in a rowboat. It was unmistakably the same hand and eye at work.

The closest comparison was with Coulter's famous masterpiece *San Francisco Fire, 1906*, which was beautifully presented in vivid color across two pages of the booklet. Following the great earthquake on April 18, 1906, a monstrous fire continued to burn for three days across the city; its flaming presence became mirrored on the bay, a sunset from hell. Coulter, who was sketching the scene for the *San Francisco Call*, rode back and forth on the Sausalito ferry helping in the evacuation of

San Francisco. This was the scene depicted in Coulter's unforgettable eyewitness painting.

In our painting, the dark smoke rising from the grand procession of ships merged dramatically into the sunset sky of reds and oranges, which in turn reflected into the water like glowing red embers of a fire. Rather amazingly, the style and palette and dramatic effect of our painting echoed the painting of the great burning city. The relationship of both compositions was uncanny and unquestionably tied the two paintings to the same hand and probably to another important event in San Francisco history.

Judging from the evidence in the Coulter monograph, not only was our painting lost and unknown, I felt that its scale and subject matter could warrant its rankings among his greatest and most important works, clearly taking its place alongside *San Francisco Fire, 1906*. But what was the event commemorated in the painting? And who or what was "S. Weber"? My only answer to the puzzle so far was the artist's name, and of that I was certain.

Months passed and the painting finally emerged from conservation in July, reincarnated and, at first, lovely to behold. The process, however, had been troublesome and arduous and highly stressful. Conservation, ultimately, would now cost $4,000. This necessitated creating a partnership in the painting to get the bill paid and to secure further funds for some advertising of the Coulter. My occasional investment partner, Rutgers Barclay, came to the rescue, and that meant sharing future profits. Soon, another snag developed. After closer study, many disappointing repairs to the painting became apparent, and I informed the conservator that the work had to be redone, which he imperiously refused to do so without further payment. We parted ways. Luckily, another conservator had recently appeared on the scene, a young man from New York, the talented John Andolsek, who I have been using ever since, and John got it beautifully right. Without the help of conservators, those plastic surgeons to ailing paintings, no dealer in antique paintings could succeed and many important paintings would be lost to art history. Virtually every Old Master painting in the museums of the world has been nurtured by a master conservator.

Instead of inquiring after the subject of the Coulter right away, I anxiously asked for opinions and a suggested value for Coulter's work from a dealer I knew in San Francisco. Somehow I wasn't too surprised when he criticized the

painting, saying it was too dark and had too much work done on it, nor could he offer any ideas as to its subject. He offered a few thousand dollars if I wanted to "turn it." Luckily, I didn't want to turn it too quickly.* Steady as she goes.

I started to make inquiries into the subject and began by first calling the National Maritime Museum (NMM) in San Francisco. It was mid-August and a time when the art world generally takes the month off. In Santa Fe, however, I was busy following clues in the Coulter mystery. Lucky for me, I found an amazing man at his post in the NMM library. William Kooiman—maritime historian, author, former crewman on the legendary World War II battleship *New Jersey*, retired ship's purser, and volunteer librarian—answered the phone and was interested in helping. At the time, I knew nothing of his fascinating background, and he even apologized that the reference librarian was on vacation. I quickly sent off an image and information to Kooiman and within a week I had a letter from him.

> *Dear Mr. Kline:*
>
> *You will be pleased to learn that I am of the opinion that I have made an identification of the Coulter painting depicting a fleet of vessels entering the Golden Gate. I first contacted Mr. Tom Coulter* [the artist's grandson] *but he had no knowledge of this particular work. At first I thought it depicted the arrival of the first Japanese diplomatic delegation to the U.S. in 1860, led by USS POW-HATAN. But a description of POWAHATAN did not match the configuration of the steamers shown in the painting. Also the tugs were of a later date. I then contacted our collection department as they have about 15 Coulter paintings as well as many sketches. As luck would have it, they have a very similar painting showing the arrival of ex-President Grant from his extended round the world tour. Please refer to the enclosed photocopies taken from the "San Francisco Alta" of September 21, 1879. The lead vessel was Pacific Mail's new*

* Nine years later, while reviewing Coulter's auction prices at AskArt.com, I belatedly learned that a large and beautiful painting of his, a generic *Sailing Ships in San Francisco Bay*, had sold the year before my inquiry, at Butterfield's in San Francisco for $68,500; in 2008, Coulter's highest price at auction was $228,000 for a comparable work, but one with no historical significance. At the time in 1997, and without ready access to the Internet yet, this valuable auction data had, alas, escaped my attention.

steamer CITY OF TOKIO. The other vessels in the arrival reception
are also described. I believe a book on Coulter is sorely needed. Lastly,
it was fun (and a challenge) doing this piece of research.
 Sincerely, William Kooiman

 Of course I was thrilled! The tattered and homeless painting in the consignment shop had been transformed into a rare and historically important American painting, and of a quality that would place it among the nation's most notable 19th century maritime paintings.

 The icing on the cake was its new value, which I estimated at $125,000. The pricing of art is a highly specialized calculus art dealers formulate from public and private values, both of the actual artist and comparative artists, and from connoisseurship, which is based on knowledge and experience and the quality of the work. Coulter had, at the time, very few auction results and none that I was able to easily track. I was, however, aware of, and had tracked for years, the strong regional market in 19th and 20th century California paintings—with rare and historic 19th century California works bringing prices in the range of $50,000–350,000+, even by little-known artists. If the condition of *General Grant* had been better, I would not have hesitated to push it to its highest value. As it was, I already felt richly rewarded to have discovered it and brought it back to life. In the end, pricing art is a subjective call, like the recognition of quality and not unlike love. When it comes to prices, I tend to side with the legendary dealer Sir Joseph Duveen, who said, "When you pay a high price for the priceless, you're getting it cheap."

 After studying a slide of the comparative Coulter painting of Grant's arrival in the NMM, I wrote to the curator regarding questions that it had raised. In my opinion, their painting, much smaller and somehow dated 1879, was clearly of a later vintage stylistically, a fact I determined from comparative examples illustrated in the Coulter monograph. Coulter had doubtless revisited the event much later due to popular demand and predated it to represent the year he painted the actual historical event. Our painting reflected the rich dark hues of French and German influence on Coulter's style, and quite appropriately, since he had just returned from several years study in Paris and probably Munich or Dusseldorf. Additionally, its vibrant

detail suggested ours was an eyewitness view of the event. I then informed Bill Kooiman of an amazing detail I had just uncovered.

It had finally dawned on me to wonder why General Grant was not depicted in this grand event. How could he be left out? In the very detailed *San Francisco Alta* reporting of the event, we are directed to "the hurricane deck where stood General and Mrs. Grant." If Coulter was out in the bay on one of the boats, I reasoned, he would have seen the Grants and certainly included them in the painting. With this direction in mind, I approached the painting with my loupe and went to the City of Tokio and found the hurricane deck and began searching with a magnified eye.

"My god, there they are!" I let out a whoop and called Jann over. She looked and gave me a big hug and it was quite emotional with tears in our eyes. We were looking back through the mists of time into another dimension, and there they were, waiting for us on the hurricane deck. I could swear I saw the General give me a quick wave of the hand. They were all the more real as tiny distant figures, sharply etched and carefully rendered, standing there alive and well, as if Coulter had just caught a glimpse of them. There was the bearded general in a suit and his wife in a beautiful formal gown looking right at me. I was overcome, catching my breath, as if I had actually seen them in the magic of that moment, as Coulter had.*

* A brief related anecdote comes to mind that I cannot resist telling. When I was in Washington, DC, in the 1970s, on the editorial staff of *National Geographic*, one day at high noon, I stood on a crowded street corner and turned to see Abraham Lincoln standing next to me, shockingly alive, a tall older man in a black suit complete with top hat and beard and a great weathered face—obviously, a Lincoln impersonator, and as good as it gets. I had a beard at the time myself, and people had pointed out my resemblance to the face of Grant on the $50 dollar bill.

"Hello, Mr. Lincoln," I said. "Don't you recognize me? It's General Grant!"

"Ah, so good to see you again, general," Lincoln said with a good laugh, and we shook hands as if old friends.

"You're looking well, general."

"And you too, Mr. President. Have you had lunch?" I asked.

He hadn't and so I invited him to join me in the *National Geographic* dining room, and I must say it turned into a wonderfully amiable historic event. Abraham Lincoln, as it transpired, was a delightful man of some fame who toured the country giving speeches on humanitarian issues. In the dining room we went to a number of tables and I introduced him to astonished friends. Following my introducing him, he then introduced me, "Have you met General Grant?" I couldn't help laughing at the coincidence when I spotted General Grant, years later, standing on the hurricane deck. I had once been a Grant impersonator!

I learned that the museum most interested in historic California paintings was the Crocker Art Museum in Sacramento and so decided to offer the Coulter to them at $125,000. They were interested after seeing transparencies and wanted me to send it on approval at my expense and, if need be, pay for its return, as well, if they passed. It is standard practice for dealers to share the shipping expenses for a painting sent on approval, but here the imperious museum curator was bullying me to shoulder the entire expense so they could look at it. Their cheap attitude gave me a sinking feeling, but I went ahead. A week later, the curator called to say they were "unable to pursue a purchase"—in a voice that would have withered a prune.

"What's wrong?" I asked her.

"I'm sorry," she said. "We are uncomfortable with the amount of conservation."

"It's in unimportant areas. Most of it is in the dead black of the bow of the lead ship, filling in the cracks with black. Why would you object to that?"

"I'm sorry."

"Most of the other ships are barely retouched. General and Mrs. Grant are pristine. The flags are all there. The water and the sky are only minutely made up. A few cracks in the paint are filled in. Some areas around the edges are in-painted. How can you reject a painting of extraordinary historical importance to California because of restoration to minor areas? It's a masterpiece by Coulter, an eyewitness historical painting for Christ's sake, a beautiful painting."

"I'm sorry."

"I expected connoisseurship for all the trouble I have gone to."

"I'm sorry," the prim curator said, and she had nothing else to say.

Before long, with the help of a San Francisco associate, Peter Fairbanks of Montgomery Gallery, we accomplished a handsome sale to a private collector in San Francisco who will no doubt donate the painting someday to a California museum (not to the Crocker, I would hope). It was one year to the month from when we had discovered it.

Nevertheless, several questions remained unanswered at the sale. There was no provenance, no historical information regarding ownership—only the consignment shop, which said it had come from a collection of odds and ends left in a storage facility, which was their usual response for other works I had found there. The answer to its past was destined to remain a mystery. And another important clue was left dangling and unexplained. Who or what was the S. Weber of the inscription? Such a vivid piece of evidence had eluded our investigations.

Ship's Log 2005

Seven years later, on November 28, 2005, with the mystery of provenance and inscription long faded from my mind, answers to the questions began to materialize from out of the blue. I had published the Coulter painting and the research on my website around 1999, and anyone searching for the artist or General Grant's Grand Tour would have found it on the Internet through the divine Google. In all those years, I had heard from only a few collectors wanting to buy it if it became available again, including one of Coulter's grandchildren. Then Barbara Skryja, a Forestville, California, historian, sent me an email. The amazing sequence of emails that followed solved the mystery.

Dear Mr. Kline:

I am a historian writing a biography of Kate Johnson, a 19th century San Francisco philanthropist. Mrs. Johnson was the benefactor for the founding of Mary's Help Hospital (now the Seton Medical Center). She hoped her vast art collection would be maintained as a gallery to support this bequest. Unfortunately, after her death in 1893, the collection was sold at auction. My research has been a slow and tedious project, working from vague newspaper citations and old auction catalogs. Mrs. Johnson owned W.A. Coulter's painting "The Arrival of Ex-President and Mrs. U.S.Grant . . . September 20, 1879, As Seen Passing Through the Golden Gate . . ." Some years ago I was allowed to examine the Coulter painting at the National Maritime Museum and I realized it was painted too late to have belonged to Mrs. Johnson.

Fortunately, I can now search for additional information on the internet where I found your gallery's entry under W.A. Coulter. I would like to contact the current owner for permission to cite this painting and possibly use the image in a published article and/or book.

Obviously delighted to hear from her, I responded and briefly recounted my experiences from memory. The next day I found my Coulter file and sent additions and revisions to what I had remembered. We emailed back and forth for several weeks when I suddenly remembered the mystery of the S. Weber inscription.

Dear Barbara:

In reviewing my material, an interesting detail of the Coulter painting has come to my attention. It was inscribed at lower left (recto)—"S. Weber". I could never figure it out. Could it be an inscription to someone who had commissioned it and perhaps sold it to the Johnsons?

Barbara replied two days later, December 21.

Dear Fred:

The inscription you described may have a connection to Kate Johnson. Her niece Suzette married C. Frank Weber in 1893 . . . Suzette, her brother, and several sisters lived in the San Francisco Bay Area . . . Since Kate Johnson hoped her art collection would be kept intact as a gallery, she did not name family members as heirs to any of her major paintings. (She possibly gave away some pieces before her death.) A few relatives found themselves bidding for items at the auction. (I'm not sure the newly married Webers would likely be buyers.) Unfortunately, I do not know who, if anyone, purchased the Coulter painting at the Nov. 1894 sale. The odd placement of the inscription makes me wonder about the date of the Coulter painting. Did you come up with a theory about why Coulter painted the later version in the Maritime Museum? Could [yours] have been another copy?

This was amazing! Barbara Skryja had supplied the last missing piece of the puzzle. I wrote her back on December 22.

> *Dear Barbara:*
>
> *Thanks for the information and for clearing up the mystery about the Weber inscription. Suzette Weber makes the only sense. Bravo! It might have originally read "for S. Weber." Kate Johnson may have given niece Suzette the painting and Suzette could have later asked Coulter himself to inscribe it. I have seen that type of inscription on many paintings. The Coulter at the Maritime Museum is obviously a later reprise of the historic event. Coulter may have painted more than two if the demand was great. The one I found leaves little doubt that it is the original. My judgment is based on its high painterly quality, its important large size, the immediacy and vitality of the scene including the Grants standing on deck, and its discernible age. Merry Christmas and congratulations on solving this mystery.*

On a little known voyage, General Grant had gone 'round the world again, this time with the artist William Coulter and me, and he had finally come home to a safe harbor.

CHAPTER 9

The Genesis Cross

Indo-Christian (post-Conquest Yukatec Maya), Mexico ca. 1521–1550; *La Cruz de las Cuatro Flores.*
Carved Wood 13 ¼ high x 7 ¾ wide x 3 ½ deep; Copyright © 2015 Kline Art Research Library

The Appearance of the First Christian Crosses in Mexico

In his 1519 eyewitness chronicle, *The Conquest of Mexico*, Conquistador Bernal Díaz del Castillo wrote: "The Captain [Cortes] had the ships' carpenter make these first crosses of wood, and set them firm before the pagan temples."

∽∾

By 1520, the Council of the Villa Rica de la Vera Cruz had already written to the King and Queen of Spain: "Your Majesties must know that when the Captain [Cortes] told the chiefs in his first interview with them that they must no longer live in the pagan faith which they held, they begged him to acquaint them with the law under which they were henceforth to live. The Captain accordingly informed them to the best of his ability in the Catholic faith, leaving them a Cross."

∽∾

Two decades later, Fray Toribio de Benavente Motolinia, a mendicant friar, wrote home to Spain circa 1540, after some twenty years of Spanish rule: "Throughout this land the symbol of the Cross is so exalted, in all the towns and along all the roads, that they say there is no other part of Christendom which so exalts it, nor where there are so many and so fine and such lofty Crosses; and especially noble are those of the churchyards, which every Sunday and feast day they adorn with roses and flowers and bowers and garlands. . . ."

The First Transformation of the Christian Cross

In their 1993 book, *Maya Cosmos: Three Thousand Years on the Shaman's Path*, two noted American anthropologists, David Freidel and Linda Schele, wrote: "Perhaps the most dramatic example of this transformation [of the ancient Mesoamerican religion] is embodied in the Maya's adaptation of the Cross of Christ, the central symbol of European domination. The Maya promptly appropriated and reinterpreted this most Christian of all symbols by merging it with the World Tree of the Center, the yax che'ilkab as the

Conquest period Yukatek Maya called it. The Christian cross became, quite literally, the pivot and pillar of their cosmos, just as the World Tree had been before."

The Merger of Christian and Precolumbian Maya Cross Imagery

In his study of the cross in Mexico, Harvard anthropologist Evon Z. Vogt wrote: "The ancient Maya 'cross' (world tree) and the Spanish cross were indeed startlingly similar in form but quite different in basic meaning. The Maya 'cross' symbolized the world tree, the axis mundi, and was personified (which surely indicated that it had an inner soul) and clothed (in jewels and mirrors), and had a spiritual relationship to supernatural ancestors. The Spanish cross was basically a structure on which Christ was crucified, but, at least in some Catholic thinking, was related to the tree of life in paradise (Nunez de la Vega: 1988), a concept that is similar to the Maya World Tree.

"After syncretism [cultural melding] the ancient Maya symbolism was added, but some new meanings were added, or at least strongly emphasized by the Maya: the cross as a boundary (between Nature and Culture, between woods and town); the cross as a guardian; and especially the cross as a symbol of collective identity for families, lineages, hamlets, towns. Further, I suspect that not only in Yucatan (Farriss 1984: 314), but in Chiapas and Sonora as well, the plethora of crosses are manifestations of drawing ideological support and symbols from Christianity to oppose Spanish rule and bolster Indian power."

<center>⤜∞⤛</center>

My discovery of a first Indian-Christian cross of the Americas in 1999 seemed as fated and as remarkable as the discovery *La Virgencita*—a first Indo-Christian representation of the Virgin Mary—had been five years before. Both were long-lost, Genesis-like objects from the first transitional years of Indo-Christian religious practice in the New World. Amazingly, both have developed into crown jewels of Mexican art and religious history. The creation of the cross, as with *La Virgencita*, closely followed the Spanish Conquest of Mexico in 1521 and the church-directed mass

conversion to Christianity of the indigenous people within the conquered Aztec Empire. Named *La Cruz de las Cuatro Flores (The Cross of the Four Flowers)*, the cross is attributed to an unknown Mesoamerican artist, very likely a Yukatek Maya Indian (from the Yucatan region) who had recently been "converted" to Christianity.

Cuatro Flores—unlike the traditional, unadorned Christian cross of the Conquistadores—integrates symbols of seeds, feathers, and flowers, which represent the 4,000-year-old Mesoamerican (or Precolumbian) religious tradition of the World Tree. This belief developed primarily in the ancient Maya culture, and this World Tree Cross is worshiped among the Yukatec Maya in the regions of Chiapas, the Yucatan, and elsewhere in Mexico today. To the indigenous people of Mexico, the World Tree represented a primary creation myth connected to the tree of life, agricultural and human fertility, and the cycle of seasons—attributes which were not attached to the Christian tradition.

Until the appearance of *Cuatro Flores*, the existence of a post-Conquest World Tree Cross was a hypothetical and legendary object, vanished into the mists of time—or most likely, destroyed by the Spanish Inquisition in their purge of all things deemed pagan and heretical. *Cuatro Flores* appears to be the sole survivor from that period, yet it represents the hidden spiritual heart of Mexico and the transformation of the ancient Mesoamerican religion at the point of the first European contact.

The Appearance of a Mysterious Cross in Santa Fe

"Lots of interest in this," the dealer said, referring to the cross in the display case, which I was eyeing intently. The cross's unique quality had caught my eye as I strolled through the crowded antique show on this long Fourth of July weekend in Santa Fe. This was the first day of the show's three-day run in the summer of 1999, and I had walked over to the Sweeney Center (now Santa Fe Community Convention Center) from my nearby gallery.

The dealer displaying the cross was a respected specialist in Spanish and Mexican Colonial works of art, the late James Caswell from California. I had bought a few things from him in previous years. When I asked about the cross, he mentioned that two prominent Spanish Colonial dealers had

already examined it, but neither one could figure it out. He was selling the carved wood cross for $1,200 and describing it as Hispano-Moorish from Mexico, circa 1700s.

"I've been after it for years in this collection in Guadalajara, and the man needed some money this year and finally sold it to me." I knew Caswell didn't make things up.

"I'm not an expert in crosses," I said, "but this seems really exceptional. How come you're not asking more?"

"I guess I don't want to take it home. You can have it for $900."

At this point, I was merely admiring this very provocative and beautiful artifact and asking a few questions, and it was not unusual for me to express admiration to other dealers for works I liked. You can't buy everything, and an exotic cross was not on my list, but its extraordinary quality had stopped me cold and drew me to it in spite of my original intentions.

Could the cross be early 16th century Mexico, with an Indo-Christian quality that was going unrecognized? I hesitated to mention my hypothesis. I could see the merit of Caswell's attribution—based on its suggestive Moorish, or Moreno, decorative details—and I even considered Ethiopian as a possibility. If Moreno, a carryover from Spain's 700 years under Muslim rule which ended in 1492, it would certainly be rare and important, too. But I kept seeing the iconography as Indo-Christian, and possibly in a Maya or Aztec style, a highly unsuspected overlay to find on a wood Christian cross from Mexico. The style was ridiculously rare and esoteric, and the fact that it was a wood artifact from the 1500s, as opposed to even material from the 1600s, was equally unusual.

Of the thousands passing through the show over this summer weekend, I would venture that I may have been the only one seriously entertaining this Indo-Christian hypothesis—at least the only one that might have admitted to it being a real possibility. My slight advantage came from studies of *La Virgencita*, the Indo-Christian-Aztec statuette of the Virgin Mary I had discovered, which at that point I still owned.

The possibility of another Indo-Christian discovery had stayed in my mind. *La Virgencita* had already been authenticated and exhibited in museums and published in a number of places, including three scholarly books. After

my successful identification of *La Virgencita*, I stayed open to the possibility that lightning might strike twice with a related object, and this second time around, I would already have a sizeable knowledge base in place.

On the following day, I made my way around the antique show once more. I kept coming back to the cross. It was a mystery to everyone who had seen it. I was close to buying it, certainly thinking about it, and was not feeling pressure from other interested parties. Perhaps I was deluding myself about its rare and improbable Indo-Christian quality. I was still resisting the prospect of time-consuming research that it could represent despite the base knowledge already acquired from my research for the *Virgencita*. If true, however, this would give the cross a circa date of 1521 into the 1550s and, like *La Virgencita*, it would be an unprecedented transitional relic from the dawn of New World history in Mexico. I could name my price. But still, I deliberated.

On the afternoon of the third and last day, I returned for one more look. Nobody could figure it out, Caswell said. The cross was aesthetically beautiful with a very unusual and brilliantly carved decorative quality that compelled me to keep wondering if this could be the Indo-Christian rarity I imagined. I had never seen decoration on a cross quite like the carved cryptic shorthand that covered the front and sides and base, and framed the four recognizable flowers. I had concluded it wasn't yet another baroque Ethiopian cross, a logical guess I had been wrestling with, since I knew the decorative symbols were foreign to Ethiopian motifs.

Could I afford the investment of time and money for another mystery? The *Virgencita* project had been exhausting, and at this time, I had not yet sold her.

But—some things are so rare and mysterious that perception becomes clouded, and you just stand there in wonderment and inaction. Finally, I removed the cross from the illuminated display case and held it for the first time. Up close, I could readily appreciate that it was centuries old. Its surface was pristine, with no wax or oil or added finish, and the wood had aged to an almost metal-like patina. I was startled to recognize that the cross was actually tripartite—with a crossbar and upright and base seamlessly fitted together. The unusual base of the cross was two-tiered and detachable from the cross, yet unquestionably original with related aging

and markings. Of all things, one tier of the base itself was supported by large seedpods, suggesting the cross may have sprouted from them. It was miraculous that the base hadn't been lost! What I had first seen as a blemish materialized as a black wrought iron nail that had been driven through the small central flower and held the crossbar and upright together. The nail continued surprisingly to the back of the cross where, hidden from view, the long spiked stem bent gracefully downward suggesting the root or sap of a plant—or even, I imagined, the dripping blood from Christ's crucifixion. The nail was a dazzling touch of artistry. Wrought iron technology had been quickly introduced by the Spanish, and its great utility soon replaced the stone tool culture of the Mesoamericans. The cross itself may have been made with an early iron chisel, but not necessarily—Precolumbian artistry with traditional stone tools was of the highest order, but stone tool use on wood offered only the rarest of comparisons.

Using my loupe, I could see that the surface of the cross was covered with minuscule aged flyspecks, which was unique to wood, and unlike the mineralization that forms on ancient objects of stone, metal, and glass. Based on my experience with wood antiquities from tribal Africa, and even ancient Egypt, I knew the flyspecks could have accumulated over centuries, likely in a warm climate zone where flies flourish. If kept out in the open in a tropical setting, the wood cross surely would have disintegrated—but obviously, judging its beautifully preserved condition, the cross was safely stored at some point in its history.

The topography of Mexico was as diverse as any on earth. And the trail of the Spanish conquistadores had spread northward from Vera Cruz on the Gulf coast and Acapulco on the Pacific coast, to the mountainous valley of Puebla, to the mile-high swamplands of Mexico City, and continued on the Camino Real into northern Mexico, and then further northward into distant Nuevo Mexico and Santa Fe, where I stood studying the cross.

Caswell was very knowledgeable, but he and the other interested parties had not pushed their imaginations far enough and were still circling around the Hispano-Moreno origins of the cross, instead of casting a wider net into the New World. Finally, after continued examination and deliberation, the mystery and the beauty of the cross became too compelling, and I had

to take the chance. Next thing I knew, the cross was mine! The strong emotional response caught me by surprise. Along with *La Virgencita*, I now had the responsibility of another lost orphan to care for. I dared to imagine a spiritual reunion of a lost son, with the cross, and to his equally lost mother, *La Virgencita*. This chance convergence was staggering.

I carried the cross in a paper bag back to the gallery and placed it on the shelf by my desk where *La Virgencita* stood. It seemed an uncanny coincidence to have them together. Now side by side, a current of kinship sparked between the cross and *La Virgencita*, and back at me.

How could I have waited to the end of the show, leaving it to chance, waiting for anyone to take it away before I acted? Strangely, I felt no urgency at the risk of losing the cross throughout the entirety of the show. It was odd indeed, this feeling that I would eventually come into possession of the cross. I could not deny it, nor could I explain it in any rational way. This was not a new perception for me, but now I was really looking at it, and finally, with a renewed faith and my eyes wide open to the work that was ahead of me.

<center>⸎</center>

As with *Virgencita*, and so much else I had discovered, it was clear that most often, objects found me providentially, beyond a rational explanation. It was always a surprise, and immensely satisfying, to see it that way and made the work flow more easily. I loved the magic and serendipity of it all and the fantastic idea that I could be the catalyst for lost art.

It probably sounds peculiar to admit it, but my quest for lost art had been, for the most part, nonspecific. I had rarely searched specifically for what I found. Yet, in this case as I clearly remember, going to the show subconsciously daydreaming that another Indo-Christian object might turn up. I trusted the metaphysics of chance to guide me, remaining open-minded and having faith in a possibility that was anyone's guess. I suppose this was something like an optimistic fatalism.

I was reminded, as I often was, of Robert Pirsig's "metaphysics of quality," which long ago had resounded with refreshing insight in his brilliantly argued philosophical novel, *Zen and the Art of Motorcycle*

Maintenance. I had read its first edition in 1974 and now—more than five million copies and thirty printings later—its music was sweeter, an old violin replayed when I would return to it. It was a magical book. Pirsig would later describe the field of metaphysics as a restaurant with a menu of 30,000 pages and no food—a Zen-like riddle suggesting the restaurant fed the mystical human spirit. Metaphysics—a branch of philosophy—offered a menu of spirit food, all in your mind, like seeking the sound of one hand clapping. "Quality," I finally understood, was one such spirit food of the mind—indefinable but still existent, as Pirsig realized—but when I went into the quiet zone, I could hear its music. The metaphysics of quality, along with my own particular iteration of the metaphysics of chance, and the Zen-like mystical consciousness of both ideas, clearly informed my quest, and luckily for me I had a muse named Jann who was my romantic inspiration—and, I might add, a great cook!

Ultimately, along with the aesthetic imperative of "quality" and the mystical imperative of "chance," I also had a materialistic imperative to fulfill if I were to profit from the mysterious art that, by chance and its quality, crossed my path. That materialistic pursuit could then put real food on a real table in a real house with a real roof over it, and real books on a shelf, pencil and paper, logs burning on the fire, a soft bed to sleep on, and brave dogs guarding the door. I do have a practical side in spite of being an optimistic fatalist, and I am always searching for a way to facilitate the convergence of these two elements.

I now realized that this optimistic fatalism has guided me over the years as a generalist art explorer. I always felt my strengths were best suited to being a generalist connoisseur, versus seeking out a specialty as so many often do, whether it is focusing on Navajo rugs or Rembrandt school paintings, Staffordshire figurines or Japanese netsuke. A specialist's pursuit, while commendable for its focused connoisseurship, would have rapidly become routine and lose the spontaneity I craved. My decision to stay a generalist is not a popular approach in the art world today, but the opportunity to freely drive a wider road and take up a new and unexpected challenge with each project is one that far outweighs any pushback that might come from other specialists in the art world. As Pirsig noted, metaphysics can easily drive one crazy, whether of "chance" or of "quality,"

but I hope my mindset proves helpful to any other pilgrims looking to travel a similar road.

<center>◦◦◦</center>

Now, with the cross, I better understood how it fit into my lifelong quest for lost art. I was understanding again in a loose philosophical sense what I was doing in my art explorers' quest. There was the simple desire for a serious challenge, the craving to escape from the monotony of complacent knowledge and the mundane workaday, and the ever-thrilling desire to venture into the unknown. Nevertheless—I had to face the fact that I was in love with a vague and sublime notion, what I called the play of things in the poem of the world, in all the diverse ambiguity of that idea. There had always been a voice inside my head saying, "Show me the magic!"—reprising a memorable line spoken by John Cassavetes in one of my favorite movies, the Shakespeare-flavored *Tempest*. Why not encourage miracles from life? Einstein himself knew the secret when he said there are only two ways to live your life: one way, as though nothing is a miracle; the other way, which he and I preferred, as though everything is a miracle. Now that I had rescued the cross, I would have to wait and see what it had in store for me.

<center>

III

Four Flowers
</center>

Jann was wonderfully excited by the cross and agreed with my Indo-Christian hypothesis. Her initial benediction over *La Virgencita* had given that project, and me, the sweet inspiration I needed, and the cross quickly came under her spell. She noted right away that flowers—major symbols in the Aztec tradition—linked the cross with *La Virgencita*. *La Virgencita* had two floral designs and the cross had four. Then and there, we named it *La Cruz de las Cuatro Flores—The Cross of the Four Flowers*. A christening always marks a serious beginning for us, and in this case it happened quickly. It was no longer just a generic cross. It now had a name and stature in our eyes, and even the connotation of a garden. As it stood for the moment, it was *Four Flowers* in search of a gardener.

<center>315</center>

⤟

Before long, I called my wunderkind friend, Dr. Khristaan Villela, a noted Precolumbian and Spanish colonial scholar, then the Thaw Professor at College of Santa Fe and already chairman of the Art History Department. Soon Khristaan came to the gallery. In less than a minute, he agreed with my attribution that the cross was probably early 16th century Indo-Christian and Maya-Aztec influenced. Just like that! Before I could catch my breath, he noted the cross's Indo-Christian qualities: its symbolism rooted in nature and fertility; its indigenous ornamentations suggesting seeds, feathers, flowers, reproduction; and possibly cryptic calendar numbers. He recognized its ephemeral style called *tequitqui* [*ta-key-key*], an Aztec word denoting the flavor of the earliest post-Conquest period—as with the style of *La Virgencita*. Khristaan then directed me to a book by two noted anthropologists, his late and legendary mentor Linda Schele of the University of Texas, and her brilliant associate David Freidel of Texas A & M. The book was *Maya Cosmos: Three Thousand Years on the Shaman's Path*, destined to be the most important book in my research on *Cuatro Flores*. It was an incredibly valuable bit of feedback, as I had not yet thought of its Maya relationship.

It was in *Maya Cosmos* that I discovered we not only had an Indo-Christian Cross of Christ, but a cross with a Maya-Aztec World Tree integrated into it—a "World Tree Cross"—which was like a Tree of Life in all its mythological Mesoamerican complexity. The World Tree itself was considered a living thing with a soul, and in it dwelt the continuum of not only nature but the religion-infused ancient culture of Mexico as well. An Indo-Christian World Tree Cross was a chimera come to life. And an important part of the history of Mexico was thus revealed within.

IV

The Conquest of Mexico Revisited

Cortes and his 400 conquistadores landed at Vera Cruz in 1519, amid people living within the Maya culture but under the Aztec Empire's influences and domination. The Maya culture, at that point, after some 3,500 years, had reached the lowest point of its power and influence. Gradually,

with the help of the Yukatec Maya and thousands of other Mesoamerican Indians seeking to overthrow the exploitive Aztec Empire, by 1521 and under the banner of the Virgin Mary, the bloody Conquest of Mexico had taken place. The New World Spanish Colonial era had begun in North America. As loyal Catholics, crosses were the first Christian symbols to be disseminated by the conquistadores. It was only some thirty years after Columbus had first landed, mistakenly on his way to China and the Indies. To the Maya, the Christian cross was no doubt recognizable as a very simplified World Tree of their ancient religious tradition, but one with a blank slate, like a first effort made by a child who could not yet perceive the complex overlay of symbols required to consecrate the cross and bring it to life. It was an unforeseen beginning and an astounding spiritual connection.

∞

As prophesized by Montezuma (1466–1520)—the Aztec chief from 1502 until his murder by Cortes in 1520—a new day had dawned with the arrival of the godlike conquistadores, who seemed to step out of a dream, like aliens from another world. With their never-imagined horses and firearms and animal-like beards, their steel armor and swords, and a language never heard under the sun, the conquistadores had arrived. But, in one of the most amazing coincidences in recorded history, the crosses of the conquistadores were instantly recognizable to the Indians, as were the related attributes of Christian theology and its supporting mythology. A fortuitous convergence of religions if ever there was! The time for transformation had come. The metaphysics of chance had landed in the New World with a big bang. And I was in the thrall of what I was seeing with *Cuatro Flores*.

I was on my way again into the labyrinth of Mexico, which I had entered five years before with *Virgencita*. A labyrinth is just a small part of it. It was time to get lost again in the cross-cultural cosmos that was Mexico, where getting lost is the only way to find your bearings. Here, one thing is always another. Duality, or even greater ambiguity, is the right perception of the great singularity that is Mexico. You accept being lost, and just relax and allow for new understandings and discoveries to reveal themselves.

V
A Measure of Rarity

The symbol of a cross began, as far as we know, as a cross-like proto–World Tree in an Olmec culture over four thousand years ago and evolved over several thousand years into an elaborate Maya World Tree Cross around A.D. 300. Then the World Tree became transformed cross-culturally around 1300, into the newly established Aztec Empire, two hundred years before the Conquest of Mexico. Finally with the Spanish Conquest, the World Tree merged into the Christian cross.

A flowering cross, similar to *Cuatro Flores*, can be seen in the circa 1400–1521 Mixtec-Aztec World Tree painting on animal skin, which is illustrated in one of the few surviving Mesoamerican ritual books—the *Codex Fejervary-Mayer*. The codex delineates the Mesoamerican *axis mundi*, their traditional view of the world.

Codex Fejervary-Mayer.
The National Museums and Galleries on Merseyside, Liverpool, England

The World Tree illustrated in the codex, designated "North Tree," to the left of the also north-facing central deity, exhibits remarkably comparative features to *Cuatro Flores*.

Detail of "North Tree," *Codex Fejervary-Mayer*.
The National Museums and Galleries on Merseyside, Liverpool, England

Cuatro Flores

At its heart, however, the cross in Mexico had always been Maya. After the Conquest, and very briefly, the World Tree transformed again and integrated into the Christian cross, which this discovery represents. That last transformation did not survive, once the notorious Spanish Inquisition caught sight of it. The Inquisition, transplanted into the New World with government officials and some priests, banned Indian artisans from creating religious objects, their motive being to erase all vestiges of the pagan religions from Mexico. What the Inquisition found was destroyed. The total destruction by the conquistadores of the magnificent Aztec capital, Tenochtitlan, on the site of present-day Mexico City, is historical proof of the birth of this intention. However, it should be noted the destruction of a conquered culture was traditional in Mesoamerica, and the Aztecs themselves were just as guilty.

With the Conquest, the ancient religious traditions had to go underground, where they remain today, still alive in thought and folkways but somehow always merged with the unavoidable mythos of Catholicism. *Cuatro Flores* is probably the earliest and purest known memory of that transition and, as such, materialized as a relic of the greatest significance and rarity. I could not find another recorded example that was produced in that earliest period. The Inquisition was very methodical in their destruction of "pagan" influences.

Miraculously, something very close to *Cuatro Flores*, with the same purity of concept and iconography, has survived in Mexico, most notably in Chiapas churches where a strong and dedicated Maya-Catholicism is practiced into the late 20th century. Green-painted world tree crosses can still be found in use there as a living object, worshiped partly in the Precolumbian Maya tradition. In fact, a tiny remnant of ancient green paint was discovered on *Cuatro Flores* in an early examination by materials scientist Dr. Susan Barger, who had also made an important materials discovery with the stone composition of *La Virgencita*. The Maya-Catholic World Tree Cross of Chiapas stands as the incarnate link to the ancient Mesoamerican cultures of Mexico, and its continued use has on occasion been fiercely defended with deadly force. The tradition is still a thorn in the side of the Mexican Federal State, which fears the resurrection and inherent political power of the indigenous people, which is to say the *real* Mexico. But that is another story.

Maya-Catholic World Tree Crosses, San Juan de Chamula, Chiapas, Mexico

My hypothesis of *Cuatro Flores* had proved correct, with important early refinement from Khristaan Villela and from Indo-Christian scholar Dr. Manuel Aguilar of California State University, Los Angeles, who examined and authenticated the cross in Santa Fe in 2005.

Vitally important additional support, regarding scientific dating and geographical placement—which was based on a dendrochronological study of the tree rings found on the base of *Cuatro Flores*—was discovered by Dr. Louis Scuderi, of the Department of Earth and Planetary Sciences, University of New Mexico. Scuderi's study—"Dendrochronologic Dating of *The Cross of the Four Flowers (La Cruz de las Cuatro Flores),*" January 22, 2004—confirmed my hypothesis of the cross's circa 1521–1550 dating and, amazingly, additionally discovered the date and location of the cut-tree from which the cross was crafted, to circa 1535 in the Puebla region of Mexico.

∽∞∾

No major obstacles had appeared. The swift acceptance of the cross was remarkable and very welcome in its smooth sailing, but in understanding its complexity, the doors keep opening. Now we could see, with a certain literalness, what had appeared in the early New World transitional period, with a real artifact that could fill in a beginning of the story which had been a legendary question mark.

Cuatro Flores is still in my private family collection, where I have delighted in its presence for many years. It should be publicly appreciated, and it will be, with a future loan to a museum interested in the cultural history of Mexico. For now, like *Holy Child*, the first exhibition of *Cuatro Flores* is here, to be widely enjoyed in the pages of my book.

<div align="center">❦</div>

LA CRUZ DE LAS CUATRO FLORES: EXAMINATION AND AUTHENTICATION

Manuel Aguilar, Ph.D., Associate Professor, Department of Art
California State University, Los Angeles

On December 8, 2005, in Santa Fe, New Mexico, at the invitation of Fred R. Kline, I inspected firsthand a small carved wood cross called *La Cruz de las Cuatro Flores* (*The Cross of the Four Flowers*), an object in the Fred and Jann Kline Family Collection (see attached Record for specific details). During several previous years, I had the opportunity to study transparencies of *Cuatro Flores* and to review Mr. Kline's research regarding his extraordinary discovery.

In my capacity as an art historian who has for many years specialized in and written about the 16th century Mexican art genre called *Tequitqui* (early Indian-Christian works), it is my opinion that *La Cruz de las Cuatro Flores* is a unique and important *Tequitqui* work of art and can be considered as well a rare masterpiece of New World Christian art.

The singular *Tequitqui* qualities of *Cuatro Flores* include its unique iconography and symbolism pointing to the fusion of the ancient Mesoamerican religion of Mexico and the newly introduced Christian religion of Europe; its small portable character, suggesting that it was probably used in early processions and altars among the newly converted Indians; its medium of carved wood, representing an amazing survival,

quite apart from the most common *Tequitqui* artifacts of carved stone— notably, the *atrial* crosses found in the early monasteries (to which *Cuatro Flores* is stylistically related) and the diverse architectural ornamentation carved on churches and buildings after the Conquest of Mexico and during the period of rebuilding.

According to a dendrochronological analysis of *Cuatro Flores* made by Dr. Louis Scuderi, *Cuatro Flores* was made from a pine tree cut circa 1535 in the Puebla region of Mexico, an area I had earlier suggested. In consideration of Dr. Scuderi's scientific data, I would offer a circa date of 1535–1560 for *Cuatro Flores*.

In all probability, the Indian master artisan who made *La Cruz de las Cuatro Flores* worked in Puebla at the Franciscan monastery of Huejotzingo. The four floral or cloverleaf symbols on *Cuatro Flores* are almost identical to the flower-like or quincunx designs carved in the *portería* (entry porch) of the monastery of Huejotzingo. I also find that the overall craftsmanship and style of carvings in the Huejotzingo *portería* suggest the same hand that made *Cuatro Flores*. I would support Fred Kline's attribution to "The Indo-Christian Master of the Huejotzingo Monastery Motifs."

The flowering cross represented by *Cuatro Flores* suggests a comparative relationship to the style of a medieval Christian cross—a variation of the Cross of St. Benedict is a possibility. It is plausible that *Cuatro Flores* may have been modeled after a small woodblock print of a cross that illustrated a friar's Bible.

Additionally and importantly, the motif of the flowering cross is also found in Mesoamerican mythology, a noted example of which is the circa 1350–1521 Mixtec-Aztec "World Tree" painting illustrated in the ritual book *Codex Fejervary-Mayer*, which delineates the Mesoamerican Cosmogram of the Center and the Four Directions of the Universe (cardinal points). The world tree designated "North Tree," to the left of the also north-facing central deity, exhibits remarkably comparative features to *Cuatro Flores*.

Both Mesoamerican and Christian flowering crosses represent the notion of resurrection. The death of Christ on the cross for the redemption of humankind was seen by the Indian people as a parallel of the concept of human sacrifice and rebirth in nature. This idea can be recognized in *La Cruz de las Cuatro Flores*, where flowers sprout from

the parts of the cross where the head, the two hands, and the heart of Christ (pierced dramatically by an iron nail) are located, suggesting that from blood and death emerges life. The base of *Cuatro Flores*, which is a representation of sacred cacao seedpods integrated into the earth, represents rebirth or resurrection in the spirit of the World Tree.

La Cruz de las Cuatro Flores, held in the Fred and Jann Kline Family Collection in Santa Fe, may be appreciated, as Mr. Kline has suggested, as a lost crown jewel of Mexican art history. It is an exceedingly rare New World object from the first transitional years of struggling evangelization and nascent religious practice which followed the Conquest of Mexico. I find it to be a masterful object that embodies, through its rare and exquisite design, the historical reality of the spiritual Conquest of Mexico.

It can be said that *La Cruz de las Cuatro Flores* is a Mesoamerican symbol that describes the cosmos, a universal Tree of Life related to the fertility of all nature, and a cross of Christ that that embodies Christian ideology and mysticism: as such, it can represent the living heart of Mexico. As an art historian who is deeply involved in the art history of Mexico, I feel fortunate to be among the first to examine and describe *La Cruz de las Cuatro Flores*.

Signed: M. Aguilar / Manuel Aguilar, Ph.D. / May 24, 2006

ANNOTATED RECORD (FRK)

A Maya-Aztec World Tree Cross (called *La Cruz de las Cuatro Flores*), in an Indo-Christian *tequitqui* style, circa 1530–1540s

Attributed to the Indo-Christian master of the Huejotzingo Monastery Motifs, presumed active circa 1530s–1540s, Puebla, Mexico, the Viceroyalty of New Spain

A carved wood cross on a carved wood base: Comprised of three carved sabino pine sections (two sections of the cross and one section of the base); one wrought iron nail (holding the two sections of the cross together); a tiny remnant of green paint on one flower.

DIMENSIONS (INCHES): Cross and the base (two separate but integrated pieces): 13¼ high x 7¾ wide x 3½ deep

CROSS (ONLY): 10¾ high x 7¾ wide x ½ deep

BASE (ONLY): 2½ high x 4 diameter (both top and bottom diameters)

CONDITION: Good overall condition. There is a small missing wedge of carved wood at the rear top and bottom of the base within an apparently continuous motif; one recent small broken-off fragment of base. Notable fly-specking on front and back of cross. The wood has no added finish and no restoration.

PROVENANCE

Private Collection, Mexico (as *Moorish-Hispanic Cross ca. 1700*)
James Caswell, Historia Antiques, Santa Monica, CA, until July 1999
Fred and Jann Kline Collection, Santa Fe, NM, July 1999
Consulting Scholars:
Dr. Manuel Aguilar: Art History (Mesoamerica), California State University, Los Angeles
Dr. Louis Scuderi: Earth and Planetary Sciences, University of New Mexico
Dr. Khristaan Villela: Thaw Professor and Chairman, Art History and Director, Thaw Art History Center, College of Santa Fe

SELECTED BIBLIOGRAPHY
(ARRANGED CHRONOLOGICALLY)

Elizabeth Wilder Weismann. *Mexico in Sculpture, 1521-1821.* Cambridge (Harvard). 1950.
Bernal Diaz. *The Discovery and Conquest of Mexico.* New York, 1956.
George Kubler. *The Art and Architecture of Ancient Mexico.* New Haven, 1962 (Third Edition, 1990).
Constantino Reyes-Valerio. *Arte Indocristiano; Escultura del Siglo XVI en Mexico.* Instituto Nacional de Antropologia e Historia, 1978.
Esther Pasztory. *Aztec Art.* New York, 1983.
Nancy M. Farriss. *Maya Society Under Colonial Rule: The Collective Enterprise of Survival.* Princeton, 1984.
Elizabeth Wilder Weismann. *Art and Time in Mexico, Architecture and Sculpture in Colonial Mexico.* New York, 1985.
Linda Schele and Mary Ellen Miller. *The Blood of Kings: Dynasty and Ritual in Maya Art.* Kimbell Art Museum and George Braziller. New York, 1986.
Fray Francisco Nunez de la Vega. *Constituciones diocesanas de obispado de Chiapa.* Universidad Nacional Autonoma de Mexico. 1988.
Evon Vogt. "Indian Crosses and Scepters: The Results of Circumscribed Spanish-Indian Interactions in Mesoamerica". Dec. 1988 Paper, Symposium "In Word and Deed . . ." Trujillo, Spain & In *Interethnic Encounters: Discourse and Practice in the New World*, SUNY Press, 1989.
Metropolitan Museum of Art (Exhibition catalogue, introduction by Octavio Paz and essays by numerous contributors). *Mexico, Splendors of Thirty Centuries.* New York, 1990.
Mary Ellen Miller & Karl Taube. *Gods and Symbols of Ancient Mexico and the Maya: An Illustrated Dictionary of Mesoamerican Religion.* New York, 1993.
David Freidel, Linda Schele, Joy Parker. *Maya Cosmos: Three Thousand Years On The Shaman's Path.* New York, 1993.

Susan Gillespie. "Power, Pathways, and Appropriations in Mesoamerican Art." In
Dorothea S. Whitten and Norman E. Whitten, Jr., eds., *Imagery and Creativity: Art
Worlds and Aesthetics in the New World*, 67-107. Tucson: Univ. Arizona Press, 1993.

Manuel Aguilar. *Tequitqui Art of Sixteenth-Century Mexico: An Expression of
Transculturation*. Ph.D. Dissertation, University of Texas, Austin, 1998.

Louise Burkhart. *Before Guadalupe: The Virgin Mary in Early Colonial Nahuatl Litera-
ture*. SUNY Albany, 2001.

Timothy Reddish. "Chamulan Catholicism: A Study in Cultural Survival" (Senior
Project paper submitted to Department of Religious Studies/Adviser Dr. Philip
Lucas, Stetson University). 2002.Published at associated link www.stetson.edu .

The Museum of Fine Arts Houston/Museo Franz Mayer.(essays by Antonio Rubial
Garcia and others; see Garcia, "The Kingdom of New Spain at a Crossroads").
The Grandeur of Viceregal Mexico: Treasures from the Museo Franz Mayer.
Distributed by University of Texas Press, 2002.

CHAPTER 10

Aaron of Exodus,
Magus in the Wilderness

Pier Francesco Mola, *Aaron, Holy to the Lord*. Private Collection.
37 ¼ x 27 ¾ inches (94.6 x 70.5 cm), oil on canvas, Unsigned

I

After 2,500 years, Aaron still drifts, an outsider in the clouds of biblical twilight, changing with the whims of orthodoxy and new perceptions. Aaron, the holy sorcerer, whose magic rod wrought miracles. Aaron, who spoke for his stuttering younger brother Moses. Aaron, first high priest of the Israelites, founder of the priestly dynasty that leads all the way to Jesus.

Aaron's mythic biography is amazing, and no doubt his actual life was amazing, too. Aaron, and surprisingly, his rare place in art history, were on my mind in Santa Fe in 1991, as I had found an unsigned portrait of Aaron—a true masterpiece—and it made me realize that I had never seen, or even heard, of a portrait of Aaron.

∽

A new wind had pushed me toward Exodus and away from the ubiquitous New Testament scenarios depicting the life of Jesus, Mary, Joseph, and the Catholic saints, subjects I most often encountered in dealing with Old Master paintings and drawings. Over the past few years, beginning with Jann's Peruzzi *Holy Family*, I had become a surprised and unsuspecting art explorer within the Judeo-Christian religious mythos, and quite willingly followed where it led. Considering the New Testament–themed art I have discovered over thirty-five years, I felt as if I was on a sort of knighted mission, despite the irony that I was not necessarily religious in a traditional sense but believed in a more cosmic and poetic form of spirituality.

With regards to Aaron, an obituary writer in the *New York Times* wouldn't know where to begin. What would the title say? Perhaps "Aaron of Exodus: With Moses, He Led the Israelites out of Egypt." Or "Aaron: With Moses Told Pharaoh 'Let my people go!'": Or perhaps even "Aaron, Forgotten Man of Old Testament and Jewish History." But what, indeed, ever happened to Aaron?

For one thing, you just don't see him in art, not like his brother Moses. Given Aaron's importance in Judaic and Christian traditions, the question puzzling me was the disappearance of Aaron in art history. Paintings of Aaron can only be found in renderings of the ill-fated Golden Calf

celebration, the most famous being *The Adoration of the Golden Calf* by Nicolas Poussin (1594–1665) in the National Gallery London. Aaron's depiction in sculpture is practically nil, as well. Wasn't he the first artist singled out in the Bible, with his creation of the golden calf sculpture, and notably, the first controversial artist as well? As perceived by God and Moses, the golden calf was not an acceptable vision of the divinity that delivered the Israelites from Egypt, but instead it was considered a blasphemous "idol," which, in itself, threatened the wrath of God. Aaron was forgiven for his part in its creation, but many of the people who urged this idolatry were executed. You would think that the imagination of artists over the centuries would have been inspired by Aaron, certainly Michelangelo's, and thus leading to Aaron being a subject in at least some artwork of the period. Yet he is nowhere to be found.

I would later find, among other revelations, that the lost portrait of Aaron I had found was quite surprisingly considered the unique single figure of Aaron to have been painted by a European Old Master artist, circa 15th–18th centuries. Another puzzle, perhaps solved by his being almost totally overshadowed by Moses. But who was the groundbreaking artist who painted his first portrait, and what was the motivation?

II

Aaron was wandering in Massachusetts, and I was in Santa Fe sitting in my study, when I happened upon him in a painting at Skinner Auction in Boston, May 10, 1991. I saw the painting in the auction catalogue as a snapshot: a small, dark, black-and-white reproduction, but I could see well enough to find it mesmerizing. It registered instantly as a masterpiece, perhaps even a great masterpiece, and with no acknowledged attribution. I could hardly sit still and immediately went to my books to see if my idea was comparative and correct for Jose de Ribera (1591–1652), the artist I had in mind.

The very dark, black-and-white catalogue picture presented a frontal presentation of a priest shown down to his waist, powerfully characterized, and clearly in the style of 17th century Italian Baroque paintings. Baroque art from the 1600s in Italy is recognizable by its dramatic and sharply realistic presentation of portraits and biblical genre, which takes a different

direction from the 16th century Italian Renaissance and its more serene approach. The Baroque period produced some of Europe's greatest and most influential artists, including Rembrandt, Rubens, Vermeer, Velazquez, Poussin, and Caravaggio.

"Aaron" related closely to the style of the influential and very innovative realist Michelangelo Merisi Caravaggio (1571–1610), whose ground-breaking, shockingly realistic style, called Caravaggesque, was widely assimilated by his many followers in Italy and in Europe after his death.

My first idea for authorship of *Aaron* was Jose de Ribera, the great Spanish-Italian master, who worked in Naples for his entire career in an evolved Caravaggesque style, particularly in his masterful portrait characterizations of saints.

Once seen, Ribera's paintings had remained vividly in my memory. After checking Craig Felton and William Jordan's beautifully illustrated Ribera catalogue from a past Kimball Museum exhibition, I could see that I might be correct or very close. Attributing this portrait of Aaron, already so rare a subject for a Old Master painting, could easily be a discovery of the highest importance to art history and a million-dollar painting as well. I called Skinner and asked for a color image, and they at least sent a color slide, but still dark, which I then projected onto a screen and studied.

The subject of the painting had been correctly identified by Skinner's as "Aaron, High Priest of the Israelites," but with no authorship other than a vague "Continental School, circa 17th–18th Century," and with a bottom-of-the barrel estimate of $3,000–5,000. It was hard to imagine the meager extent of Skinner's research and expertise that went into misrepresenting such an obviously important painting, but I was overjoyed that I might have a fighting chance to buy it. All I needed was a little money—$5,000 or $7,000 might do it—but at that moment, my treasury for purchasing art was too low to even bid to the low estimate.

The catalogue had come out of the blue, without a subscription, probably in a promotional campaign to a list of dealers in Santa Fe and around the country. And there was *Aaron*, item #1, first out of the gate in the "Fine American and European Paintings sale. The sale would be in three weeks. I felt certain that no one would miss it, especially the Old Master dealers

in New York and London. It was a fantasy to think I might have a chance, but I couldn't let it go. Where would I find the money? I wanted to be, at least, the dark horse in the race to come.

The painting depicted the single figure of Aaron, his face in pious concentration, and offered a deeply psychological and uncommonly sensitive portrayal. Among Aaron's priestly garments, he wore a crown-like headdress called a miter, commonly seen on Roman Catholic bishops, yet oddly a Hebrew inscription stood out on the gold headband. A Jewish priest was an odd concept, but then I had a lot to learn. I had thought Aaron surely might have been a rabbi, but, as I soon learned, the rabbinical tradition would come much later.

I called the late Rabbi Leonard Hellman in Santa Fe to translate the inscription, *Koddesh Le YHWH*, which he quickly read as "Holy to the Lord." He explained that YHWH is the Orthodox Jewish manner of transcribing "Lord" or "God," thus avoiding the actual word "*Yahweh*," which in the Orthodox tradition would itself present a sacrilegious image. Hellman said Aaron was beginning the celebration of Yom Kippur at sunset and the setting was the wilderness tabernacle during the exodus from Egypt. The brilliant red cap on Aaron's miter, placed close to the horizon, suggested the setting sun; in brilliant echo, he held a silver censer with a glowing red ember within. You could smell the incense, hear the prayers, and sense the aura of devotion.

The carefully rendered Judaic iconographic details in the portrait are rarely depicted in old masterworks. The overwhelming majority of religious subjects from all the Old Master artists are thematically Catholic, going back to Cimabue and Giotto in the 13th and 14th centuries. Here, with Aaron, the artist appeared to be reading Exodus, where the adornments of High Priest Aaron are described. Most important is the beautifully rendered breastplate around Aaron's neck. As recounted in Exodus, the breastplate was made by the renowned craftsman Bezalel, who set into it twelve stones to represent the twelve tribes of Israel. The breastplate contained a mysterious inner oracle known as Urim and Thummim that could be asked questions. In keeping with Aaron's magical powers, he could read the glittering of the stones and divine an answer. Aaron was the first biblical fortune-teller.

Later research soon revealed a revelation that helped to explain the painting's creation. The unusual subject of Aaron probably had a direct relationship to mid-17th century Jewish history, as well as Catholic history, characterized by a controversial messianic movement involving a Turk named Sabbatai Zevi (1626–1676), a Sephardic rabbi and kabbalist who claimed to be the long-awaited Jewish Messiah. Zevi's influence spread to communities all the way to England, creating a religious contagion promising the universal cure of a Second Coming. The Zevi zeal and doubtless his messianic message was noted by the Catholic Church as a possible threat to Jesus. The need to further establish Aaron in the Judeao-Christian priestly tradition, and thus linking him to Jesus and securing Jesus' spot as the true Messiah, was suggested in this painting, which shows signs of the influence of the Roman Catholic Church and the creation of *Aaron* during the mid-1600s.

<p style="text-align:center">∽</p>

Theology aside, I was still seeking the answer to the whodunit. I had Ribera in mind as a likely lead, but first things first. The auction was looming and I had no money, so I had to find someone who had money to invest, someone who trusted my eye. I had new friend who I will call St. Anthony, or a more down-to-earth St. Tony. He was indeed as Catholic as St. Anthony and, as time would tell, a real saint of a guy.

St. Tony had read an article I had published in *Art and Antiques* magazine ("You Never Know," July 1989), where I recounted a number of serendipitous art discoveries. He called to say he loved my art adventures and asked me if I would look into a painting he owned that was attributed to Guido Reni. His Reni looked quite good—I felt the attribution to be sound—and I helped him sell it at auction, but the last step had been a disappointing experience. I was not personally acquainted with the Reni specialist, the late D. Stephen Pepper, although we had paid him $1,000 for an imperious and inconclusive "quick" look. The painting, without his blessing, brought a modest percentage of the $100,000-plus we had hoped. After ensuring that they had scared off potential competition, I suspected the wily Dr. Pepper and his associates had purchased it. My best advice to

St. Tony should have been to hold on to it, but he was willing to gamble and I needed the generous commission he promised. I think he gambled for my sake, out of compassion for my limited finances. After that bad luck, I felt I had burned my bridge to a possible patron. A year would pass before *Aaron* came along, and I hoped he could help me reinstate some karmic goodwill.

After several dead ends with investors closer to home, I called St. Tony on Long Island, and with renewed confidence he agreed with my enthusiastic pitch—without seeing an image of *Aaron* and accepting its unattributed, unsigned status. He would back my bid up to $8,000, and we would fairly divide future profits.

<div style="text-align:center">⤜∾⤛</div>

It was a cold and rainy May evening in Boston when the Skinner auction opened with "'Aaron,' Continental School 17th–18th century." From Santa Fe I began to bid over the phone. It was quickly getting expensive. My phone connection said an old man in the front row was bidding against me. The bidding pushed past $8,000 but I couldn't stop. It kept going up as I aggressively topped the old man's bid. By then, I had independently set another limit at $20,000, and who knows where I would find the cash, but I was on a mission. The auction agent did not know the bidder, had never seen him before, just an old guy who "liked it." Suddenly the bidding stopped with my last bid. I was told the New York dealers were late in arriving, held up by the rain, and they were upset to learn that it had sold for $18,700. The big spenders from New York surely would have topped my bid.

With good-natured acceptance, at the unexpected doubling of the financial stakes, St. Tony understood. "I'm betting on you," he said. "As you can see, I'm a gambler, and I've got a feeling we're backing a winner. Spend what you need to get it in shape." After he had paid Skinner and allowed the painting to be sent to me, I sent him a photograph and he saw "Aaron" for the first time in color, and he loved it. We were now partners in an extraordinary long-distance relationship that never ceased over twenty years to honor the trust we had in each other, in spite of never having met face-to-face. "St. Tony" is not a name I have pulled out of thin air.

Soon I was in touch with Professor Craig Felton, then chairman of the Art History Department at Smith College and the ranking Ribera specialist in the United States. After studying the transparency I sent, he said Ribera was not the artist. Of that he was certain. It was close, however, and surely a beautiful 17th century Italian Baroque painting, but not Ribera. He offered to help gather opinions from other scholars and ultimately identify the author of *Aaron*. Dr. Felton knew everybody and frequently traveled to the art capitals of the world. When I mentioned tantalizing commissions down the line and contracting for his services as a consultant, he politely refused; just happy to do it, he said, but perhaps we could cover some minor expenses for further research once he was soon in Britain and Europe on a previously planned trip. Personable and scholarly without being pedantic, Felton and I quickly became relaxed friends. I was feeling all around lucky. Already one saint had appeared, now here was another. *Aaron* and the mystery surrounding him seemed to radiate magic.

Another great Italian Baroque painter of the period, Giovanni Francesco Barbieri (1591–1666), best known as "Guercino" (the squinting one), had been suggested by a few prominent art historians upon viewing *Aaron*. But Felton was still not satisfied. Before going to Europe, he said there was one very important opinion he was after, the late Robert Manning, an extraordinary connoisseur and collector whom he would personally visit in a nearby state and show a transparency.

Upon seeing *Aaron*, Robert Manning thought it was yet another Italian Baroque painter, Pier Francesco Mola (1612–1666), and Felton was very persuaded. I bought a book of Mola's paintings, and I too was persuaded. In fact, I could see that *Aaron* amazingly shared the exact model as the Louvre's famous Mola, *Barbary Pirate* (see color insert), the artist's best known painting and the only one he ever signed, with a 1650 date as well. Along with the exact likeness in the intense faces of the two models, and even the *Barbary Pirate*'s feather and its echo in *Aaron*'s palm leaf in the landscape (this is not merely an accidental coincidence), I continued to find additional signature comparative details in a catalogue of his paintings. I could see Mola's unmistakable hallmarks repeated in *Aaron*, including: distinctive sky and clouds, sparing use of red in a diagonal placement, and exacting depiction of ornament. With a probable date of 1650, which

brought it within the appropriate time frame, we had a highly assured answer to whodunit. I informed St. Tony, and he was pleased we were making progress.

Mola was one of the leading Roman artists of his time. He was a favored artist of Pope Innocent X and was held in high esteem by the most prominent noble houses in Rome and by royalty across Europe. Today, he is recognized for his exceptional mastery in portraiture, history painting, landscape, and his distinctive drawings. I could see that *Aaron* compared most favorably to Mola's significant works in other museum collections: to the Getty's *The Vision of Saint Bruno*, the Metropolitan Museum's *Rest on the Flight into Egypt*, and certainly to the Louvre's *Barbary Pirate*. In recent years, several of his paintings have topped $1 million at auction. He made only about fifty paintings—due to an assortment of legal problems and illness—so his work is rare as well.

P. F. Mola, *Barbary Pirate*. 68 x 48 in. Oil on canvas signed and dated 1650. Louvre Museum, Paris.

Mola, *Aaron* Mola, *Barbary Pirate*

On his own initiative, Felton began to look into the provenance of *Aaron*. We knew it had come to Skinner from a Christian seminary collection in New England. Digging deeper, I found it had been donated anonymously to the seminary in the 19th century and since then had been in storage. An old sticker on the frame suggested it had been purchased at an auction in New York City before being donated to the seminary. Felton went searching in the Getty Museum provenance archives and discovered the original source. In all probability, *Aaron* had been commissioned along with a companion portrait of Moses (still lost) by Lorenzo Onofrio Colonna (1637–1689), Duke of Paliano and Castiglione, Grand Constable of the Kingdom of Naples, whose great art collection at his Palazzo Colonna in Rome was world renowned. The size and description of *Aaron* matched our painting—ironically, the artist was not identified! In 1689, the painting descended to his son Filippo Colonna (1663–1714), and from there it was lost with no further record until turning up at the auction in New York centuries later.

Before long, Felton had traveled to London with the promise he would show a transparency to Sir Denis Mahon (1910–2011), a legendary collector

and art historian who was revered as one of the great connoisseurs of 17th century Italian Baroque painting. Sir Denis enthusiastically supported the Mola idea.

Some years later, I don't hesitate to mention, I wrote to Sir Denis and asked his opinion for a drawing of mine which I had attributed in a detailed paper to Annibale Carracci. A few months later, I answered the phone at my gallery, and it was Sir Denis calling from London to congratulate me for the Carracci discovery. I called Felton and told him. "You should feel anointed," he said. I passed along the great moment to all the collectors I knew. In so highly competitive a world, these genuine acts of artistic appreciation, feedback, and willingness to engage in an exchange of ideas are increasingly rare and worth applauding.

⚬∞⚬

Back in the States, with the attribution and provenance of *Aaron* coming together, I was saddened to find that attempts to sell the Mola *Aaron* at Sotheby's and Christie's auction failed. I think the Jewish priest with the Catholic bishop's hat was just too strange to attract the right level of enthusiasm. In spite of continuing support for the Mola attribution from eminent scholars like Keith Christiansen at the Metropolitan Museum of Art, Dawson Carr then at J. Paul Getty Museum, and independent Washington, DC, art historian and Mola scholar William Kloss, I could not find a buyer. Despite the place Aaron occupies in biblical history, his story does not seem to excite the same passion as other characters in that mighty narrative. St. Tony now owns the painting, having purchased my interest, and it still resides today in his Long Island home.

⚬∞⚬

Clearly, *Aaron*'s aesthetic quality and its metaphoric and naturalistic power places the painting alongside Mola's masterpieces, and among the most extraordinary Baroque paintings of the 17th century. *Aaron* still has not been exhibited in a museum. Mola's companion portrait of his brother Moses is still lost.

CHAPTER 11

A Vermeer Discovery

Anything will give up its secrets if you love it enough.
—George Washington Carver (1864–1943, American botanist)

Johannes Vermeer; *St. Praxedis*, oil on canvas, Private Collection,
on long-term loan to National Museum of Western Art, Tokyo

339

The 17th century Dutch painter Johannes Vermeer (1632–1675), master of an unequalled realism, had only modest success during his short lifetime. He negotiated sales of his own paintings to a few wealthy collectors in his hometown, Delft, where he was also an art dealer in the works of other artists. His time period in art history, known as the Dutch Golden Age, generally spanned the 17th century, and included Rembrandt van Rijn (1606–1669), Frans Hals (1582–1666), and Jan van Goyen (1596–1656), among eminent artists.

Tragically, Vermeer died at forty-three in a time of war and economic depression, ridden by debt and stress, and generally unknown beyond Delft. He left a wife and eleven children—at his sudden death, his wife noted that he was fit one day, and then dead the next. Unlike Rembrandt, Vermeer did not have students, and thus his influence as a teacher was not carried forward with followers beyond his death. He worked secretively, and even mysteriously—much like an alchemist employing an eccentric scientific technique with the aid of a magical brush—working slowly, but exceedingly fine.

Vermeer produced perhaps forty paintings in his lifetime; at the time of his death, many remained unsold in his estate. These paintings were sold cheaply, bartered away to tradesmen, used to repay loans, and thence scattered around Delft. Today it is believed that most, but not all of them, have been accounted for and gathered in museums. And it took a very long time for the museums to wake up. It wasn't until 1866—more than 200 years after Vermeer's death—that French art historian Theophile Thore-Burger had a revelation and recognized that Vermeer was worth looking at again and blew the dust off two centuries of neglect. The art world took excited notice.

Today, a small, perhaps an 18 x 15-inch oil on canvas by Vermeer, say the long-lost *Gentleman Washing His Hands*, would fetch $100 million-plus at auction—or even more, privately, with a dealer who had the savvy to ask the right price from the right billionaire collector. And the exciting thing is that there are lost Vermeers still out there. And not just one. If it's out there, it's likely on damaged canvas with flaked paint, filthy, probably unsigned, and maybe with an improbably low asking price of around $500. The possibility of finding such a treasure loomed large in my subconscious dreams.

In a little-known episode from recent art history, the dream of a Vermeer discovery did come true for the late Spencer Samuels, a New York connoisseur and wealthy dealer in Old Masters, who was one of my earliest mentors, a man never too busy to be warm, kind, and helpful to a novice dealer with endless questions. One day in 1985, I asked him over the phone what he was working on, and he said it was the greatest art treasure I might imagine, and that he had been working on it since 1969. He made me guess and, after Leonardo da Vinci (how ironic with my first guess, given the discovery of *Holy Child* fifteen years later!), I said Johannes Vermeer. Yes, Spencer said, I have a Vermeer, and it looks like it's going to be accepted. But it had not been quite that simple.

In 1969, Spencer purchased the painting from the estate of New York collector Jacob Reder, who had bought it at a minor New York auction in 1943. *Saint Praxedis* had recently been in an exhibition of Florentine Baroque art at the Metropolitan Museum of Art, and it was catalogued as by Italian painter Felice Ficherelli, called "Riposo" (1605–ca. 1669)—which had been its established authorship in the Reder collection. Then, out of the blue, the Met conservators discovered a signature, "Meer 1655," which suggested Vermeer, and so another line of discussion arose. In a review of the exhibition, the noted British art historian Michael Kitson suggested *Saint Praxedis* could be an authentic Vermeer, based on a stylistic comparison with an early Vermeer, *Diana and Her Companions*, a mythological scene. Kitson's opinion sparked Spencer's interest—to his eye, the style also resembled that of the young Vermeer. And thus, Spencer Samuel's quest began.

Saint Praxedis shows a particularly serene and beautiful female saint kneeling down and gathering, in a vase, the blood of a decapitated martyr who lies headless nearby. This mix of beauty and horror is clearly not everyone's first choice for a painting in the dining room. The grim scene had no doubt turned many away from looking at it closely.

Less than a handful of Vermeer's accepted paintings from this early period existed as comparisons, and to make matters worse, an infamous group of faked early-style Vermeer paintings of religious subjects—by 20th century master forger Han van Meegeren—had corrupted and confused

thinking in the art world since World War II. If it did in fact resemble an early Vermeer, some pundits suggested it could be a remnant from this forger's stockpile. What did Spencer Samuels know about Vermeer anyway?

After years of searching for more evidence to support Spencer's bright but fading Vermeer idea, lo and behold, the signed original Riposo painting of *Saint Praxedis* turned up in the Old Master market, suggesting that Spencer had a copy. Not a fake, mind you, but an old copy, a very good one, and logically, another version painted by the artist Riposo himself. But a copy by Vermeer? Why would Vermeer copy a Riposo? The failure of Spencer's attribution seemed assured.

For years, scholarly opinions seemed to be going against him—in effect they were saying, "It doesn't look like a Vermeer." Then a breakthrough! Further study had revealed a hidden, abraded, practically unreadable, but possible second signature close to the one already noted. But was it even a signature? It seemed unreadable. The discovery and the unraveling of this inscription, hanging on for dear life (and you can imagine Spencer's anticipation), was detected by the esteemed art historian and NYU Professor Egbert Haverkamp-Beggeman. After much deciphering of this code-like vestige—"Meer N R o o"—a feat that no one else had been able to achieve, Haverkamp-Beggeman pieced it together and was able to conclude it read, "Meer naar Riposo," which translated as "Vermeer after Riposo." Vermeer had copied a Riposo! Reasonably considered, it was an admiring *copy* Vermeer had made of another artist's work, perhaps as a study to improve his technique. But still, would the picture itself now stand up to scrutiny? The race wasn't yet won. Now, with the appearance of the second signature, further scientific study of the paint itself was called for. Happily, nothing was found to disqualify it.

Saint Praxedis, Vermeer's earliest known painting and a most unexpected work, finally was published in 1986 by National Gallery of Art curator and Vermeer scholar Arthur Wheelock, a generation after Spencer began his studies on it. Spencer, who had already gathered his millions and toiled away for the love of art, nevertheless sold it the next year, with Wheelock's benediction, for undisclosed multimillions to a collector in Princeton, New Jersey, the late Basia Piasecka Johnson (1937–2013). Basia (staying with the manner of a fairy tale) inherited $500 million of the Johnson & Johnson

fortune from her late husband, J. Seward Johnson Sr.—whom she married after working as his cook and chambermaid! Cinderella had blossomed into a serious art historian and one of the world's great collectors. When Basia's estate was auctioned after her death, Vermeer's copy of Riposo brought only $10.6 million at Christie's in 2014. After all, considering this comparatively low price for a Vermeer, it was merely a youthful copying exercise and not an original creation by the artist. But in its favor, *Saint Praxedis* was rare and important and, in the end, integral to understanding the progression of Vermeer's career. It was an extraordinary triumph for art history and for the unrelenting vision of Spencer Samuels.

<p style="text-align:center">⌇∾⌇</p>

Spencer knew the Vermeer was right all along. His connoisseur's eye and intuition wouldn't let it rest, despite the roadblocks thrown in his way with the van Meegeren forgeries muddying the waters, the ubiquitous nay-saying of scholars, and then Vermeer's unsuspected and eccentric choice to copy Riposo. He persevered and with his discovery rewrote Vermeer's history. Spencer knew what he was after and he never gave up. And then, there is the double benefit of Riposo being famously resurrected too: "He influenced Vermeer!" can now be a rallying cry for enthusiasts of that artist. It's never too late with art.

Spencer's work on his Vermeer taught me a valuable lesson in perseverance and his example has helped me stay the course over the entirety of my own adventurous career as an "art explorer." It is the passion for art that fuels the fire and after all these decades searching for lost art, this field has remained a true labor of love for me, with each new project becoming a continuing dance with art.

Sometimes things happened quickly, sometimes over years, even decades, with all the unimagined yet necessary twists and turns—like with Leonardo's *Holy Child*, or the New World *Virgencita*, or the gathering of George Caleb Bingham's many lost paintings. In the end, you never know what will turn up, but in looking at art, it is good to remember that you will only see what you know. With the connoisseur's eye and a touch of the poet in the mix, great discoveries still await the art explorer's quest.

Ars longa, vita brevis, occasio praeceps, experimentum periculosum, iudicium difficile. (Art long-lasting, life short, opportunity fleeting, experiment treacherous, judgment difficult)
—Hippocrates (b. 460 B.C., d. 357 B.C.)

ABOUT THE AUTHOR

Photo: Angela Zimm

F red R. Kline (b. 1939) is an art historian, writer, and poet, private art
dealer, sculptor, journalist, and teacher. Over the last thirty-six years,
Kline's discoveries of lost art have been widely featured, including twice in
the *New York Times* ("An 'Art Explorer' Finds the Real Creators of Works,"
2002, and "A Poem by Wild Bill Hickok," 1986); *Art and Antiques* ("You
Never Know: An Ongoing Search for Lost Art in America," 1989); and
in the art history textbook *Framing America: A Social History of American
Art* by Francis Pohl (3rd ed., 2012), which highlighted and illustrated his

discovery of the ca. 1530 Indo-Christian sculpture, *La Virgencita del Nuevo Mundo*, among the first post-conquest New World works of art.

Many of Kline's discoveries have been acquired by museum, corporate, and private collections—notable among them the Thaw Collection of Master Drawings at the Morgan Library, the J. Paul Getty Museum, the Metropolitan Museum of Art, the Jenness Collection of Master Drawings at Clark Art Institute, the Leeds Museum, and the Frances Lehman Loeb Art Museum at Vassar College.

His discoveries include: Old Master paintings by Jan Brueghel the Elder (2), Pier Francesco Mola, Luis de Morales, Gottlieb Schick, Jan van Goyen, Theodore Gericault, James Peale (2), and Sir Edward Landseer; master drawings by Leonardo da Vinci, Baldarsare Peruzzi, Andrea del Sarto, Annibale Carracci, Frans Snyders, Joseph Anton Koch, Vincent Van Gogh, Eugene Delacroix, Raphaelle Peale, George Bellows (oil sketch and two drawings), and Robert Motherwell; and 19th and 20th century American paintings, including: John Quidor, Thomas Eakins, and twenty-seven lost paintings by George Caleb Bingham appearing in the Bingham Catalogue Raisonne Supplement (est. 2005), of which he is director-editor.

Kline also uncovered an extraordinary folio of undocumented lost works by the French sculptor Henri Gautier-Brzeska (1891–1915) containing drawings, personal photographs (his last photograph before dying in WW I), letters, and the original H. S. Ede manuscript of *Savage Messiah*.

During the 1970s, Kline was a writer on the editorial staff of *National Geographic*, publishing articles in the magazine and in books and surviving adventures in the Arctic and American cities. His public sculpture *Temple of the Hills* in Santa Fe was chosen for national recognition in 1995 by *Art in America* and the Smithsonian Outdoor Sculpture Survey. At the invitation of U.S. poet laureate Josephine Jacobsen, he recorded selections from his four books of poems at the Library of Congress.

He lives with his two dogs on a ranch near Santa Fe, New Mexico, a 20-acre forested nature preserve at an altitude of 7,200 feet, where he has also established the Kline Art Research Library, open to students and scholars. His wife and partner of 30 years, Jann Kline, died in 2011.

ACKNOWLEDGMENTS

I wish to acknowledge, with gratitude, the invaluable assistance of my editor Jessica Case at Pegasus Books, my agent Matt Bialer at Greenburger Associates, and my dancing partner, Angela Zimm.

The publisher would like to thank Maria Fernandez and Katie McGuire.

ILLUSTRATION CREDITS

INDEX